The
NEWSPAPER
DESIGNER'S
HANDBOOK

The
NEWSPAPER DESIGNER'S HANDBOOK
Fifth edition

WRITTEN & DESIGNED BY **TIM HARROWER**

Boston Burr Ridge, IL Dubuque, IA Madison, WI New York San Francisco St. Louis
Bangkok Bogotá Caracas Kuala Lumpur Lisbon London Madrid Mexico City
Milan Montreal New Delhi Santiago Seoul Singapore Sydney Taipei Toronto

McGraw-Hill Higher Education &

*A Division of The **McGraw-Hill** Companies*

THE NEWSPAPER DESIGNER'S HANDBOOK, FIFTH EDITION

Published by McGraw-Hill, an imprint of The McGraw-Hill Companies, Inc. 1221 Avenue of the Americas, New York, NY, 10020. Copyright 2002, 1998, 1995, 1992, 1989, by The McGraw-Hill Companies, Inc. All rights reserved. No part of this publication may be reproduced or distributed in any form or by any means, or stored in a data base or retrieval system, without the prior written consent of The McGraw-Hill Companies, Inc., including, but not limited to, in any network or other electronic storage or transmission, or broadcast for distance learning.

Some ancillaries, including electronic and print components, may not be available to customers outside the United States.

This book is printed on acid-free paper.

4 5 6 7 8 9 0 QPD/QPD 0 9 8 7 6 5 4 3

ISBN 0-07-240761-1

Publisher: *Phillip A. Butcher*
Editor: *Valerie Raymond*
Marketing manager: *Kelly May*
Project manager: *Jean R. Starr*
Production supervisor: *Lori Koetters*
Media producer: *Jessica Bodie*
Supplement producer: *Vicki Laird*
Photo researcher: *Judy Kausal*
Cover illustration: *Fred Ingram and Steve Cowden*
Typeface: *11.3/12.8 Minion*
Compositor: *H & S Graphics, Inc.*
Printer: *Quebecor World Dubuque Inc.*

Library of Congress Cataloging-in-Publication Data

Harrower, Tim.
 The newspaper designer's handbook / written & designed by Tim Harrower.-- 5th ed.
 p. cm.
 Includes index.
 ISBN 0-07-240761-1 (acid-free paper)
 1. Newspaper layout and typography. I. Title.

Z253.5 .H27 2002
686.2'252--dc21

 2001034512

www.mhhe.com

THIS BOOK IS FONDLY DEDICATED TO:

Robin, 70%

Mom and Dad, 10%

Pat, 5%

Assorted friends and pets, 15%

CONTENTS

PREFACE

long, long time ago, people actually loved reading newspapers. Imagine.

They'd flip a nickel to the newsboy, grab a paper from the stack and gawk at headlines that screamed:

SOLONS MULL LEVY HIKE BID!

They'd gaze lovingly at long, gray columns of type that looked like this —

— and they'd say: "*Wow!* What a lot of news!"

Today, we're different. We've got color TVs, home computers, portable CD players, glitzy magazines. We collect data in a dizzying array of ways. We don't need long, gray columns of type anymore. We won't *read* long, gray columns of type anymore.

In fact, when we look at newspapers and see those long, gray columns of type, we say: "*Yow!* What a waste of time!"

Today's readers want something different. Something snappy. Something easy to grasp and instantly informative.

And that's where you come in.

If you can design a newspaper that's inviting, informative and easy to read, you can — for a few minutes each day — successfully compete with all those TVs, CDs, computers and magazines. You can keep a noble old American institution — the newspaper — alive for another day.

Because let's face it: To many people, newspapers are dinosaurs. They're big, clumsy and slow. And though they've endured for eons, it may be only a matter of time before newspapers either:

◆ become extinct (this has happened to other famous forms of communication — remember smoke signals? The telegraph?). Or else they'll:

◆ evolve into a new species (imagine a portable video newspaper/TV shopping network that lets you surf the sports highlights, scan some comics, then view the hottest fashions on sale at the TechnoMall).

PREFACE

Those days are still a ways off. For now, we just do our best with what we have: Ink. Paper. Lots of images, letters, lines and dots. A good designer can arrange them all quickly and smoothly, so that today's news feels familiar and . . . new.

But where do newspaper designers come from, anyway? Face it: You never hear children saying, "When I grow up, my dream is to *lay out the Opinion page.*" You never hear college students saying, "I've got a major in rocket science and a minor in *sports infographics.*"

No, most journalists stumble into design by accident. Without warning.

Maybe you're a reporter on a small weekly, and one day your editor says to you, "Congratulations! I'm promoting you to assistant editor. You'll start Monday. Oh, and . . . you know how to lay out pages, don't you?"

Or maybe you've just joined a student newspaper. You want to be a reporter, a movie critic, a sports columnist. So you write your first story. When you finish, the adviser says to you, "Uh, we're a little short-handed in production right now. It'd really help us if you'd design that page your story's on, OK?"

Now, traditional journalism textbooks discuss design in broad terms. They ponder vague concepts like *balance* and *harmony* and *rhythm.* They show award-winning pages from The New York Times or The Wall Street Journal.

"Nice pages," you think. But meanwhile, you're in a hurry. And you're still confused: "How do I connect *this* picture to *this* headline?"

That's where this book comes in.

This book assumes you need to learn the rules of newspaper design as quickly as you can. It assumes you've been reading a newspaper for a while, but you've never really paid attention to things like headline sizes. Or column logos. Or whether pages use five columns of text instead of six.

This book will introduce you to the building blocks of newspaper design: headlines, text, photos, cutlines. We'll show you how to shape them into a story — and how to shape stories into pages.

After that, we'll look at the small stuff (logos, teasers, charts and graphs, type trickery) that makes more complicated pages work. We'll even show you a few reader-grabbing gimmicks, like subheads, to break up gray columns of type:

YO! CHECK OUT THIS ATTENTION-GRABBING SUBHEAD

And bullets, to make short lists "pop" off the page:
- ◆ This is a bullet item.
- ◆ And so is this.
- ◆ Ditto here.

We'll even explore liftout quotes, which let you dress up a quote from somebody famous — say, Mark Twain — to catch your reader's eye.

Yes, some writers will do *anything* to get you to read their prefaces. So if you made it all this way, ask yourself: Did design have anything to do with it?

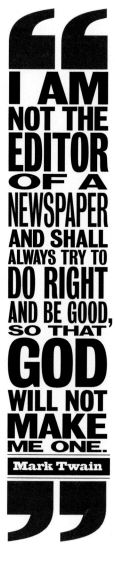

"I AM NOT THE EDITOR OF A NEWSPAPER AND SHALL ALWAYS TRY TO DO RIGHT AND BE GOOD, SO THAT GOD WILL NOT MAKE ME ONE.
Mark Twain"

A BRIEF WORD OR TWO ABOUT THIS FIFTH EDITION

For this edition, we've added a chapter on Web design, a CD-ROM of exercises, new "Troubleshooting" Q&A's at the end of each chapter. And we've added color — lots of spiffy new examples of color pages, photos and graphics.

Now, most pages at most newspapers, we realize, are still black and white. And we certainly didn't want a lot of readers *honked off* at us for going overboard with this color thing. So we deliberately held back, keeping a large proportion of black-and-white images throughout the book.

Whether you're a big daily or a tiny weekly, a tab or a broadsheet, color or black and white — you'll find plenty of helpful answers in the pages ahead. Enjoy!

— *Tim Harrower*

SOME QUICK HISTORY

THE SIMPLE BEGINNINGS

Publick Occurrences, America's first newspaper, made its debut 300 years ago. Like other colonial newspapers that followed, it was printed on paper smaller than the pages in this book, looking more like a pamphlet or newsletter.

Most colonial weeklies ran news items one after another in deep, wide columns of text. There were no headlines and very little art (though it was young Ben Franklin who printed America's first newspaper cartoon in 1754).

After the Revolutionary War, dailies first appeared and began introducing new design elements: thinner columns, primitive headlines (one-line labels such as *PROCLAMATION*) and — this will come as no surprise — an increasing number of ads, many of them parked along the bottom of the front page.

Colonial printing presses couldn't handle large sheets of paper, so when Publick Occurrences was printed in Boston on Sept. 25, 1690, it was only 7 inches wide, with two 3-inch columns of text. The four-page paper had three pages of news (the last page was blank), including mention of a "newly appointed" day of Thanksgiving in Plimouth. (Plimouth? Publick? Where were all the copy editors in those days?)

THE 19TH CENTURY

Throughout the 19th century, all newspapers looked pretty much the same. Text was hung like wallpaper, in long rows, with vertical rules between columns. Maps or engravings were sometimes used as art.

During the Civil War, papers began devoting more space to headline display, stacking vertical layers of *deckers* or *decks* in an endless variety of typefaces. For instance, The Chicago Tribune used 15 decks to trumpet its report on the great fire of 1871: *FIRE! Destruction of Chicago! 2,000 Acres of Buildings Destroyed. . . .*

The first newspaper photograph was published in 1880. News photos didn't become common, however, until the early 1900s.

This 1865 edition of The Philadelphia Inquirer reports the assassination of President Lincoln with 15 headline decks. Like most newspapers of its era, it uses a very vertical text format: When a story hits the bottom of one column, it leaps to the top of the next to continue.

MORE QUICK HISTORY

THE EARLY 20TH CENTURY

By about 1900, newspapers began looking more like — well, like *newspapers.* Headlines grew bigger, bolder and wider. Those deep stacks of decks were gradually eliminated to save space. Page designs developed greater variety as news became departmentalized *(Crime, Foreign, Sports* and so on).

The '20s saw the rise of the big-city tabloids — those half-sheet papers packed with photos and sensational sledgehammer headlines.

As the years went by, papers kept increasing the traffic on each page, using ever more photos, stories and ads.

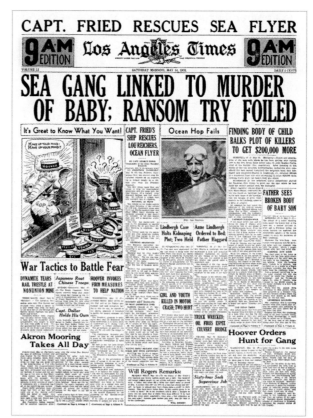

By the 1930s, most newspapers had the ability to run cartoons, photos and wide headlines, as we see in this 1932 edition of the Los Angeles Times. Note the number of stories on this page. For decades, American front pages commonly displayed 15-20 story elements. With those all-cap headlines, these pages gave readers a strong sense of urgency.

THE NOT-TOO-DISTANT PAST

By today's standards, even the handsomest papers from 20 years ago look clumsy and old-fashioned. Others, like the page at right, look downright ugly.

Still, most of the current trends in page design were in place by the late '60s:

◆ more and bigger photos;

◆ more refined headline type (except for special feature stories and loud front-page banners);

◆ a move from 8- and 9-column pages to a standardized 6-column page;

◆ white gutters between columns instead of rules.

As printing presses continued to improve, full-color photos became common in the early '80s, thus ushering in the modern era of newspaper design.

This 1966 sports page from The Oregon Journal is astoundingly bad — but to be fair, it's a typical example of mid-'60s design. The bizarre shapes of its photos and stories collide in a disorganized jumble. After printing pages like these for years, editors finally realized that taking page design seriously might not be such a bad idea.

CURRENT TRENDS

Compared to the newspapers of yesteryear, today's news pages look lively and sophisticated. That's partly due to technological advances. But today's editors also realize that readers are inundated by slickly designed media, from movies to Web sites to TV commercials. Sad to say, most consumers judge a product by the package it comes in. They simply won't respect a product — or a newspaper — that looks old-fashioned.

To look modern, newspapers now use:

◆ **Color.** Full-color photographs have become standard on section fronts across the country. Throughout the paper, color is applied both decoratively (in ads and illustrations) and functionally (in photos, in graphics, and in logos and headers that organize pages to help guide readers).

◆ **Informational graphics.** Papers don't just report the news — they *illustrate* it with charts, maps, diagrams, quotes and fast-fact sidebars that make complex issues easier for readers to grasp.

◆ **Packaging.** Modern readers are busy. Picky. Impatient. So editors try to make every page as user-friendly as they can by designing briefs, roundups, scoreboards, promos and themed packages that are easy to find and quick to read.

◆ **Modular layout.** We'll explore this later. In a nutshell, it simply means all stories are neatly stacked in rectangular shapes.

In the past, newspapers were printed in a variety of sizes. Today, virtually all newspapers are printed either as *broadsheets* (large, full-sized papers like USA Today or The Oregonian, shown above) or *tabloids* (half-sized papers like The National Enquirer — OK, maybe that's a bad example — or, say, The Christian Science Monitor).

In the pages ahead, we'll examine examples of modern American newspaper design. Most of these are broadsheet pages, but remember: Whatever your paper's format, the same basic design principles apply.

On this front page you can see modern packaging at work in those news briefs, in the aggressive promos at the top of the page, and in the packaging of that lead news story.

CURRENT TRENDS

This page from the Detroit Free Press provides an appealing example of front-page formatting. The centerpiece story, on Detroit rapper Eminem, fills half the page with a dramatic, magazine-style layout. (Note, however, the absence of art in those other news stories.) Promos and indexes run along the top and down the right edge of the page.

For more than a month, Americans waited for the official results of the 2000 election. When Bush finally won, it was a huge story, which is why the Asbury Park Press gave it such special play: the big headline, the little Bush cutout, the giant, old-fashioned eagle logo. It's a treatment reserved for breaking news of historic interest.

Many newspapers have considered using Page One as a menu that shows readers what's inside the paper. The Pittsburgh Post-Gazette is one of the few to actually try the idea. There are no stories on this front page – just colorful promos for the day's top stories. (This edition is sold only on the street, not delivered to subscribers.)

PAGE ONE DESIGN

Today's Page One is a blend of traditional reporting and modern marketing that tries to answer the question: What *grabs* readers?

Is it loud headlines? Big photos? Juicy stories? Splashy colors? Or do readers prefer thoughtful, timely analyses of current events?

Hard to say. Though newspaper publishers spend fortunes on reader surveys, they're still unsure what front-page formula is guaranteed to fly off the racks. As a result, most papers follow one of these Page One design philosophies:

◆ **The traditional:** No fancy bells or whistles — just the top news of the day. (For tabloids, that means 2-4 stories; for broadsheets, 4-6.) Editors combine photos, headlines, and text — usually lots of text — in a sober, straightforward style.

◆ **The magazine cover:** These pages use big art and dynamic headlines to highlight a special centerpiece. In tabloids, this package dominates the cover (and may even send you inside for the text); in broadsheets, a front-page package is given lavish play, flanked by a few subordinate stories.

◆ **The information center:** Here, the key words are *volume* and *variety*. By blending graphics, photos, promos and briefs, these fast-paced front pages provide a window to what's inside the paper, a menu serving up short, appetizing tidbits to guide readers through the best of the day's entrees.

But the options don't end there. Some papers run editorials on Page One. Some add cartoons. Some print obituaries, calendars, contests — even ads. Almost anything goes, as long as readers accept it, enjoy it and *buy* it.

CURRENT TRENDS

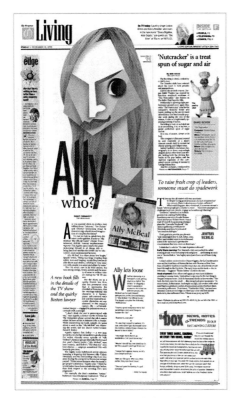

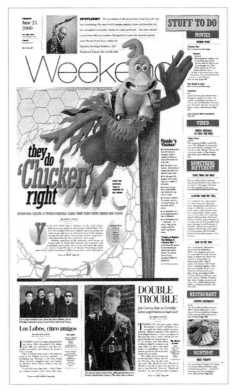

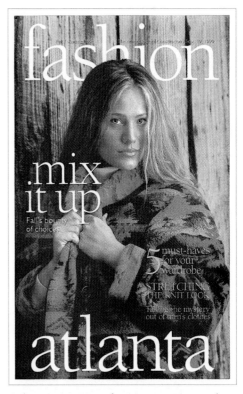

Popular feature pages provide lots of variety: lifestyle stories, columns, humor, entertainment. At The Oregonian, this Living cover tries to avoid predictability. There's a daily columnist, but some days (like this one) he writes only 6-8 inches. There's an offbeat column, The Edge, running down the left edge of the page. And a small box (The Box) is for quick news notes.

Entertainment coverage is enormously popular with readers — and full-page spreads like this provide terrific opportunities for flash and flair. On this Detroit Free Press section front, a chicken cutout flies right off the page; below it, another movie and a concert are previewed. And down the right side of the page, editors compile a best-bet roundup of videos, films, clubs, etc.

At larger newspapers, feature coverage expands to include food, travel and fashion — topics that lend themselves to big, magazine-style treatments. This is the fall/winter edition of Fashion Atlanta in The Atlanta Journal-Constitution, a special supplement with lots of color, lots of photos and lots of ads. It takes a team of editors, designers, writers, photographers and stylists to pull it off.

FEATURE PAGES & SECTIONS

As time goes by, feature sections become more popular — and their range gets more ambitious. Most modern feature sections offer a mix of:

◆ **Lifestyle coverage:** Consumer tips, how-to's, trends in health, fitness, fashion — a compendium of personal and social issues affecting readers' lives.

◆ **Entertainment news:** Reviews and previews of music, movies, theater, books and art (including comprehensive calendars and TV listings). Juicy celebrity gossip is always popular, too.

◆ **Food:** Recipes, nutrition advice, new products for home and kitchen — all surrounded by coupon-laden advertising that shoppers clip and save.

◆ **Comics, columnists and crosswords:** From Dear Abby to Dilbert, from Hagar to the horoscope, these local and syndicated features have faithful followings.

Feature sections often boast the most lively, stylish page designs in the paper. It's here that designers haul out the loud type, play with color, experiment with unusual artwork and photo treatments.

Many feature sections dress up their front pages by giving one key story a huge "poster page" display. Other papers prefer more traffic, balancing the page with an assortment of stories, briefs, calendars and lists.

And while most papers devote a few inside pages to features, some bigger publications — those with plenty of writers and designers — produce daily themed magazines: *Money* on Mondays, *Health & Fitness* on Tuesdays, *Food* on Wednesdays and so on.

CURRENT TRENDS

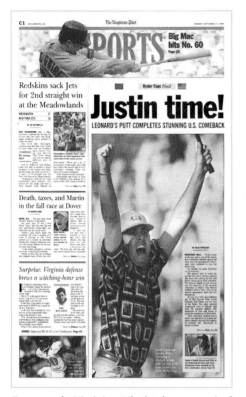

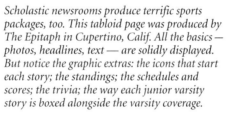

For years, the Virginian-Pilot has been recognized for its stylish, aggressive page design — and here, you can see how bold presentation brings a sports page to life. From the Mark McGwire promo at the top of the page to the huge play of the Ryder Cup golf photo, this layout is lively and fun (the way sports should be), yet still disciplined and organized. Note the text inset into that lead photo.

Scholastic newsrooms produce terrific sports packages, too. This tabloid page was produced by The Epitaph in Cupertino, Calif. All the basics — photos, headlines, text — are solidly displayed. But notice the graphic extras: the icons that start each story; the standings; the schedules and scores; the trivia; the way each junior varsity story is boxed alongside the varsity coverage.

Whenever big sporting events roll around — the Super Bowl, the World Series, scholastic state championships, the Olympics — you have a golden opportunity to create special sections, design special logos, run jumbo photos — and empty the page of all competing stories. Note the combination of big story/small roundups on this daily Olympic page from the Detroit Free Press.

SPORTS PAGES & SECTIONS

Television seems to be the perfect medium for sports coverage. It's immediate. Visual. Colorful. Yet in many cities, more readers buy newspapers for sporting news than for any other reason. Why?

A good sports section combines dramatic photos, lively writing, snappy headlines and shrewd analysis into a package with a personality all its own. And while sports coverage centers around meat-and-potatoes reporting on games, matches and meets, a strong sports section includes features that aren't provided by most other media:

◆ **Statistics:** Scores, standings, players' records, team histories — true sports junkies can't get enough of this minutiae. It's often packaged on a special scoreboard page or run in tiny type (called *agate*).

◆ **Calendars and listings:** Whether in small schools or big cities, fans depend on newspapers for the times and locations of sporting events, as well as team schedules, ski reports, TV and radio listings.

◆ **Columnists:** Opinionated writers whom sports fans can love or loathe — the more outspoken, the better.

◆ **Inside poop and gossip:** Scores, injury reports, polls, predictions, profiles and analyses that aren't easily available anywhere else.

Sports pages (like features) offer opportunities for designers to run photos more boldly, to write headlines more aggressively — and to create dynamic graphics packages that capture the thrill of victory in a visual way.

CURRENT TRENDS

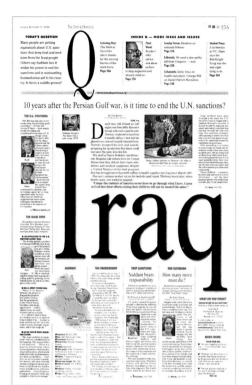

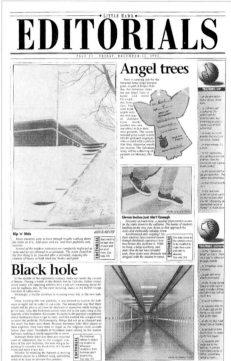

This page from the Asbury Park Press is a classic example of a modern editorial page. On it, you'll find the masthead (a who's who of newsroom big shots), an editorial cartoon, a wordy editorial column, some letters from readers, a "Today in History" feature and today's Doonesbury comic strip. Most papers' editorial pages are heavily formatted like this.

Larger papers, especially dailies, run longer opinion columns on the page opposite the editorial page (the op-ed page). At the biggest papers, the opinion/editorial staff gets a separate section on Sundays, which provides a home for in-depth analyses like this one in The (Raleigh) News & Observer: a look at the history, the controversy and the options for peace with Iraq.

Here's a creative alternative to the traditional editorial page. The Little Hawk, an Iowa City high-school paper, uses a variety of photos and a mini-mum of text to present its editorial comments. (Note the small boxes accompanying each photo-editorial, where the staff summarizes its position.) Down the right edge of the page, editors give thumbs-up/thumbs-down to a variety of issues.

OPINION PAGES & EDITORIALS

Juxtaposing news and commentary is a dangerous thing. How are readers to know where cold facts end and heated opinions begin? That's why nearly every newspaper sets aside a special page or two for backbiting, mudslinging, pussy-footing and pontificating: It's called the editorial page, and it's one of America's noblest journalistic traditions.

The basic ingredients for editorial pages are nearly universal, consisting of:

◆ **Editorials,** unsigned opinion pieces representing the newspaper's stance on topical issues;

◆ **Opinion columns** written by the paper's editors, by local writers or by national-ly syndicated columnists;

◆ **An editorial cartoon,** a sarcastic illustration that lampoons public figures or political policy;

◆ **Letters from readers,** and

◆ **The masthead,** which lists the paper's top brass (editors, publishers, etc.) along with the office address and phone number.

In addition — because editorial pages are often rigidly formatted — many papers run a separate opinion page (see example, top center). These pages pro-vide commentary and opinion, too, as they examine current issues in depth. And like sports and feature sections, they set themselves apart from ordinary news pages by using stylized headlines, interpretive illustrations and more elaborate design techniques.

CURRENT TRENDS

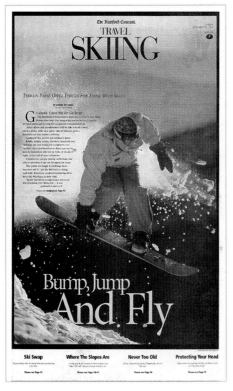

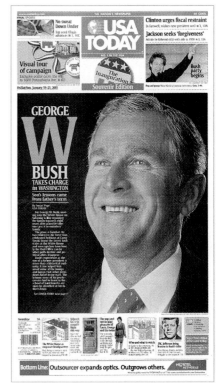

Almost any topic, serious or sporting, can inspire a special section. In the Northeast, there's huge reader interest in skiing and snowboarding, so it's a natural for The Hartford Courant to produce a November travel section like this one: 12 pages of photos, profiles, guides to gear — and in the middle, a two-page map that lists the best ski areas throughout New England.

How can you entice kids to read the newspaper? Many papers produce special sections like this one – "X-Press" from The St. Petersburg Times – in hopes of attracting young readers. Along with bright colors, zoomy images and wacky layouts, these pages usually offer cartoons, puzzles, hobby tips, movie reviews and opportunities for children to read their own words in print.

Though USA Today's front page usually follows the same daily format, on special occasions it's able to create a page like this: a "souvenir" edition for Bush's inauguration. Beneath the dramatic centerpiece are promos for inside stories and features on Bush fashions, Bush history, political predictions, inaugural schedules, etc.

SPECIAL PAGES & SECTIONS

Most newspapers settle into predictable routines from issue to issue, repeating the same standard formats — news, opinion, features, sports — day after day. (Fortunately, a little predictability is good: It keeps readers happy and editors sane.)

But opportunities often arise for producing special pages or sections with design formats all their own. These include:

◆ **Special enterprise packages** on hot topics or trends (*AIDS, The Homeless, How You Can Save Our Planet*);

◆ **Special reports** on news events, either published in advance (*Baseball 2002* or *Summer Olympics Preview*) or as a wrap-up (*The Tragedy of Flight 1131* or *That Championship Season: The Pittsburgh Penguins*);

◆ **Special-interest packages** — often printed regularly — that target a specific audience (pages for kids or teens; sections for women, senior citizens, hunters, farmers).

Editors now realize how specialized readers' tastes have become. Just look at the enormous variety of magazines and cable-TV channels consumers can choose from. That's why newspapers offer an increasingly wide range of pages and sections that cater to readers' diverse interests: Fitness. Computers. Religion. Skiing. After extensive readership surveys, one paper created a sewing page; another launched a weekly page for Civil War buffs.

Every community is unique. What are *your* readers most interested in?

THE NEWSPAPER OF THE FUTURE

The "Digital Daily" doesn't exist yet, but it won't be long before we all carry a similar portable laptop computer that can play music and movies, surf the Web and, yes — download instant news reports.

As you can see, this electronic newspaper is customized: It searches for news topics of interest to the user, then flashes the headlines below.

Simply touch the photo and it plays a video clip, complete with sound. Press the arrow button and the news story fills the screen, complete with text, graphics, videos and library links — true interactive journalism.

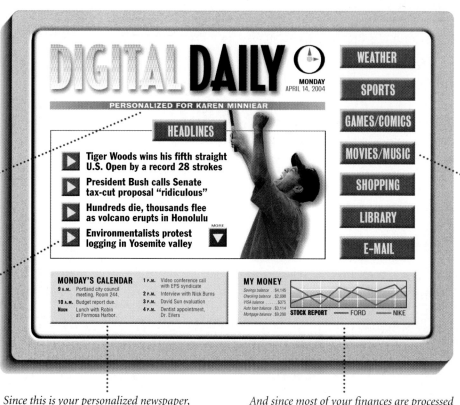

This is the 3 p.m. edition of your newspaper. But since the news is constantly revised and updated, you can access the paper anytime you like.

Down the right side of the screen is the index. Press these buttons to read the latest news, watch video clips of sports and movie highlights, enjoy the animated comics, do a little mail-order shopping, answer e-mail. . . . Get the picture? Best of all, anytime you want to explore a subject in greater depth, you can search the database in the newspaper's library.

Since this is your personalized newspaper, it keeps track of your personal life, too. Here's your calendar for the day, programmed to alert you as your next appointment approaches.

And since most of your finances are processed electronically, your newspaper tracks your current bank balances — in addition to monitoring the performance of your stocks.

What's to become of newspapers in 10 years? Will paper be plentiful, or will newpapers go wireless? Will *advertising* be plentiful, or will papers go bankrupt?

As more and more newspapers bite the dust, publishers ponder their future. Some have begun exploring alternatives for 21st-century journalism:

◆ **Audiotext:** News by telephone, where you can dial up weather, sports scores, horoscopes or restaurant reviews.

◆ **Web sites:** The gateway to journalism of the future, enabling newspapers to post text and graphics on the Internet and experiment with hypertext, sound, video and other emerging technologies.

◆ **Personalized digital newspapers:** You'll someday watch video clips, listen to sound bites and explore animated graphics in your digital newspaper. Touch-sensitive screens will let you enter commands and search databases. But this won't be a mass-market publication; imagine instead that this paper caters to *your* personal interests. Want the latest news on tennis, tornadoes and Tasmania? Once you program your paper to prioritize your preferences, it'll edit the news for *you.*

Yes, newspaper technology is evolving. But questions remain: Who'll produce this new media? Who'll pay for this expensive technology? What sort of device will *play* these computerized pages? And most importantly:

How will you wrap fish in it?

MORE ON ▶

◆ **Online design:** An entire chapter on how to design newspapers for the Web**227**

As we observed in the Preface (you *did* read the Preface, didn't you? After all the work we put into it? Listen, it's not *nearly* as dull as it looks. ...) you're probably eager to unravel the Mysteries of Page Design. But before you begin banging out prize-winning pages, you need to understand a few basics.

You'll need to learn some vocabulary. You'll need to become familiar with the tools of the trade. But most of all, you'll need to grasp the fundamental components of page design: headlines, text, photos and cutlines.

This book is designed so you can skip this chapter if you're in a hurry. Or you can just skim it and catch the highlights. So don't feel compelled to memorize everything immediately. But the better you understand these basics now, the more easily you'll be able to manipulate them later on.

To make this book handier to use, we've repeated the chapter contents in detail along the bottom of each chapter's introductory page. And each section within this book is cross-referenced, too, with those handy **MORE ON** guides in the upper-right corner of the page. As you study each topic, you can jump around through the book to expand upon what you're learning.

WHAT IT'S CALLED

To succeed in the design world, you need to speak the lingo. In a typical newsroom, for instance, you'll find *bugs, bastards, dummies, reefers,* maybe even a *widow* in the *gutter.* (If our mothers knew we talked like this, they'd never let us become journalists.)

Not all newsrooms use the same jargon, but there's plenty of agreement on most terms. Here are some common elements found on Page One:

Teasers
*These promote the best stories inside the paper (also called **promos** or **skyboxes**)*

Flag
*The newspaper's name (also called the **nameplate**)*

Infographic
A diagram, chart, map or list that conveys data pictorially

Deck
A smaller headline added below the main headline (shown here is a summary deck, which summarizes news stories)

Display head
A jazzed-up headline that adds drama or flair to special stories

Jump line
A line telling the reader what page this story continues on

Logo
A small, boxed title (with art) used for labeling special stories or series

Cutline
*Information about a photo or illustration (also called a **caption**)*

Reverse type
White words set against a dark background

Headline
The story's title or summary, in large type above or beside the text

Refer
A brief reference to a related story elsewhere in the paper

Mug shot
A small photograph (usually just the face) of someone in the story

Byline
The writer's name, often followed by key credentials

Initial cap
*A large capital letter set into the opening paragraph of a special feature (also called a **drop cap**)*

Standing head
A label used for packaging special items (graphics, teasers, briefs, columns, etc.)

Index
A directory of contents

The Bugle-Beacon (front page mockup):

The Bugle-Beacon

FINAL EDITION THURSDAY, SEPTEMBER 20, 2001 50 CENTS

ECSTASY USE SURGES AMONG YOUNG PEOPLE

Bob Bailey, Office of National Drug Control Policy director, warned Thursday of an "explosive increase" in young people's use of the drug ecstasy. According to the office's annual report, more than twice as many high school seniors reported using the drug in 2001 than in 1997.

Youths reporting ecstasy use
10%
8
6
4
2
0
1997 1998 1999 2000 2001
Eighth grade
Twelfth grade
Source: Office of National Drug Control Policy
THE BUGLE-BEACON STAFF

Teen drug use rising dramatically, Bush warns

A report shows some signs of improvement, but also reveals teens' increasing use of powerful "club drugs"

By HOLLY LUKAS
United Press International

WASHINGTON — President Bush on Wednesday praised recent signs of progress in curbing drug use but bemoaned the fact that "drug continue to exact a tremendous toll" on young people dabbling in steroids and "club drugs" such as ecstasy.

In receiving the final report from his drug policy adviser, Bush said he was glad that the report showed drug-related murders are at their lowest level in 10 years and that drug use by young people ages 12 to 17 is down 21 percent since 1997.

But, he said, studies also are providing disturbing evidence of increased use of steroids, ecstasy and other drugs.

"Too many young people are still using alcohol, tobacco and illegal substances," Bush said. "We must never give up on making our children's futures safe and drug-free," he said. "Despite our progress, drugs continue to exact a tremendous toll on our nation."

Use of MDMA, once mainly an East Coast drug, has spread rapidly across the country, McCaffrey said, with an "explosive increase in exposure among our children."

"They think it's a frog drug, it's a dance-

of National Drug Control Policy, noted that drug education and prevention efforts have not kept up with the onslaught of new drugs such as ecstasy, known chemically as methylenedioxymethylamphetamine, or MDMA.

People who use ecstasy normally experience feelings of euphoria and an increased desire for social interaction. They also experience dramatic increases in blood pressure, heart rate and body temperature.

◆ **Drug danger:** Doctors warn that DME, a common pain-killer, may be addictive. Story on **Page A5**

all-night, feel-good drug," McCaffrey said. But ecstasy also may permanently impair the brain's neurochemical functions, McCaffrey said, "never mind the possibility of dropping dead the first time you use it.

"We've got 5 million chronically addicted Americans. If we don't have them in effective drug treatment programs, we can't ever break the cycle of crime, violence, accidents, health costs that come from drug abuse," McCaffrey said in an interview Thursday on CBS' "The Early Show."

Man freed after serving 29 years on Death Row

Patrick Minniear claims he never met the mob boss he was convicted of murdering back in 1972

By TERRENCE HOHNER
The Associated Press

CAMBRIDGE, M— A former bookie who serv— more than 29 years for an und— murder he said he didn't— at was released Thursday— conviction was thrown out at request of prosecutors.

Prosecutors said newly discovered FBI files from the 1970s cast doubt on 63-year-old Patrick Minniear's guilt.

It appeared to be yet another embarrassment for the FBI's Boston office, which is under scrutiny for some agents' allegedly cozy relationships with the mob.

Last month, Justice Department investigators looking into allegations of corruption in the office gave Minniear's lawyer secret FBI reports from the time around Deegan's 1972 murder. The documents showed that an informant had given the FBI a list of suspects that did not include Minniear's name.

Minniear was convicted in part on the testimony of mob hitman Joseph "The Animal" Barboza, one of the names on the list.

Superior Court Judge Margaret Hinkle on Thursday ordered Minniear released without bail, criticizing the FBI for withholding information that could have led to Minniear's acquittal.

"It is now time to move on," the judge said. "Mr. Minniear's long wait is over."

About 50 friends and relatives of Minniear broke into applause at the ruling.

Prosecutors would not say Friday whether they plan to retry Minniear.

The former prosecutor and defense attorneys in the Deegan killing have said they didn't know about the FBI informant reports at the time of the trial. An FBI spokeswoman declined comment Friday.

le the courtroom, surrounded by his— ldren and grandchildren
See CONVICT, Page A3

TRAPPED BY A TWISTER

Ada Plum's 1988 Volvo, above, was flipped and demolished by the 150-mph winds generated by the Mudflap twister. The twister, seen at left heading east out of Mudflap August 22, left 14 people injured and caused, at least estimate, more than $3 million in damages.

DEREK PAXTON / THE BUGLE-BEACON

When last month's tornado ripped through Mudflap, Ada Plum was driving home from prison — little suspecting that her worst fears were about to come true. Now, for the first time, she tells her astonishing story.

BY MANUEL HUNG of The Bugle-Beacon staff

When the winds began to blow on the afternoon of Thursday, August 22, Ada Plum looked up from her lunch and muttered, "Oh, dear — I hope my little Keekee won't be caught outside in the rain." Keekee, Ada's 2-year-old Siberian husky, hated getting wet, preferring to spend her days lounging beneath the old oak rolltop desk in Ada's living room.

Keekee was outside. Caught in the impending storm. Soon to die in a twister the likes of which Mudflap hadn't seen in 57 years.

Ada finished her cheese and began sweeping up the crumbs. She headed for the exit of Mudflap Community Home, where she works as a bedpan disposal engineer. She looked around for her umbrella.

Gone.

She looked around for her car keys.

Gone.

She looked for her raincoat, her galoshes, her orange vinyl rain.

All gone. Gone, as if to say, "Stay inside, Ada. Please. Stay inside."

But Ada was determined to venture out into the storm. And this would be the time to mention, dear reader, that this story is complete and utter hooey. I'm sitting here trying to fill the space with real-looking words, knowing that a few of you — just a precious few — well, that may be an exaggeration, since I don't know how precious you actually are — but anyway, like I was saying, I'm trying to fill out this column with realistic-looking prose so it looks like an actual news page, even though in truth I'm parked here in my quiet Oregon office typing on a cool January afternoon. But enough about me. Let's continue our story, shall we?

Ada found her keys, and her boots, and she walked out into the rain. The wind had picked up, blowing more fiercely by the minute, and it slapped her through the parking lot like a big, wet hand. She lunged inside her Volvo and started the engine.

The sky was morning green — a dark, soupy green, the kind of green you'd get if you poured ink into a bowl of pea soup. No, wait: the kind of green you'd get if you put a frog and a whole bunch of leeches into a blender. Or maybe the kind of green you'd get if you left a pork chop in your basement until it was stinky and moldy.

As she pulled out of the hospital parking lot and turned east on Highway 119, she saw the telephone poles begin to sway and the traffic lights begin to crash down onto the road, and she thought to herself: "Gee, I hope Keekee doesn't get, like, crushed by a tree or something." And then it hit her: the giant tornado.

See TORNADO, Page A11

Hospital defends maternity ward staffing policy

By MARK WIGGINTON
The Bugle-Beacon

Despite a growing number of complaints and increased pressure from critics, nurse staffing in Washington County General Hospital's maternity ward will remain at current levels.

"We're an easy target," says Thomas C. Trennell, chief administrator. "We've had our share of ups and downs, and critics think things are much simpler than they actually are."

Trennell's ups and downs began last February, when three infants died after a gas leak was traced to the ward's basement. Since that time, nearly a dozen other babies have been diagnosed with illnesses ranging from dysentery to cholera. The latest inci-

dent, reported last Saturday, involved a two-day-old girl who died of Sudden Infant Death Syndrome in the ward during a short-lived nursing strike.

Critics have complained that the ward is seriously understaffed, and that it's just a matter of time before tragedy strikes again.

"Maternity wards should not be dangerous places," says Patti Spooner, head of the Washington County Midwives Association.

"But I hear mothers all over town swearing they'll never give birth in that hospital again. Something has to be done, beginning with better staffing."

Currently, only three nurses per shift will ordinarily report to the maternity ward on weekends, a number merely half the typical
See MATERNITY, Page A11

Carolyn Bolin, director of nursing, cuddles a newborn boy in the maternity ward of Washington County General Hospital Wednesday morning.
CURT WIGGINTON / THE BUGLE-BEACON

CHILDCARE IN CRISIS
THIRD IN A SERIES

WHAT'S INSIDE

Advice	C3	Metro	B1
Arts	C4	Movies	C4
Business	D6	Nation	A5
Classifieds	D5	Obituaries	A7
Clubs	C3	Sports	D1
Comics	C6	Stocks	D7
Editorial	A6	TV	C8
Horoscope	C3	Weather	B20
Living	C1	Weddings	C2
Lottery	A2	World	A8

Circulation hot line 555-7868
Classified ads 555-7890
Newsroom tip line 555-7800

WEATHER
Clear and cool; chance of evening showers.

72 48
HIGH LOW

Complete weather, page B20

141141700030

WHAT IT'S CALLED

As you can see, Page One is often loaded with devices designed to entice and entrap prospective readers. Inside the paper, however, graphic elements become more subtle, less decorative. They're there to inform and guide readers, not sell papers.

Here are some typical design elements used on inside pages:

MORE ON ▶

◆ **Terms:** *A glossary of newspaper design terms and jargon....* **251**

Folio
A line showing the page number, date, paper's name, etc.

Jump line
The page number this story continues from

Liftout quote
*A quotation from the story given graphic emphasis (also called a **pull quote** or **breakout**)*

Subhead
A boldface line of type used to organize the story and break up gray text

Gutter
The white space running vertically between elements on a page

Bastard measure
Type set in a different width than the standard column measure

Sig
*A special label set into stories giving typographic emphasis to the topic, title, writer's name, etc. (also called a **bug** or **logo**)*

Standing head
A label used for packaging special stories or features

Jump headline
A headline treatment reserved for stories jumping from another page (styles vary from paper to paper)

Photo credit
A line giving the photographer's name (often adding the paper or wire service he or she works for)

Text
Type for stories set in a standard size and typeface, stacked in columns (or legs)

Sidebar
A related story, often boxed, that accompanies the main story

Cutoff rule
A line used to separate elements on a page

Cutout
*A photo in which the background has been cut away (also called a **silhouette**)*

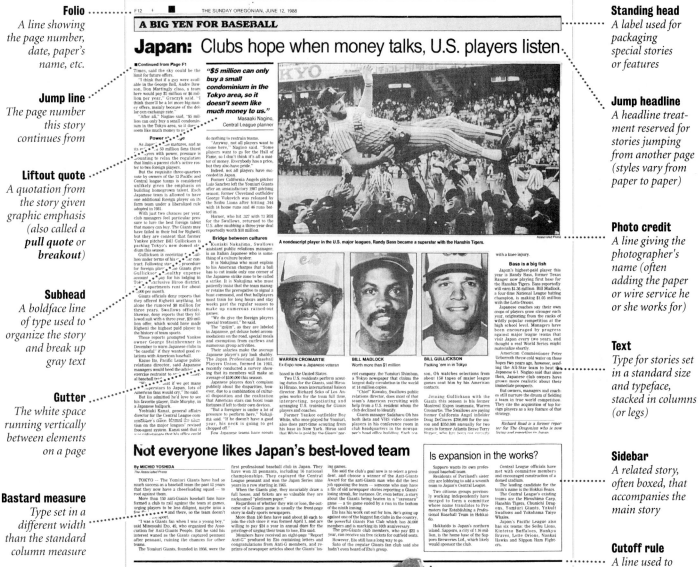

A nondescript player in the U.S. major leagues, Randy Bass became a superstar with the Hanshin Tigers.

Don Drysdale (left) and Bob Gibson, shown during a joint appearance at a baseball camp, dominated National League pitching in 1968. Drysdale pitched 58 consecutive scoreless innings, a major league record.

TOOLS OF THE TRADE

In the old days, page designers spent a lot of time drawing boxes (to show where photos went). And drawing lines (to show where text went). And drawing *more* boxes (for graphics, sidebars and logos).

Nowadays, most designers do their drawing on computers. But those old tools of the trade are still handy: pencils (for drawing lines), rulers (for measuring lines), calculators (for estimating the sizes of those lines and boxes), and our old favorite, the proportion wheel (to calculate the dimensions of boxes as they grow larger or smaller).

Even if you're a computer whiz, you should know these tools and terms:

MORE ON ▶

◆ **The proportion wheel:** *A guide to how it works.....* **252**

◆ **Terms:** *A complete glossary of design jargon...................* **253**

Pencil: *Yes, your basic pencil (with eraser) is used for drawing dummies. Designers who draw page dummies with pens are just showing off.*

Grease pencil: *These are used for making crop marks on photos. Afterward, these markings can easily be rubbed off with cloth.*

Knife: *In art departments and composing rooms, X-ACTO knives (a brand name) are used for trimming photos, cutting stories and moving items around when pages are assembled — or "pasted up" — before printing.*

Calculator: *Designers often use calculators for sizing photos and computing line lengths in a hurry (unless you're a whiz with fractions). Test yourself: If you have an 18-inch story, and it's divided into 5 columns (or legs) with a map in the second leg that's 3 inches deep – how deep would each leg be?*

POINTS, PICAS, INCHES: HOW NEWSPAPERS MEASURE THINGS

If you're trying to measure something very short or thin, inches are clumsy and imprecise. So printers use *picas* and *points* for precise calibrations. There are 12 points in one pica, 6 picas in one inch — or, in all, 72 points in one inch.

This is a 1-point rule; 72 of these would be one inch thick.

This is a 12-point rule. It's 1 pica thick; 6 of these would be 1 inch thick.

Points, picas and inches are used in different places. Here's what's usually measured with what:

Points	Picas	Inches
◆ Thickness of rules	◆ Lengths of rules	◆ Story lengths
◆ Type sizes (cutlines, headlines, text, etc.)	◆ Widths of text, photos, cutlines, gutters, etc.	◆ Depths of photos and ads (though some papers use picas for all photos)
◆ All measurements smaller than a pica		

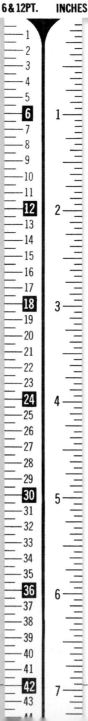

Pica pole: *This is the ruler used in newsrooms. It has inches down one side and picas down the other. You can see, for instance, that 6 picas equal one inch; you can also see that it's 42 picas down to that line at the bottom of this page.*

Proportion wheel: *This handy gizmo is used to calculate proportions. For instance, if a photo is 5 inches wide and 7 inches deep, how deep will it be if you enlarge it to 8 inches wide? Using a proportion wheel can show you instantly.*

TOOLS OF THE TRADE

In the '80s and '90s, newspapers became pioneers in desktop publishing. And as a result, computers have transformed every corner of the newsroom. So if you're serious about newspapering, get comfortable with computers. They're indispensable when it comes to:

◆ **Writing and editing stories.** Most newsrooms tossed out their typewriters 20 years ago. Reporters and editors now use computers to write, edit and file stories, conduct interviews (via e-mail), fit headlines, search Internet databases and library archives — the list goes on and on.

◆ **Producing photos.** Digital photo processing lets you adjust every aspect of an image electronically. Newsrooms using digital cameras are able to dispense with darkrooms entirely.

◆ **Pagination.** Today, virtually all publications are *paginated* – that is, pages are created and printed electronically with desktop publishing software. (This book, for instance, was produced using QuarkXPress, which has become the industry standard.)

◆ **Creating illustrations and graphics.** With a good drawing program, it's easy to create full-color artwork in any style. And even if you're not an artist, you can buy clip art or subscribe to wire services that provide topnotch graphics you can rework, resize or store for later use.

MORE ON ▶

◆ **Scanning:** *How to import images into your computer electronically* **112**

◆ **Printing color:** *How computers separate color to produce full-color pages* **206**

COMPUTER ACCESSORIES

Floppy disks and CDs: *Information can be stored in a computer's internal memory, OR it can be transported from computer to computer via portable disks. Floppy disks (far left) came first; they can hold a megabyte or two. Compact disks (CDs) are far more powerful, storing 600 megabytes of data — perfect for big photo, video or music files.*

Scanner: *This device can capture photos or artwork electronically. It scans images like a photocopying machine, after which you can adjust their size, shape and exposure on your computer screen — avoiding the darkroom altogether. For more on scanning, turn to page 112.*

Printer: *Once you design your masterpiece on the computer, how do you print the thing out? Many desktop publishers use laser printers like this one: high-resolution devices that output near-professional-quality type and graphics.*

Modem: *A device that allows computers to communicate with each other and transmit data (text, images, audio) over telephone lines — thus making the Internet possible. Most new computers now come equipped with internal modems to link users to e-mail services and the World Wide Web.*

BASIC TYPOGRAPHY

◄ THEN | NOW ►

For hundreds of years — since Gutenberg began printing Bibles in the 15th century — type was set by hand. Printing shops had composing rooms where compositors (or typesetters) selected characters individually, then loaded them into galleys one row at a time: a slow and clumsy process.

Over time, printers began using machines to set type. A century ago, Linotype keyboards created type slugs from hot metal. In the 1960s, phototypesetters began using film to print typographic characters. And today, computers make typesetting so cheap and easy, almost anyone can create professional-looking type.

Before we start examining headlines and text, we need to focus on type itself. After all, consider how many hours you've spent reading books, magazines and newspapers over the years. And all that time you *thought* you were reading paragraphs and words, you were actually processing long strings of *characters*, one after another. You're doing it now. Yet like most readers, you surf across these waves of words, oblivious to typographic details.

When you listen to music, you absorb it whole; you don't analyze every note (though some musicians do). When you read text, you don't scrutinize every character, either – but some designers do. They agonize over type sizes, spacing, character widths, line lengths. Because when you put it all together, it makes the difference between handsome type and type t h a t looks like this .

All music starts with the 12 notes in the scale. All newspaper design starts with the 26 letters in the alphabet. If you want to understand the difference between Mozart and Metallica, you've got to ask, "How'd they do *that* with *those notes?*" If you want to understand the difference between good design and garbage, you've got to ask, "How'd they do *that* with *those letters?*"

Take the garbage below. Observe how it bombards you with a variety of sizes, shapes and styles, each with its own unique characteristics:

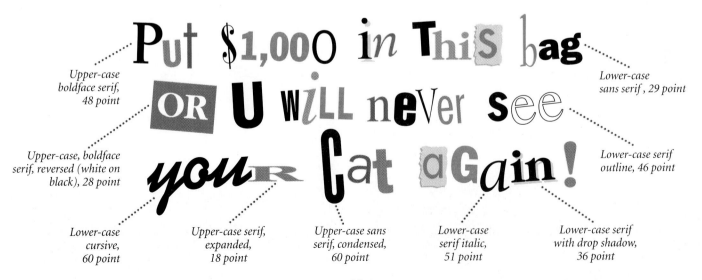

Upper-case boldface serif, 48 point

Lower-case sans serif, 29 point

Upper-case, boldface serif, reversed (white on black), 28 point

Lower-case serif outline, 46 point

Lower-case cursive, 60 point

Upper-case serif, expanded, 18 point

Upper-case sans serif, condensed, 60 point

Lower-case serif italic, 51 point

Lower-case serif with drop shadow, 36 point

BASIC TYPOGRAPHY

TYPE FONTS & FAMILIES

There are thousands of typefaces out there, with names like Helvetica and Hobo, Baskerville and Blippo. Years ago, before printing became computerized, type foundries would cast each typeface in a variety of sizes. And each individual size of type was called a *font*:

MORE ON ▶
......................................
◆ **Display headlines:** *Tips on designing creative feature headlines..............* **196**

This is a font — a complete set of characters comprising one specific size, style and weight of typeface, including numbers and punctuation marks. As you can see, this Futura Condensed Bold font contains dozens of characters — and this font is just one member of the Futura family.

16-POINT FUTURA CONDENSED BOLD

ABCDEFGHIJKLMN
OPQRSTUVWXYZ *Upper-case characters*
abcdefghijklmn *Lower-case characters*
opqrstuvwxyz
1234567890 *Numbers*
&.,:;""''?!()•/#¢$%* *Punctuation marks, etc.*

All the individual Futura fonts are part of the large Futura *family.* And many type families (like Futura) include a variety of *weights* (lightface, regular, boldface) and *styles* (roman, italic, condensed).

Most type families are classified into two main groups: *serif* and *sans serif.*

Serif type *has tiny strokes, or serifs, at the tips of each letter. The typefaces at right are all members of the Times family — perhaps the most common serif typeface used today.*

This is 18-point Times.
This is 18-point Times Italic.
This is 18-point Times Bold.
This is 18-point Times Bold Italic.

Serif type families often include a wide variety of weights and styles. Times, however, is crafted in just two weights (regular and bold) and two styles (roman and italic).

Sans serif type *("sans" means "without" in French) has no serifs. The typefaces at right are all members of the Futura family, one of the most popular sans-serif typefaces used today.*

This is 18-point Futura.
This is 18-point Futura Condensed Light Oblique.
This is 18-point Futura Heavy Outline.
This is 18-point Futura Extra Bold.

The Futura family, on the other hand, is available in an extremely wide range of weights (from light to extra bold) and styles (including regular, oblique and condensed).

Some typefaces are too eccentric to be classified as either serif or sans serif. *Cursive type,* for example, mimics hand-lettered script. *Novelty type* strives for a more quirky, decorative or dramatic personality.

Cursive type *looks like handwritten script. In some families the letters connect; in others they don't. This font is 18-point Diner Script.*

Dear John — I'm leaving forever, you slimy weasel.

HI-YO, SILVER!
BOINGGG!!

Novelty type *adds variety and flavor. It works well in small doses (like headlines, ads and comic strips) but can call a lot of attention to itself.*

BASIC TYPOGRAPHY

HOW TO MEASURE TYPE SIZE

We measure type by *point size* — that is, the height of the font as calculated in points. (Points, you'll recall, are the smallest unit of printing measurement, with 72 points to the inch.) This sizing system originated in the 18th century, when type was cast in metal or wood. What's curious is this: Back in those olden days, a font's point size measured not the type characters but the printing block that *held* those characters:

Point size *refers to the height of a font — or more specifically, the height of the slug that held the letters back in the days of metal type. Because those fonts were manufactured only in standard point sizes — 9, 10, 12, 14, 18, 24, 30, 36, 48, 60, 72 — those remain common type sizes today.*

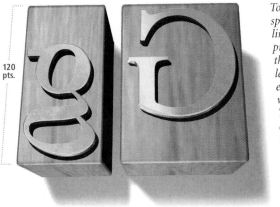

120 pts.

To adjust the space between lines of type, printers added thin strips of lead below each row of wood blocks. That's why, even today, the spacing between lines of type is called "leading."

Sizing type is a slippery thing because point sizes don't always correspond to reality. A 120-point typeface, for example, is never *exactly* 120 points tall. And what's more, the actual height of 120-point typefaces often varies from font to font.

And then there's *x-height,* the height of a typical lower-case letter. Fonts with tall x-heights look bigger than those with short x-heights — even when their point sizes are identical:

This line of 14-point Bookman looks bigger than this line of 14-point Bernhard Modern.

As you can see, a number of variables come into play when you size a font. But by learning to identify the basic components of type — and how they affect readability — you'll be able to analyze type more intelligently:

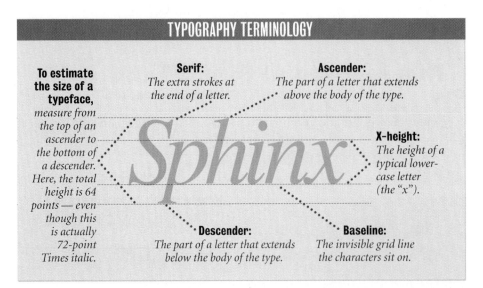

TYPOGRAPHY TERMINOLOGY

To estimate the size of a typeface, *measure from the top of an ascender to the bottom of a descender. Here, the total height is 64 points — even though this is actually 72-point Times italic.*

Serif: *The extra strokes at the end of a letter.*

Ascender: *The part of a letter that extends above the body of the type.*

X-height: *The height of a typical lower-case letter (the "x").*

Descender: *The part of a letter that extends below the body of the type.*

Baseline: *The invisible grid line the characters sit on.*

BASIC TYPOGRAPHY

Using type right out of the computer is like wearing a suit right off the rack — it won't look its best until you tailor it a bit. By tailoring type (adjusting shapes and spaces) you can increase its efficiency, enhance its readability and dramatically alter its personality.

Most page-layout software lets you modify type *vertically* and *horizontally:*

MODIFYING TYPE VERTICALLY

Point size: Changing the point size changes the height of a font. The bigger the size, the taller the type:

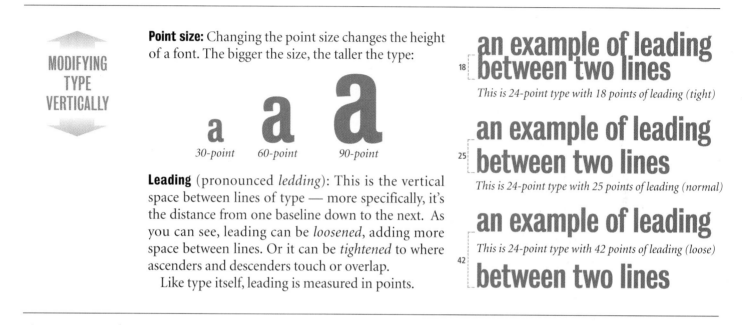

a — 30-point
a — 60-point
a — 90-point

18 — an example of leading between two lines
This is 24-point type with 18 points of leading (tight)

25 — an example of leading between two lines
This is 24-point type with 25 points of leading (normal)

42 — an example of leading — *This is 24-point type with 42 points of leading (loose)* — between two lines

Leading (pronounced *ledding*): This is the vertical space between lines of type — more specifically, it's the distance from one baseline down to the next. As you can see, leading can be *loosened,* adding more space between lines. Or it can be *tightened* to where ascenders and descenders touch or overlap.

Like type itself, leading is measured in points.

MODIFYING TYPE HORIZONTALLY

Tracking (or *kerning**): Just as you can tighten or loosen the *vertical* spacing between lines, you can adjust the *horizontal* space between letters — though even the slightest changes in tracking can affect the type's readability:

tracking
This is 24-point type with normal tracking (no extra spacing between characters)

t r a c k i n g
This is 24-point type with loose tracking (+40 units between characters)

tracking
This is 24-point type with tight tracking (-15 units between characters)

Set width (or *scaling*): Computers can stretch or squeeze typefaces as though they're made of rubber — which can look lovely or lousy, depending. Set width is usually expressed as a percentage of the font's original width:

set width
This 24-point type has a normal set width (100%)

set width
This 24-point type is condensed, with a narrow set width (50%)

set width
This 24-point type is expanded, with a wide set width (200%)

* Technically, **tracking** is the overall spacing between *all* characters in a block of text, while **kerning** is the reduction of spacing between *pairs of letters*. For instance, if you kerned these two letters:

AW

— they'd look like this:

AW

THE FOUR BASIC ELEMENTS

Newspaper pages are like puzzles — puzzles that can fit together in a number of different ways.

Though pages may seem complicated at first, you'll find that only four basic elements — four kinds of puzzle pieces — are essential. And because these four elements get used over and over again, they occupy 90% of all editorial turf. Once you master these four basic building blocks, you've mastered page design. (Well, that's not entirely true — but it makes the job sound easier, doesn't it?)

The four elements are:

- ◆ **Headlines:** the oversized type that labels each story;
- ◆ **Text:** the story itself;
- ◆ **Photos:** the pictures that accompany stories; and
- ◆ **Cutlines:** the type that accompanies photographs.

This is how the page actually printed . . .

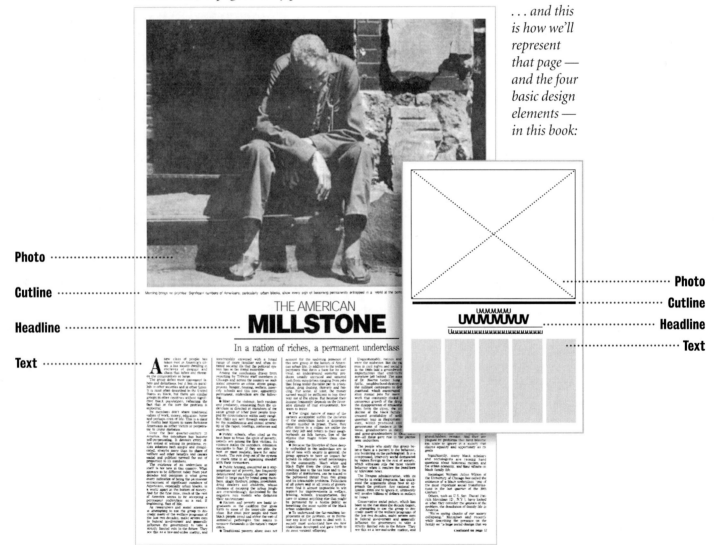

. . . and this is how we'll represent that page — and the four basic design elements — in this book:

Photo

Cutline

Headline

Text

Photo

Cutline

Headline

Text

In the pages ahead, we'll examine each of these elements in brief detail. If you're in a hurry to begin designing pages, you can browse through this material now and come back to it when you need it.

HEADLINES

When you study a page like the one at right — which probably happens every time you stand in the checkout line at the grocery store — there's one thing that leaps out, that grabs you, that sucks you in and suckers you into digging into your pocket, yanking out some change and *buying* the thing:

The headlines.

Headlines can be mighty powerful. In fact, they're often the strongest weapon in your design arsenal. Stories can be beautifully written, photos can be vivid and colorful — but neither is noticeable from 10 feet away the way headlines are.

You may never write headlines as strange and tacky as these tabloid headlines are (although to give credit where it's due, notice how cleverly crafted they are). If you stick strictly to design, you may never even write heads at all (since most headlines are written by copy editors). But you still need to know what headlines are, where they go, and what styles and sizes are available.

Magic words bring you money, love & health!
Say these ancient chants and change your luck forever!

WEEKLY WORLD

NEWS

Space probe photos look like Dodge City in the 1880s

MUMMY NIGHTMARE!
Wife keeps hubby's corpse at home in bed — for 8 years!

WILD WEST TOWN FOUND ON VENUS!

'This is like something out of the Twilight Zone,' says scientist

Monster croc chokes to death on bone in a witch doctor's nose!

ZAPPED
Killer electrocuted while sitting on his jail cell toilet seat

INCREDIBLE FROG BOY!
Mom gives birth to human tadpole, say stunned docs

PET ROOSTER PULLS DROWNING CHILD FROM AN ICY POND!

10-year-old girl dies — after eating her own hair, say docs

Though this page has little to do with "serious" journalists like us, you've got to admit those Futura headlines are pretty effective.

WRITING GOOD HEADLINES

Because this is a book on design, not copy editing, we won't rehash all the rules of good headline writing. But we'll hit the highlights, which are:

◆ **Keep them conversational.** Write the way people speak. Avoid pretentious jargon, odd verbs, omitted words *(Solons hint bid mulled).* As the stylebook for The St. Petersburg Times warns, "Headlines should not read like a telegram."

◆ **Write in present tense, active voice.** Like this: *President vetoes tax bill.* Not *President vetoed tax bill* or *Tax bill vetoed by president.*

◆ **Avoid bad splits.** Old-time copy-deskers were fanatical about this. And though things are looser these days, you should still try to avoid dangling verbs, adjectives or prepositions at the end of a line.

Instead of this:

Sox catch up with Yankees

Try this:

Sox catch Yankees in playoffs

Above all, headlines should be accurate and instantly understandable. If you can improve a headline by leaving it a little short or by changing the size a bit, do it. Headline effectiveness always comes first.

Remember, headlines serve four functions on a newspaper page:

1 They summarize story contents.

2 They prioritize stories, since bigger stories get bigger headlines.

3 They entice readers into the text.

4 They anchor story designs to help organize the page.

HEADLINES

TYPES OF HEADLINES

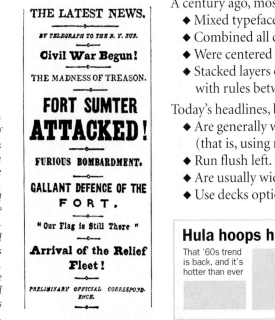

This headline is from The New York Sun of April 13, 1861. Papers often wrote a dozen decks like this before finally starting the story. Why no wide horizontal headlines in those days? Because those old type-revolving presses locked metal type into blocks to print each page. Type set too wide would come loose and fly off the cylinder as the presses spun around.

A century ago, most newspaper headlines:
- ◆ Mixed typefaces at random.
- ◆ Combined all caps and lower case.
- ◆ Were centered horizontally.
- ◆ Stacked layers of narrow decks atop one another, with rules between each deck.

Today's headlines, by comparison:
- ◆ Are generally written downstyle (that is, using normal rules of capitalization).
- ◆ Run flush left.
- ◆ Are usually wide rather than narrow.
- ◆ Use decks optionally, as in this example:

That's called a *banner* headline, and it's the standard way to write a news headline. But it's not the only way. Below are some alternatives — headline styles that go in and out of fashion as time goes by. (These headlines all use Helvetica.)

Kickers
Kickers lead into headlines by using a word or phrase to label topics or catch your eye. They're usually much smaller than the main head, set in a contrasting style or weight.

Hammers
Hammers use a big, bold phrase to catch your eye, then add a lengthier deck below. They're effective and appealing, but they're usually reserved for special stories or features.

Slammers
Who dreams up these nutty names? This two-part head uses a boldface word or phrase to lead into a contrasting main headline. Some papers limit these to special features or jump headlines.

Tripods
This head comes in three parts: a bold word or phrase (often all caps) and two lines of deck squaring off alongside. Like most gimmicky heads, it usually works better for features than for hard news.

Raw wraps
Most headlines cover all the text below; this treatment lets text wrap alongside. It's a risky idea — but later on, we'll see instances where this headline style comes in handy.

Sidesaddle heads
This style lets you park the head beside, rather than above, the story. It's best for squeezing a story — preferably, one that's boxed — into a shallow horizontal space. Can be flush left, flush right or centered.

HEADLINES

HOW TO SIZE HEADLINES ON A PAGE

If we had to generalize about headline sizes, we could say that *small* headlines range from 12- to 24-point; midsize headlines range from 24- to 48-point; *large* headlines range upward from 48-point.

Beyond that, it's difficult to generalize about headline sizes. Some papers like them big and bold; others prefer them small and elegant. Headlines in tabloids are often smaller than headlines in broadsheets (though not always).

Still, this much is true: Since bigger stories get bigger headlines, headlines will generally get smaller as you move down the page. Here are some examples:

MORE ON ▶

◆ **Butting headlines:** *When it's permissible and how it works....* **75**

◆ **Standing heads:** *How they differ from headlines...............* **133**

◆ **Display headlines:** *Treatments that add variety and graphic pizazz to feature headlines* **196**

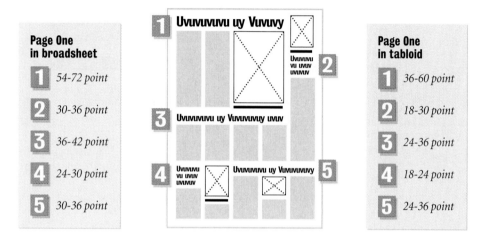

Page One in broadsheet

1 — 54-72 point
2 — 30-36 point
3 — 36-42 point
4 — 24-30 point
5 — 30-36 point

Page One in tabloid

1 — 36-60 point
2 — 18-30 point
3 — 24-36 point
4 — 18-24 point
5 — 24-36 point

NUMBER OF LINES IN A HEADLINE

Traditionally, newspapers have used a coding formula for headlines that lists: 1) *the column width,* 2) *the point size* and 3) *the number of lines.* Using that formula, a 3-30-1 headline would be a 3-column, 30-point headline that runs on one line, like this:

Rock 'n' roll causes acne, doctor says

(Not shown actual size)

Headlines for news stories usually run on top of the text. That means a wide story needs a wide headline; a narrow story needs a narrow one. So in a narrow layout, that headline above could be rewritten as a 1-30-3 (1 column, 30-point, 3 lines deep):

Rock 'n' roll causes acne, doctor says

Since 5-10 words are optimum for most headlines, narrow stories may need 3-4 lines of headline to make sense; wide headlines can work in a line or two.

The chart below will give you an idea of how many lines usually work best:

HOW MANY LINES DOES A HEADLINE NEED?					
If headline is this wide (in columns): 1	2	3	4	5	6
Then make it this deep (in lines): 3-4	2-3	1-2	1	1	1

TEXT

Text is the most essential building block of newspaper design. It's the gray matter that communicates the bulk of your information.

But text doesn't have to be gray and dull. You can manipulate a wide range of typographic components to give text versatility and personality.

Take this record review, for instance:

Typeface & size
These record titles use 9-point Futura Condensed (note the variety of styles: bold, italic, all-cap, etc.).

The text uses 9-point Utopia — a common size for newspaper text.

Leading
The text uses 10 points of leading. Since it's 9-point type, that means there's one point of space between descenders and ascenders.

Tracking & set width
We've tightened the tracking just a bit (-2), so the characters nearly touch. And the set width is slightly condensed (95%).

Paragraph indents
The first line of each new paragraph is indented 9 points.

Hanging indents
In a way, these are the opposite of paragraph indents. The first line is flush left; all subsequent lines are indented to "hang" along the edge of those black bullets (or dingbats).

Extra leading
We've added 8 points of extra leading here between the end of one review and the start of the next. There's also 3 points of extra leading between the boldface title info and the text that follows.

BITE ME LIKE A DOG
Toe Jam
(Nosebleed Records) ★★★

Looking for some tunes that'll make your eardrums bleed and suck 50 points off your I.Q.?

Grab yourself some Toe Jam.

On "Bite Me Like a Dog," these five veteran Seattle death-metal-mongers unleash 14 testosterone-drenched blasts of molten sonic fury, from the opening salvo of "Lost My Lunch" to the gut-wrenching closer, "Can't Love You No More ('Cuz I'm Dead)." Lead vocalist Axl Spandex has never sounded more satanic than on the eerie "Sdrawkcab Ti Yalp."

Of course, the big question for every Toe Jam fan will be: Does this record match their ageless 1997 classic, "Suckadelic Lunchbucket"?

Sadly, no. But really, what could?
— *Forrest Ranger*

THE VILLAGE IDIOTS UNPLUGGED
The Village Idiots
(Doofus Records) ★

What awesome potential this band has! You'd have to be living in a cave on some remote planet not to remember how the music biz was abuzz last year when these rock legends joined forces, refugees from such stellar supergroups as:

✦ Nick O. Teen and The Couch Potatoes;
✦ Men With Belts;
✦ Potbelly; and, of course,
✦ Ben Dover and Your Silvery Moonbeams.

What a letdown, then, to hear this dreck. One listening to "The Village Idiots Unplugged" and it's your *stereo* you'll want unplugged.
— *Ruby Slippers*

HOG KILLIN' TIME
Patsy Alabama
(Big Hair Records) ★★★★

Some still call her "The Memphis Madonna." But Patsy Alabama now swears her days as "The Cuddle-Bunny of Country Music" are over.

REVIEWS, PREVIEWS & MUSICAL MUSINGS

And with her new record — and her new band, The Rocky Mountain Oysters — she proves it.

Patsy's songwriting is a wonder: sweet, sassy and so doggone *powerful*. In the waltzy weeper "I Love When You Handle My Love Handles," she croons:

Some nights are rainbows
Some are cartoons
And some call you softly
* to dance below the moon*

© 1999, Millie Moose Music, Inc.

Aw, shucks. That gal will dang near bust your heart. Buy some hankies. Then buy this record.
— *Denton Fender*

ROCKS IN YOUR SOCKS
Ducks Deluxe
(NSU-Polygraph) ★★

If the idea of a 22-piece accordion orchestra appeals to you — playing such polka-fied disco classics as "Shake Yer Booty" fronted by a vocalist named Dinah Sore, whose fingernails-on-the-blackboard screechings make Yoko Ono sound like Barbra Streisand — then friend, this is your lucky day.

For the rest of you, avoid this sonic spewage like the plague.
— *C. Spotrun*

NEWS & NOTES: The April 14 benefit for **Window-Peekers Anonymous** has been canceled. . . . Rapper **Aaron Tyres** will sign autographs at noon Sunday at The Taco Pit. . . . **The Grim Reapers** are looking for a drummer. Interested? Call 555-6509.

Got a music news nugget? A trivia question? A cure for the common cold? Write to In Your Ear, P.O. Box 1222.

Sans serif type
Papers often use sans-serif faces to distinguish graphics, logos and side-bars from the main text. This Futura font is centered, all caps, and reversed (white type on a dark background).

Italic type *is used to emphasize words — as in "powerful" here. It's also used for editor's notes (below), foreign words or literary excerpts — for instance, these song lyrics.*

Agate type
Fine print set in 5- or 6-point. Also used for sports scores and stocks.

Flush right type *runs flush to the right edge of the column.*

Flush left type *runs flush to the left edge of the column. Many papers also run cutlines and news briefs flush left (ragged right).*

Justified type
The text has straight margins on both the right and left edges.

Boldface type
Boldface is often used to highlight key words or names. It's irritating in large doses, however.

Editor's note
This uses Utopia — but note how the extra leading, italics and ragged-right style set it apart from the text.

TEXT

Newspapers measure stories in inches. A short filler item might be just 2 inches long; a major investigative piece might be 200. But since one inch of type set in a *wide* leg is greater than one inch of type in a *narrow* leg, editors avoid confusion by assuming all text will be one standard width (that's usually around 12 picas).

You can design an attractive newspaper without ever varying the width of your text. Sometimes, though, you may decide that a story needs wider or narrower legs; those non-standard column widths are called *bastard* measures.

Generally speaking, text becomes hard to follow if it's set in legs narrower than 10 picas. It's tough to read, too, if it's set wider than 20 picas.

The ideal depth for text is between 2 and 10 inches per leg. Shorter than that, legs look shallow and flimsy; longer than that, they become thick gray stacks. (We'll fine-tune these guidelines in the pages ahead.)

SHAPING TEXT INTO COLUMNS

Text is flexible. When you design a story, you can bend and pour the text into different vertical and horizontal configurations, as these examples show:

Suppose you have a 12-inch story. It can be designed as one leg 12 inches deep. . .

OR

It can also be doubled up into two equal legs, each 6 inches deep. . .

OR

It can become three legs, each 4 inches deep. . .

OR

Note *how the text seems shorter (and more readable) as it widens.*

It can be four legs, 3 inches deep. . .

OR

It can even be spread into six legs, each 2 inches deep.

OR

It can be five legs, each 2.4 inches deep. . .

A lot of math is involved in page design, especially when you calculate story lengths and shapes. To succeed, you need a sense of geometry and proportion — an understanding of how changing one element in a story's design affects every other element.

Here's that same 12-inch story — but now it wraps around a photograph. Can you see how, if the photo became deeper, each column of text would need to get deeper, too?

PHOTOS

There's nothing like a photograph to give a newspaper motion and emotion. As you can see in these classic images from pages of the past, photojournalism lies at the very heart of newspaper design:

Clockwise from top: *Babe Ruth bids farewell; Harry Truman celebrates election victory; a captured Viet Cong officer is shot in Saigon; the space shuttle Challenger explodes; Buzz Aldrin walks on the moon; Jack Ruby shoots Kennedy assassin Lee Harvey Oswald.*

PHOTOS

Every picture tells a story — and every story deserves a picture. Today's readers are so spoiled by TV and magazines that they now expect photos — color photos, yet — to accompany nearly every story they read.

Now, you may not have the space for that many photos. You may not have enough photographers to *shoot* that many photos. And printing color may be virtually impossible.

But try anyway. Add photos every chance you get. Without them, you simply can't produce an appealing newspaper.

MORE ON ▶

◆ **Horizontals:**
Tips on sizing and designing............... **50**

◆ **Verticals:**
Tips on sizing and designing............... **53**

◆ **Plus:** *A complete chapter on photos...* **99**

THE THREE BASIC PHOTO SHAPES

It sounds obvious, but news photos come in three basic shapes. Each of those shapes has its strengths and weaknesses. And each is best suited to certain design configurations.

The three shapes are *rectangular*: horizontal, vertical and square.

Horizontal
This is the most common shape for news photos. We view the world horizontally through our own eyes, and when you pick up a camera, this is the shape you instantly see — though some subjects (like basketball players and space shuttle launches) may demand a vertical composition.

Vertical
Vertical shapes are often considered more dynamic than either squares or horizontals. But verticals can be trickier to design than squares or horizontals. Because they're so deep, they often seem related to any stories parked alongside — even if they're not.

Square
Squares are sometimes considered the dullest of the three shapes. In fact, some page designers and photographers avoid squares altogether. Remember, though, that the content of a photo is more important than its shape. Accept each photo on its own terms, and design it onto the page so it's as strong as possible — whatever its shape.

CUTLINES

It's a typical morning. You're browsing through the newspaper. Suddenly, you come face to face with a photo that looks like this:

You look at the pig. You look at the men. You look at the bulldozer. You look back at the pig. You wonder: *What's going on here?* Is it funny? Cruel? Bizarre? Is that pig *doomed?*

Fortunately, there's a cutline below the photo. It says this:

> **Highway workers use a loader to lift Mama, a 600-pound sow, onto a truck Monday on Interstate 84 near Lloyd Center. The pig fell from the back of the truck on its way to the slaughterhouse. It took the men two hours to oust the ornery oinker.**

Ahhhh. Now it makes sense.

Sure, every picture tells a story. But it's the cutline's job to tell the story behind every picture: *who's* involved, *what's* happening, *when* and *where* the event took place. A well-written cutline makes the photo instantly understandable and tells readers *why* the photo — and the story — are important.

CUTLINE TYPE STYLES

Cutlines are quite different from text. And to make that difference clear to readers, most newspapers run cutlines in a different typeface than text. Some use boldface, so cutlines will "pop" as readers scan the page. Some use italic, for a more elegant look. Some use sans serifs, to contrast with serif text. (This book uses a serif italic font — Minion — for its cutlines.)

SERIF BOLDFACE, JUSTIFIED	SERIF ITALIC, RAGGED RIGHT	SANS SERIF, JUSTIFIED, WITH BOLDFACE LEAD-IN
President George W. Bush greets Yasir Arafat at the White House on Thursday as the two leaders met for a new round of Mideast peace negotiations.	*President George W. Bush greets Yasir Arafat at the White House on Thursday as the two leaders met for a new round of Mideast peace negotiations.*	**SUMMIT BEGINS** — President George W. Bush greets Yasir Arafat at the White House on Thursday as the two leaders met for a new round of Mideast peace talks.

CUTLINES

How long should cutlines be? Long enough to describe, briefly, all significant details in the photo. Some photos are fairly obvious and don't require much explanation. Others (old historical photos, works of art, photos that run without stories) may need lengthy descriptions.

And what about photos of clubs or teams? Should every face — all 19 of them — be identified? Most newspapers set guidelines for such occasions, so it's hard to generalize. But remember that readers expect cutlines to offer quick hits of information. So don't overdo it.

Where do you dummy cutlines? On news pages, they generally run *below* each photo. But for variety, especially on feature pages, cutlines can also run *beside* and *between* photos, as shown below:

MORE ON ▶

◆ **Mug shots:** *They've got their own style of cutlines* **46**

◆ **Photo spreads:** *Cutline treatments and placement* **119**

BELOW

The Bugle-Beacon/PAT MINNIEAR

*Cutlines below photos usually align along both edges of the photo. They should **never** extend beyond either edge. Some papers set extra-wide cutlines in two legs, since they can be difficult to read. (For more on this, see page 39.) Another rule of thumb: In wide cutlines, be sure the last line extends at least halfway across the column. This line barely makes it.*

BESIDE

*This cutline is set **flush right** along the edge of the photo. (Notice how ragged left type is somewhat annoying to read.) Try to dummy sidesaddle cutlines along the outside of the page. That way, the cutlines won't butt against any text type, which could confuse your readers and uglify your page.*

*This ragged right cutline is **flush left** against the photo and flush to the bottom. And it's too thin. Cutlines usually need to be at least 6 picas wide. If they're narrow, they shouldn't be very deep.*

BETWEEN

Ideally, every photo should have its own cutline. But photos can also share one common cutline, as these two do. Just be sure you make it clear which photo (at left or at right) you're discussing. And make sure the cutline squares off at either the top or bottom. Don't just let it float. (Notice how this cutline is justified on both sides.)

DRAWING A DUMMY

How can you show your colleagues, in advance, where stories will go on a page? Or what size headlines should be? Or where the photos go?

Mental telepathy? No. You draw a dummy.

Now, you might be tempted (especially if you create pages on a computer) to bypass dummy-drawing and, instead, squat in front of a computer and noodle aimlessly for hours until you *discover the solution.* Wrong. Big waste of time. You might work more efficiently if you draw a page diagram in advance — a *dummy* — before you try to assemble the real thing.

Dummies are generally about half the size of actual pages but proportioned accurately (i.e., if your design calls for a thin vertical photo, it shouldn't look square on the dummy). For greater precision on complex pages, designers often draw life-sized dummies. But for most pages, a small-sized dummy like the one below is sufficient.

And often necessary.

MORE ON ▶

◆ **Modular design:**
Want to see how this page would look if the story elements were rearranged? Turn to page........... 82

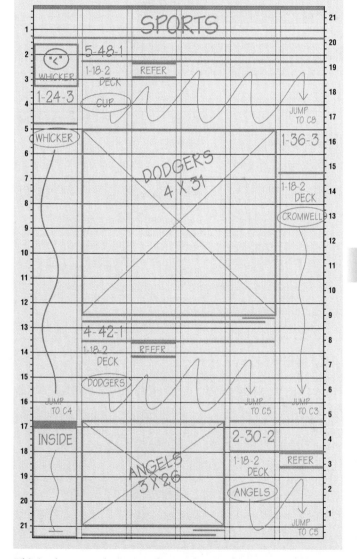

This is where pages begin. An editor or designer draws a series of lines and boxes to indicate where photos, cutlines, headlines and text will go. This page is pretty simple: not too many stories or extras.

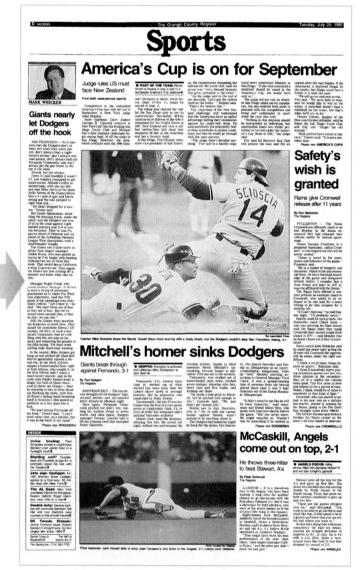

And here's how that dummy translated into print. Note how every story jumps (continues on another page). That makes the page easier to build, since text can be cut according to the diagram on the dummy.

DRAWING A DUMMY

Every newspaper has its own system for drawing dummies. Some, for instance, size photos in picas; others use inches, or a combination of picas and inches. Some papers use different colored pens for each different design element (boxes, photos, text). Some use wavy lines to indicate text, while others use arrows — or nothing at all.

Whatever the system, *make your dummies as complete and legible as you can.* Be sure that every dummy contains:

Page or section
headers, if any

Column logos,
sigs or bugs,
clearly labeled

Any rules, boxes
or borders,
clearly marked

Sizes and slugs for
all art (photos,
maps, charts, etc.),
with cropping
instructions, if
necessary

Cutlines and credit
lines for all photos

Story name (or slug)
and column width,
if it's in a bastard
measure; slug can
be circled for
emphasis

Arrows or lines to
show position and
movement of text

Any special
instructions to the
composing room
(layout advice, late
stories, trimming
directions, etc.)

Page number,
date and edition
(if applicable)

Liftout quotes or
other secondary
graphic elements (if
typeset separately
from the main story,
include their name
or slug)

Jump lines, including
page number where
text will continue

Headlines, clearly
coded (with deck
codes, if necessary)

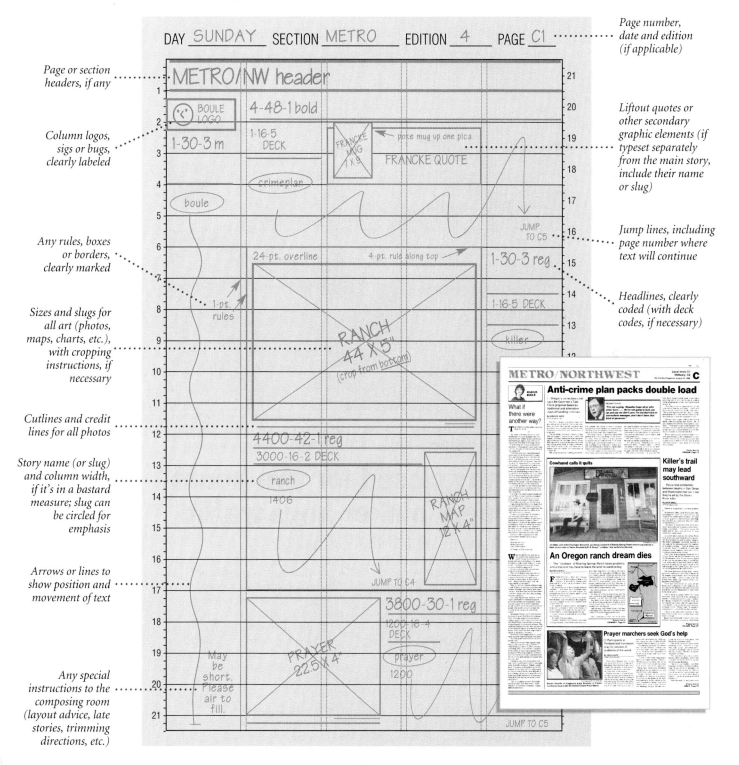

DRAWING A DUMMY

Drawing a dummy isn't an exact science. Stories don't always fit the way you want. And even when you're dead certain you've measured everything perfectly, you'll inevitably find yourself fudging here and there once you start pasting things up.*

So relax. When it's time to fine-tune a page, you can always trim a photo. Plug in a liftout quote. Write a bigger headline. Change a deck. Shuffle ads around. Add some extra leading between paragraphs. Cut an inch or two from the story. Or (*horrors!*) start over.

* In the old days — like, say, oh, 10 years ago — photos, headlines, cutlines and text were printed individually on separate strips of paper, then pasted into place on a grid sheet. That camera-ready page was called a *paste-up* (though all those strips of paper were fastened with wax, not paste). Some of you old-timers may still build pages this way; the rest of you probably use computer programs like PageMaker or QuarkXpress.

MORE ON ▶

◆ **Making stories fit:**
Options to try when stories turn out too short or too long**86**

AN EXAMPLE OF HOW DUMMYING WORKS

Let's take a finished layout and build a dummy from it — a reverse of the usual procedure. That way, you can see how the different parts of a dummy work together to create a finished page.

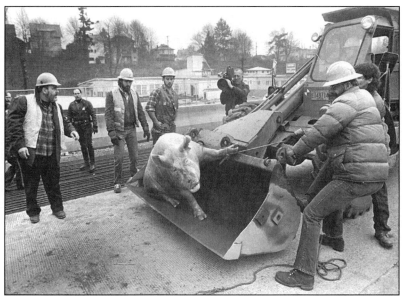

The Oregonian / KRAIG SCATTARELLA

Highway workers use a loader to lift Mama, a 600-pound sow, onto a truck Monday on Interstate 84 near Lloyd Center. The pig fell from the truck on the way to slaughter.

Freeway closed for two hours as ornery oinker hogs traffic

Westbound traffic on Interstate 84 near the Lloyd Center exit was backed up for nearly two miles early Monday when a 600-pound hog on the way to slaughter fell from the back of a truck.

For nearly two hours, the sow refused to budge.

Fred Mickelson told police that he was taking six sows and a boar from his farm in Lyle, Wash., to a slaughterhouse in Carlton when Mama escaped.

"I heard the tailgate fall off, and I looked back and saw her standing in the road," Mickelson said with a sigh. "I thought: 'Oh, no. We've got some real trouble now.' "

Mickelson said Mama was "pretty lively" when she hit the ground, lumbering between cars and causing havoc on a foggy day. There were no automobile accidents, however.

After about an hour of chasing the pig with the help of police, Mickelson began mulling over his options, which included having a veterinarian tranquilize the hog.

About 10 a.m., a crew of highway workers arrived and decided to use a front-end loader to pick up the sow and load her back into the truck.

DRAWING A DUMMY

STEP BY STEP:
HOW TO DRAW
A DUMMY

1 Measure all the elements in the example on page 34, and this is what you'll find:

◆ **Text:** The text is in two legs. Each leg is 12 picas and 2 points wide — often written *12p2* (which is a fairly standard column width for newspaper text). Each leg is 2 inches deep. The whole story, then, is 4 inches long.

◆ **Headline:** Measure from the top of an ascender to the bottom of a descender, and you'll find it's a 24-point headline. There are two lines, with a slight space *between* lines. So the whole headline is roughly 48 points (4 picas) deep.

◆ **Photo:** We usually measure photo widths in picas or columns. (This one is two columns wide — or 25p4.) And though some papers measure photo depths in inches, it's better to use picas. (This photo is 18 picas — 3 inches — deep.)

◆ **Cutline:** Note the spacing above and below this cutline. From the bottom of the photo to the top of the headline is roughly half an inch: 3 picas.

MORE ON ▶
..
◆ **Basic terms:** *Definitions of terms like picas and points* **16**
◆ **Headlines:** *How they're measured and how to code them ...* **25**

2 Suppose we want to design this story into the top left corner of the page. Grab a blank dummy sheet. Find the two left-hand columns. Move up to the top, and we'll begin drawing in the elements.

At the top of the page, draw a box to represent the photo. Make it two columns wide; count down 3 inches for the depth. Run a big "X" into the corners. (The "X" is a traditional way to indicate this is a photo, not an ad or a box for another story.)

Always remember to write the size of the photo. In this case, it's 2 columns wide, 18 picas deep — or 2 X 18, for short.

3 Next comes the cutline. There are different ways to indicate cutlines on dummies, but here's how we'll do it:

Calculate how many lines of cutline there'll be (in this case, two). Allowing a little air under the photo, draw a line where the bottom of the cutline will be. Here, it's about a half-inch below the photo.

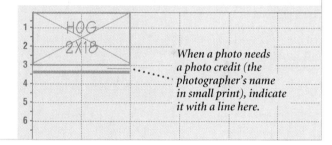

When a photo needs a photo credit (the photographer's name in small print), indicate it with a line here.

4 Now dummy a 2-24-2 headline. Most designers just draw a horizontal line and jot down the headline code — and that's quick and easy.

But you might want to imitate the *feel* of the headline by drawing either a row of X's or a squiggly horizontal wave to represent each line of headline. Then write the headline code at the beginning of the line.

Allow a few picas of space between the cutline and the headline. Like this:

This effect is easy to do: just waggle a pencil up and down, back and forth along the edge of a ruler.

5 Finally, indicate where the text goes. There are many ways to do this: straight lines, wavy lines, arrows. Some papers just leave blank space.

For now, let's use a directional line. Write the name (or *slug*) of the story where the text begins; under it, draw a line down the center of the leg. When you reach the bottom of the leg, jog the line up (the way your eye moves) to the top of the next leg. This will trace the path of the text, like so:

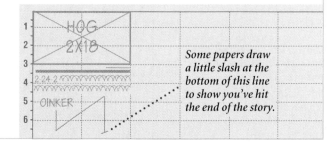

Some papers draw a little slash at the bottom of this line to show you've hit the end of the story.

A SAMPLE DUMMY: BROADSHEET

This is a typical page dummy for a 6-column broadsheet newspaper. Most tabloids, on the other hand, are roughly half this size and use a 5-column format (see facing page).

How dummies work:

◆ The numbers along the left margin show inches measured down from the top of the page. The entire page, as you can see, is 21½ inches deep.

◆ The numbers along the right margin show inches measured up from the bottom of the page. These are useful for dummying ads.

◆ The vertical lines represent columns. A 6-column photo, for instance, would be as wide as the entire page.

◆ Each horizontal line represents an inch of depth. A leg of text that's 1 inch deep would take up just one of those segments.

Need a dummy?

You'll need lots of blank page dummies like this to do the exercises at the end of each chapter. Feel free to duplicate this dummy as often as you like if no others are available for you to practice on.

But better yet: Create a page dummy like this that's customized for your newspaper.

A SAMPLE DUMMY: TABLOID

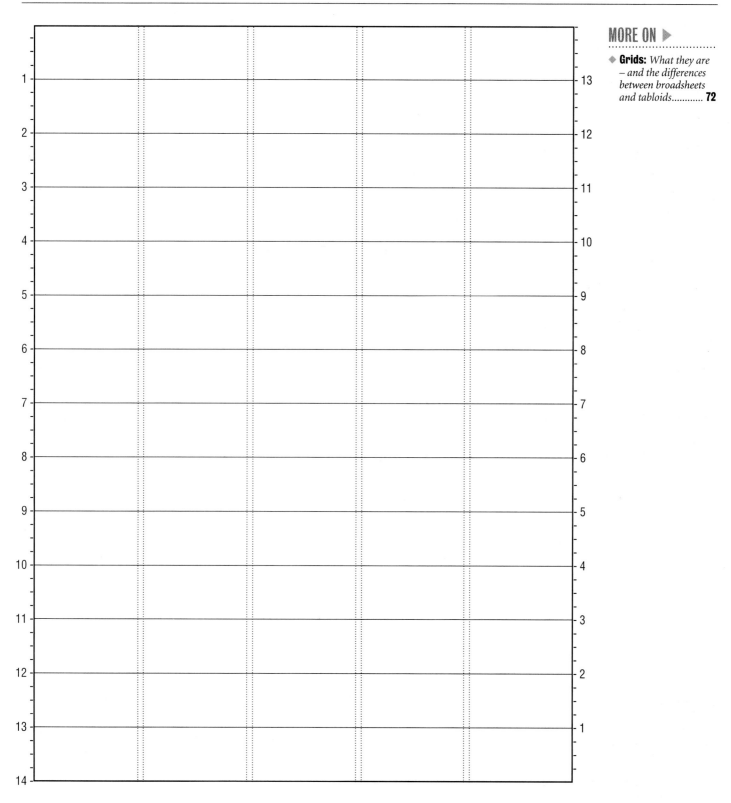

Dummies such as these show the basic *grid* pages use. And as we'll see later, the grid is the underlying pattern that organizes each page into columns. You'd use this dummy, for example, to design tabloid pages on a 5-column grid – but that's not the only grid that tabloids use. Some use 4, 6, 7, 8, even 9 columns. But a 5-column grid is probably the most common tab format.

TROUBLESHOOTING

Quick answers to questions frequently asked by designers perplexed about the design fundamentals:

Q: **I've been told that newspapers should only use three typefaces. Is that true? If not, how many typefaces does a newspaper need?**

There's no magic number when it comes to typefaces. In fact, there's no simple formula for type selection *at all*. With so many fonts so readily available these days, it's easy to mix and match typefaces until you find the combination that suits your paper's personality. For instance, look at these two contrasting options:

This page features a variety of logos, liftout quotes, headlines and decks — and the only type family it uses is Berkeley. By mixing bold, light, italic and reversed type, you can achieve a wide range of effects. Thus, it's possible to design your entire paper with just one type family.

Some newspapers use only a couple of fonts, it's true. Some use dozens, but it results in chaos. So as a starting point, your shopping list should include:

◆ *An easy-to-read text type.* Find a font that's handsome, not too quirky, and comfortable to read at small sizes. You don't need to use this font anywhere else — just for text.

◆ *A typeface for all your headlines.* If you want to run headlines in a variety of styles and weights, use a versatile family that offers plenty of variations. You can designate different weights or styles for decks, liftout quotes, promos, etc.

◆ *A typeface for special touches* — logos, sigs, section flags, etc. This is where much of your typographic personality will come from: those regular design elements scattered throughout your paper.

◆ *A typeface for special text.* Your sidebars, graphics, jump lines and cutlines need to look a little different from the standard text beside them. Again, find a family that offers a variety of bold, light and italic fonts.

That's four families there. And you could easily identify other specific jobs for certain fonts to do (*We'll use Electra ONLY for the big headline on Page One. . .*). As long as all those typefaces work together to help readers consistently understand what's what, feel free to mix fonts until you find the right combination.

Now we've assigned different jobs to different fonts, and you can see how the page's personality starts to change. We now use Decotura for logos, Griffin for headlines Berkeley in the quotes, promos and text. We're experimenting, but giving specific fonts specific duties.

Q: **Go back to text type for a minute. What's the best size and font to use for body type?**

Remember, fonts vary greatly in their personalities *and* in their apparent sizes. Here, for instance, are three different samples of 9-on-10 text type:

This is Nimrod. It looks somewhat blocky because of its large x-height, but it's popular and readable. It also seems a bit thicker than other fonts.

This is Utopia. It has a smaller x-height than Nimrod and appears lighter on the page, but many find it more handsome. It also looks fine condensed a bit, like this.

This is Century. You can see right away how its shorter x-height makes it appear smaller than those other two fonts. But it's still an elegant and extremely readable typeface.

Since readers' eyes (and bodies) deteriorate as they age, consider how aged your audience is. Student publications often run 8-point text. But if you've got readers over the age of 50, take pity on them. Run tests (on actual newsprint) to find a font and size that seems attractive — and that all your readers can actually *read*.

For more on testing text type, see page 225.

TROUBLESHOOTING

 At our newspaper, we run cutlines in two or three legs under wide horizontal photos. Is that a good idea?

Though it sounds like a good idea in theory — keeping cutlines readable by running them in narrow legs — in reality, it can cause readers to stumble as they read from leg to leg. Since most cutlines are only a sentence or two, it's easy to follow them if they're just a few lines deep. See for yourself:

At some papers, this is the style for wide cutlines — justified type arranged into columns to keep from running too wide. But the type often spaces out like this, and the words collide from leg to leg. It gets too confusing.

Instead, we recommend running the cutline the full width of the photo. Yes, it's wider than you might ordinarily choose to run text type — but readers can easily track a cutline like this if it's not too deep. And it looks a lot less confusing.

 We're a small newspaper on a tight budget. What software do we need to put out a well-designed newspaper?

You need fonts, of course. And virus protection. And assorted utilities to keep your system bug-free. But to produce a complete publication, you need:

◆ *A page-layout program* like QuarkXPress (used by most professionals) or PageMaker (used mostly by students).

◆ *A drawing program* like Freehand or Illustrator, which is useful for creating charts, maps and artwork. (Even if you use clip art because you don't have an artist on staff, you'll need these programs to manipulate those images.)

◆ *A photo-adjustment program* like Photoshop for massaging digital images.

That's all you really need. If there's money left over in the budget, spend it on software *training*, so you can maximize the potential of those programs.

 At our paper, copy editors often condense headlines electronically to make to make them fit better. Is that a bad idea?

You mean, taking a headline like this — — and squeezing it like this?

Pope admits: Yes, I'm Catholic Pope admits: Yes, I'm Catholic

Some papers do that. They do it with text type, too, to make stories fit. But it looks seriously unprofessional. Don't do it. Please. Code your headlines and text so they're typographically excellent — the tracking, leading, scaling — and don't mess with them. If a headline won't fit, rewrite it so it does. Leave the type alone.

What hardware, software and typefaces did you use to produce this book?

◆ *Hardware:* A Macintosh G4 with a 19-inch monitor; the scanning was done on an industrial-strength Heidelberg Nexscan flatbed and a Celsis drum scanner.

◆ *Software:* QuarkXPress for layout; Photoshop for imaging; TypeStyler for crafting special type effects (like that "Q" above).

◆ *Fonts:* Minion for text and cutlines; Bureau Grotesque for headlines, page headers and subheads; Frutiger Condensed for graphics and sidebars.

EXERCISES

ANSWERS ▶ **240**

1 Approximately what size is the big type below? _____

ONE
INCH
SQUARE

What size am I?

2 Fill in the blanks below with the correct typographic terms:

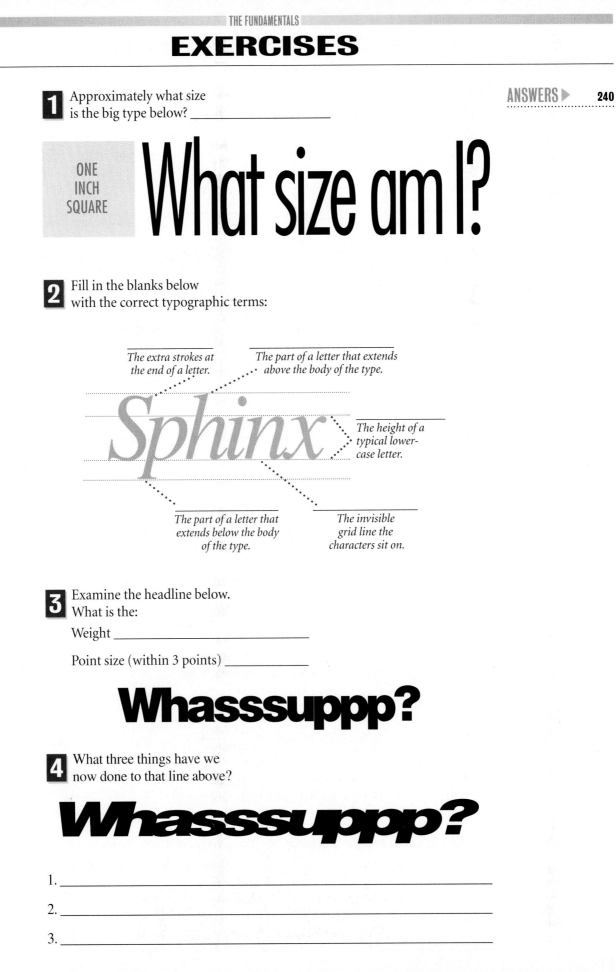

The extra strokes at the end of a letter.

The part of a letter that extends above the body of the type.

The height of a typical lower-case letter.

The part of a letter that extends below the body of the type.

The invisible grid line the characters sit on.

Sphinx

3 Examine the headline below. What is the:

Weight _____

Point size (within 3 points) _____

Whasssuppp?

4 What three things have we now done to that line above?

Whasssuppp?

1. _____

2. _____

3. _____

EXERCISES

5 Examine the type at right. Identify five significant type characteristics.

> Here is another
> typographic brain-teaser

1. _____ 4. _____

2. _____ 5. _____

3. _____

6 What four things have we done to that boxed type in question 5?

> HERE IS ANOTHER
> TYPOGRAPHIC BRAIN-TEASER

1. _____ 3. _____

2. _____ 4. _____

7 What are the pica dimensions of that box in question 5? _____

8 How thick is the border of that box in question 5? _____

9 What are the four differences between the column on the left and the column on the right?

Best picture: "Gladiator"
Best actor: Russell Crowe in
"Gladiator"
Best actress: Julia Roberts
in "Erin Brockovich"

● **Best picture:** "Gladiator"
● **Best actor:** Russell Crowe in
 "Gladiator"
● **Best actress:** Julia Roberts
 in "Erin Brockovich"

1. _____ 3. _____

2. _____ 4. _____

10 The headline below uses fairly common typefaces. If you have access to a computer, duplicate this headline as closely as possible; if not, describe as completely as you can the typographic components involved:

EXERCISES

11 Below is a three-column news story. Using the dummy sheet below, draw a dummy for this layout. (Be sure to include headline coding.)

Crazed pig closes freeway again

For the second time, an ornery oinker causes chaos on the highway

Mama is one freedom-loving hog.

Twice in the same day, Mama broke free from her captors and bolted for daylight. Twice in the same day, she created massive traffic jams.

And twice she was dragged, kicking and squealing, back into captivity.

Westbound traffic on Interstate 84 near Lloyd Center was backed up for two miles Monday when Mama, a 600-pound hog on the way to slaughter, fell from the back of a truck.

For nearly two hours, the sow refused to budge.

Fred Mickelson told police that he was taking six sows and a boar from his farm in Lyle, Wash., to a slaughterhouse in Carlton when Mama escaped.

"I heard the tailgate fall off, and I

The Oregonian / KRAIG SCATTARELLA

Highway workers use a loader to lift Mama, a 600-pound sow, onto a truck Monday on Interstate 84 near Lloyd Center. The pig fell off the truck on the way to slaughter.

looked back and saw her standing in the road," Mickelson said with a sigh. "I thought: 'Oh, no. We've got some real trouble now.' "

Mickelson said Mama was "pretty lively" when she hit the ground, lumbering between cars and causing havoc on a foggy day. There were no automobile accidents, however.

After about an hour of chasing the pig with the help of police, Mickelson began mulling over his options, which included having a veterinarian tranquilize the hog.

About 10 a.m., a crew of highway workers arrived and decided to use a front-end loader to pick up the sow and load her back into the truck.

ANSWERS ▶ 240

Headlines, text, photos, cutlines. Those are the basic pieces in the great Newspaper Design Puzzle. Over the years, page designers have tried assembling their puzzles in every conceivable way. Some solutions worked; others didn't.

In the pages ahead, we'll show you what works, what doesn't and what comes close. You may think there are thousands of design combinations for every story and every page, but there are really just a few basic formats you can count on. And those formats are well worth knowing.

In this chapter, we'll show you the different shapes a story can take, whether it's:

◆ a story without art;

◆ a story with a mug shot;

◆ a story with a large photograph;

◆ a story with two photographs.

Later on, we'll show you how to combine stories to make a page. But first things first.

There's a lot of information in the pages ahead. Don't try to absorb it all at once. Many of these examples were designed to be swipeable formats; the next time you're laying out pages, look through the section that applies, explore your options and choose a format that fits the bill. You'll soon understand why some layouts succeed and others fail.

Uvuvuvuvuy uvuvuv uy Vuvuvvuyvu

STORIES WITHOUT ART

In a typical newspaper — whether it's The New York Times or a tiny rural weekly — about 70% of the stories run without any art, 25% use just one piece of art (a photo, chart or map), and only 5% use two or more pieces of art. Something like this:

MORE ON ▶

◆ **Designing pages without art:** *Tips and techniques for creating attractive pages when photos aren't available* **74**

Here's a typical section front from the Portland Press Herald in Maine. There's a huge fire photo in the center of the page (but the text of the story is on the next page). One other story uses one photo — and the other three stories, along with the news briefs, use only headlines and text. When you turn the page. . .

. . . on the second page of that section there's another fire photo (this time with text). That top story adds a map and a small sidebar. All the other elements on the page use only text: the news story in the top left corner; the four jump stories (continued from the previous page); the calendar along the bottom.

So relax. Most of the stories you'll design will consist of just headlines and text. And since there are only a few ways to design stories without art, it's hard to goof them up.

Basically, when you combine headlines and text, they tend to move along the page either *vertically* or *horizontally*:

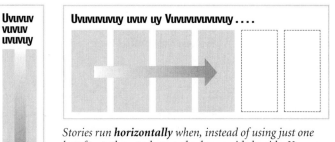

*Stories run **vertically** when the headline is on top, the text drops straight down below it — and that's that until the text ends.*

*Stories run **horizontally** when, instead of using just one leg of text, they stack several columns side by side. You can keep adding new legs — and extending the headline — until you run out of room at the right edge of the page.*

SHAPING STORIES INTO RECTANGLES

One of the basic design guidelines is this: **Whether square, horizontal or vertical, stories should be shaped into rectangles.**

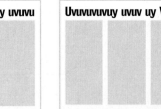

STORIES WITHOUT ART

VERTICAL STORY DESIGN OPTIONS

A hundred years ago, stories were all dummied vertically. Printers would simply run text in a strip below the headline, and when it reached the bottom of the page, they'd either end the story or jump the text up into the next column.

Nowadays, that's considered dumb dummying. In fact, you should try to avoid dummying legs more than 12 inches deep, since long legs look dull, gray and intimidating. In short: the longer the story, the more it needs to go horizontal.

In a typical news story (right), the headline sits atop the text. (In features, you'll soon see, that rule is often broken.)

Vertical stories are clean and attractive. They're the easiest shape to follow — just start at the headline and read straight down. Vertical design does have drawbacks, however:
- *Long vertical legs like these can get tiring to read.*
- *Headlines are harder to write when they're this narrow.*
- *Pages full of these long, skinny legs look awfully dull.*

HORIZONTAL STORY DESIGN OPTIONS

Horizontal shapes are pleasing to the eye. And they create the illusion that stories are shorter than they really are.

Again, avoid dummying legs deeper than 12 inches. But avoid short, squat legs, too. For most stories, legs should generally be at least 2 inches deep — never shorter than 1 inch.

Horizontal layouts flow left to right, the way readers naturally read. You'll create the most attractive designs by keeping legs between 2 and 10 inches deep. Note how the headline covers the text and sits directly above the start of the story.

TWO UNUSUAL OPTIONS TO PONDER

Probably 99% of all stories look like those above: basically vertical or horizontal, with the headline running above the text, covering the entire story like an umbrella.

Life is full of exceptions, however, and here are two more: the raw wrap and the sidesaddle headline (below). They both break the rule about headlines running above all the text. And they're both potentially awkward. (See how those right-hand legs of text could collide into any text above them?)

But in the right situations, they're handy. For now, view them with suspicion — but stay tuned.

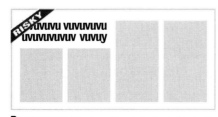

Raw wrap: *The headline is indented into the left-hand legs while the text wraps up alongside and aligns with the top of the headline.*

Sidesaddle headline: *The headline runs in the left-hand column — flush left, flush right or centered. The text runs alongside.*

MUG SHOTS

Yes, you can design stories without art. But your pages will look lifeless and gray.

After all, most stories are about people: people winning, losing, getting arrested, getting elected. (Often they get elected first, *then* arrested.) Readers want to know what those people look like. So show them.

Remember, mug shots attract readers. And attracting readers is your job.

◆ **Size:** Mugs usually run the full width of a column, 3-4 inches deep (though you can indent half-column mugs into the text).

◆ **Cropping:** Mug shots should fill the frame tightly — but not *too* tightly. Leave air above the hair, if you can; avoid slicing into ears, foreheads or chins.

◆ **Cutline:** Every mug needs a cutline. Mug cutlines often use a two-line format: The first is the person's name; the second is a description, title, etc.

OPRAH WINFREY
Awarded the National Book Foundation's 50th anniversary medal for her book club.

VERTICAL STORY DESIGN OPTIONS

In vertical designs, mug shots go at the very top of the story. In descending order, then, arrange story elements like this: *photo, cutline, headline, text.* Any other sequence may cause confusion.

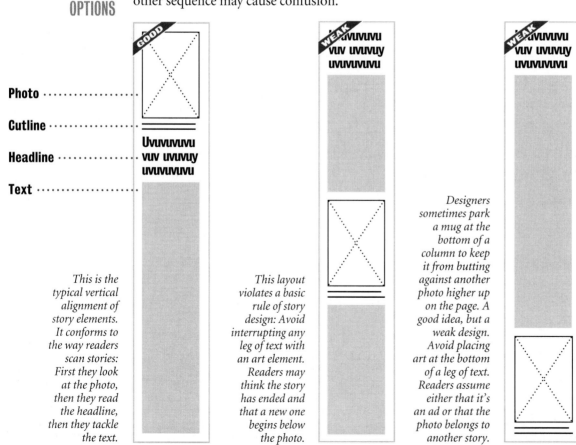

Photo · · · · · · · · · · ·
Cutline · · · · · · · · · · ·
Headline · · · · · · · · · · ·
Text · · · · · · · · · · ·

This is the typical vertical alignment of story elements. It conforms to the way readers scan stories: First they look at the photo, then they read the headline, then they tackle the text.

This layout violates a basic rule of story design: Avoid interrupting any leg of text with an art element. Readers may think the story has ended and that a new one begins below the photo.

Designers sometimes park a mug at the bottom of a column to keep it from butting against another photo higher up on the page. A good idea, but a weak design. Avoid placing art at the bottom of a leg of text. Readers assume either that it's an ad or that the photo belongs to another story.

MUG SHOTS

HORIZONTAL STORY DESIGN OPTIONS

Because mug shots are usually one column wide, it's easy to attach them to a horizontal story: Simply square them off beside the headline and text.

And this is where a little math comes in. Assume the mug is 3 inches deep. Assume the cutline is roughly a half-inch deep. That adds up to a total depth of 3½ inches.

For short stories like this, headlines are small: roughly a half-inch to an inch deep. That makes every leg of text in this design approximately 3 inches deep.

Here's a typical layout for a 6-inch story:

To keep the story rectangular, the headline aligns with the top of the photo; the bottom of each leg squares off with the bottom of the cutline. To make sense, the headline needs 5-10 words: two lines' worth.

If each leg of text in this design is roughly 3 inches deep, that means you can keep adding on legs to accommodate a 9-, 12- or even a 15-inch story.

Note how, as the headline gets wider, it goes from two lines (above) to one (left). But since bigger stories use bigger headlines, the depths of the legs will stay roughly the same.

You can position that mug shot at either edge of the story, too. Since most mugees generally stare straight ahead, one side's just as good as the other.

Note how the headline covers only the text — not the photo. Sometimes, though, extending the headline above the mug may help all the elements fit better.

Longer stories need more depth, so they'll wrap beneath the mug. **Note:** Since the text has just grown one column wider, notice how the headline needs to extend one more column, too.

The mug can now go in any leg except the first — and many designers would choose one of the middle legs. Try to maintain at least 1 pica of space between the cutline and the text. And always dummy at least 1 inch of text under any photo.

In longer stories, a mug can run in any leg (except the first leg — nothing should come between the headline and the start of the text). Or you can park several mugs side by side:

Notice how these three mugs are evenly aligned. Two reasons for that: 1) It's ordered, balanced and pleasing to the eye; 2) It gives each mug equal weight instead of emphasizing one person disproportionately.

MUG SHOTS

MORE ON ▶

◆ **Adding mugs to story designs** *that already use a larger photo*...................**66**

◆ **Raw wraps:** *How they help keep headlines from butting*... **78**

◆ **Liftout quotes:** *Formats and guidelines*.............. **136**

◆ **Wraparounds & skews:** *Tips on special text treatments*................... **190**

SOME EXTRA STORY DESIGN OPTIONS

Don't start thinking that layouts *must* be either vertical or horizontal. We've simply made those distinctions to help you develop a feel for story shapes. You'll soon see that, as stories get more complex, they expand both vertically *and* horizontally — and that's where you can improvise and bend the rules.

For example:

Here's a layout that isn't purely vertical, since it uses not one but two legs side by side. And it's not purely horizontal, since it's more deep than wide. But it's a good design solution when you need to fit a short story into a square-shaped hole. And it could easily be deepened to accommodate a longer story.

Note the rules we've observed in dummying this story:
◆ *The headline covers all the text.*
◆ *All elements align neatly with each other.*
◆ *There's at least an inch of text below the photo.*
◆ *The entire story is shaped like a rectangle.*

We've now examined the most basic configurations for stories with mugs. The preceding examples also work well for nearly any story where you add a small graphic (a one-column map, chart, list, etc.) instead of a mug shot.

Now examine these new variations below. Notice the top two designs; they show you what happens when the headline fails to cover all the text.

Remember the raw wrap? Here it is again, this time with a mug atop the second leg. This design works well in a 2-column layout like this: It would keep headlines from butting if another story started to the right of this one.

This is a variation of the raw wrap, but few papers use it. It's basically a vertical design cut in half, with the bottom half parked alongside the top. The question is: What happens if there's a story above this one?

Half-column mugs let you add a photo without wasting too much space. These wraparounds work best in wide legs; text should be at least 6 picas wide where it wraps around a mug or it's too thin to read comfortably.

This popular format combines a mug with a liftout quote. It's more attractive and more informative than just a mug shot by itself.

TEXT SHAPES

To repeat once more: Always shape stories into rectangles. That means all four edges of the story should align — or "grid off" — with each other, as they do in this example:

This story is designed into a square-shaped rectangle. The legs are all even lengths, and all outside edges of the story align with each other. It's a clean, well-ordered story design.

This example, by the way, shows you another solution for adding two mugs to a story: putting one atop the other. It's a well-balanced treatment that gives both mugs equal weight.

Beginning designers often find themselves wrenching text into bizarre shapes as they try to make stories fit. Or they'll choose risky, offbeat designs when simpler layouts would be more effective.

If you have that problem, try looking at your stories a different way: Focus on the shapes of your text blocks.

TEXT SHAPES: THE GOOD, THE BAD & THE UGLY

Ranked from best to worst, these are the most typical shapes for text blocks. Arrows follow the flow of the reader's eye through the text.

1 *This is the safest shape of all: a rectangle. Whether in one leg or many, it's clean and clear: no odd wraps, leaps or bends.*

2 *L-shaped text results when text wraps under a photo. It's still a neat and readable shape.*

3 *U-shapes break up boring stacks of text, but beware of giant leaps to the top of that right leg.*

4 *These shapes (called doglegs) are often inevitable when you design around ads. Try to avoid them otherwise, since art placed below text is often mistaken for an ad.*

5 *This backward "L" is a risky shape. Readers may think the text starts in that second leg; besides, that second leg will butt into any leg above it. Be careful.*

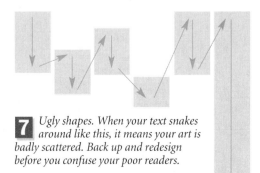

6 *Avoid forcing readers to jump blindly across art parked in the middle of one leg or sandwiched between two legs. It might sometimes work, but it's usually risky.*

7 *Ugly shapes. When your text snakes around like this, it means your art is badly scattered. Back up and redesign before you confuse your poor readers.*

ONE HORIZONTAL PHOTO

After a while, story designs start to fall into predictable patterns. In fact, it's possible to dummy photos onto pages without ever actually *seeing* the photos. Just stack all the pieces in a neat, attractive way, and there you are.

That's possible. But it's not recommended. Every photo is unique; every image needs special consideration before you size it and shove it in a convenient slot. Here, for instance, is a typical photo, along with typical considerations you should make before doing any designing:

MORE ON ▶

◆ **Photos:** *A complete chapter on cropping, photo spreads and more*.............. **99**

A FEW FACTS ABOUT THIS PHOTO

1 *In 1985, photographer Lois Bernstein of The Virginian-Pilot came upon three bloodied youngsters huddled by the side of the road. The girl, 16, and her twin 12-year-old brothers had just left the wreckage of their car after smashing into a tree.*

The photo caused a stir when it ran in the paper the next day. "Three of my children were still in hospital beds," said the children's father. "I was hurt. I was upset." The family's friends accused the paper of using a tragedy to sell papers.

Yet the photo is honest and powerful. It later won numerous awards. Would you have run this photo if you had been in the newsroom that day?

5 *Many photos are* ***directional*** *— i.e., the action in the photo moves strongly left or right, requiring you to design the story so the photo faces the text. Here, the children are facing slightly right. But that's not directional enough to matter; text could be dummied on either side of the photo.*

6 *Some design gurus try to crop their photos into a rectangular shape known as the "golden mean." This shape — basically 3 X 5, roughly the shape of the photo shown here — was discovered by the ancient Greeks and is often thought to be the most harmonious proportion known to man. That's pretty cosmic. Unfortunately, not too many ancient Greeks design newspapers these days, so don't worry about golden rectangles. Just use the shape that best suits the image.*

2 *How big should this photo be played? An image this dramatic has maximum impact if it runs 3 or 4 columns wide — i.e., quite a bit bigger than shown here. Run larger than that, the photo's grisly content would offend some readers; run smaller, the photo's drama and emotion would be lost.*

3 *For some stories, you need several photos to show readers what happened. Here, for instance, the photographer may also have shot the wrecked car, the tree it collided with, the police at work, and so on. But would additional photos have robbed this shot of its impact? Would they have been necessary — or just padding?*

4 *Notice the cropping on this photo. Along the right edge, you can see a hint of a car's bumper; along the bottom, the shoulder of the road. When this photo first ran in the paper, Bernstein cropped it as you see it here. But she now prefers a crop that focuses more tightly on the arms and faces of the children. Which do you prefer?*

Unlike mug shots — which come in one standard shape and size and are generally interchangeable — full-sized photos require thoughtful analysis. So before you begin designing a story, you must consider each photo's:

◆ **Size.** How big must the photo run? (If it's too small, faces and places become indecipherable; if it's too big, you hog space.) Does the photo gain impact if it's larger? Is there room on the page for jumbo art?

◆ **Direction.** Does the action in the photo flow strongly in one direction (someone running, pointing, throwing a ball)? If so, it's best to design the story so the photo faces the text. Images that seem to move into the wrong story — or off the page — may misdirect your readers.

◆ **Content.** Is one photo enough to tell the story? Is the package more informative with two or more? Or is the photo meaningless, routine, expendable — something that could make room for another story?

ONE HORIZONTAL PHOTO

As we've previously seen with stories using mug shots, this vertical layout conforms to the way most readers scan stories. They're attracted by the photo; they read down, through the cutline, into the headline; then, if they're still interested, they read the text.

Your design goals, then, are: 1) keeping all elements in the proper order; 2) avoiding long, gray legs of text; and 3) avoiding confusion with any other story parked beside the photo (a topic we'll explore in the next chapter).

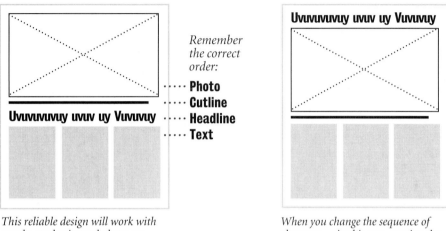

Remember the correct order:

.... **Photo**
.... **Cutline**
.... **Headline**
.... **Text**

This reliable design will work with nearly any horizontal photo, no matter how deep, wide or directional it is — as long as all four elements are stacked in the correct order.

When you change the sequence of elements — in this case, putting the headline above the photo — you risk confusion. In news stories, the headline should touch the start of the story.

As we saw on page 49, text blocks work best as rectangles (as opposed to L-shapes, U-shapes, doglegs, etc.). That makes the examples on this page — both vertical and horizontal — safe, effective solutions.

Whenever you try to square off text beside a photo, you'll probably need to wrestle with photo shapes and story lengths to make the math work out. But remember: Every story is (be careful, but it's true) *cuttable.*

If the photo faces right:
This is the better solution, since the action of the photo will flow into the text. To anchor this design, both the photo and the text block need ample width; the photo should be at least 2 columns wide.

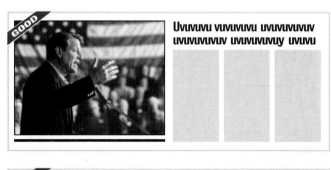

If the photo faces left:
Re-arrange the elements so the text is parked on the left. Remember that all elements must square off at both the top and the bottom; this design won't work if the text comes up short.

A word about armpits: In these examples, note how the headline runs beside the photo, covering only the text. That's the cleanest way to dummy a headline in this format. But you can also run the headline all the way across both the text and photo (that's called an "armpit"):

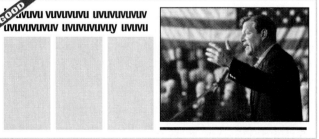

The advantages:
◆ *It connects the photo to the text more tightly. On busy pages, that can help organize stories.*
◆ *One long, loud banner headline can give the story more punch.*

ONE HORIZONTAL PHOTO

MORE ON ▶

◆ **Raw-wrap head-lines:** *Using them to keep headlines from butting*.....................**78**

◆ **Feature designs:** *A chapter on special headlines and photo treatments*.............**183**

SOME EXTRA STORY DESIGN OPTIONS

To a designer's eye, the previous examples are appealing because they're so neatly aligned, so cleanly balanced. Yet these two designs directly below are more common, and perhaps more effective.

The reason? Notice how effectively the headline and text surround the photo to create a self-contained package. There's no way a reader can mistake which story the photo belongs to.

Here, an L-shaped text block wraps below the photo. If you wanted to play the photo bigger, you could run it 3 columns wide. For longer stories, you could deepen each leg of type — or wrap another leg of type along the right side of the photo and extend the headline farther.

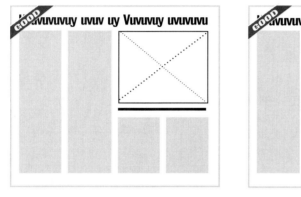

Here, the text wraps around three sides of the photo. Some editors prefer this layout to the one at left because: 1) it's symmetrical, and 2) it breaks up those long, gray legs of text more effectively.

Other design options are risky or downright clumsy. Here are a few more examples to consider — or to avoid altogether:

This, you'll recall, is a raw wrap — where instead of covering the entire story, the head-line is parked in a left-hand leg or two. It's not a bad solution, but it's best reserved for times when you dummy two stories side by side and you need to keep headlines from butting. With a raw wrap, the photo lets you get away with that.

Avoid running photos below text. There's too great a danger readers will think the photo's an ad, or that it belongs to a story below. Wrap text below or beside art — not above it.

Wrap text around art, did we say? Dropping art into the middle of a story disrupts the logical flow of the text; readers will fumble to figure out which leg goes where. Avoid interrupting a leg of text with a photo.

SWIPEABLE FEATURE FORMATS

These designs are intended for special feature stories. Some of them will need fancy headlines, long decks or text wraps to work effectively.

Very symmetrical. A graceful U-shape centers the headline and deck.

More symmetry. Here, the text encircles the headline (which could also be boxed).

This sidesaddle headline uses a long deck. The text squares off alongside.

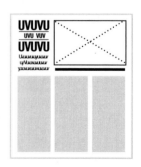

Another sidesaddle head in a narrow stack. This one squares off beside the photo.

ONE VERTICAL PHOTO

If you understand the design options for horizontal photos, you'll have no problem with verticals. If anything, verticals offer less design flexibility than horizontals. They're a more dramatic shape, but flowing a story's text around or beside a big vertical photo can be tricky.

MORE ON ▶

◆ **Photos:** *A chapter on cropping, sizing, photo pages, etc.* **99**

A FEW FACTS ABOUT THIS PHOTO

1 *This photo of teen singing sensation Britney Spears was shot by Joel Davis during a concert at a county fair near Portland, Ore. Getting high-quality action photos of pop superstars is usually a difficult, demanding task. The lighting is poor. Photographers are often forced to stand far away, using telephoto lenses and grainy high-speed film. And photos are usually allowed only during the first few songs. It's not surprising that concert photos often fall flat.*

2 *Designers should generally avoid telling photographers what to shoot. But here, you know before the concert even starts that you'll want a shot of Britney (not the band). Since she's a singer, you'll probably want a dramatic close-up of her while she's singing. And since she doesn't play piano or guitar, you can assume the photo will probably be vertical. This shot, then, is exactly what the designer — and the readers — might expect.*

3 *Would you run this photo in your newspaper? There's something decadent, almost obscene about Britney's pose, her skin-tight top, the grasping hands of the dancers in the background — but you could argue that it's a classic pop-junk moment that perfectly captures the spirit of her music. (You could also argue that we see more lewd behavior on MTV all day long.)*

4 *One dramatic photo like this can single-handedly carry a story by itself. For some performers, however, you might want additional photos to supplement the story by showing other musicians, wild sets, crazily attired crowd members or onstage action (dancing, guitar-bashing, etc.). Bigger stars deserve bigger spreads.*

5 *It never fails — the photographer captured this appealing, eye-popping image (an image so popular, it's repeatedly stolen from The Oregonian's photo library), but because of space limitations, the photo never ran in the paper. If it HAD run, how big should it have been?*

◆ **A word about square photos:** On previous pages, we explored design options using horizontal photos. In the pages ahead, we'll explore options for vertical photos. So what about squares?

Square photos, you'll recall, have a reputation for being dull. But because they can adapt to all the design options we're showing you, there's no need to give them special treatment. Just modify the principles you've learned and you can dummy squares easily and painlessly.

ONE VERTICAL PHOTO

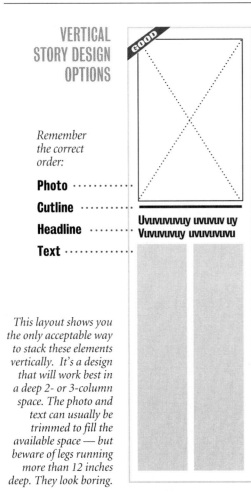

*Remember
the correct
order:*

Photo · · · · · · · · · ·

Cutline · · · · · · · ·

Headline · · · · · · · ·

Text · · · · · · · · · · ·

*This layout shows you
the only acceptable way
to stack these elements
vertically. It's a design
that will work best in
a deep 2- or 3-column
space. The photo and
text can usually be
trimmed to fill the
available space — but
beware of legs running
more than 12 inches
deep. They look boring.*

Since dominant vertical photos usually run either 2 or 3 columns wide, that makes them pretty big — anywhere from 5 to 15 inches deep. Stick a headline and a story below that, and you've got a sleek, dynamic design (if you have enough room for a layout that deep). The only drawback is that it's so far from the top of the photo to the bottom of the text: Will the story hold together on a page full of other distractions?

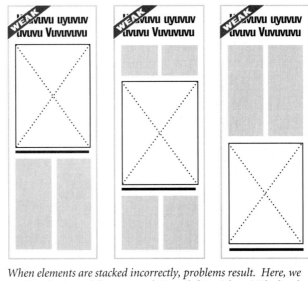

When elements are stacked incorrectly, problems result. Here, we see three basic guidelines ignored. From left to right: 1) The headline should always touch the start of the story; 2) Avoid interrupting any leg of text with an art element; 3) Avoid running art below text.

Stacking photos and stories side by side requires careful measurement but creates a graceful design. Note how, in the examples below, the headline covers only the text. (Running a wide headline atop both the photo and the text is a secondary option — see page 51.)

Note, too, how both examples use 2-column photos. A 3-column vertical photo would be extremely deep (8-15 inches). And that could make those legs of text excessively deep and gray.

For directional photos: *Position the photo on the proper side — whichever side forces the action in the photo to move toward the text . . .*

. . . but remember that non-directional photos work well on either side. Your decision should be based on how the overall page fits together.

ONE VERTICAL PHOTO

OTHER STORY DESIGN OPTIONS

In this L-shaped wrap, all the elements work well together. But consider how deep those left-hand legs could become, especially with a 3-column photo. To break up the gray, designers often dummy a liftout quote into that second column.

This U-shaped wrap keeps those two long legs of text from merging into one gray slab. But beware: 1) Those two legs under the photo will look flimsy if they're not deep enough; and 2) It's a long trip from the bottom of the third leg to the top of the fourth.

Raw wraps (like this one) keep headlines from butting when stories are dummied side by side. But this layout is less graceful than those above. The headline is often huge to keep from being overpowered by the photo and text. Still, it's acceptable.

As a rule, news headlines should run above all text — and only text. But there are times, especially on Page One, when you need a big photo/big headline combo. Running a 1-column headline over that leg of text gives you a cleaner design, but a lot less oomph.

SWIPEABLE FEATURE FORMATS

These designs are intended for special feature stories. Some of them will need fancy headlines, long decks or text wraps to work effectively.

A symmetrical, centered U-shape. Box this design if other stories run above.

Here, the headline runs above the photo. Again, may need to be boxed.

An airy design, one that can look awkward if all the proportions aren't right.

Sandwiching that headline between the text and photo creates risky, L-shaped text.

THE DOMINANT PHOTO

Editors and page designers try hard to be fair. And that's noble. But as you may already know, some news is more important than others. Some stories are more interesting than others. And some photographs, for one reason or another, are simply *better* than others.

Readers expect newspapers to make decisions for them: to decide which stories are the biggest, which photos are the best. Readers want editors to *edit* — not just shovel everything onto the page in equal-sized heaps.

Equality can get boring. Take a look:

A scary-looking lamprey eel lunges at a passing angelfish in the zoo's new Coral Life exhibit. This eel, captured off the coast of Grand Bahama Island last month, is one of nearly a dozen different species of eel populating the exhibit.

Dundee, a 3-year-old koala, was a gift from the Sydney International Zoological Gardens in Australia. Dundee spends most days sleeping and most nights eating bamboo shoots. Next year, the zoo will begin an experimental koala breeding program.

A nosy South Saharan giraffe says hello from the newest zoo exhibit, Beasts of the Serengeti. Still a juvenile, this giraffe will grow to a height of 25 feet.

WHO'S NEW AT THE ZOO

They're here. After three years of planning, politicking and pleading, more than 100 new critters have settled in at the Minniear Memorial Zoo — and next Monday, the doors swing open to the public to kick off a month-long celebration.

"It's the thrill of a lifetime for me to host this event," says zoo director Krystyna Wolniakowski. "It's the highlight of my career to have assembled such an amazing array of animals."

From koalas to kangaroos, elephants to eels, they're all waiting to meet you beginning 8 a.m. Monday. For information, call (977)755-2351.

Dosser pelicans populate America's eastern seabord. This handsome male is one of seven in the zoo's new marine exhibit.

A 2-foot-long gekko scales a glass wall in his cage.

A South American green tree frog peers out from an arcadia bush. The zoo now owns a dozen of these poisonous, yet wonderfully wide-eyed amphibians.

Photos by ROBIN FOX / The Daily Bladder

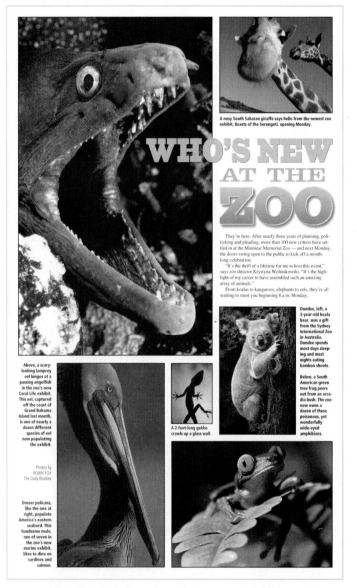

A nosy South Saharan giraffe says hello from the newest zoo exhibit, Beasts of the Serengeti, opening Monday.

WHO'S NEW AT THE ZOO

They're here. After nearly three years of planning, politicking and pleading, more than 100 new critters have settled in at the Minniear Memorial Zoo — and next Monday, the doors swing open to the public to kick off a month-long celebration.

"It's the thrill of a lifetime to host this event," says zoo director Krystyna Wolniakowski. "It's the highlight of my career to have assembled such an amazing array of animals."

From koalas to kangaroos, elephants to eels, they're all waiting to meet you beginning 8 a.m. Monday.

Dundee, left, a 3-year-old koala bear, was a gift from the Sydney International Zoo in Australia. Dundee spends most days sleeping and most nights eating bamboo shoots.

Below, a South American green tree frog peers out from an arcadia bush. The zoo now owns a dozen of these poisonous, yet wonderfully wide-eyed amphibians.

Above, a scary-looking lamprey eel lunges at a passing angelfish in the zoo's new Coral Life exhibit. This eel, captured off the coast of Grand Bahama Island last month, is one of nearly a dozen different species of eel now populating the exhibit.

A 2-foot-long gekko crawls up a glass wall.

Photos by ROBIN FOX The Daily Bladder

Dosser pelicans, like the one at right, populate America's eastern seabord. This handsome male, one of seven in the zoo's new marine exhibit, likes to dine on sardines and salmon.

Here's what happens when all elements have equal weight. For one thing, the photos lose any sense of hierarchy. Which critter is most appealing? Most interesting? Most dramatic? But see how the design suffers, too? This page is static, boxy — like a page from a scrapbook. There's no sense of movement because the design isn't guiding your eyes. This effect results whenever you park two or more similarly sized photos near each other.

Here's a page that prioritizes the best images, mixing shapes and sizes. Feel the difference? This page has motion. Variety. Impact. We see that some photos (and some animals) clearly have more drama and appeal than others.

This principle applies whether there are two or 10 photos on the page:
Always make one photo dominant — that is, substantially bigger than any competing photo.

THE DOMINANT PHOTO

A strong photograph will anchor a story — or an entire page. Two evenly sized photos side by side, however, will work against each other. They'll compete. They'll clash. Or worse, they'll just sit there in two dull lumps.

There are times when photos may work better if they're equally sized (a before-and-after comparison, a series of mugs, some frames of time-elapsed events). But usually, you must make one photo dominant.

When you evaluate photos to decide which deserves bigger play, ask yourself:

◆ **Do we really need two photos?** Are they that different from each other? Does the story require this extra graphic information? If so, keep asking:

◆ **Does one have stronger content?** Does it capture a key moment of drama? Does it show motion and/or emotion? Does it enhance and explain the story?

◆ **Does one have higher readability?** Does it need to be BIG to show faces, details or events? Or will it pack some punch in a smaller space?

◆ **Does one have superior quality?** Better focus? Exposure? Composition?

◆ **Does one have a preferable shape?** Would I prefer a vertical? A horizontal? A square? Will one shape create a stronger overall design for the story?

Below are four photos from a news feature we'll call *Hog Farm Holiday.* In the pages ahead, we'll pair the photos in different ways to create different story designs. But first, ask yourself: Which should be the lead (dominant) photo?

MORE ON ▶

◆ **Dominant photos:** *Using art to anchor a page design* **81**

◆ **Photos:** *A complete chapter on cropping, photo spreads, etc...* **99**

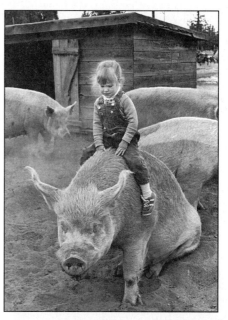

Left: *It's not every day you see a girl riding a pig. That's a memorable image, one that's bound to arouse the curiosity of readers. It's probably the stronger of the two verticals, since it also shows more of the barnyard than any other photo.*

Below: *The baby pigs are cute, and this photo provides our only look at animals minus the humans. This photo doesn't read as well as the others when it's run small, however.*

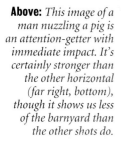

Above: *This image of a man nuzzling a pig is an attention-getter with immediate impact. It's certainly stronger than the other horizontal (far right, bottom), though it shows us less of the barnyard than the other shots do.*

Right: *This photo of the farmer is his only appearance in these four shots. And though this photo isn't as engaging as the other vertical, it would be a good choice for a secondary photo if the farmer plays a role in the story.*

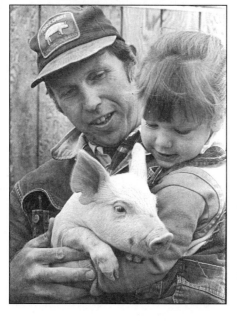

BIG VERTICAL, SMALL HORIZONTAL

Suppose you choose to use these two photos to accompany your story. The girl riding the pig will be your dominant (or lead) photo; the guy nuzzling the pig is secondary. Since neither is strongly directional, you have some flexibility in placement.

In the examples below, we'll show you the most common story design solutions for news pages, along with some swipeable feature layouts. We can't predict every possible option, so feel free to explore other alternatives.

STORY DESIGN OPTIONS

Here's what you get when you stack the photos **vertically:**

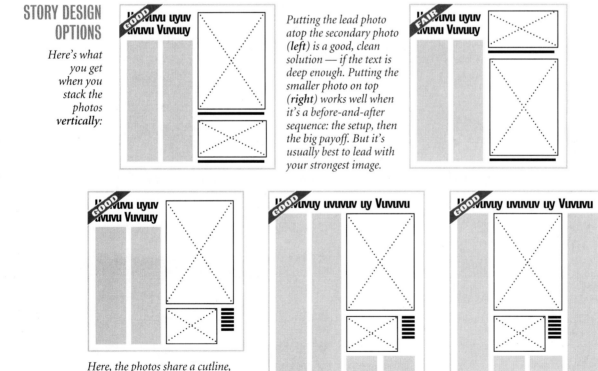

Putting the lead photo atop the secondary photo (**left**) *is a good, clean solution — if the text is deep enough. Putting the smaller photo on top* (**right**) *works well when it's a before-and-after sequence: the setup, then the big payoff. But it's usually best to lead with your strongest image.*

Here, the photos share a cutline, and the shapes become less blocky, less tightly packed than the example above. Note that the cutline goes to the **outside** *of the story. For longer stories, the text wraps below the photos, and the headline extends. . .*

. . .across the two new right-hand legs of text. The danger here is that those two left-hand legs of text are getting awfully deep. A liftout quote in the second leg would help. . .

. . .but better yet, moving the photos into the middle two legs creates a U-shaped text block that's not as gray-looking. One question: Is it too high a jump to that last leg?

BIG VERTICAL, SMALL HORIZONTAL

STORY DESIGN OPTIONS

Here's what you get when you stack the photos horizontally:

The biggest problem with those preceding examples is space — having enough depth on the page to stack the photos on top of each other, and having enough text to square off alongside them.

The examples below extend horizontally and are a bit more flexible:

MORE ON ▶

◆ **Feature page design:**
A chapter on special headlines and photo treatments............ **183**

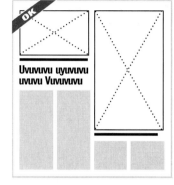

*This layout works only with text short enough to square off along the bottom edge of the dominant photo. Another option: If you make that horizontal photo smaller, you can dummy a joint cutline **between** the two photos.*

Stack the photos side by side this way and what do you get? A raw wrap. Not bad — the package holds together pretty well. Still, look for better options before using this one.

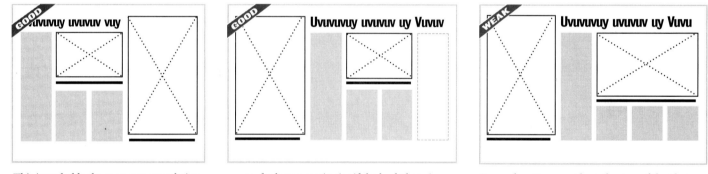

This is probably the most common design for a big vertical, small horizontal (as long as the lead photo isn't directional to the right). The text is L-shaped; everything is dummied to the left of the lead photo. . .

. . . or, for longer stories (or if the lead photo is strongly directional to the right), the whole design can be flopped. The text is still L-shaped. If needed, you can add an additional leg of text and extend the headline one more column, as well.

Remember: You must keep the sizes of the photos properly balanced. Here, the secondary photo is played too big and competes with the lead photo. Note, too, that this sort of L-shaped text isn't quite as graceful as text blocks that are rectangular.

SWIPEABLE FEATURE FORMATS

These designs are intended for special feature stories. Some of them will need fancy headlines, long decks or text wraps to work effectively.

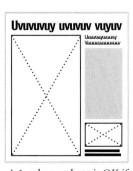

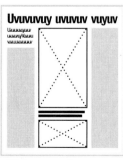

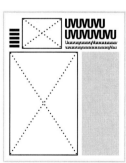

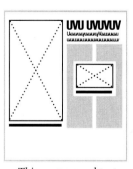

A 1-column photo is OK if the leg is set wide like this. If the story's boxed or at the bottom of the page, the photo can go below the text.

We've warned you not to let art separate legs of text. But if the story is boxed and the design is symmetrical, this might still work.

Centering the small photo above the lead creates room on the left side for a joint cutline, room on the right for a headline/deck combo.

This wraparound text treatment lets you indent the smaller photo. Don't let those legs of text get unreadably thin, however.

BIG HORIZONTAL, SMALL VERTICAL

With a different dominant photo — the pig-smooching close-up as lead art, the pig-riding shot as secondary art — you create a package that focuses more on the people than the barnyard. And since neither photo is strongly directional, you'll have plenty of freedom in positioning the art.

As on previous pages, the designs below represent common solutions for pairing these two photos. Studying them will give you a sense of how some design principles work — and why others *don't*.

STORY DESIGN OPTIONS

If you have enough width, you can stack the photos side by side. Note that the photos are exactly 3 and 2 columns wide, squaring off with the columns of text below. This looks OK, but it's a bit blocky, and the cutlines butt.

Or try this option instead: Keep the photos the same height, but crop them so they share one thin cutline between them (cutlines should be at least 6 picas wide).

OR

Or here, the depths of the photos vary, and the cutline runs below the shallower photo. Ideally, the bottom of the cutline should square off with the bottom of the lead photo.

OR

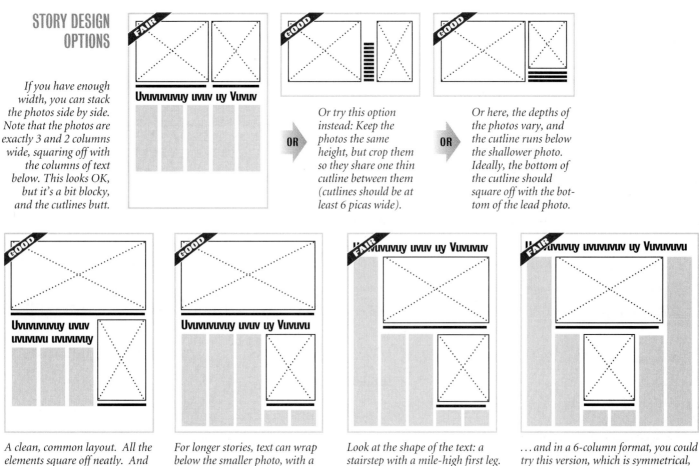

A clean, common layout. All the elements square off neatly. And note that the smaller photo could go on either side of the page.

For longer stories, text can wrap below the smaller photo, with a wider headline. That photo could move to the middle, if you prefer.

Look at the shape of the text: a stairstep with a mile-high first leg. For long stories, this would work in the 5-column format here. . .

. . . and in a 6-column format, you could try this version, which is symmetrical, almost elegant. But the outside legs are awfully steep, and the text shape is odd.

BIG HORIZONTAL, SMALL VERTICAL

ANOTHER OPTION: RAW-WRAP HEADLINES

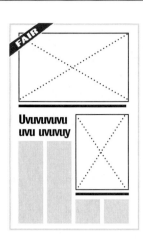

Compare these two designs with the two middle patterns at the bottom of page 60. Which do you prefer? The only difference is that these use raw-wrap headlines. If you want to use a display headline — or if you need to avoid a long horizontal head — then these are preferable. Otherwise, beware the awkward text wrap.

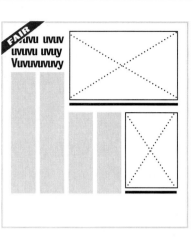

ONE-COLUMN PHOTOS: BIG ENOUGH?

As a rule, mug shots are the only photos that consistently succeed in a one-column size. And horizontals almost never "read" (i.e., show details clearly) when they're that small. But on occasion — when space is tight, or you just want to squeeze in a bit more art — you can run a vertical photo one column wide instead of two. Just make sure the photo *reads:*

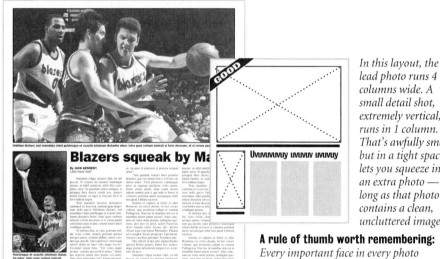

In this layout, the lead photo runs 4 columns wide. A small detail shot, extremely vertical, runs in 1 column. That's awfully small, but in a tight space it lets you squeeze in an extra photo — as long as that photo contains a clean, uncluttered image.

A rule of thumb worth remembering:
Every important face in every photo should be at least the size of a dime.

SWIPEABLE FEATURE FORMATS

These designs are intended for special feature stories. Some of them will need fancy headlines, long decks or text wraps to work effectively.

A vertical, symmetrical design. A narrow head and deck are centered in 3 wide bastard legs. This layout. . .

. . .gets flashier (and riskier) if you wrap text around the top photo and jump over the center leg.

A sidesaddle headline (with deck) creates a neat, logical design. But box this layout or keep other stories away.

A new twist: mortising the small photo on top of the dominant photo. The head then fills in alongside.

TWO VERTICALS

Always try to vary the sizes *and* shapes of the photos you use. Though there's nothing wrong with dummying two verticals together, you'll see in the layouts below that your options are limited — and occasionally awkward.

STORY DESIGN OPTIONS

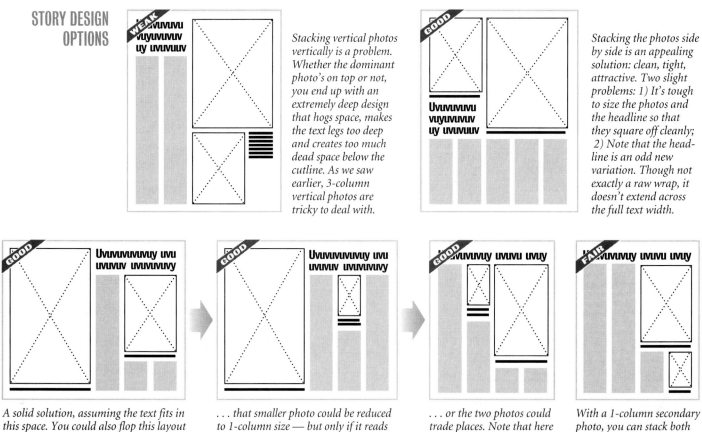

Stacking vertical photos vertically is a problem. Whether the dominant photo's on top or not, you end up with an extremely deep design that hogs space, makes the text legs too deep and creates too much dead space below the cutline. As we saw earlier, 3-column vertical photos are tricky to deal with.

Stacking the photos side by side is an appealing solution: clean, tight, attractive. Two slight problems: 1) It's tough to size the photos and the headline so that they square off cleanly; 2) Note that the headline is an odd new variation. Though not exactly a raw wrap, it doesn't extend across the full text width.

A solid solution, assuming the text fits in this space. You could also flop this layout and dummy the lead photo to the right of the secondary photo. Or...

...that smaller photo could be reduced to 1-column size — but only if it reads well this small. At this size, you can park it in either of the two right-hand legs...

...or the two photos could trade places. Note that here we've run the lead photo 2 columns wide instead of 3.

With a 1-column secondary photo, you can stack both photos vertically — though the text legs are a bit long.

TWO VERTICALS

MORE ON ▶

◆ **Boxed stories:** *How they work and when to best use them* **76**

◆ **Bad juxtapositions:** *How they happen and how to avoid them* . **92**

◆ **Mortises and insets:** *Guidelines for overlapping photos* **193**

WHAT HAPPENS WHEN STORIES COLLIDE

Designing stories into rectangular shapes (also called *modular design,* since pages consist of discrete, movable modules) is the surest way to create well-ordered pages — as long as you follow the rules.

But even when you follow the rules, confusion occasionally results from a bad juxtaposition of elements, especially when you dummy text alongside a large vertical photograph. See for yourself:

1 *Here's a simple and common story design: a big vertical photo with the text running vertically down the left side. So far, there's no problem, no confusion.*

2 *Here's another common design: This time, it's a story dummied to the right of a big vertical photo. Again, it's a clean, correct layout. No problems yet.*

3 *But if you saw this page in a newspaper, how would you decide which story goes with the big vertical photo? The layout works either way. You'd have to scan both stories, then try to decide.*

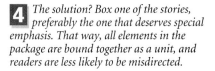

4 *The solution? Box one of the stories, preferably the one that deserves special emphasis. That way, all elements in the package are bound together as a unit, and readers are less likely to be misdirected.*

Later, we'll look more closely at guidelines for boxing stories. But for now, be aware that your story designs may seem quite simple and obvious to you — but quite ambiguous and confusing to your readers.

SWIPEABLE FEATURE FORMATS

These designs are intended for special feature stories. Some of them will need fancy headlines, long decks or text wraps to work effectively.

A wide headline, a photo at the bottom, a little text: It's risky, but will work if it's boxed or if it runs at the bottom of the page.

This odd design puts three vertical stacks side by side: 1) lead art and cutlines; 2) sidesaddle head, deck and small photo; 3) text.

Another 1-column secondary photo. But here, the photo is centered between the two columns, and the text wraps around it.

This design insets the small photo over the corner of the lead photo and fills in the other elements from there. Beware — this one's risky.

TWO HORIZONTALS

Pairing two horizontal photos is more common — and a bit less limiting — than pairing two verticals. Remember, however, that it's important to vary the shapes of the photos you use. So think twice about running two horizontals together if a better combination is available.

Which of these photos should be dominant? Most designers would choose the guy nuzzling the piglet because it's cute (the photo, not the pig). Keep in mind, too, that the second photo — that row of piglets — won't "read" if it's too small. (As you see it printed here, it's about a column-and-a-half wide.) That means it *must* run at least two columns wide.

STORY DESIGN OPTIONS

Stacking the photos vertically works well. Note the shared cutline; there's a danger of wasted white space in the bottom corner if the bottom photo is too narrow or the cutline is too short.

Stacking the photos horizontally also works well. A shared cutline like this will generally butt tightly against both photos. It's OK if it's shallow, but fill that cutline space as much as possible.

Stacking the photos horizontally works well in this configuration, too — though you need the full width of a 6-column page for this layout. Note how we've indented the cutline a half-column to add some white space.

A common solution. The smaller photo is dummied into the upper-right corner of an L-shaped text block. . .

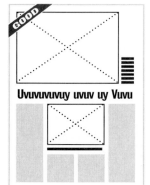

. . .or here, the smaller photo is centered. Note the cutline treatment for the lead photo, an option offering more flexibility.

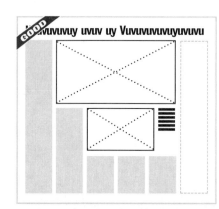

Again, note the added flexibility of sharing a cutline. In this case, the smaller photo can be 2-3 columns wide. You also have the option of adding another leg of text along the right edge.

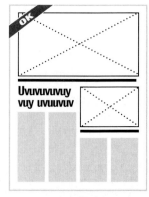

This raw-wrap headline treatment is acceptable, but not preferable. Use it if you're avoiding a horizontal headline.

TWO HORIZONTALS

Throughout this chapter, we've offered common solutions to common design situations. If we wanted to, we could easily fill several pages with rejects — designs that, for one reason or another, are too ugly to print.

Instead, let's take a moment to analyze a few close calls. These layouts are well-intentioned but still wrong enough to be avoided.

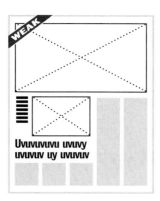

This layout demonstrates the basic problem with text shaped like a backward "L": Too many readers won't know where the story starts. Even if the headline ran horizontally between the two photos, your eye would ignore those short legs on the left and assume the story starts in that fourth column.

Here's a configuration that looks magazine-y, somehow. But in newspapers, you're smart to avoid confusing layouts like this. Where does the reader go at the end of that first leg: under the big photo, or all the way back up to the top? This is the risk you take whenever art interrupts the flow of the text.

*There are two big problems here:
1) The headline is too small, narrow and insignificant (a very unnecessary raw wrap);
2) Too many readers will think the story starts to the right of that second photo. Remember: Readers often assume that the tallest leg is the one that starts the story.*

Here's a design with a subtle flaw— it gives us a package in two totally independent chunks: a photo chunk at the top and a story chunk below. Since it's so far down to the story, the elements don't connect well. In fact, those photos could mistakenly be paired with any story running in an adjacent column.

With the right photos in the right place on the right page, this design might work well. But as a rule, resist the temptation to run photos under text or to run the dominant photo under the secondary photo. It might work on features — especially if they're boxed — but be careful with hard news.

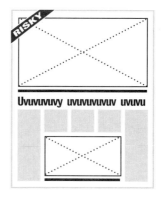

Here's another layout you'd see in a magazine. It might even work, boxed, on a feature page. But for most news stories, avoid dummying photos at the bottom of a story. Readers assume that's an ad position. Or that any photo parked below one story belongs to the next story. Why risk confusing readers if you don't have to?

SWIPEABLE FEATURE FORMATS

These designs are intended for special feature stories.

Here are three variations of the same idea: Put the small photo below the lead, then square off the headline beside one of the photos. All three will work, depending on the headline wording and photo cropping.

ADDING MUG SHOTS

Most of the photos you'll dummy with news stories will be *live* (meaning they're timely and unstaged). Mug shots, on the other hand, are *canned* (that is, shot at some neutral time and place, then put in the can — stored — until you need them).

And though it's a good idea to add mug shots to stories whenever possible, try not to confuse the reader by mixing live and canned photos. Add mugs — but dummy them slightly apart from news photos, as a subtle signal to readers.

Also, consider adding liftout quotes to mugs whenever possible. Combining people's faces with their words connects them to the story, provides extra commentary and creates a graphic hook to attract more readers.

MORE ON ▶

◆ **Mug shots:** *Tips for dummying them with stories* **46**

◆ **Liftout quotes:** *How to design and dummy them effectively* **136**

*Legs of text usually run alongside dominant vertical photos. And mug shots can be added atop any leg except the first. Here, a liftout quote was included with the mug (assuming the quote is either **by** or **about** the person pictured).*

Here, the quote runs below, rather than beside, the mug shot. Either way is acceptable. You could even park a second mug shot — with its own quote — alongside this one.

With a big horizontal photo, the text will usually run underneath. The most logical spot for a mug shot (with or without an added lift quote) is in one of the middle legs, to help break up the repetitive grayness of the text.

If appropriate, two or three mugs can run alongside each other at the top of those middle legs of text. Those mugs, all evenly sized, work together as a unit. And the headline helps distance them from the live photo at the top of the story.

With a dominant vertical and a secondary horizontal, a mug can be dummied into the far corner of the text. Note how this layout helps distance the mug from the two live photos. And even with this growing number of elements, the whole story holds together as a unit.

With a dominant horizontal and a secondary vertical, you can always add a mug in the middle leg. Again, in this design the two live photos are dummied tightly together, while the mug is kept separate by either the headline or text.

TROUBLESHOOTING

Quick answers to questions frequently asked by designers perplexed about story design:

Q: **Some newspapers deliberately run stories in non-modular doglegs. Is that wrong? Or a new trend?**

Yes, just when you think a design guideline is etched in stone — *ALL STORIES MUST BE SHAPED LIKE RECTANGLES* — along comes a newspaper with a contrary philosophy, like the one at right.

In the past few years, a handful of papers — most notably, the Baltimore Sun and the St. Louis Post-Dispatch — have encouraged this "traditional" (as opposed to modular) style of layout. Their reasons:

◆ It allows bigger, wider headlines to accompany thinner, vertical legs of text — a good way to attract attention, especially on Page One.

◆ It sets your paper apart from the competition — a valuable edge in a crowded big-city newspaper market.

◆ It has a "retro" feel that some readers may actually prefer (after all, The New York Times' front page has been designed that way nearly forever).

Done well, "traditional" design has a distinctive style and energy. Done sloppily, it's a mess. Are doglegs making a comeback? Not yet — but stay tuned.

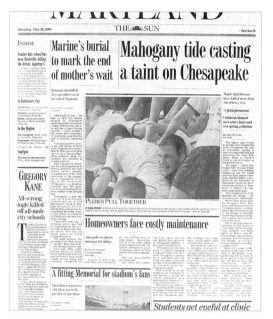

"Traditional" story layout on a Baltimore Sun news page. Note how every story is deliberately designed to dogleg.

Q: **How big do photos have to be? My photo editor is always complaining that we run our photos too small.**

Remember that newsroom photo-editing adage: *Every face should be at least the size of a dime.* And though there are exceptions to every rule, that's a good place to start. Both photos shown here, for instance, are just 5 picas wide (that's not quite an inch). And while the woman at left is still "readable," those jocks at right aren't.

In general, small photos should be the exception, not the rule. Tiny images work best:

◆ As mug shots, either indented into the text or combined with liftout quotes;

◆ As promos, which send us elsewhere in the paper to see that small image full-sized;

◆ As columnist logos.

Q: **When you look at the text in magazines, it hops over photos, illustrations and quotes all the time. Why can't newspaper design have that much freedom?**

Magazine design, like yearbook design, is fun in ways that newspaper design *isn't.* You can run huge photos that fill entire pages. You can "bleed" images (i.e., print photos that run right off the edge of the paper). And yes, you can position story elements in riskier ways.

Why? Look at the magazine page at left. The text leaps over quotes — but when there's only one story on the page, readers probably won't get lost. On newspaper pages (right), there's more traffic — so avoiding confusion becomes more essential.

This magazine layout forces readers to jump around liftout quotes — but because there are no other stories or ads to add confusion, the design succeeds.

On a busy newspaper page, there are more stories, so designers need to avoid confusing readers with unnecessary leaps and angles.

TROUBLESHOOTING

Q: In vertical layouts, you're supposed to put the photo on top, then the cutline, then the headline. But when are you allowed to run the headline on top?

The most common exception to that *photo-cutline-headline-text* guideline is the example at right: a major, end-of-the-world news story that warrants a major, end-of-the-world headline. As you look at this page, notice two things:

◆ The headline, "A Night of Fury," isn't the headline for one specific story — it's the headline for the *page*. And though you may not have studied page design yet, you can see that each of the two stories below that dominant photo has its own separate headline. So in a way, "A Night of Fury" functions more as a *title* than as a standard headline.

◆ Remember that most newspapers are folded in half after they're printed — and when readers first see the front page, they see only what's above the fold. Thus, most editors insist that, no matter how big the story or how huge the photo, the headline has to appear above the fold; otherwise, readers may walk past the news racks and squint cluelessly at the page. Imagine how this page would have looked with just the flag and the photo showing above the fold. (Remember, too, that fire/bomb/earthquake photos require more explanation than tornado photos do.)

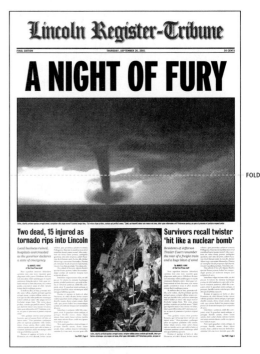

FOLD

Q: Do mug shots always have to run small? Or is it permissible to run them as dominant art sometimes?

That depends on the story, the quality of the mug shot — and how desperate you are. But yes, a mug shot can function as lead art, especially if it's an appealing portrait like the one below. (An ordinary mug shot — some dazed-looking person leaning against a blank wall — might be deadly dull and would only get worse as you enlarge it.)

Make sure the mugee is a newsmaker worthy of big play. Crop dramatically, turning it into an extremely tight vertical (left) or horizontal. Add a liftout quote with typographic flair. Or place two mugs on either side of the layout, like bookends, to provide a point-counterpoint faceoff between two combatants.

Q: How directional does a photo need to be before you've GOT to run it on one side of the layout, facing the text?

That's a matter of debate. Take the photo at left, for instance. His head is turned away from us — but his eyes look straight ahead. So is it a directional photo? Some designers would say yes, and they'd insist on running it on the right side of this page. Others would say no — that unless a photo has directional *action*, it's not important which side it's dummied on.

Now take a look at this baseball photo. The catcher is about to fling the ball onto page 69. Does that bother you? It should; this is a clear example of a photo that needs to face into its story, especially on a busy page. (And no, you can't *flop* the photo; see page 126 for more on that.)

EXERCISES

ANSWERS ▶ 242

*Designing a story is like performing brain surgery: You can't learn to do it by reading a book. You've got to **practice.** And doing these exercises lets you practice what you've learned so far. If you want to use a dummy sheet, you can trace or copy the sample dummy on page 36 or 37.*

1 What are your two best options for dummying a 5-inch story without any art? How would you code the headline for each option if it were dummied at the top of Page One? At the bottom of an inside page?

2 You've got a 9-inch story with one mug shot. (Assume your newspaper runs its mug shots 3 inches deep.) What are your three best options for dummying this story?

Will this story work in a 3-column format?

3 Here's a layout that uses two mug shots. There are several things wrong with it. How many problems can you identify?

4 Today is a busy news day: lots of news. The big story is a 12-inch piece about a local drug bust. This photo accompanies that story:

Hint:
As printed here, this photo is 29 picas wide and 20 picas deep. Assuming you work at a paper where columns are roughly 12 picas wide, here's how deep this photo would be if it were sized for:

◆ *1 column: 8 picas*
◆ *2 columns: 17 picas*
◆ *3 columns: 26 picas*
◆ *4 columns: 35 picas*
◆ *5 columns: 44 picas*
◆ *6 columns: 53 picas*

For more on sizing photos by using a proportion wheel, see page 252.

There are a number of ways you could dummy this story for a 6-column broadsheet newspaper. But what design solution would you recommend?

EXERCISES

To make this exercise easier, don't worry about sizing these photos exactly. Instead, dummy them using their rough shapes and assume you can crop them slightly to fit the layout that works best.

5 Here are the two best photos from last night's Rolling Stones concert. Your editor wants to run them both. Which should be the dominant photo?

This Stones review will be the lead story for the Arts page. The story design *must* be 5 columns wide; it can be as deep as you like, however. The review that accompanies these photos is 12 inches long. What's your best solution?

6 What's wrong with each of these news story designs?

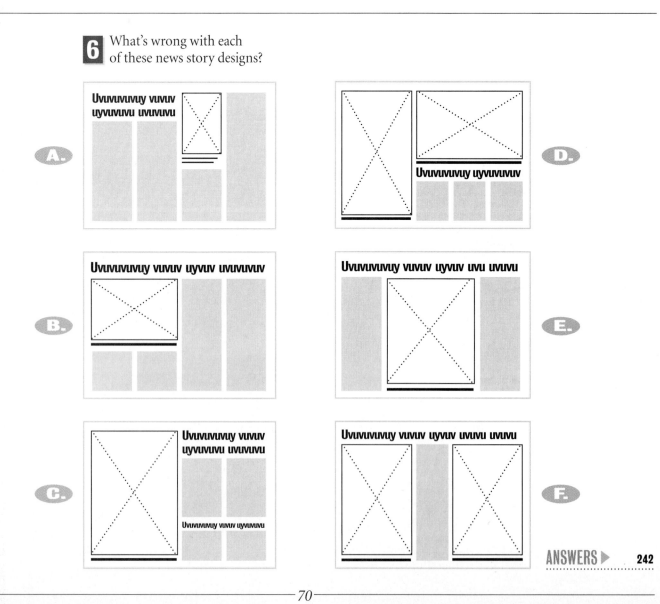

A.

B.

C.

D.

E.

F.

ANSWERS ▶ 242

Design trends come and go. What's cool today may look hopelessly lame in a decade or two (if newspapers still *exist* in a decade or two). Tastes change. Journalistic philosophies change, too.

The same goes for theories of page design. Some design experts insist that the upper-left corner is a page's prime position; thus, you should put your top story there. Others claim that the upper-*right* corner is the best-read spot on the page, and that you should put your top story *there*. Still others advise putting *strong* elements in *weak* positions (like the bottom corners) to ensure that readers will stay interested wherever their eyes wander.

Confusing, eh? Then forget what the experts say and remember this: Readers will look where you *want* them to. If you know what you're doing, you can create a page that's logical, legible and fun to read — and you can guide the readers' eyes anywhere you choose.

This chapter explores current principles of page design. Now that we've studied stories as independent units — modules — we'll begin examining ways you can stack those modules together to create attractive, well-balanced pages. (Some designers disparage modular makeup, but that's too complicated to get into now.) Once you understand how these principles work, you can adapt them to any pages you design — whatever the style or topic.

GRIDS

Before you design a page, you've got to know: What *grid* does this page use?
What's the underlying pattern that divides this page into columns? A page grid
provides the structure — the architecture —that keeps elements evenly aligned:

3-column grid: *Often used by newsletters; note how limited the options are for photo and text widths.*

4 columns: *A common grid for tabloids. More flexible than a 3-column grid, and the text is comfortably wide.*

5 columns: *Probably the most popular tabloid grid. It's also commonly used on broadsheet section fronts.*

6 columns: *The standard grid for broadsheets, since most ads are sold in these universal column widths.*

7 columns: *An intriguing tabloid grid; note how that seventh leg can be used for sidebars, cutlines, etc.*

BROADSHEET GRIDS Newspapers, you'll recall, come in two basic sizes: broadsheet and tabloid.
Broadsheets are twice the size of tabloids. And the large broadsheet page provides
room for longer stories, bigger photos, more expansive headlines.

Most broadsheets use a 6-column grid — especially on inside pages, where ads
are sold in standard widths that require columns about 12 picas wide.

On section fronts, however, broadsheet news pages use a variety of grids:

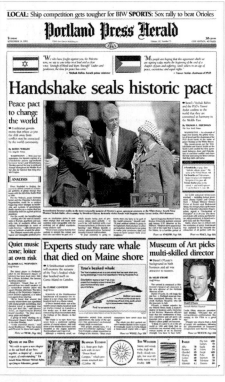

6 columns: *At The Portland (Me.) Press Herald, all elements (except those downpage promos) align along a 6-column grid. Most broadsheet papers use this grid, particularly on their inside pages.*

10 columns: *In the '90s, The Oregonian used an 11-column grid (see page 6) to provide a home for quotes, graphics, cutlines, etc. Those 11 columns became 10 during a 1999 redesign.*

12 columns: *For years, the front page of USA Today was designed on a restrictive 7-column grid. But after a redesign in 2000, the front page converted to this more flexible 12-column grid.*

GRIDS

MORE ON ▶
.................................
◆ **Special grids :** *How
rails can help you
display graphic
extras* **180**

**TABLOID
GRIDS**
Though large-circulation dailies are usually broadsheets, many other papers —
including weeklies, student newspapers and special-interest journals — prefer
the advantages of the tabloid format:

◆ Their smaller size makes tabs easier to produce and cheaper to print.

◆ They're popular with readers: handier, less bulky, faster to scan.

◆ Editors and advertisers find that their stories and ads can dominate a page
more effectively than in a broadsheet.

Tabloids are roughly half the size of broadsheets. If you took broadsheet paper,
turned it sideways and folded it, you'd create two tabloid pages:

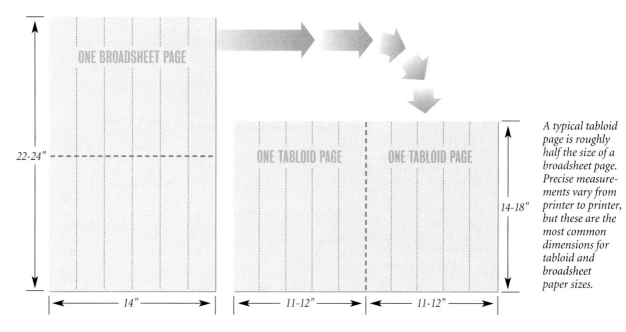

ONE BROADSHEET PAGE

ONE TABLOID PAGE ONE TABLOID PAGE

22-24"

14-18"

14"

11-12" 11-12"

*A typical tabloid
page is roughly
half the size of a
broadsheet page.
Precise measure-
ments vary from
printer to printer,
but these are the
most common
dimensions for
tabloid and
broadsheet
paper sizes.*

Though the 5-column format is most common in tabloids, some prefer 4
columns — while others are experimenting with 7-, 8-, even 9-column grids:

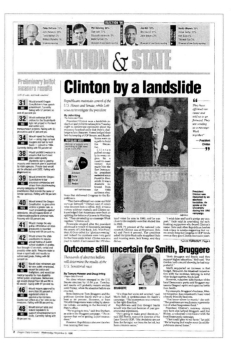

*The Fauquier (Va.) Citizen uses a 7-column grid to full advantage in the two sports pages shown above.
At right, what looks like a 4-column grid in the Oregon Daily Emerald is actually an 8-column grid.*

PAGES WITHOUT ART

NOTE ▶

Some of you work with tabloids. Some of you work with broadsheets. As a compromise, the examples in this chapter — like the one below — will use 5 columns (as most tabloids do) but will show the shape and depth of broadsheet pages.

Until now, we've looked at different ways of designing *stories*. Now, we're ready to design *pages*. And a well-designed page is really nothing more than an attractive stack of stories. Sounds simple, right?

So we'll start simply. With just text — no photos. That way, you'll be able to see that, with or without art, you build a page by fitting rectangles together as neatly as you can.

In the old days, editors designed pages by stacking stories side by side in deep vertical rows. Today, the trend is more horizontal, and it's possible to build pages in long, horizontal rows like the example below. Simple as it is, a page like this will get the job done:

MORE ON ▶

◆ **Headlines and headline sizes:** *A quick guide for both broadsheet and tabloid* **25**

◆ **Designing pages with art:** *Guidelines for adding photos to gray pages like this one* **80**

◆ **Inside pages:** *Creating modular designs, working with ads* **88**

This page design is simple, but it still observes some basic design principles:

Story placement:
The strongest story goes at the top of the page. By "strong," we're referring to news value, impact or appeal. As you move down the page, stories become less significant.

Headline sizing:
Page position dictates headline size. The lead story will have the biggest headline; headlines then get smaller as you move down the page.

Story shapes:
As we've learned, stories should be shaped like rectangles. And here, you can see how keeping stories rectangular keeps pages neat and well-organized. Whether stories are stacked vertically or horizontally, whether they use art or not, that principle always applies on open pages like this. (Later, when we look at pages with ads, you'll see it's not always this easy to keep stories rectangular.)

The design of this page is clean, but its impact on readers is probably weak. Why? It's too gray. Too monotonous. There's nothing to catch our eye. The only contrast comes from the headlines.

In a perfect newspaper, every story might have some sort of art: a photo, a chart, a map or — at the very least — a liftout quote. In reality, though, actually *producing* all those extras would take a colossal amount of work and might look pretty chaotic.

A better rule of thumb is this: *Make every page at least one-third art.* In other words, when you add up all the photos, graphics and display type on a page, they should occupy at least a third of the total real estate. Some pages should use even more art than that (sports and feature section fronts, for instance).

There are times, however, when photos just don't materialize. When there are no quotes to lift. When there's no time — or no artist — to add a chart or graph. Your page may be gray, but it doesn't have to be dull. Instead of simply stacking stories in rows (as in the example above), you can add variety by:

◆ **Butting headlines.**
◆ **Boxing stories.**
◆ **Using bastard measures.**
◆ **Using raw wraps and alternative headline treatments.**

In the pages ahead, we'll see how these techniques work on pages without art.

PAGES WITHOUT ART

TOM MIX DIES IN CRASH

Troy Tops Illini 13-7; Texans Beat Bruins 7-0

| 115,000 to Join Pontifical Mass for Peace Today | KIMBROUGHS DRIVE GAINS EARLY SCORE | TROY ATTACK IN 3D PERIOD DOWNS ZUPPKE | Hitler Warned By Greece; Nazis Seize Bucharest |

Cleric Leaders Aiding Papal Envoy in Coliseum | **Western Film Hero Killed in Arizona**

U-Boats Stage Battle With British Navy | **Von Wiegand Says:** *Europe Conflict Moving to Egypt* | *Troops March in Triumph to Balkan Capital*

Axis Plans Check of British in Mediterranean

Nobody likes ugly heads. But it took newspapers years to figure out how to slap headlines onto every story without jamming them into a chaotic jumble. Until the 1960s, most newspapers ran vertical rules in the gutters between stories. When their headlines stacked alongside each other, they looked like tombstones (hence the term *tombstoning*, another name for butting heads).

For years, the First Commandment of Page Design has been: *Don't butt heads.* That's good advice. Butt-headed design can cause confusion like this:

President Bush meets Frisbee title-holder Castro in Miami Beach to challenge record

By Robin Fox/ The Times By John Hamlin/ The Times

Occasionally, though, you'll need to park two stories alongside each other, and when you do, their heads may butt. But to minimize the problem:

◆ **Mix styles, fonts or sizes.** The idea here is: If headlines must butt, make them very dissimilar. If one's boldface, make the other light or italic. If one's a large, 1-line horizontal, make the other a small, 3-line vertical.

◆ **Write short.** Let a little air separate the two headlines. That usually means writing the headline on the left a few counts short, just to be safe.

With stories stacked like this — in wide horizontal layers — you're not forced to butt any headlines. But should we add a vertical shape to break up the monotony?

Here, the top two headlines butt a bit. But the one on the left is bigger (by at least 12 points) and it's written short. The page now has a vertical element to relieve the tedium.

Here, two different pairs of headlines butt. But some would say the page now has more motion, more interesting shapes. By bending the rules, we've added variety.

PAGES WITHOUT ART

BOXING STORIES

Another way to break up monotonous gray page patterns is by boxing stories. As we saw on page 63, putting a box around a story (with a photo) is one way to avoid confusing readers with ambiguous designs:

MORE ON ▶

◆ **Bad juxtapositions:** *How they happen, and how to avoid them* **92**

◆ **Rules and boxes:** *Where (and where not) to use them* **143**

Which story does this photo belong to? Hard to tell. You'd have to scan the text and the cutline to figure it out.

If you draw a box around the story and its photo, you join them into one package — and avoid confusing readers.

Boxing a story also gives it visual emphasis. It's a way of saying to the reader, "This story is *different* from the others; it's *special.*"

Don't box a story just because you're bored with a page and want to snazz it up. Instead, save boxes for stories that deserve special treatment:

◆ A light feature on a page full of hard news.
◆ Small sidebars attached to bigger stories.
◆ Standing columns (news briefs, opinion, etc.) that appear regularly.
◆ Stories with risky or complicated designs whose elements might otherwise collide with other stories and confuse readers.

*Boxing this deep vertical story breaks up the monotony of the page and says to the reader, "This story is different." Give this treatment, then, **only** to special stories or columns.*

Here, we've created the effect of two lead stories on one page: one across the top and one that's boxed. See how these story shapes move your eye around the page?

At the top, we've boxed the lead story's sidebar — and it's obvious that the two stories work together as a unit. At the bottom, we've given a graphic nudge to a small feature.

MEASURING COLUMN WIDTHS INSIDE BOXES

To figure out how wide legs of text will be when you put a story in a box:

1 **Measure** the width of the box (in picas);
2 **Decide** how many legs of text there will be;
3 **Subtract** 1 pica for each gutter inside the box (including the two gutters on the outer edges); *and finally,*
4 **Divide** by the number of legs.

PAGES WITHOUT ART

BASTARD COLUMN MEASURES

OK, stop snickering. Bastard measures are *serious* design devices. And they're handy, too — especially when you need extra flexibility in sizing photos. (More on this later.)

As we've seen, most papers use a fixed number of columns on each page. But bastard measures let you deviate from the standard text width:

MORE ON ▶
.....................................
◆ **Bastard measures:**
How they add extra flexibility in sizing photos **87**

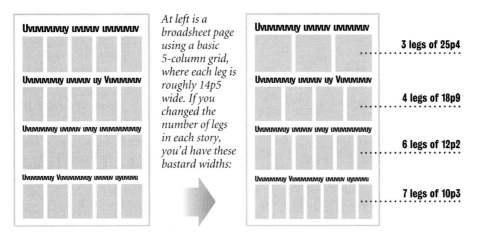

At left is a broadsheet page using a basic 5-column grid, where each leg is roughly 14p5 wide. If you changed the number of legs in each story, you'd have these bastard widths:

3 legs of 25p4

4 legs of 18p9

6 legs of 12p2

7 legs of 10p3

Bastard measures add graphic emphasis to a story by freeing it from the rigid page grid. (In the above left example, see how the columns and gutters align in a strict vertical pattern?) Changing column widths is a subtle but effective way to show that a story is special or different:

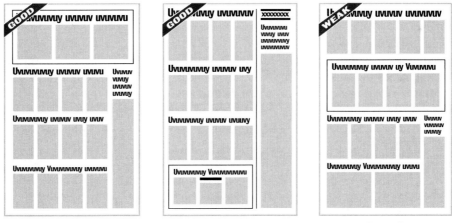

A good combination: a box with a bastard measure. This adds emphasis to the lead story and helps set it apart. The page is orderly; the relative news value of each story is clear.

A wider measure can enhance a columnist (right column) or other special story (bottom). Note, too, how the column rule helps separate that right column from the other stories.

Too many bastard measures can get confusing. Why create two competing lead stories? Why run that bottom story in wide legs? In short: Don't ignore your basic page grid.

Bastard measures alter the grid patterns on a page — which can be either good (relieving monotony) or bad (creating chaos). Some papers don't allow any bastard measures; others allow them only when a story is boxed. So remember to use the proper amount of restraint.

A warning about something that should be obvious by now: *Don't change column widths within a story.* Widths may change from story to story, from page to page — but once you start a story in a certain measure, each leg of that story on that page should stay the same width. No cheating.

PAGES WITHOUT ART

USING RAW WRAPS

Raw wraps let you park two stories side by side without butting their headlines. But use raw wraps with caution. They work only at the top of a page, beneath a rule or beneath a boxed story; otherwise, as you can see, they'll collide with other columns of text and confuse your readers:

MORE ON ▶

◆ **Types of headlines:** *A summary of non-standard options ...* **24**

◆ **Raw wraps:** *How to use them to keep headlines from butting* **81**

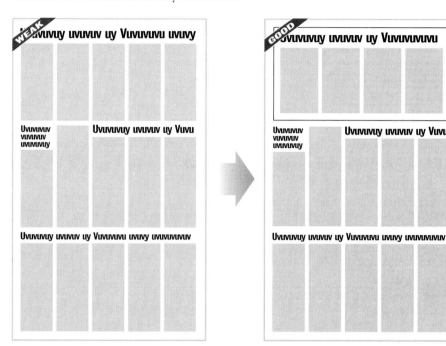

Here's that typical photo-free page again. You can see how that raw-wrapped headline adds variety to the story shapes. But see how the second leg of that raw-wrapped story collides with the text above it? That's the danger of raw-wrapping stories in the middle of the page.

*A better combination. Here, the lead story is boxed in a bastard measure. That gives it extra emphasis and staggers the column alignment, making it unlikely that readers will be misdirected. You **could** box the raw-wrapped story instead, but remember: Save boxes for stories whose content is special. Don't use boxes to salvage weak designs.*

OPTIONAL HEADLINE TREATMENTS

No one ever said all headlines had to look the same. Adding variety to your headlines can add oomph to your page designs. But don't overdo it. Save special headline treatments for special stories. If you use too many offbeat headlines on a page, their styles may clash and create distraction.

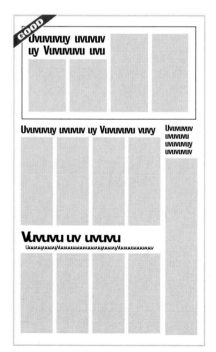

At the top of the page: a raw-wrap headline inside a boxed story (in bastard measure). Some papers raw-wrap headlines at the top of the page simply to avoid an excess of long, 1-line banner heads. Below, a hammer head (with deck) gives extra impact to a special analysis or feature story.

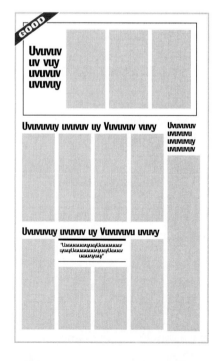

At the top of the page: a sidesaddle headline. Like raw wraps, these must be used carefully to avoid collisions between legs of different stories. Note, too, that if the story's legs are too deep, the headline will float in too much white space. At the bottom of the page, a liftout quote lures readers as it breaks up the gray text.

PAGES WITHOUT ART

If your pages consistently look like the one at left — a gray hodgepodge crowded with short stories — you may need more photographers. Or you may need to start packaging short, related items into special formats.

The advantages:

◆ Instead of scattering news briefs or calendar listings throughout the paper, you anchor them in one spot. That's a smarter, cleaner solution.

◆ You create more impact for your main stories by keeping those smaller ones out of their way.

◆ You appeal to reader habit (since most of us prefer finding material in the same spot every issue).

"Roundup" packages of briefs usually run down the left-hand side of the page. By stacking briefs vertically, it's easier to add or cut material to fit precisely. Note how this column runs in a wider measure, separated from the rest of the page by a cutoff rule. A box would also work well to isolate these briefs.

By flopping the page design at far left, we can see how the page looks when you run a special column down the right-hand side. Here, a "man-in-the-street" interview uses mugs and quotes to anchor and enliven an otherwise gray page.

Some papers run news roundups horizontally across the top of the page, though the text often wraps awkwardly from one leg to another. Note the raw wrap at the bottom of the page. This is how it looks when you box a raw-wrapped story (in bastard measure) below another story. Is that solution acceptable?

Here's how a roundup column looks when it's stripped across the bottom of the page. Again, the biggest drawback is the awkwardness of wrapping short paragraphs from one leg to the next. In this example, a black bar labels the column and separates it from the rest of the page.

PAGES WITH ART

As a page designer, your job isn't just drawing lines, stacking stories and keeping everything from colliding. It's *selling* stories to readers. People won't eat food that looks unappetizing; they won't swallow information that looks unappetizing, either. And that's why you gotta have art.

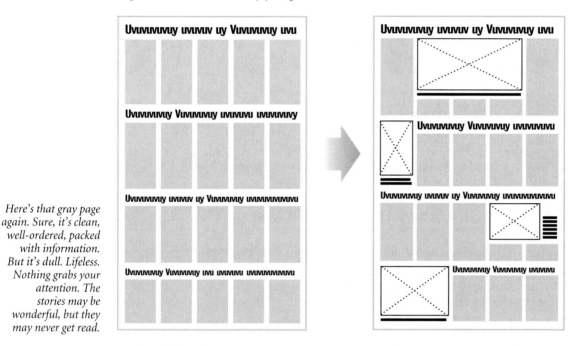

Here's that gray page again. Sure, it's clean, well-ordered, packed with information. But it's dull. Lifeless. Nothing grabs your attention. The stories may be wonderful, but they may never get read.

Here's that same page, with art. There's less room for text now, so stories must either be shortened or jump to another page. But it's worth it. Remember, most readers browse around until something compels them to stop. By adding photos, maps or charts, you catch their interest — then deliver the information.

Art is essential. And informational art — not just decoration — is the very heart of newspaper design. Adding art to your pages:
- ◆ Supplements *textual* information with *visual* information.
- ◆ Adds motion, emotion and personality that's missing in text alone.
- ◆ Attracts readers who might otherwise ignore gray type.
- ◆ Increases the design options for each page.

GUIDELINES FOR PAGES WITH ART

When you add art to page designs, you enhance their appeal. You also increase the risk of clutter and confusion. So go slowly at first. Once you feel comfortable adding art to stories, keep adding it. It's (arguably) better to make a page too dynamic than too dull. Or as one veteran designer put it: "I like to take a page right to the edge of confusion, then back off a bit."

A dizzying number of possibilities — and pitfalls — await when you design full pages. The most important guidelines are:

◆ **Keep all story shapes rectangular.** You've heard this a dozen times. But it's the key to good modular design.

◆ **Vary your shapes and sizes** (of stories as well as art). Avoid falling into a rut where everything's square. Or vertical. Or horizontal. Or where all the stories are 10 inches long. Give readers a variety of text and photo shapes.

◆ **Emphasize what's important.** Play up the big stories, the big photos. Place them where they count. Let *play* and *placement* reflect each story's significance as you guide the reader through the page.

On the next page, we'll look more closely at three crucial guidelines:
- ◆ **Give each page a dominant image.**
- ◆ **Balance and scatter your art.**
- ◆ **Beware of butting headlines.**

PAGES WITH ART

GIVE EACH PAGE A DOMINANT IMAGE

Most beginning page designers run art too small. As a result, pages look weak. Meek.

So be bold. Run your best art big. And when you use two or more photos on a page, remember that one of them should dominate.

Even if there's only *one* photo on a page, it should run big enough to provide impact and interest — to visually anchor the page.

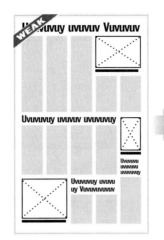

Here's a page where no photo dominates. As a result, it looks text-heavy and unexciting.

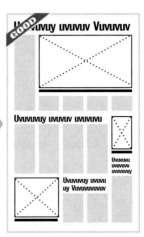

Here, that top photo is two columns wider — and now it dominates a dynamic page.

BALANCE & SCATTER YOUR ART

Use photos to anchor your pages, but remember to balance and separate your art, too. When photos start stacking up and colliding, you get a page that's:

◆ **confusing,** as unrelated art distracts us and intrudes into stories where it doesn't belong. *Or:*

◆ **lopsided,** as photos clump together in one part of the page and text collects in another.

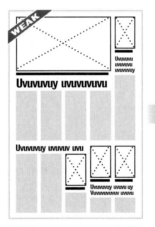

This layout seems to pair the lead photo and top mug, as well as the three mugs below. It's confusing and top-heavy.

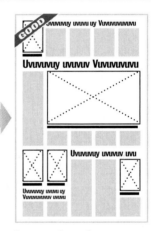

Smarter photo placement avoids collision or confusion. The page is better-balanced when the art's apart.

BEWARE OF BUTTING HEADLINES

We've seen how you can bump heads (carefully) when you *need* to. But on most well-designed pages, head butts are unnecessary. Clumsy. And confusing to readers.

Instead, think ahead. Rather than butting headlines, use art to separate stories. In many cases, that's where raw-wrapped headlines offer a smart alternative to a crowded page.

With two sets of butting headlines, this page is clumsy and confusing. But if you use the photos to separate stories. . .

. . . it's a much cleaner layout. Notice how the raw wrap (bottom left) makes it easy to run two stories side by side.

MODULAR PAGE DESIGN

We've mentioned the term *modular design* before. And as you begin designing full pages, the idea of treating stories as modules — as discrete rectangular units — gains new meaning.

Take a moment to study the sports page below. Notice how every story is a rectangle — and how all those modules fit together to form a well-balanced, well-organized page.

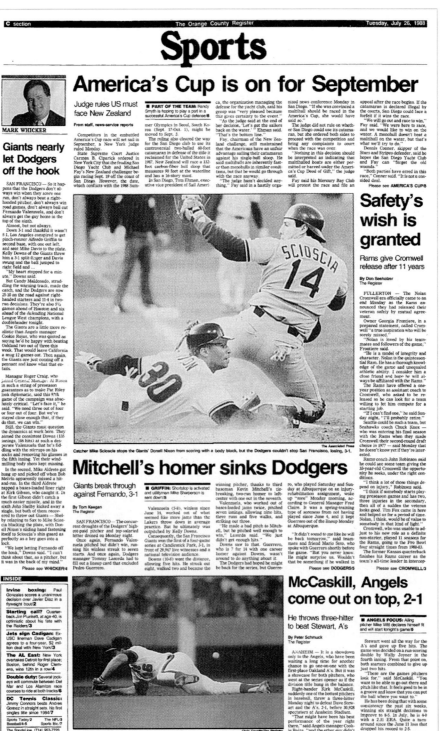

MODULAR PAGE DESIGN

Could that page have been assembled differently — or better? Let's rearrange
the modules to see how other options might have turned out:

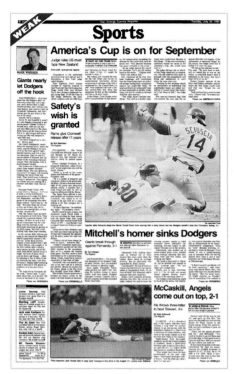

The problem: two thin vertical stories side by side, their heads nearly butting. That's a weak juxtaposition, though the rest of the page is OK.

Move the dominant photo all the way to the top and you get two gray text blocks dulling things up in the middle of the page. Otherwise, it's OK.

To break up that gray (example at left), move that bottom story up, then dummy the America's Cup story at the bottom. A good balance.

Could that small photo run at the top of the page? Well, not like this. The two photos collide, and now there's no art at all downpage.

Here, we lead with the smaller photo. Does this design feel odd? Usually, big photos play better when they're placed near the top of the page.

A mirror image of the original. Nothing wrong with it, but columnists traditionally run down the left side of the page. Does that matter to you?

FRONT PAGE DESIGN

Every paper has its own news philosophy. And that philosophy is most visibly reflected on Page One: in the number of stories, the play of photos, the styles of headlines, the variety of graphics. Designing the front page is no tougher than designing other pages. But the standards are higher — and deadlines are tighter.

Here are a few current examples of broadsheet Page One design. Study them closely. Have they observed the design principles we've discussed?

MORE ON ▶
.................................
◆ **Page One design:**
Current trends and philosophies.............. 7

Each spring, miller moths flock to the Rocky Mountains by the billions, infesting houses and cars, and creating an enormous nuisance. This is how the Greeley, Colo., daily designed their big moth story: with 3-D bugs landing all over the page. Is this a frivolous way to cover the story — or is it a clever packaging device that gives the page personality?

The Virginian-Pilot consistently bends the rules on its front page, often experimenting with untraditional treatments of photos, typography and page architecture. Look, for instance, at the type on the lead photo, and the lowercase italic headline on that second story. Do these elements seem too informal — or refreshingly modern?

A remarkably sophisticated page – in its use of photos, type and color – from the award-winning daily at Ball State University. Notice how that centerpiece dominates the page. Is it because the package is so well-designed – or because the other two stories on the page are gray by comparison?

An unusual approach to Page One: Notice how little traditional text this page contains. Instead, it combines a Q&A, a calendar, and a sideways flag (with promos) down the left-hand edge. Still, the page is anchored by traditional story elements: a package using a dominant photo and a hammer headline. Does it all work?

FLOW CHART: SECTION FRONT DESIGN

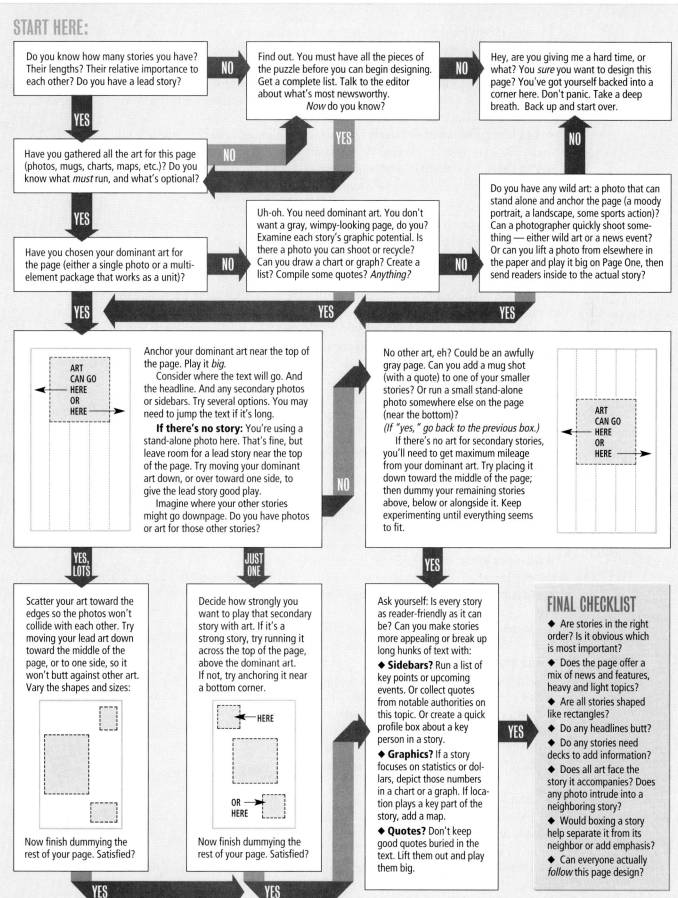

START HERE:

Do you know how many stories you have? Their lengths? Their relative importance to each other? Do you have a lead story?

NO →

Find out. You must have all the pieces of the puzzle before you can begin designing. Get a complete list. Talk to the editor about what's most newsworthy. *Now* do you know?

NO →

Hey, are you giving me a hard time, or what? You *sure* you want to design this page? You've got yourself backed into a corner here. Don't panic. Take a deep breath. Back up and start over.

YES ↓

Have you gathered all the art for this page (photos, mugs, charts, maps, etc.)? Do you know what *must* run, and what's optional?

NO / **YES**

YES ↓

Have you chosen your dominant art for the page (either a single photo or a multi-element package that works as a unit)?

NO →

Uh-oh. You need dominant art. You don't want a gray, wimpy-looking page, do you? Examine each story's graphic potential. Is there a photo you can shoot or recycle? Can you draw a chart or graph? Create a list? Compile some quotes? *Anything?*

NO →

Do you have any wild art: a photo that can stand alone and anchor the page (a moody portrait, a landscape, some sports action)? Can a photographer quickly shoot something — either wild art or a news event? Or can you lift a photo from elsewhere in the paper and play it big on Page One, then send readers inside to the actual story?

NO ↑

YES ← **YES** ← **YES**

ART CAN GO HERE OR HERE

Anchor your dominant art near the top of the page. Play it *big*.
Consider where the text will go. And the headline. And any secondary photos or sidebars. Try several options. You may need to jump the text if it's long.
If there's no story: You're using a stand-alone photo here. That's fine, but leave room for a lead story near the top of the page. Try moving your dominant art down, or over toward one side, to give the lead story good play.
Imagine where your other stories might go downpage. Do you have photos or art for those other stories?

No other art, eh? Could be an awfully gray page. Can you add a mug shot (with a quote) to one of your smaller stories? Or run a small stand-alone photo somewhere else on the page (near the bottom)?
(If "yes," go back to the previous box.)
If there's no art for secondary stories, you'll need to get maximum mileage from your dominant art. Try placing it down toward the middle of the page; then dummy your remaining stories above, below or alongside it. Keep experimenting until everything seems to fit.

ART CAN GO HERE OR HERE

NO

YES, LOTS ↓ **JUST ONE** ↓ **YES** ↓

Scatter your art toward the edges so the photos won't collide with each other. Try moving your lead art down toward the middle of the page, or to one side, so it won't butt against other art. Vary the shapes and sizes:

Now finish dummying the rest of your page. Satisfied?

Decide how strongly you want to play that secondary story with art. If it's a strong story, try running it across the top of the page, above the dominant art. If not, try anchoring it near a bottom corner.

← HERE

OR → HERE

Now finish dummying the rest of your page. Satisfied?

Ask yourself: Is every story as reader-friendly as it can be? Can you make stories more appealing or break up long hunks of text with:
◆ **Sidebars?** Run a list of key points or upcoming events. Or collect quotes from notable authorities on this topic. Or create a quick profile box about a key person in a story.
◆ **Graphics?** If a story focuses on statistics or dollars, depict those numbers in a chart or a graph. If location plays a key part of the story, add a map.
◆ **Quotes?** Don't keep good quotes buried in the text. Lift them out and play them big.

YES →

FINAL CHECKLIST

◆ Are stories in the right order? Is it obvious which is most important?
◆ Does the page offer a mix of news and features, heavy and light topics?
◆ Are all stories shaped like rectangles?
◆ Do any headlines butt?
◆ Do any stories need decks to add information?
◆ Does all art face the story it accompanies? Does any photo intrude into a neighboring story?
◆ Would boxing a story help separate it from its neighbor or add emphasis?
◆ Can everyone actually *follow* this page design?

YES **YES**

MAKING STORIES FIT

No matter how hard you try, no matter how carefully you plan, no matter how drool-proof your page designs seem, stories have a habit of coming up short. Or long. So what do you do?

Once a page is assembled, minor tweaking is easy. Major repairs, however, can be tricky and time-consuming. You may need to back up and re-dummy a story or two. But first, find out what went wrong. Ask yourself:

◆ **Was there a planning problem?** Did someone change a story's length? Did someone swap or re-crop photos? Were ads sized wrong? Omitted? Killed? Or:

◆ **Was there a production problem?** Were text and photos correctly placed? Headlines correctly sized? Are all elements — bylines, cutlines, refers, logos, liftout quotes — where they're supposed to be?

If a story's close to fitting — say, within a few inches — try some of these options, either while you're designing the page or after it's assembled:

MORE ON ▶

◆ **Liftout quotes:** *Some basic styles and guidelines* **136**

◆ **Decks:** *Styles and guidelines for sizing and dummying* **138**

IF A STORY TURNS OUT TOO LONG

◆ **Trim the text.** As a rule of thumb, stories are usually cuttable by 10%. For instance, a 10-inch story can usually lose an inch without serious damage; a 30-inch story can lose a few inches. (And your readers may actually thank you.)

◆ **Trim a photo.** Shave a few picas off the top or bottom, if the image permits it. Or, if necessary, re-size the photo so you can crop more tightly.

◆ **Trim an adjacent story.** If you find that a story is trimmed to the max, try tightening the one above or below it.

◆ **Drop a line from the headline.** But be careful — short headlines that make no sense can doom an entire story (see chart, page 25).

◆ **Move an ad.** Either into another column or onto another page.

IF A STORY TURNS OUT TOO SHORT

◆ **Add more text.** If material was trimmed from a story, add it back. Or if you have time, break out a small sidebar that highlights key points or tells readers where to go for more information.

◆ **Enlarge a photo.** Crop the depth more loosely. Or size it a column larger.

◆ **Add a mug shot.** But be sure it's someone *relevant* to the story.

◆ **Add a liftout quote.** Find a meaningful remark that will attract readers. And follow our advice at right.

◆ **Add another line of headline.** Or better yet, expand the decks on those long and medium-sized stories.

◆ **Add some air between paragraphs.** This old composing-room trick lets you add 1-4 points of extra leading between the final paragraphs of a story. But go easy: If you overdo it, those paragraphs begin to float apart.

◆ **Add a filler story.** Keep a selection of optional 1- or 2-inch stories handy to drop in as needed.

◆ **Add a house ad.** Create small promos for your paper. Have them available in a variety of widths and depths.

◆ **Move an ad.** If permissible, import one from another column or page.

In addition to these quick fixes, there are two more techniques — using bastard measures and jumping stories — that are a bit more complicated.

> "
> *If you add a liftout quote, find one that's provocative and enticing. And designing in some white space below (like we're doing here) can help you fill deeper holes.*
> "

MAKING STORIES FIT

NON-STANDARD (BASTARD) MEASURES

Most of the time, photos fit fine into standard column widths. But on some pages, they're just too small in one column measure — and just too big in another.

At times like these, bastard measures can be the answer — especially on feature pages, where photos predominate.

Take this column of text you're reading right now, for instance. Most text in this book is set 29 picas wide. But to maintain the best possible proportions for those four examples at right, we've narrowed this leg of text, running it in a bastard width — 9 picas — alongside the illustrations.

1 *Suppose you're dummying a 6-inch story with a mug. You need to fill this space that's 3 columns wide, 5 inches deep. What's your best option?*

2 *With a 1-column mug, the story fits in 2 legs, leaving a column empty.(A 2-line headline would force text into that third leg but wouldn't fill it.)*

3 *You could try running the mug 2 columns wide, but it wastes way too much space. Only 3½ inches of text will fit into that left-hand column.*

4 *The solution? Running 2 bastard legs in place of the usual 3. The text is 4 inches deep, but it's half-again as wide as a 1-column leg — so it fits.*

MORE ON ▶

◆ **Jump headlines:** *Guidelines for making jump stories effective* **146**

◆ **Page grids:** *How a better grid might let you size photos with more flexibility* **94**

JUMPING STORIES

There will be times — many, many times — when you'll need to fit a 30-inch story into a 10-inch hole. When that happens, you can either:

◆ Cut 20 inches from the story (lots of luck), or

◆ Start the story on one page and finish it on another.

When stories runneth over like that, they're called *jumps*. Jumps are controversial. Many editors hate them. Many readers hate them, too. But designers love them, because they give you the freedom to stretch and slice stories in otherwise unimaginable ways.

(That age-old journalistic question — "Do readers actually follow stories that jump?" — has yet to be answered definitively. My own hunch? If a story's engrossing enough, readers will follow it *anywhere*. Otherwise, they'll use the jump as an excuse to bail out.)

When you jump a story:

◆ **Make it worth the reader's while.** It's pointless — and annoying — to jump just a few short paragraphs at the end of a story. Jump *at least* 6 inches of text, unless the story is simply uncuttable and there's no other option.

◆ **Start the story solidly** — with *at least* 4 inches of text — before you jump it. Otherwise, the story may look too insignificant to bother reading.

◆ **Jump stories to the same place** whenever possible. Readers will tolerate jumps more forgivingly once they're trained to always turn to the back page, the top of Page 2, the bottom of Page 3, etc.

◆ **Jump stories once** — and once only. You'll lose or confuse too many readers if you jump a few inches to Page 2, then snake a little more text along Page 3

Please turn to **JUMPS, Page 146** ▶

INSIDE PAGES

News stories exist to inform readers. Ads exist to make money for publishers. Can you guess which is more important?

Right. *Ads.*

The big difference between a front page and an inside page is that, on inside pages, you coexist with a loud, pushy heap of boxes — ads — stacked upward from the bottom. Now, some stacks look better than others. But whatever format they use, ad stacks are dummied onto pages *before* the news is — and thus dictate the shape of the news hole you're left with.

Today, these three formats are most often used for dummying ads:

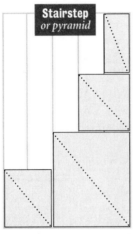 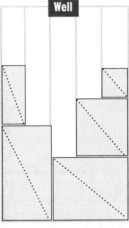 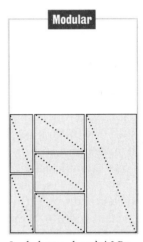

Stairstep *or pyramid*	**Well**	**Modular**

This traditional format lets every ad touch news copy, which is important to many advertisers. But for editors, it creates ugly-looking news holes. It also creates a pyramid effect on facing pages.

As ads stack up on both sides of the page, a well forms in the middle — hence the name. Like stairstepped ads, wells can get ugly; designers have been known to call them "Ad Stacks From Hell."

Looks better, doesn't it? By stacking ads in modular blocks, pages looks more orderly and attractive, and readership actually improves. This solution may become more common in the future.

As you can see, those two old-fashioned ad configurations — stairstep and well — offer tough challenges for page designers. What's the best way to squeeze stories into those oddly shaped spaces? Here's some advice:

Many pages are doomed to ugliness before you even start designing. That's because the ad staff and the newsroom aren't communicating. As a result, ad lay-downs become unmanageable, forcing you to waste precious time trying to overcome unnecessary obstacles.

To avoid headaches, work with the ad staff to:

◆ **Use modular ad formats.** Snaking stories around steeply stairstepped ads punishes both readers and advertisers. Square off ads whenever possible.

◆ **Use house ads** to smooth out any small, awkward holes.

◆ **Establish guidelines for key pages.** Negotiate dependable news holes where you need them most. Reach an agreement that Page 2 will always be open, for instance, or that Page 3's left-hand column is off-limits to ads.

◆ **Establish limits.** If ads are stacked too high — say, an inch from the top of the page — dummying even the simplest headline and story is impossible. Ideally, ads should either stack clear to the top or start at least 2 inches down.

◆ **Get permission to move ads.** Ad positions aren't etched in stone. Reserve the right to move ads if necessary. Just don't abuse the privilege.

INSIDE PAGES

◆ **Work with the ad stacks.** Yes, it's best to dummy stories into rectangles — but on pages crowded with ads, that may not work. Doglegging text is common on inside pages, and it's often your only option.

Before you begin dummying, explore how best to subdivide each page. Work with the ads to block out clean, modular story segments. Start at the bottom, if necessary; sometimes you can smooth things out by stretching one wide story atop an uneven stack of small ads. Or try working backward from an awkward corner. But wherever possible, square off stories along the edges of ads.

As these ads stairstep down the page, stories square off alongside. You may need to cut some text to create these modular shapes, but the page will be more readable than one full of doglegs.

With a banner head-line, that top story would have looked shallow and awkward. But by using a sidesad-dle head, the elements fit together neatly. The box and the bastard measures are both optional.

◆ **Use alternative head-line treatments.** On pages where ads crowd right to the top, you may barely have enough depth for a headline and an inch of text. That's where sidesaddle headlines come in handy (see the example at left).

Another option: Use raw-wrap headlines to dummy two stories side by side at the top of a crowded page.

◆ **Give every page a dominant element.** On crowded pages with tiny news holes, this may be impossible. And on other tight pages, even squeezing in a small photo may be difficult. But try to anchor each page with a strong image or a solid story. Don't just crowbar cluttered gray clumps of copy together (see example at right).

◆ **Avoid dummying photos or boxed stories near ads.** Ads are boxes. Photos are boxes. And readers can't always tell one box from another. So unless you want photos and sidebars mistaken for ads, always keep a little text between the two (see example below).

Keep headlines away from ads, too. This is difficult to do, but remember that a headline butting into an ad can be just as clumsy as one that butts into another headline.

Two problems here: That top photo sits on an ad and could easily be mistaken for an ad itself. In the middle of the page, that boxed story is sandwiched between ads — and, like the photo, seems to look like another ad.

The more crowded the page, the less necessary (and more difficult) it is to add photos. Note how this page plays up one dominant story — and how slight doglegs around ads are not a problem.

◆ **Save good stories for pages with good news holes.** Instead of constantly dummying your best stories and photos around nasty ad stacks, can you pour in flexible material like calendar listings? Briefs? Obituaries? Many papers successfully relegate low-priority materi-al to pages where ads are ugliest.

Consider an ad laydown strategy that alternates open pages with tight ones – or provides reasonably loose news holes in key positions throughout the paper. That way, you don't have to wrestle with ads on every page; you can satisfy your advertisers' needs to be near strong news material while still giving yourself room to design a few attractive pages.

The Philadelphia Inquirer has created consistently brilliant examples of double-truck design. We'll look at three examples here and on the next page. To mark astronaut John Glenn's return to space in 1998, the Inquirer created a special section that looked at past and future missions, offered guides to books and museums, and provided this double-truck guide to the planets.

In 1995, a fire killed 23 primates at the Philadelphia Zoo. So when the zoo opened its new primate house in 1999, the Inquirer produced a special supplement full of monkey stories, Web-site guides, maps of the new exhibits, comparisons of humans and apes — and this double-truck centerpiece, a collection of primate profiles introducing 11 of the zoo's new inhabitants to readers.

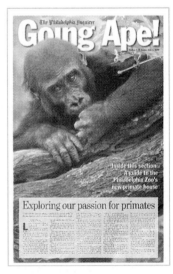

DOUBLE TRUCKS

This double-truck spread from The Philadelphia Inquirer was part of a special report examining problems in the city's schools. Note how the design flows right across the central gutter. Note, too, how well balanced and proportioned the artwork and text are. Most importantly, note how well planned this entire package is. Instead of three or four 20-inch stories, this spread uses charts, graphs and short lists to get its information across.

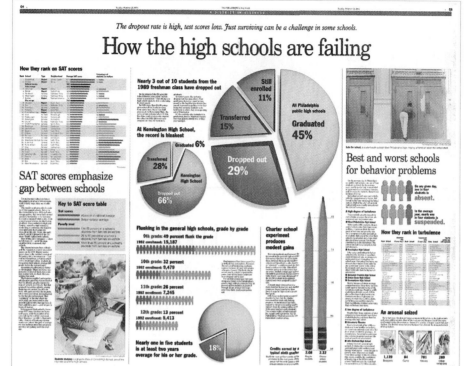

MORE ON ▶

◆ **Double-truck design:** *How student papers avoid messy and predictable pages***94**

When two facing pages print across the gutter on one sheet of newsprint — say, the two pages in the center of a section — it's called a *double truck.* Double trucks are rare in broadsheets, but popular in tabloids. They'll work best if you:

◆ **Clear off all ads.** Make it one big, modular, editorial block. Any ads will either intrude, get buried or be mistaken for editorial matter.

◆ **Treat both pages as one horizontal unit.** Ignore the gutter between pages; spread your elements from left to right in a balanced, orderly way. Keep the flow of text clean. Anchor the design with a bold headline and strong dominant photo.

◆ **Save them for special occasions.** Readers expect these packages to be special; don't let them down. Save double trucks for news features, infographics, photo layouts or major events. Add color and graphic effects. Think big. Have fun.

DESIGNING TWO FACING PAGES

You can also apply special treatment to two facing pages anywhere in the paper. As with actual double trucks, it's important to treat facing pages as one wide unit. If you're careful, you can even run elements across the central gutter; photographs and illustrations align more successfully than headlines or text (see example, right). Readers are generally pretty tolerant, but don't push your luck.

This photo spread from The Times (Beaverton, Ore.) ran on two facing pages — not a true double truck. We've printed it here the way many readers saw it: with the pages slightly out of alignment and a gutter opening up through the lead photo and headline. That's a problem, but not a serious one if you position the columns of text carefully.

BAD JUXTAPOSITIONS

As newspaper designer Phil Nesbitt once said: People and puppies must both be trained to use a newspaper.

In olden days, readers were trained to read newspapers *vertically* — and since every story on every page ran vertically, readers were rarely confused about which photo went with which story.

Today, however, stories run in vertical and horizontal modules that change from page to page. And on every page — with every *story* — we expect our readers to instantly deduce which photo connects to which text.

We don't always make their choices easy (as in the example at right: Is Nixon the escaped lunatic? Is that gorilla

Ax-wielding lunatic escapes from asylum

By ROBIN FOX
Special writer, The Bugle Beacon

Non equidem insector delendave carmin Livi esse reor, memini.

Ex-president Nixon visits new grandchild

By ROBIN FOX
Special writer, The Bugle Beacon

Gorilla mom gives birth at city zoo

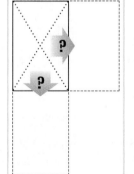

Non equidem insector delendave carmina Livi ess mundi.

Killer gorilla goes bananas, trashes tire store

By ROBIN FOX
Special writer, The Bugle Beacon

photo a portrait of Nixon's new grandchild?). So it's especially important to analyze every page design as objectively as you can, to determine:

◆ if a photo sits at the intersection of two stories in a way that confuses or misdirects the reader.

◆ if two stories — or their headlines — seem inappropriate together on the same page. (Those two ape stories in the example above will seem related to many readers, thus creating a false impression.)

◆ if an advertisement seems to comment upon a neighboring news story.

It's easy to embarrass yourself, your readers and the subjects of your stories (both apes *and* humans) by dubious dummying. When in doubt, either *move it* or *box it* — whatever it takes to make your design perfectly clear.

THE PROBLEM: OVERLAPPING MODULES

To avoid blunders like that example above, beware of modules that seem to overlap, whether horizontally (on both sides of a photo) or both vertically *and* horizontally (beside and below a photo):

Horizontally

Two stories, one photo — and the reader must guess where the photo belongs. To fix:
◆ *Box or screen one of the stories;*
◆ *Divide them with a column rule; or*
◆ *Run a large headline across the top of the photo and its text.*

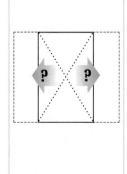

Horizontally and vertically

Dummying photos into corner intersections can be dangerous. To avoid confusion:
◆ *Box or screen one of the stories;*
◆ *Make sure any story below an unrelated photo is at least one column wider or narrower.*

RULES OF THUMB

On this page, we've collected the key design principles presented in this book. Use this list as a quick reference; the numbers running along the right margin show pages where you can find more information.

LAYOUT & DESIGN

◆ All stories should be shaped like rectangles. Pages should consist of rectangles stacked together. **[44]**
◆ Avoid placing any graphic element in the middle of a leg of type. **[46, 137]**
◆ Avoid placing art at the bottom of a leg of type. **[46]**
◆ Text that wraps below a photo should be at least one inch deep. **[47]**
◆ In vertical layouts, stack elements in this order: *photo, cutline, headline, text.* **[46]**
◆ Every page should have a dominant piece of art. **[56]**
◆ A well-designed page is usually at least one-third art. **[74]**
◆ Avoid dummying a photo directly on top of an ad. **[89]**
◆ Avoid boxing stories just to keep headlines from butting; it's best to box stories only if they're special or different. **[76]**

TEXT

◆ The optimum depth for legs of text is from 2 to 10 inches. **[27]**
◆ Avoid dummying legs of text more than 20 picas wide, or narrower than 10 picas. **[27]**
◆ Use italics, boldface, reverses or any other special effects in small doses. **[195]**
◆ Type smaller than 8 point is difficult to read. Use small type sparingly, and avoid printing it behind a screen. **[195]**

HEADLINES

◆ Every story needs a headline.
◆ Headlines get smaller as you move down the page. Smaller stories get smaller headlines. **[25]**
◆ 5-10 words is optimum for most headlines. **[25]**
◆ Never allow an art element to come between the headline and the start of a news story. **[51]**
◆ Don't butt headlines. If you must, run the left headline several counts short, then vary their sizes and the number of lines. **[75]**
◆ Writing headlines: Avoid stilted wording, jargon, omitted verbs, bad splits; write in the present tense. **[23]**

PHOTOS

◆ Shoot photos of *real* people doing *real* things. **[100, 107]**
◆ Directional photos should face the text they accompany. **[50, 51]**
◆ When in doubt, run one big photo instead of two small ones. **[57]**
◆ When using two or more photos, make one dominant — that is, substantially bigger than any competing photo. **[57, 81]**
◆ Try to vary the shapes and sizes of all photos (as well as stories) on a page. **[80]**

CUTLINES

◆ To avoid confusion, run one cutline per photo; each cutline should touch the photo it describes. **[31, 119]**
◆ When cutlines run beside photos, they should be at least 6 picas wide. **[31]**
◆ When cutlines run below photos, square them off as evenly as possible on both sides of the photo. They should not extend beyond either edge of the photo. **[31]**
◆ Avoid widows in any cutline more than one line deep. **[31]**

JUMPS

◆ Run at least 4 inches of a story before you jump it. **[87]**
◆ Jump at least 6 inches of a story (to make it worth the reader's effort). **[87]**
◆ Jump stories once and once only. Whenever possible, jump to the same place. **[87]**

TROUBLESHOOTING

*Quick answers to
questions frequently
asked by designers
perplexed about
page design:*

Q: **What are the best grids for newspapers to use? And once you choose a grid, do you have to use it everywhere — or can grids vary from page to page?**

For years, newspapers have been using the same dull grids: 6-column grids for broadsheets, 5-column grids for tabs. That's usually because the standard 1-column ad is about 2 inches wide, and news columns are sized to accommodate ads. Which is fine for pages with ads. But what about when ads *aren't* a factor — on open pages, or inside pages above the ad stacks? Wouldn't it be nice to have more flexibility? More options for column widths? (See examples at left.)

So — want to explore new grid options? Take a typical page from a recent issue of your paper and rebuild it on an upgraded grid. If you're a tab, try 7, 8 or 9 columns. If you're a broadsheet, try 9, 10, 11 or 12. Resize the art, reflow the text, rewrite the cutlines and headlines, and see if you discover an advantage — visually, typographically, journalistically — to fitting your stories onto a different grid.

Two warnings, however:

◆ An oft-quoted typographic adage suggests that the optimum width for standard text is a column that's *an alphabet and a half* wide:

abcdefghijklmnopqrstuvwxyzabcdefghijklm

The optimum column width for 9-point Nimrod, shown here, works out to be 15p6.

You can certainly put narrower legs to use for cutlines, liftout quotes, decks, etc. But legs skinnier than 5 picas wide are tough to pour type into. And remember, the narrower the leg, the more necessary smaller, condensed type becomes.

◆ If you're designing a tab, you may want to avoid a 6-column grid; if you're designing a broadsheet, beware the 7-column grid. Both force columns of text to be uncomfortably narrow, resulting in pages that look messy and stripey.

And yes, you can mix grids within a newspaper. For example, you could design all your open pages on a 9-column grid — but on most inside pages, when that grid won't accommodate standard ad sizes, you could revert to a simpler grid using wider columns. No one but you will know (or care).

Here's a typical story on a 6-column grid. But notice how gray it is, and how small that 1-column photo is. What if you want more flexibility, more design options?

If you run the photo 2 columns wide, it takes up a lot more space and may not always fit into that shape. What if we could run that photo 1½ columns wide instead?

On a 12-column grid — instead of 6 — we have twice as many options: for the photo size, the deck, the cutline. (Note the liftout quote; will it work positioned there?)

Q: **At our school paper, we design a special double-truck spread each issue. How can we make it look better?**

◆ *Upgrade your grid.* If *ever* a design situation called for a special grid, it's a double truck. Remember: More columns mean more design options. And the biggest problem with most double trucks is the way they end up looking like the example at right: a big headline; four 15-inch stories, each shoved into a corner; random art scattered to fill the holes.

◆ *Plan your package.* Upgrade your reporting AND your design by collaborating in advance to produce a package with appealing sidebars. See page 177 for more on this.

TROUBLESHOOTING

Is it possible to design a page *without* a big, dominant photo?

Sure. That old *every-page-must-have-a-dominant-photo* rule resulted from years of chaotic pages swimming in smallish photos. Nobody likes messy page designs — especially photographers, who love to see their best photos anchoring big stories. (In fact, too often the downside of letting photographers design pages is that, as the photos get bigger, the story count dwindles, and the pace of the pages slows to a crawl.)

BUT if you're careful and smart, you can avoid chaos and still design successful pages without big photos. You can group small photos into a central cluster. You can anchor the page with an infographics package (as in the example at left). You can run big headlines as dominant art (as in the terrific page at right — notice, by the way, how small all its images actually are). But that basic principle remains: Without *something* to anchor it, a busy page gets chaotic.

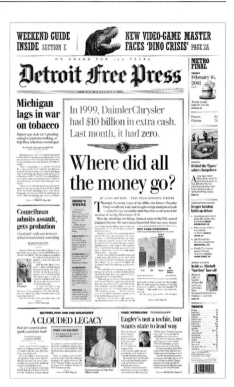

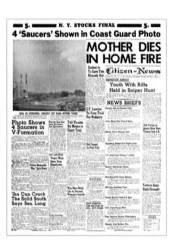

We always run five stories on Page One. Is there some rule that dicates how many stories should run on a typical front page?

It changes over time. Most broadsheet newspapers typically run four, five or six stories on Page One; a half a century ago, they ran *dozens* (see example at left). Newsy tabloids may run three or four cover stories; other tabs prefer single-topic covers, like magazines.

So what's your paper's personality? Newsy, with lots of traffic? Stylish and artsy, with dramatic photos and big type? It's a question of style. Staffing. Budget. Newshole. Reader preference.

The best answer: Avoid falling into a rut where every issue looks the same. Page-design monotony will bore you *and* your readers. Consider mixing up the story count from issue to issue, page to page, letting the news — not newsroom habit — dictate the pace.

I've noticed a lot of papers use rules between stories. Is that a good idea? Or is it cheating?

For centuries, newspapers used rules (horizontal and vertical lines) to separate stories. Back in the '60s and '70s, rule-less gutters became popular, but nowadays rules are back. And most of the best-designed papers use them.

Advantages: Rules organize stories and pages into neat stacks. They even let you get away with butting headlines and colliding art elements, up to a point (see right).

Disadvantages: When drawn down the middle of a narrow gutter, rules can crowd the text beside it. And if you widen the gutter to alleviate the crowding, sliding stories slightly sideways, your page grid can look wonky and unaligned. Rules work best with wider gutters.

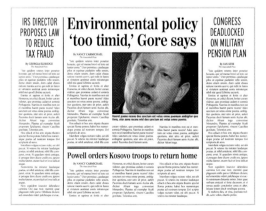

EXERCISES

ANSWERS ▶ 245

1 You need to dummy text in a box that's 40 picas wide. How wide will each leg be if there are 4 legs? If there are 3 legs? If there are 2 legs?

2 You're laying out an inside page in a 5-column format. The ads stack up pretty high; your available space for news is 6 inches deep and the full page (5 columns) across. You need to dummy two stories: one 15 inches long, the other 10 inches. Neither has art. You can trim one inch out of either story, if necessary — but no more. How many design options do you have?

3 There are several things wrong with each of these three page designs. Like what, for instance?

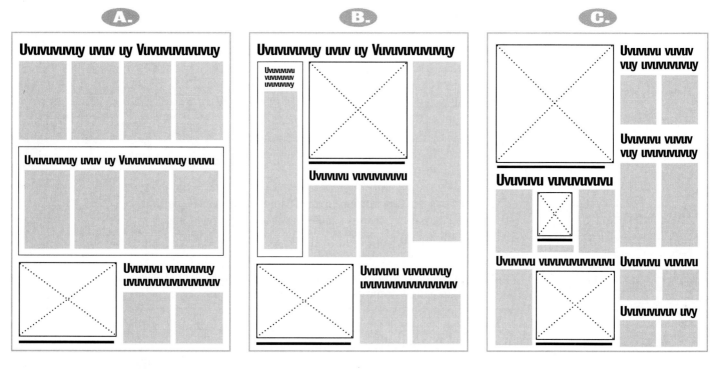

4 The four layouts below all use the same story elements. Which one of the four layouts is the best, and why?

EXERCISES

5 When the layout above ran in the newspaper, some editors complained that the Campaign '88 promo box was positioned poorly. It appears as if it's part of the Hyundai story to its left. How would you redesign this part of the page to avoid that problem, using the sizes shown here?

6 At left is Page One of a typical tabloid. It uses a 5-column format; the left-hand column is reserved for news briefs.

Design this page with the following three elements:

1) A 10-inch lead story with a good horizontal photo;

2) An 8-inch story with a horizontal photo; and

3) A 4-inch bright (an upbeat, offbeat feature).

EXERCISES

7 Here's an inside page for a tabloid. Down the right side, there's a column of news briefs. Draw a dummy that shows how you'd design this page with the following elements:

◆ A lead story — about 15 inches long, but cuttable* — that uses a strong, deep vertical photo;

◆ A secondary story — about 12 inches long, but cuttable — with a mug shot;

◆ A short, bright feature story — about 4 inches long.

Note: There are two somewhat different, but acceptable, solutions for this page. Try your best to figure out both options.

* By "cuttable," we're talking a couple of inches, max — nothing too drastic.

TIGHT
BRIEFS

Interdum vol-
gus rectum
videt, est ubi
peccat. Si vet-
eres ita
miratur lau-
datque poetas,
ut nihil ante-
ferat, nihil illis
comparet,
errat. Si
quaedam nimis
antique, si per-
aque dure
dicere credit
eos, ignave
multa fatetur,
et sapit et
mecum facit et
Iova iudicat
aequo.

Non equidem
insector delen-
dave carmina
Livi esse reor,
memini quae
plagosum mihi
parvo Orbilium
dictare; sed
emendata
videri pul-
chraque et
exactis mini-
mum distantia
miror. Inter
quae verbum
emicuit si forte
decorum, et si
versus paulo
concinnior
unus et alter,
iniuste totum
ducit ven-
ditque poema.

Si meliora
dies, ut vina,
poemata red-
dit, scire
velim, chartis
pretium quotus
arroget annus.
scriptor abhinc
annos centum
qui decidit,
inter perfectos
veteresque
referri debet
an inter vilis
atque novos?

Excludat iurgia
finis, "Est
vetus atque
probus, cen-
tum qui per-
ficit annos."
Quid, qui
deperiit minor
uno mense vel
anno, inter
quos referen-
dus erit? Vet-
eresne poetas,
an quos et
praesens et
postera respu-
at aetas?
"Iste quidem
veteres inter
ponetur hon-
este, qui vel
mense brevi
vel toto est
iunior anno."

Utor permisso,
caudaeque
pilos ut
equinae paula-
tim vello
unum, demo
etiam unum,
dum cadat
elusus ratione
ruentis acervi,
qui redit in fas-
tos et virtutem
aestimat annis

ANSWERS ▶ 245

On March 4, 1880, the New York Daily Graphic became the first newspaper to print a photograph. And from that day to this, newspaper photographers have wondered: "Will they *ever* give us any respect?"

You can't blame photographers for feeling paranoid. Newsrooms, after all, are dominated by editors who were once reporters, who believe news means text, who think photos make nice decoration — but if space gets tight, and they need to cut either the story or the photo, you know how they'll vote.

Trouble is, those editors are badly mistaken. Our culture has become overwhelmingly *visual*. In today's media, images are strong; text, by comparison, is weak. If you want to convey information, photos can be as valuable as text. If you want to hook passing readers, photos are even *more* valuable than text.

Until now, this book has treated photos as boxes parked on the page. But there's more to it than that. Photographs are essential for good design, and good design is essential for photos.

In this chapter, we'll take a closer look at the art and science of photojournalism.

SOME PHOTO GUIDELINES

There's a lot to learn about shooting photos, cropping and sizing them, transforming them into halftones, designing them into photo spreads. . . but before we begin, let's summarize some basic photojournalistic guidelines:

◆ **Every photo should have a clean, clear center of interest.** A good photo, like a well-written story, is easy to read. It presents information that's free of clutter and distractions. Every photo must be sharply focused and cleanly composed, so its most important elements stand out instantly.

◆ **Every photo should look natural.** In amateur snapshots, people smile stiffly at the camera; in professional news portraits, people are loose, natural, engaged in activity. Whenever possible, shoot *real* people doing *real* things, not gazing blankly into space or pretending to be busy.

◆ **Every photo should have a cutline.** It's surprising how often editors think, "Well, everyone knows who *that* is: It's Millard Fillmore!" Never assume readers are as smart as you are — or that they even intend to *read the story*. Identify everything: all faces, places and activities.

◆ **Every photo should be bordered.** Don't allow the light tones of a photo to blur into the whiteness of the page. Frame each image with a border — a plain, thin rule running along the edge of the photo (1-point is standard; in this book, we use .5 point). But don't overdo it. Thick, arty borders around photos and cutlines may separate them from each other — or from the stories they accompany.

◆ **Every photo should be relevant.** Readers don't have time for trivia in text; they don't want to see it in photos, either. Show readers images that have a direct connection to today's news (the movers and shakers, winners and losers — not squirrels playing in the park). Photos must provide information, not decoration.

◆ **Every face should be at least the size of a dime.** It's rare that photos are played too big in newspapers, but they often run too small — especially when the key characters shrink to the size of insects. If you want images with impact, shoot individuals, not crowds. Then size photos as large as you can.

This photo has a clean, clear center of interest: an old war veteran caught in a nostalgic salute. It's a sharp, strong image, with no background clutter to distract us. And it seems to be an honest portrait — not posed or artificial.

This action photo of airborne skateboarders is a compelling shot. But notice how the white clouds blend into the whiteness of the page. Without a border to frame this image, it's hard to know where the photo begins or ends.

This photo of Bill Clinton on the 1992 campaign trail is interesting — but only if it runs bigger than this. At the size shown here, its impact is lost. The faces in the crowd blur together, and Clinton himself fades into the background.

GOOD PHOTOS

What makes a photograph good? In the pages that follow, five photographers from The Oregonian (Portland's daily paper) present their favorite images — and explain what makes these photos strong.

Ben Brink:

"We were in Wajir, a border town in northeast Kenya, back in the fall of '92. The situation in Somalia was a combination of war, drought and famine which caused hundreds of thousands of people to flee the country. I went over with the Northwest Medical Teams before the U.S. troops went in. And this clinic is right out on the desert floor, amongst the acacia trees, where these nomadic tribes set up their huts.

"This is a little boy from one of the tribes who was brought in by his mother. At this point, the doctors are trying to rehydrate him with a mixture of salt and water. I'm across the clinic with a long lens. As I started to shoot, it was interesting how many sets of hands were attending to him: keeping him calm, keeping him down, keeping him from wiggling as needles went into him. He'd been thrashing around earlier, but at this moment he calmed down and seemed to be very serene. He couldn't fight it anymore.

"He's exhausted. His strength is gone. Yet his eyes are looking straight at you, so peaceful and calm and resigned. And now all these giving hands come in to do the best they can to save him.

"I was there for a couple weeks, and I saw him come back day after day. He looked a little better, but his body was ravaged by the dehydration. I don't know if he lived."

GOOD PHOTOS

Tom Treick:

"This is the last few seconds of the Sun Bowl in 1999. That's Joey Harrington, the Oregon Ducks' starting quarterback. He was MVP of the game. A very energetic guy.

"The Sun Bowl was one of those games that was close right down to the last second. I was the paper's only photographer there. So I had a dilemma: Do I stay on the field, hopefully getting the key play where Minnesota wins?

"In the back of my mind, I'm thinking, 'Do I have that great picture yet? No, I don't. Where am I gonna get it? I'm running out of time.' Something kept telling me: 'Harrington's the key.' I decided, with a minute to go, that I would go to the Oregon bench and find Harrington. I had been covering the Ducks all season, and I knew how this guy acted. I thought, 'I can't go wrong, because one way or the other, he's going to be a picture.'

"He was standing on the bench, and you could see that he was worried. I was just locked onto him. All of a sudden, his expression changed, I heard the crowd roar, and he just exploded. [Minnesota had fumbled.] Until I developed the film, I didn't know for sure what I had. But I knew I had something."

GOOD PHOTOS

Michael Lloyd:

"This was shot during the West Coast swing of President Clinton's '92 campaign. Traveling on a national campaign is a bizarre, unreal experience. It's so frantic. The days start at daybreak and go until you drop at night. You're traveling in a pack: all the national media, the West Coast media (people like me), and at each stop, a contingent of local media that joins this national circus. So you're desperately jockeying for any position to make a decent picture of the 'event,' as they're called. It's an exercise in physical endurance, as well as photography.

"These were supporters who showed up to meet Clinton at his arrival at a Wyoming airport. And I've always liked the way this photo captures a sense of chaos: You've got a disjointed arm with a campaign sign coming in, another anonymous hand jutting in from the other side, Clinton shaking hands with one hand while posing for a picture at the same time. You've got this forest of boom microphones from the TV crews. And everybody is there to have their image made in some way, except for the Secret Service guy who's very carefully watching the whole damn show. And me.

"I shot the picture and handed my film off to a local Associated Press photographer, who processed the film and picked a frame to transmit back to Portland. It wasn't until weeks afterward that I even saw what I shot. This picture would have been one I'd have chosen, but it never ran in the paper.

"I've seen so much stuff over the years that I've covered politics that's embodied in this picture — I've always loved it on a personal level. It gives the viewer a feeling of really being there in the middle of it all."

GOOD PHOTOS

Kraig Scattarella:

"This is the aftermath of a fatal fire where a relative has just come on the scene and realized that her grandson was killed. The emotion overwhelmed her, and all she wanted to do was run inside and see the body. The fireman stepped in to hold her back and comfort her.

"The news editor was adamant about NOT using this picture.* He felt that it was an invasion of these people's privacy — which it is. It's their moment of grief. My selling point for this picture was that these people didn't have any smoke detectors in their house. In the story it mentions that; they had just moved into the house a day or two before. And anybody that sees that picture is going to think of himself in that situation and think, 'I don't want this to happen to me.'

"This is the picture you dream about, that all photojournalists strive for — when all the elements fall together to make a complete picture that can stand alone, without words. If you can capture a moment like this, then you've done your job 100%."

* The photo did run, though.

GOOD PHOTOS

Ross Hamilton:

"FOODday (the weekly food section) was doing a story on farmers' markets in the Portland area. And my job was to find an image that conveyed the ambiance of these markets. More often than not, you try to get an image of people eating or negotiating for food with colorful fruits and vegetables in the foreground. You use what's at your disposal there, and a lot of it is colorful and photogenic — but it can be static and predictable, too. I always try to find something visually that will stop the viewer.

"I was at this market in Beaverton for several hours without really having gotten that much. A woman came up behind me and said, 'Excuse me — but I noticed you were taking photographs. You have to go take a look at the watermelon salespeople.'

"I had already been there an hour earlier, and I had photographed this girl sitting there, reading. She's the daughter of the woman whose stand this is — watermelon growers from Hermiston, in northeastern Oregon.

"But when I got there, there she was, asleep, somewhat uncomfortably, in the bin of watermelons. People were walking by, seeing her and just smiling knowingly. I like their presence in the background.

"The photo is nicely layered, compositionally. And it's a surprise. It's unusual. A person asleep on top of watermelons is not something you see every day. But it's also appealing because it's a kid in peaceful repose, seemingly safe among the passers-by in the market. It's a simple, direct, pleasing composition.

"It ran, quite big, on the cover of Metro. I attacked the layout folks, selling this as enterprise art. And they couldn't resist. It's a sweet slice of life — like a watermelon."

BAD PHOTOS

Light pole sticking out of subject's head (poor mix of foreground and background).

Harsh shadows on subject's face.

Subject is out of focus. And photo is underexposed (too dark).

Unflattering and unnatural pose.

Scratches and assorted darkroom crud.

Image is flopped (printed backward) — note the words on the sign.

Distractions in the background.

Subject is off-center, awkwardly cropped; no strong center of interest.

Photos can be bad in a mind-boggling number of ways. They can be too dark, too light, too blurry, too tasteless, too meaningless or too *late* to run in the paper. They can, like the photo above, show blurry blobs of useless information — depicting, with frightening clarity, a chubby guy with a streetlight growing out of his head.

Be grateful, then, whenever a photographer hands you a sharp, dramatic, immaculately printed photograph. And avoid turning good photos into bad ones by cropping them clumsily. By playing them too small. Or by dummying them where they compete with another photo or intrude into the wrong story.

Remember, photographers often use terms like "hack," "mangle," "kill" and "bury" to describe what editors do to their photos. So be careful. People who talk like that shouldn't be pushed too far.

MAKING THE BEST OF BAD PHOTOS

What can you do to salvage a bungled photo assignment?

◆ **Edit carefully.** Find the most informative frame on the roll. Is there one successful image that shows more than the rest? A telling face, gesture, action?

◆ **Crop aggressively.** Focus our attention on what works in the photo — not what doesn't. Play up what's important and eliminate the rest.

◆ **Run a sequence.** Sometimes two small photos aren't as bad as one big weak one. Consider pairing a couple of complementary images.

◆ **Reshoot.** Is there time? A willing photographer? An available subject?

◆ **Try another photo source.** Was there another photographer at the scene? Would older file photos be appropriate?

◆ **Use alternative art.** Is there another way to illustrate this story? With a chart? A map? A well-designed mug/liftout quote? A sidebar?

◆ **Retouch mistakes.** With a grease pencil, airbrush or photo-retouching software, tone down distracting backgrounds, sharpen contrast, add highlights.

◆ **Bury it.** By playing a photo small, you can de-emphasize its faults. By moving it farther down the page, you can make it less noticeable.

◆ **Mortise one photo over another.** It's risky, but may help if there's an offensive element you need to eliminate or disguise. (See page 193.)

◆ **Do without.** Remind yourself that bad art is worse than no art at all.

BAD PHOTOS

Photojournalistic clichés have plagued editors for decades. Some, like "The Mayor Wears a Funny Hat," may have some merit (either as entertainment or as a peculiar form of revenge).

Others, like the examples shown below, have almost no redeeming value — except to friends, relatives and employees of those in the photo. Shoot these space-wasters if you must, but look for alternatives (*real* people doing *real* things) every chance you get.

THE "GRIP & GRIN"

Usual victims: Club presidents, civic heroes, honors students, school administrators, retiring bureaucrats.

Scene of the crime: City halls, banquets, school offices — anyplace civic-minded folks pass checks, cut ribbons or hand out diplomas.

How to avoid it: Plan ahead. If someone *does* something worth a trophy, take a picture of him (or her) *doing* it. Otherwise, just run a mug shot.

THE EXECUTION AT DAWN

Usual victims: Any clump of victims lined up against a wall to be shot: club members, sports teams, award winners, etc.

Scene of the crime: Social wingdings, public meetings, fund-raisers — usually on a stage or in a hallway. Also occurs, pre-season, in the gym.

How to avoid it: Same as the Grip & Grin — move out into the real world, where these people actually *do* what makes them interesting.

THE GUY AT HIS DESK

Usual victims: Administrators, bureaucrats, civic organizers — anybody who bosses other people around.

Scene of the crime: In the office. Behind the desk.

Variations: The Guy on the Phone. The Guy on the Computer. The Guy in the Doorway. The Guy Leaning on the Sign in Front of the Building.

How to avoid it: Find him something to do. Or shoot a tighter portrait.

THE BORED MEETING

Usual victims: Politicians, school officials, bureaucrats — anybody who holds any kind of meeting, actually.

Scene of the crime: A long table in a nondescript room.

How to avoid it: Run mug shots and liftout quotes from key participants. Better yet: Find out in advance what this meeting's *about,* then shoot a photo of *that.* Illustrate the topic — not a dull discussion about it.

CROPPING PHOTOS

Most photographers shoot 35mm film, which produces a frame like the one at left. But that doesn't mean all your photos must be shaped like that — or that you're required to print the entire image a photographer shoots.

To get the most out of a photograph, you *crop* it. Cropping lets you re-frame the image, creating a new shape that emphasizes what's important — and deletes what's not.

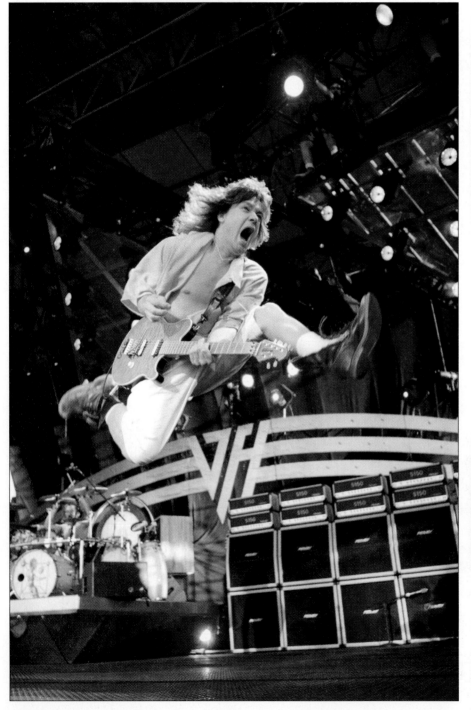

Three ways to crop the same photograph:

◆ *Full frame (left) shows us the full photo image. And from this angle, guitarist Eddie Van Halen's leap looks truly dramatic — but does all that empty space lessen the photo's impact?*

◆ *A moderately tight crop (above) focuses on Eddie. By zeroing in this closely, we've eliminated all the excess background.*

◆ *An extremely tight crop (below) turns the photo into an attention-getting mug shot. We've tilted the image, too, to make it vertical. But does this crop damage the integrity of the original?*

CROPPING PHOTOS

Yes, a photo can be cropped to fit any space, regardless of its original shape. But designers who do that are insensitive louts. That's like taking a 20-inch story and cramming it into a 10-inch hole: not a smart move.

Always try to edit and crop photos *first*, before you dummy the story. Once you've made the strongest possible crop, *then* design a layout that displays the photo cleanly and attractively.

To do all that, you must learn where to crop — and where to stop.

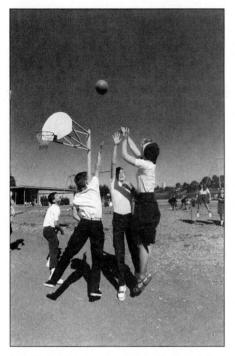

This is the photograph as originally shot, full frame. Notice the excessive amount of empty space surrounding the central action.

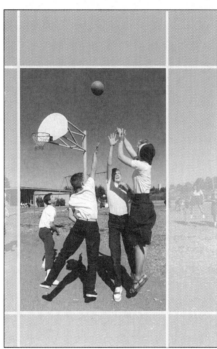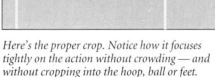

Here's the proper crop. Notice how it focuses tightly on the action without crowding — and without cropping into the hoop, ball or feet.

This is a bad crop. It's too tight. We've chopped off the top of the ball, amputated feet and jammed the action against the edge of the frame.

A GOOD CROP:

◆ **Eliminates what's unnecessary:** sky, floor, distractions in the background.

◆ **Adds impact.** Your goal is to find the focal point of a photo and enhance it, making the central image as powerful as possible. Remember the old adage: Crop photos until they *scream*.

◆ **Leaves air where it's needed.** If a photo captures a mood (loneliness, fear, etc.), a loose crop can enhance that mood. If a photo is active and directional, a loose crop can keep action from jamming into the edge of the frame.

A BAD CROP:

◆ **Amputates body parts** (especially at joints: wrists, ankles, fingers) or lops off appendages (baseball bats, golf clubs, musical instruments).

◆ **Forces the image into an awkward shape** to fit a predetermined hole.

◆ **Changes the meaning of a photo** by removing information. By cropping someone out of a news photo or eliminating an important object in the background, you can distort the meaning of what remains — whether deliberately or accidentally.

◆ **Violates works of art** (paintings, drawings, fine photography) by re-cropping them. Artwork should be printed in full; otherwise, label it "detail."

Notice how a fairly ordinary image gains impact from a tight, dramatic crop.

SIZING PHOTOS

20%

30%

40%

50%

75%

The original print is this size. All enlargements and reductions are sized in proportion to this.

100%

125%

Notice how you can see the image's jagged pixels (a form of digital blur) when you enlarge it too much.

300%

Cropping photos is one way to create new shapes. You can also resize (or *scale*) photos: enlarging them *up* or reducing them *down*.

When you change the size of a photo, you measure its new size as a percentage of the original. As you see here, a photo that's half the size of the original is called a 50% reduction; a photo three times the size of the original is a 300% enlargement. You determine these percentages by using rulers and proportion wheels (see page 252) or by importing images electronically into a page-layout program and letting the computer do the math for you.

It's also possible — though not advisable — to alter an image in weird, wacky ways by changing just one of its dimensions: for instance, enlarging it *horizontally* while reducing it *vertically*. This sort of gimmickry is easy to do with computers, either deliberately or accidentally, so be careful. When you distort a photo's true proportions, you damage its credibility.

A little knowledge is a dangerous thing — and once you learn how to squish and stretch images electronically, you might be tempted to try these kinds of effects. As a rule, avoid this (whether intentionally or by accident).

35% *width,* **70%** *depth*

150% *width,* **70%** *depth*

HALFTONES & SCREENS

Once a photo has been cropped, it still needs to be reprocessed before it's printed in the paper. There are three reasons for this:

1 The photo may need to be reduced or enlarged to a new size.

2 Its brightness, contrast or clarity may need fine-tuning to improve the way it reproduces on newsprint.

3 Printing presses cannot print gray. They can only create the illusion of gray by changing the photo into a pattern of dots called a *halftone*.

Halftone dots are created either by re-shooting the photo through a halftone screen or by reprocessing the photo digitally. The dots usually run in diagonal rows or lines (left); the density of a halftone screen is measured by the number of lines per inch.

MORE ON ▶

◆ **Screens & reverses:** *How dot screens are used with type.......* **194**

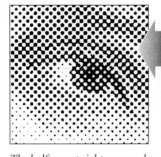

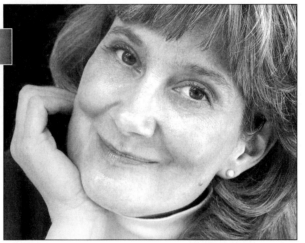

The halftone at right was made by passing the original photo through a 133-line screen (133 lines per inch). In the enlarged area above, you can see how halftone dots create the gray tones in the subject's eye.

This 133-line screen is common in magazines and books. Because they use smoother paper and high-quality presses, the dots will hold — and the results show crisp detail.

The finer the dot screen, the smaller the dots. The smaller the dots, the less visible they are. The less visible they are, the more realistic the photo appears.

For realistic-looking photos, then, you should use the finest dot screen your paper can handle. Newspapers, unfortunately, often use rather coarse screens — one reason their photos don't look as slick as those in books and magazines.

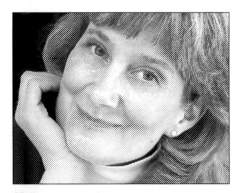

65-line screen: *This is a very coarse screen, with only 65 rows of dots per inch. The dots are quite apparent, but at least the ink won't smear too badly when printed on rough newsprint by an unreliable printing press. Unless you're plagued by production problems, however, avoid screens this coarse.*

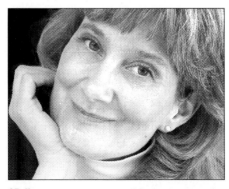

85-line screen: *Because of the limitations of newsprint, this is the most common screen density newspapers use — though some papers using state-of-the-art presses have had success using 100- or 120-line screens. If the screen is too fine, the dots may smudge or disappear, resulting in blotchy, uneven printed images.*

Horizontal line screen: *Most halftones use ordered rows of dots. But you can also run photos through a variety of alternative screens to stylize images dramatically. A random pattern of dots produces a mezzotint, much like an old etching; using lines instead of dots (at 50 lines per inch) creates the effect above.*

SCANNING IMAGES

How do you get photos and artwork into your computer? It's easy. All you need is a *scanner*, a machine that captures images electronically – *digitizes* them – so you can adjust them, store them or print them later.

To the casual observer, scanners look and perform much like photocopying machines. Here's how the scanning process works:

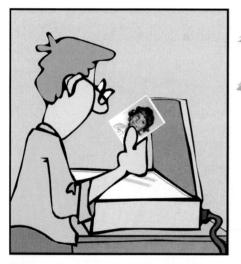

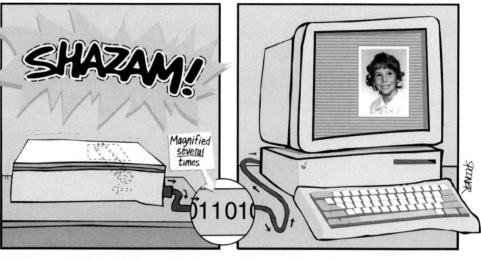

1 Preparing to scan: *Take your original image — a photo, a drawing, some type — and lay it facedown on the scanner's glass surface. Special software will allow you to crop the image, re-size it — even adjust its contrast.*

2 Scanning the image: *The scanner lights up like a photocopying machine as it duplicates the image electronically, converting it into microscopic dots or pixels (picture elements). The more dots the scan uses, the finer the resolution will be.*

3 Importing the image: *Once it's scanned, the electronic image can be imported into a page-layout program, where you can further adjust its size and shape. The image can then be printed alone or as part of a finished design.*

SCANNING TERMINOLOGY

Since scanning software is generally user-friendly, you won't need years of training to get good results. But it *will* help to know some basic terms:

Grayscale: A scan of a photograph or artwork that uses gray tones (up to 256 different shades of gray, to be exact).

Line art: An image comprised of solid black and white — no gray tones.

Image size: The physical dimensions of the final scanned image.

File size: The total number of electronic pixels needed to create a digital image, measured in kilobytes. The more pixels an image uses, the more detail it will contain.

Dots per inch (dpi): The number of electronic dots per inch that a printer can print — or that a digital image contains. The higher the dpi, the more precise the image's resolution will be — up to a point, anyway.

Lines per inch (lpi): The number of lines of dots per inch in a halftone screen. The higher the lpi, the more accurate the printed image will be.

Resolution: The quality of detail in a digital image, depending upon its number of dots per inch (dpi).

TIFF: One of the most common formats for saving and printing scans (an abbreviation of *Tagged Image File Format*).

EPS: Another common format for saving and printing images, especially illustrations (short for *Encapsulated PostScript*).

Moire (mo-ray) pattern: An eerie dot pattern that's formed when a previously screened photo is copied, then reprinted using a new halftone screen.

A grayscale image
uses shades of gray.

A line art image
uses only solid black.

A low-resolution image
uses fewer dots, which means it's less detailed.

SCANNING IMAGES

◆ **Name and store your scans carefully**. Think about it this way: When you import an image into a page-layout program, you might think you're looking at the *actual scan* when you see it on your screen – but you're not. You're looking at a low-resolution rendering of the original scan. (Which is a clever idea, actually; otherwise, a page full of huge scans could require umpteen millions of megs of memory, becoming overloaded and slow.)

When you finally decide to print that page, however, your computer traces a path back to its original images and uses *that information* for printing. Which means two things: You need to store all scans until they're finally printed. And you need to store them in a consistent place, so that your computer will be able to find them when it's time to print.

◆ **Allow for dot gain.** Images often *print* darker than they appear on your monitor. Ask your printer how your screen dots will behave when the ink hits the paper – and learn to compensate consistently every time you scan.

◆ **Crop and scale images as you scan.** You can save memory by scanning only that part of the image you plan to print. Remember, too, that if you plan to enlarge an image when you import it, you should scan it at a higher resolution; if you plan to reduce it, scan at a lower resolution.

◆ **Consider using low-resolution scans for big jobs.** If your computer's a little slow, you might save time if you scan those complicated images *twice*: a low-resolution version that won't slow you down while you work on the page, and a high-resolution scan that you can import when you're ready to print.

◆ **Keep your file sizes as small as possible.** Unnecessarily large scans waste memory, slow down your software, take longer to print – and don't always mean higher quality output, anyway. As a rule of thumb, the dpi of a grayscale image (the resolution you *scan* it at) should be *twice* its lpi (the resolution you *print* it at). In other words, if you print at 100 lpi, you should scan at 200 dpi.

Yes, image resolution can get confusing – all those dpi's and lpi's are tough to keep straight. If you're unsure how to measure "high" or "low" resolution when you're scanning or printing, consult this chart:

INPUT		OUTPUT	
Grayscale or color images *(measured in dpi)*	**Line art images** *(measured in dpi)*	**Screens for photos** *(measured in lpi)*	**Printer quality** *(measured in dpi)*
HIGH RESOLUTION *(magazines, books)*			
300	1200	133-150	1200-2400
FAIR RESOLUTION *(newspapers)*			
200	800	85-100	600-1200
LOW RESOLUTION *(Web images)*			
72	72	Web images are viewed, not printed	

Using this chart:
If, for instance, you need to print an ordinary newspaper photo, you'll need to scan it as a 200-dpi grayscale, then print it using an 85- or 100-line screen on a printer that prints at least 600 dpi. If at any point in the process you used lower numbers, your quality would drop. Or another way to use this chart: If you're printing at 600 dpi, there's no need to scan grayscales any higher than 200 dpi – your printer can't reproduce the detail in a higher-resolution scan.

STAND-ALONE PHOTOS

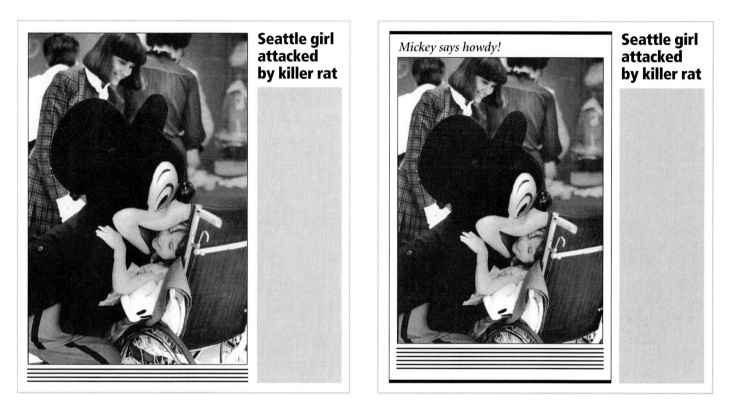

In the example at left, you'd assume that's an actual photo of the Seattle girl being attacked by a rat, like the headline says. But no — it's actually a sweet, funny, *stand-alone photo* that's completely unrelated to the story. In the layout at right, the photo is boxed separately, to show readers it's a separate element. (You could argue that it's in poor taste to dummy these two items alongside each other *at all,* but we're trying to make a point here.)

The point is this: Photos often run independently. You don't need text or a newsworthy hook to justify printing a strong photo image. These photos, sometimes called "wild" art because they're free-form and unpredictable, can add life to pages where stories are dull and gray (sewer commission meetings, budget conferences, etc.). Stand-alone photos should be encouraged, but they must be packaged in a consistent style that instantly signals to readers that the photo stands alone.

Some papers create a stand-alone photo style using an overline (a headline over the photo). Its text, below, is larger than a standard cutline.

Some papers run a screen in the background of the box. And instead of using overlines, some start cutlines with a boldface phrase or **read-in.**

Stand-alone boxes can be used with two or more photos. But as those boxes grow bigger, you'll need to follow the guidelines for photo spreads.

PHOTO SPREADS

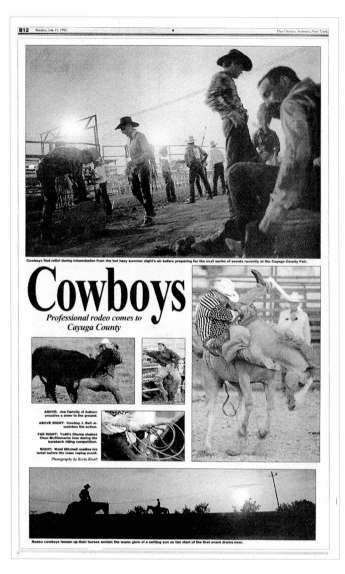

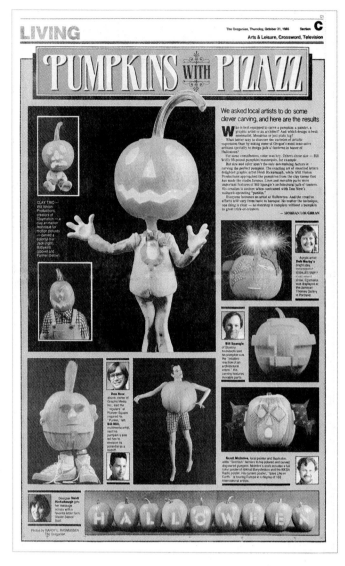

This photo page from The Citizen in Auburn, New York, tells a story of professional rodeo cowboys. Note the variety of shapes and sizes; note the balance and flow of the layout. As this paper's photo editor put it: "Compelling, high-impact images help readers not only understand the story, but feel it."

Unlike the rest of the newspaper, where photos compete for space with text (and often lose), photo spreads are self-contained visual packages that give special photos the big, bold play they deserve. They're usually used for:

◆ **Covering a major event** (a disaster, election night, the Big Game) from a wide variety of angles — often from several photographers.

◆ **Exploring a topic or trend** (the homeless, neo-Nazis, a skateboarding craze), taking readers on a tour of people and places they've never seen.

◆ **Profiling a personality** (an athlete, a disease victim, a politician), painting a portrait by capturing a person's moods, activities and surroundings.

◆ **Telling a story** with a definite beginning, middle and end (the birth of a baby, a Marine's ordeal in boot camp, an artist in the act of creation).

◆ **Displaying objects/places** (a tour of a new building, fall fashions, hot toys for Christmas), where photos catalog an inventory of items.

Photo spreads are different from standard news layouts. They bend and break the rules: They let you play with headlines and use unorthodox widths for cutlines and text. Text, in fact, often becomes a minor element on photo pages. Some pages run just a short text block; others use long stories, but jump most of the text to another page to maximize the photo display.

This Halloween page from The Oregonian displays an assortment of customized pumpkins and their creators. Since there's no storytelling here — no dramatic beginning, middle or end — the main design consideration is fitting all the photos onto the page in an orderly, attractive way.

PHOTO SPREADS

At many papers, photographers shoot special assignments, then design their own photo pages. Usually, however, the layout is done by an editor or designer who's handed some photos, given a headline and asked to leave space for a certain amount of text. Here's a typical example of how that might work:

DESIGN EXERCISE: PHOTO SPREADS

Using these four photos, let's design a photo page for a tabloid. The photos were shot at a folk music festival, so the headline can simply say "Folk Fest." There's no story, but let's assume someone will write a short text block (3-4 inches) to describe the event.

This shot is the photographer's favorite. He wants it to be the dominant image on the page. And this is the way he'd like the photo cropped. You can make slight cropping changes to suit your layout, but you should always respect the composition suggested by the photographer.

Another nice shot. This little girl was a real crowd-pleaser, so be sure to run this photo big enough that we can see her.

This shot provides "color," showing the ordinary folks attending the folk festival. It's an appealing alternative to the performance shots. And besides, it's a vertical, and the layout needs at least one alternative to those other three horizontals.

This is the scene-setter (sometimes called an "establishing shot") showing the stage platform. As these four photos demonstrate, a good photo layout combines close-up, mid-range and wide-angle shots to tell the whole story.

PHOTO SPREADS

Here are six layouts using those photos from the facing page:

This layout alternates the sizes of photos — big, small, big, small — to achieve balance. Note how the page is bordered by two sets of outer margins: 1) a thin margin around the entire page, and 2) a wider indent beside the text and that vertical photo. Balancing two sets of indents gives you more flexibility in sizing photos and keeps pages from getting too dense.

This layout is a mirror image (with minor changes) of the page at far left. The text runs in two legs instead of one, and there are now two pairs of shared cutlines. Notice how, of all the layouts on this page, this one is the most tightly packed. The rest all allow more air in their outer margins.

This layout treats the headline as an independent art element, placing it squarely in the center of the page, aligned with the two photos below it. The leg of text then runs beside it — an arrangement that might not work in a standard news story but fits neatly here. Note how all the open space runs along the left edge of the page.

This page moves the text into a bottom corner. Since there's not enough text to fill the hole, it's indented (to match the photo indents on the right side of the page), and the photo credit pads the remaining space. Note how the text is indented more than the headline — a kind of hanging indent. A final note: Placing cutlines in a top corner sometimes looks awkward, but here it balances the cutline in the bottom corner of the page.

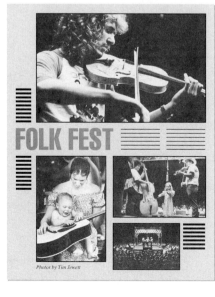

This design is a variation on the layout directly above. Placing the headline and text in the center of the layout divides the photos into two separate groups. Is that a problem? Regardless, the page looks well-balanced and appealing.

This approach is an old favorite: Park the scene-setter beside the head-line at the top of the page, then smack readers with the loud lead photo. The text begins below the lead photo, directly beneath the headline. That breaks the usual rule about keeping headlines with text — but it works here. Note how the elements above and below the lead photo align with each other; all are indented equally along the edges of the page.

PHOTO SPREAD GUIDELINES

The following guidelines apply not just to photo pages but to feature sections and special news packages as well. You'll find that most of these principles hold true whether you're using photos, illustrations, charts or maps.

Note: You don't have to design picture pages with gray background screens; we just added screens to these examples to make the photo shapes easier to see.

PHOTO GUIDELINES

◆ **Talk to the photographer (and the reporter).** Learn about the story so you can prioritize the photos. Find out what's dominant, what's secondary, what's expendable. Make sure the page displays material fairly and accurately.

◆ **Mix it up.** Use different shapes. Different sizes. Different perspectives. Tell the story with a variety of visuals: horizontals and verticals, tight close-ups and wide-angle scene-setters. Keep things moving. Surprise our eyes.

The layout at left looks static and dull because the photos are all similar in shape and size. Nothing grabs your eye. The page at right mixes shapes and sizes, and, as a result, looks interesting and inviting.

◆ **Design for quality, not quantity.** Yes, you want variety — but one good picture played well is worth two small ones played weakly. Mix it up, but be a tough judge. If you overcrowd the page, all the photos lose impact.

◆ **Position photos carefully.** Are photos strongly directional? (Don't let them collide or face off the page.) Are they sequential or chronological? (Give the page order — a beginning and an end, a setup and a punchline.)

◆ **Make one photo dominant.** Play it big. Give it clout. Anchor it solidly, *then* play the other photos off of it. And remember: Dominant photos usually work best in the top half of the layout:

The layout at left seems bottom-heavy and poorly balanced. Compare that to the effect of the page at right. It uses the same elements, but here the lead photo has been dummied on top.

HEADLINE GUIDELINES

◆ **Write your headline first.** Pages look better and come together more easily if you have a headline before you start designing. If you leave a hole for someone to fill later, you may get a dull headline that doesn't quite fit.

◆ **Use a display headline (with a deck) if appropriate.** Don't limit yourself to standard banner headlines. Try something with personality: a clever, punchy phrase with a descriptive deck below it. Create something bold. Don't be shy.

PHOTO SPREAD GUIDELINES

TEXT GUIDELINES

◆ **Don't run too much text — or too little.** Most photo pages need text to explain why they're there. But anything under 3 inches may get buried; huge text blocks, on the other hand, turn the page gray and crowd out photos.

◆ **Keep text blocks modular.** Never snake text over, around and through a maze of photos. Keep text rectangular. Park it neatly in a logical place.

◆ **Ask for leeway on story sizes.** Sure, you dummy as closely as you can, but those 37-inch stories sometimes *have* to be cut — or padded — to fit. Make sure writers and editors give you flexibility on story lengths.

CUTLINE GUIDELINES

◆ **Give every photo a cutline.** Several photos may share a cutline if the layout requires it, but make sure it's clear which description fits which photo.

◆ **Add flexibility by running cutlines beside or between photos.** But don't float them loosely — plant them flush against the photo they describe. If cutlines use ragged type, run ragged edges *away* from the photo.

◆ **Push cutlines to the outside.** In weak designs, cutlines butt against headlines or text. In strong designs, cutlines move to the outside of the page, where they won't collide with other type elements:

In the layout at left, one set of cutlines butts against the headline; another bumps into the bottom of a leg of text. Both problems have been fixed in the layout at right, where the cutlines have been moved to the outside.

◆ **Credit photos properly.** You can do this by dummying a credit line along the outer edge of the design, or by attaching credit lines to each photo (or just to the lead photo, if they're all shot by the same photographer).

OTHER DESIGN ADVICE

◆ **Add a little white space.** Don't cram text and photos into every square pica. Let the page breathe with what's called "white space" or "air." But don't trap dead space between elements; push it to the outside of the page:

Note how pockets of dead space seem scattered through the page at left. At right, all the extra space has been pushed to the outer edges of the layout. As a result, the elements fit more neatly.

◆ **Use an underlying grid.** Don't just scatter shapes arbitrarily. A good grid aligns elements evenly and maintains consistent margins throughout the page.

◆ **Use screens sparingly.** A gray background screen can help organize and enhance layouts. But too much gray makes pages drab — so be careful.

MORE ON ▶

◆ **Cutlines:** *Basic guidelines on sizing and placement* **30**

◆ **Dominant photos:** *Why you need them, and how to choose them* **56**

◆ **Photo credits:** *Style and placement options* **141**

◆ **Screens:** *What they are and where to use them* **194**

◆ **Display headlines:** *Tips on how to design them* **196**

STUDIO SHOTS

Photojournalism is an honest craft. It records real people in real situations, without poses or props. But suppose you need a photo of a hot new bikini. A can of beans. An award-winning poodle. Will that photo be *real, honest* photojournalism?

No, it's a studio shot. And unlike news photos, where photographers document events passively, studio shots let photographers manipulate objects, pose models, create props and control lighting.

Studio shots — or any other set-up photos, whether they're shot in a studio or not — are used primarily for features, and primarily for:

◆ **Fashion.** Clothes by themselves are dull; clothes worn by a model who smiles or flirts will yank readers into the page.

◆ **Food.** Making food look delicious in a 2-column black-and-white photo is a lot tougher than you think, but it's absolutely essential for accompanying food stories.

◆ **Portraits.** Special faces deserve special treatment. Studio shots with dramatic lighting or dark backgrounds (into which you can reverse the type) let you glamorize the subjects of those in-depth personality profiles.

◆ **Incidental objects.** Remember, it's important to show readers the actual album covers, book jackets and new products mentioned in features and reviews. Show — don't just tell.

MORE ON ▶

◆ **Photo cutouts:** *How to turn studio shots (like the fashion model at left) into silhouettes* **192**

Different cultures have different attitudes about showing skin. In Europe, for instance, newspapers feature frequent nudity; British and Canadian tabloids use scantily-clad Page 3 girls to boost sales. In the U.S., you'll see sexier models than this in most newspapers' department-store underwear ads. So is this bikini photo too sexist and exploitative to run in your newspaper?

Studio shots provide the ideal solution for fashion and food illustrations, as these burger and bikini photos show. But they can also convey ideas (at left, a revenge fantasy for computer users). And they can dramatically capture the mood of any personality you're profiling.

PHOTO ILLUSTRATIONS

Note how beautifully the headline and text integrate with this cartoon-like photo illustration from the San Jose Mercury News. It's comical and sweet, conveying the story's topic with drama and humor.

This award-winning photo by T. J. Hamilton of The Grand Rapids Press illustrates a feature story on the parental pressures of raising children. It's cute and compelling — and it's a perfect complement to the story's headline: "Handle With Care."

Sometimes the best way to illustrate a story is to create a photograph where actors or props are posed to make a point — as if it were a drawing. The result is a *photo illustration.*

Photo illustrations are usually studio shots. But unlike fashion photos or portraits, photo illustrations don't simply present an image; they express an idea, capture a mood, symbolize a concept, tell a visual joke.

Photo illustrations are often excellent solutions for feature stories where the themes are abstract (love in the office, teen suicide, junk-food junkies) — stories where real photos of real people would be too difficult to find or too dull to print. But keep in mind, a good photo illustration:

◆ **Instantly shows what the story's about.** A photo illustration shouldn't confuse or distract readers. It should present one clean, clear idea that requires no guesswork and avoids misleading meanings. And it *must* match the tone and content of the text.

◆ **Should never be mistaken for reality.** Newspaper photos are honest: They show real people doing real things. Readers expect that. So if you're going to change the rules and create some fantasy, make it obvious. Distort angles, exaggerate sizes, use odd-looking models (at right) — do *something* to cue the reader that this photo isn't authentic. It's dishonest to pass off a fake photo (someone pretending to be a drug addict) as the real thing. Even warning readers in a cutline isn't enough; readers don't always read cutlines.

◆ **Works with the headline.** The photo and the headline must form a unit. They must work together to convey *one* idea, not two.

◆ **Performs with flair.** A good photo illustration displays the photographer's skill and cleverness with camera angles, lighting, special effects, poses and props. In a world where newspaper graphics compete against slick TV and magazine ads, you either excel or you lose. If your photo illustration looks bland and uninspired, you lose.

ILLUSTRATIONS

Newspapers are packed with illustrations. Some aim to amuse: comics, for instance. Some appear in ads, selling tires and TVs. Some promote stories in teasers. Some jazz up graphics and logos.

And then there are more ambitious illustrations, ones that (like photos) require more space, more collaboration between writers, editors and designers — and bigger budgets.

Here's a look at the most common types of newspaper illustrations:

COMMENTARY & CARICATURE

The first illustration ever printed in an American newspaper was an editorial cartoon in Ben Franklin's Pennsylvania Gazette. It showed a dismembered snake, with each section representing one of the 13 colonies. It carried the caption "JOIN or DIE."

Editorial cartoons have gotten a lot funnier since then. Today, they're expected to be humorous, yet thoughtful; provocative, yet tasteful; far-fetched, yet truthful. That's why editorial cartooning is one of the toughest jobs in journalism — and why successful editorial cartoonists are rare.

This editorial cartoon, by Nick Anderson of the Louisville Courier-Journal, relies on a hip drawing style, crisp hand lettering and a wicked sense of satire.

A similar type of illustration, the commentary drawing, also interprets current events. Like editorial cartoons, commentary drawings usually run on a separate opinion page. Unlike editorial cartoons, commentary drawings accompany a story or analysis, rather than standing alone. They don't try as hard to be funny but still employ symbols and caricatures to comment on personalities and issues.

Caricatures, however, aren't limited to opinion pages. They're often used on sports or entertainment pages to accompany profiles of well-known celebrities. A good caricature exaggerates its subject's most distinctive features for comic effect. Like editorial cartooning, it's a skill that's difficult to master, and should probably be avoided if:

◆ The subject's face isn't very well-known.

◆ The story is too sensitive or downbeat for a brash style of art.

◆ The artist's ability to pull it off skillfully is doubtful.

A goofy caricature of goofy comedian David Letterman. Artist Ron Coddington has exaggerated Dave's gap-toothed grin to an absurd extreme (and note bandleader Paul Shaffer tucked beneath Dave's arm).

ILLUSTRATIONS

Three illustrations, three different styles, one artist: Steve Cowden of The Oregonian created these pages entirely on the Macintosh with Freehand software.

FLAVOR DRAWINGS

Feature pages often focus on abstract concepts: drugs, diets, depression, dreams and so on. Many of those concepts are too vague or elusive to document in a photograph.

That's where illustrations can save the day. Flavor drawings — drawings that interpret the tone of a topic — add impact to the text while adding personality to the page.

Finding the right approach to use in an illustration takes talent and practice. (It can create thorny staff-management problems for editors, too. An awful lot of amateur illustrations look — well, awfully amateurish. And it's surprisingly hard to tell a colleague, *"Your drawing stinks."*)

Flavor drawings can be silly or serious, colorful or black-and-white. They can dominate the page or simply drop into a column of text to provide diversion.

Be careful, however, not to overload your pages with cartoons. Readers want *information*, not decoration. They can sense when you're just amusing yourself.

CLIP ART

Illustrations are terrific — *if* you have the budget to hire artists or pay for free-lance artwork. But what if you don't?

Advertisers have had that problem for years. And when they need images of generic-looking people and products to spruce up their ads, they often use *clip art*: copyright-free cartoons and drawings.

Clip art is plentiful and cheap. You can buy catalogs and CD-ROMs containing thousands of, say, holiday images (Santas, turkeys, pumpkins and valentines) at ridiculously low prices.

For a classier look, you can "borrow" historic old engravings, like the one at right, from copyright-free pictorial archives. With the right story, those classic images can be evocative and effective.

But be selective. Clip art often looks lowbrow. At its worst, it's *extremely* cheesy. So don't junk up your news stories because you're desperate for art. Make the news look like news, not like the ads down below.

A CHECKLIST: FINDING FEATURE ART

Feature pages require good art. To produce good art, you need good ideas. And you need those good ideas *before* stories are written, *before* photos are shot, *before* you start to design the page. Begin searching for ideas before deadline pressures force you to take shortcuts.

Stumped on how to illustrate a page? The following checklist can help guide you to the graphic heart of a feature story:

PHOTO SOLUTIONS

CAN WE SHOOT PHOTOS?

Can we illustrate this story photojournalistically — showing real people in real situations? Look for:

Events	**People**	**Places**	**Objects**
What events or actions are connected with this story? What do the main characters *do* that's interesting? (A reminder: Talking, thinking and sitting at a desk are *not* interesting.) What can readers do after they've finished the story?	Who is the key player? Are there several? What kind of portrait shows us the most about them? What emotions do they experience in this story? Can one mood-oriented portrait convey the idea? Is there a situation where emotions and actions intersect?	Can location/setting help tell the story, either: ◆ With a main character posed in a dramatic location? ◆ With several main characters working or interacting? ◆ Without people (focusing instead on buildings or scenery)?	What items are integral to the story? Examples: ◆ Machines ◆ Tools & equipment ◆ Works of art ◆ Vehicles ◆ Clothing Can they be used as lead art? Turned into a diagram? Explained in detail in a sidebar?

CAN WE OBTAIN PHOTOS (FROM AN OUTSIDE SOURCE)?

◆ A wire service? ◆ Other media (TV networks, movie studios, professional or student newspapers)?	◆ Organizations (government offices, museums, clubs, stores, companies mentioned in the story)?	◆ The newsroom library? A local library? ◆ The personal archives of people in the story?	◆ Books or magazines (with approval from the publisher or copyright holder)? ◆ Stock photo services?

If photos won't tell the story, then maybe you should consider:

ART SOLUTIONS/PHOTO ILLUSTRATIONS

DOES THE STORY FOCUS ON AN ABSTRACT TOPIC? Can one strong image capture that topic and anchor the page? Or are several smaller images needed?

SHOULD WE CREATE A:
◆ *Drawing?* (Is an artist available? Or do we prefer the realism of a photo?)
◆ *Photo illustration?* (Is a photographer available? Or do we want a freer, more fanciful solution?)

To pull strong images out of the story, ask yourself:

CAN WE WRITE THE HEADLINE? A clever headline will often inspire a graphic hook. Wander through the story and look for key words and phrases. Loosen up and noodle around with:

Puns. *Give Peas a Chance. The Noel Prizes. Art and Sole.* **Alliteration and rhyme.** *FAX Facts. High-Tech Home Ec. Tool Time.*	**TV, movie or song titles.** *Born to Run. The Right Stuff. All in the Family. Rebel Without a Clue. Running on Empty. Home Alone.*	**Popular quotes, proverbs or slang expressions.** **A quote or phrase** lifted from the text of the story.	**A key word** from the story: A name *(Skipper).* A place *(Gilligan's Island).* An emotion *(The Crying Game).* A sound or feeling *(Yum!).*

A CHECKLIST: FINDING FEATURE ART

No headline yet? Or is it clever, but still vague?

BRAINSTORM IMAGES. Wander through your topic again, but this time compile a list of concepts, symbols, visual clichés. Analyze the story in terms of:

Who. What personality types (or stereotypes) are involved? How can you exaggerate their personalities? Are there victims? Villains? Can you use props or symbols to represent people in the story?	**What.** What objects, feelings or actions are involved? What clichés or symbols come to mind? Isolate them. Mix and match them. What happens if you exaggerate or distort them? See anything humorous? Dramatic?	**When.** When does the action occur? Are there moments when the topic is most dramatic or humorous? At what times does the topic begin or end? What was the history of this topic?	**Where.** Where does this topic occur? Where does it start? Finish? If you were filming a movie, what dramatic angles or close-ups would you use?	**Why.** What does this story mean? What's the end result, the ultimate effect? What's the reason people do it, dread it, love it? And why should we care?

Once you've compiled a list of images, try to combine them in different ways. View them from different angles. Or try these approaches:

◆ **Parody.** There's a world of symbols and clichés out there waiting to be recycled. Some are universal: an egg (frailty, rebirth), a light bulb (creativity), a test tube (research), a gun (danger), an apple (education). You can play with the flag, dollar bills, road signs, game boards. Or parody cultural icons: The Statue of Liberty. The Thinker. Uncle Sam. "American Gothic."

◆ **Combination.** Two images can combine to form a fresh new idea. If your story's about people trapped by credit cards, create a credit-card mousetrap. If your story's about some puzzle at City Hall, create a City Hall jigsaw puzzle. And so on.

◆ **Exaggeration.** Distort size, speed, emotion, repetition. Is there a BIG problem looming? Is something shrinking? Fading? Taken to an extreme, what would this subject look like? How would affected people look?

◆ **Montage.** Arrange a scrapbook of images: photos, artifacts, old engravings from library books. Try to create order, interplay or point of view.

OTHER GRAPHICS SOLUTIONS

By now, you may have found a solution that seems like pure genius to you. But beware: Ideas don't always translate into reality. Your solution must work instantly for hundreds of readers. So before you proceed, run a rough sketch past your colleagues to test their reactions. If it doesn't fly, drop it.

Remember, too: Informational art is usually better than decorative art. Will your illustration inform, or is it just a silly cartoon? Does it make a point, or convey fuzzy emotion? Is it big simply because you need to fill space?

You can still salvage your idea — but consider using it along with:

Infographics. Dress up charts, graphs, maps or diagrams as lead or secondary art. Show your readers how things work, what they mean, where they're headed. Use the design to teach — not just entertain.	**Sidebars** (with or without art). You can create lists, glossaries, how-to's, polls (see our list on page 153). If you add enough art (mug shots, diagrams, book jackets, etc.) you can make a sidebar carry the whole page.	**Big, bold type effects.** Often a display headline that's aggressive enough can serve as a page's dominant element — you could even work a piece of art *into* the headline. Or try starting the text with a HUGE initial cap.	**Mug shots and liftout quotes.** Drop these in wherever pages look gray. Or play them up as dominant elements by adding rules, screens, shadows. Or group a series of mug/quotes in a bold, colorful way.

If you're still trying to dress things up, try a combination of boxes, screens or background wallpaper effects. This is just fancy footwork, however — distracting the reader to disguise your lack of art.

A FINAL WARNING: If you've come this far and still don't have a solid solution, re-think your story. If it's too vague for you, it's probably too vague for readers.

RISKY BUSINESS

In your search for the Ultimate Page Design, you may be tempted to try some of these effects. But before you do, read on:

STEALING

Before you "borrow" an image from an outside source, be sure you're not violating copyright laws. Old art (like the Mona Lisa) is safe; copyrighted art can be used if it accompanies a review or a breaking news story. But copyright laws are complex — as are laws governing the reprinting of money* — so get good advice before you plunge into unfamiliar territory.

FRAMING

There are countless design books and computer programs loaded with decorative clip art and fancy frames. Someday, you'll be tempted to embellish an elegant image with a glitzy border. Don't do it. Art and photos should be bordered with thin, simple rules. Anything overly ornate just distracts readers' attention from what's important. Emphasize information — not decoration.

FLOPPING

Printing a photo backward, as a mirror image of itself, is called *flopping.* Usually, it's done because a designer wants a photo facing the opposite direction, to better suit a layout. But that's dishonest and dangerous. It distorts the truth of the image. *Never* flop news photos; flop feature photos or studio shots only as a last resort, and only if there's no way to tell you've done it.

RESHAPING

As we've learned, photos work best as rectangles with right-angle corners. Cutting them into other "creative" shapes distorts their meaning, confuses readers and clutters up the page. Put simply: Slicing up photos is the mark of an amateur. There's rarely a valid reason for doing it, so put the idea right out of your mind.

TILTING

Sometimes you get art that's so wild 'n' wacky, you just *gotta* give it an equally nutty layout. OK — but beware. Unless you choose appropriate art, tilt it at just the right angle and skew the type smoothly, you'll look silly. Even though pros try it once in a while (see page196), save it for when you really need it.

SILHOUETTING

If a photo is weakened by a distracting background or needs a dramatic boost, you can carefully cut out the central image and run it against the white page. That works well with some photos, poorly with others — but usually should be be avoided for news photos. For more advice and warnings, see page 192.

**For instance, you may reproduce dollar bills only at sizes 150% or larger, or 75% or smaller.*

TROUBLESHOOTING

Q: Is there anything wrong with using a stand-alone photo as the dominant art on Page One?

If you ask readers what they want Page One to be, most would answer *"newsy."* They want data. Highlights. Summaries. Stories.

Newspapers often forget this. They sink into a lazy rut, running big photos of cute kids and sunsets on Page One. Usually, this is because editors get preoccupied with meetings and money stories for which there are no interesting photos — so at the last minute they panic and yell, "Quick! Get me a photo! Somebody run to the park and shoot me a *squirrel!*" Which results in pages like this:

When it comes to warm 'n' fuzzy front-page photo clichés, the worst of the repeat offenders are these:

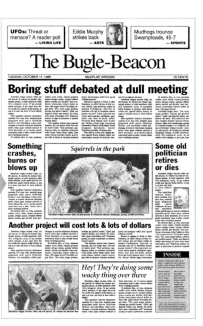

Balloons *Cute kids* *Flowers* *Squirrels* *Clowns*

Many newspapers adhere to the adage that *you should never run wild art as lead art.* In other words, if you consistently run soft, stand-alone photos as lead art, it's a sign you're not doing enough photojournalism, enough packaging or enough planning. (See page 176 for more on planning better front-page packages.)

Q: My editor insists on running grip-and-grin photos in the paper. He says that readers want to see *faces* of people in the community. Is he right?

You know what newspapers do best? Two things: *teaching* and *storytelling.* In a way, that's our sacred mission — giving people data they need to lead better lives, and capturing the drama of life in the 21st century. *Teaching* and *storytelling. Data* and *drama.* Good teaching conveys data; good storytelling conveys drama.

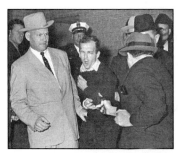

Keep those words in mind as you thumb through a newspaper. A photo of some guy holding a trophy teaches us nothing. It tells no story. A photo of that same guy *doing* the thing that earned him the award — helping the children, building the park — would convey more data and drama. It would be an immeasurably superior image.

Look at the photo at left. Why is it a classic? Consider all the *data* it contains: the who, the what, the where, the how. Now consider the *drama* it contains: an actual murder, occurring right before your eyes.

Apply this same standard to every photo in your newspaper. You'll realize that's why those grip-and-grin photos are so journalistically weak: Those awkward-looking people could be anybody anywhere. Only their families and friends will care about those photos; the other 99% of us will turn the page, looking for *real* news.

Always search for the true photograph behind every story — the real activity, not the phony ceremony. And if your editor insists on running "cheese" photos anyway, consider creating a cheese page to house all those trophy-clutching grip-and-grins. That way, you can keep your *news* separate from your *cheese.*

At the Bainbridge Island Review, this page gives local award-winners their moment of glory.

TROUBLESHOOTING

Q: We're a small paper on a tight budget, and we can't afford to hire artists. What are the best sources for clip art?

The good news is: There's plenty of affordable clip art out there. The bad news: Most of it is junk. If you buy Art Explosion — a CD with 125,000 images on it — here's a sample of what you'll find under the heading of "Education":

Which of these images are useful, and which are junk? That'll depend, day to day, on what you're looking for. Your best bet is to buy a disk *loaded* with art so you can pick and choose more easily. Or visit Web sites for companies like Art Parts and EyeWire, which offer quickie images like those above as well as bigger, better illustrations you can buy individually.

Q: Our paper is small; our photo staff is virtually nonexistent. What can we do to get better photos into the paper?

◆ Consider buying stock images. Like clip-art illustrations, stock photos help most when you need generic art for stories like the one at right. Visit Web pages for PhotoDisc, EyeWire and Corbis; you can download images quickly and cheaply.
◆ Buy a reliable, drool-proof digital camera. Train everyone to use it for mug shots and simple portraits.
◆ Quit shooting everything at eye level, 10 feet away. Stand on tables; squat on the floor. Find fresh angles. Zoom in and out.
◆ If you shoot a lot of portraits, carry a black sheet. It can add instant drama and let you reverse type into the background.

Q: Our photo editor won't allow us to run any headlines on photos, or to use any photo cutouts, because it damages the images' integrity. Is that true?

For years, photo cutouts and superimposed headlines were taboo in newsrooms. But look at magazines now. Look at *news*magazines like Time and Newsweek; they run shadowed photo silhouettes and fancy reversed headlines everywhere.

A dramatic news story as it might appear in a newsmagazine, with reversed type and the headline atop the photo.

Newspapers are behind the curve when it comes to stylizing images. They still treat photos, especially local photos, like sacred art objects.

You can argue either side and never get anywhere. So try this: bring a pile of magazines into the newsroom. Analyze the cutouts, the superimposed headlines. Discuss what works, what doesn't. See if you can reach agreement on where to draw the line. Designate certain places in the paper (Features, Sports, the front-page promos) where it's OK to bend the rules.

For more on this controversy, see pages 192 and 249.

If that same story ran in a newspaper, the headline, text and photo would all be designed as separate rectangles.

EXERCISES

ANSWERS ▶ 248

1 Below are four photos that accompany a story about a woman jockey. Using all four, create a full-page photo spread for a broadsheet feature section, with the headline *"On the Fast Track"* (and you'll need to add a deck below the headline, as well). The story is very long, so assume you can jump as much text as you need.

Crop the photos as you see fit. But before you begin, ask yourself: Which photo should be dominant?

EXERCISES

2 The photos for that woman jockey spread (previous page) were good, both in content and technical quality. But if you were the photo editor for that page, and there was time to go back and shoot more photos, what might you ask for? What's missing?

3 The three layouts below were created from those jockey photos. Can you find at least three things wrong with each of these page designs?

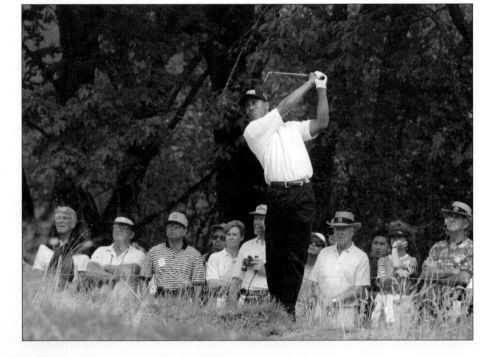

4 At left is a photo of Tiger Woods playing in a local golf tournament. This is your photographer's best shot. (Unfortunately, he wasn't able to get a dramatic closeup or reaction shot of Tiger.)

The sports editor insists on leading with this photo. So how would you crop it?

ANSWERS ▶ 248

A newspaper is a product — like corn flakes. Like corn flakes, newspapers are good for you. Like corn flakes, newspapers are a part of America's breakfast routine. And like corn flakes, newspapers seem alike from one brand to another.

So how do you make *your* brand of corn flakes tastier to consumers? You dress it up in a colorful box. Design a snappy-looking name. Play up a catchy promotion *(FREE WHISTLE INSIDE!)* or lift out some quotable phrase ("High-fiber nutrition with real blueberry goodness") to catch the eye of passing shoppers. Finally, you stick in all the extras that are required to be there — ingredients, the date, the company address — as neatly and unobtrusively as you can.

All that holds true for newspapers, too. And in this chapter, we'll examine the graphic nuts and bolts used to assemble newspapers: logos, flags, bylines, decks, teasers, liftout quotes and more.

Previously, we looked at ways to design individual stories. In this chapter, we'll explain how to label and connect related stories. How to break up deep columns of gray text. How to add graphic devices that sell stories to readers.

In other words, how to pack more real corn goodness into every bite.

THE FLAG

Let's begin at the top of Page One, with one of journalism's oldest traditions: the *flag*. Though newspapers have tried boxing it in a corner, flipping it sideways or floating it partway down the page, most papers choose the simplest solution: anchor the flag front and center to lend the page some dignity.

Usually, designers have little input when it comes to flags, which are only over-hauled maybe once every few decades, if that often. (Flags, incidentally, are often mistakenly called "mastheads." But a masthead is the staff box full of publication data that usually runs on the editorial page.)

There are two contrasting philosophies of flag design. One requires that flags evoke a sense of tradition, trust, sobriety — and indeed, most Old English flags look downright *religious*. But others argue that flags are like corporate logos and should look fresh, innovative, graphically sophisticated. (Some papers try to play it both ways: conservative, yet a bit stylish.)

Examine the flag collection below. What clues do they offer to their papers' personalities?

Some papers float their flag in white space to give it prominence. Others add *ears* (text or graphic elements in the corners beside the flag) to fill the space. Papers stick a variety of items in their ears and flags: weather reports, slogans ("All the News That's Fit to Print") or *teasers* promoting features inside the paper:

What's essential in a flag? The name of the paper. The city, school or organization it serves. The date. The price. The edition *(First, Westside, Sunrise)*, if different editions are published. Some papers include the volume number — but though that may matter to librarians, readers don't keep score.

LOGOS & SIGS

STANDING HEADS AND SECTION LOGOS

As you travel through a newspaper, you pass signposts that tell you where you are. Some are like big billboards ("Now entering **LIVING**"). Others are like small road signs ("Exit here for *Movie Review*").

Every paper needs a well-coordinated system of signposts — or, as they're often called, *headers* or *standing heads.* Just as highway signs are designed to stand apart from the scenery, standing heads are designed to "pop" off the page. They can use rules, decorative type, fancy screens or reverses — but it's essential that their personalities differ from the ordinary text, headlines and cutlines they accompany.

Compare, for example, these two headers (also called *section flags* or *logos*):

This section logo uses the same typeface as the headlines — they're both the same size and weight, too. Nothing sets the logos apart from the day's news; they just don't "pop" off the page.

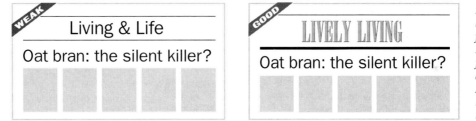

Here, the section logo looks entirely different from the headline below. It uses an all-caps serif font. It's screened, with a thin drop shadow. And a thick rule sets the header apart from the live stories downpage.

A *logo* is a title or name that's customized in a graphic way. Logos can be created with type alone, or by adding rules, photos or other art elements.

Section logos, like those above, help departmentalize the paper. In small tabloids, they should appear atop the page each time the topic changes (from Features to Opinion, for instance). Bigger papers use section logos to identify each separate section, often adding teasers to promote what's inside:

Some newspapers use standing heads to label the content on every single page. Others reserve that treatment for special themed pages *(Super Bowl Preview)* or investigative packages *(Guns in Our Schools: A Special Report).*

Either way, those added signposts guide readers most effectively when they're designed and positioned consistently throughout the paper, in a graphic style that sets them apart from the "live" news. For example, look at this bold system of section flags used at the Colorado Springs Gazette:

Unlike most section logos (which run the full width of the page), those at the Gazette run in the top left corner, heading a column of briefs.

Notice the Gazette's unusual front-page flag: a big brown "G," which gives the paper a unique brand identity. A smaller "G" is used on all the section fronts.

LOGOS & SIGS

As we've just seen, section logos and page headers are used to label sections and pages. But labels are necessary for special stories, too. And those labels for stories are called *logos, sigs* or *bugs*.

Story logos are usually small enough to park within a leg of text. But whatever their size, they need to be designed with:

◆ A graphic personality that sets them apart from text and headlines;

◆ A consistent style that's maintained throughout the paper; and

◆ Flexible widths that work well in any design context.

It's important to dummy logos where they'll label a story's content without confusing its layout — which means they shouldn't disrupt the flow of text or collide with other elements.

Here are some of the most common ways to dummy logos with stories:

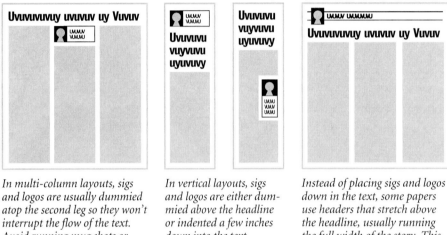

In multi-column layouts, sigs and logos are usually dummied atop the second leg so they won't interrupt the flow of the text. Avoid running mug shots or photos in that second leg — the logo will look odd whether dummied above or below other art, and both images will fight for the reader's attention.

In vertical layouts, sigs and logos are either dummied above the headline or indented a few inches down into the text. Indenting logos is tricky, though, since text should be at least 6 picas wide — which doesn't leave room for long words in a logo.

Instead of placing sigs and logos down in the text, some papers use headers that stretch above the headline, usually running the full width of the story. This is a very clean, clear way to label special features, but it takes up more space than the other formats — and doesn't do anything to break up gray legs of text.

COLUMN LOGOS

Column logos are a way to label special writers, those regularly appearing personalities whose names and faces deserve prominent display. These logos (also called *photo sigs*) are usually reserved for writers whose columns are subjective, opinionated or humorous — and whose columns hopefully become a regular reader habit. (To support that habit, then, it's important to dummy the column in the same style and the same place each time it runs.)

Column logos usually consist of:

◆ The writer's name.

◆ The writer's likeness (either a photo or a sketch).

◆ A catchy title: *Dear Abby, Screen Scene* or (yawn) *On the Town.*

ON THE TOWN
BY REED DARMON

REED DARMON
On the Town

on the
town
BY REED DARMON

REED DARMON

LOGOS & SIGS

SIGS & BUGS

Column logos promote the personalities of *writers*. Sigs and bugs, on the other hand, identify *topics*. They're a functional yet decorative typographic treatment that's used to label:

◆ Briefs and non-standard news columns (*Business Notes, People, World Roundup*);

◆ Opinion pieces that appear on news pages (*News Analysis, Movie Review*);

◆ Regularly appearing features (*NFL Notebook, Action Line!, Money Matters, Letters to the Editor*).

At some papers, there's even a trend toward labeling more and more stories by topic (*City Council, Medicine, Tennis*). That's difficult to do consistently throughout the paper — quick, what's a one-word label for a story about two jets that nearly collide? — but when it works, it's a helpful way to guide busy readers from topic to topic.

Other papers use sigs that refer to stories on other pages or include fast facts (as in that bottom movie review sig at right).

Sigs can be designed in a variety of sizes and styles, adding rules, screens or graphic effects to catch readers' eyes. But every paper should use a consistent graphic treatment for all its logos. That means the style you use for **POP MUSIC** should also be appropriate for **OBITUARIES**.

Ghostbusters 3
★★★

Starring: Bill Murray, Dan Aykroyd, Sigourney Weaver
Director: Ivan Reitman
Rating: PG for crude language, nudity, slime

MORE ON ▶

◆ **Fast-fact boxes:** *Ideas for capsulizing information like that movie review box below* **158**

SERIES LOGOS

Series logos are a way to label special packages (a five-day series on *Racism in the Classroom*) or stories that will continue to unfold over an extended period (like *Election 2004* or *Revolt in China*).

Series logos (called icons at some papers) usually consist of:

◆ A catchy title that creates reader familiarity;

◆ A small illustration or photo that graphicizes the topic;

◆ Optional refer lines to other pages or to tomorrow's installment.

Logos are usually one column wide or indented into the text — and as these examples from The Detroit Free Press show, they come in a variety of styles:

LIFTOUT QUOTES

"If I repent of anything, it is very likely to be my good behavior. What demon possessed me that I behaved so well?"

— Henry David Thoreau

WOODY ALLEN

"I don't want to achieve immortality through my work. I want to achieve it through not dying."

"We are healthy only to the extent that our ideas are humane."

— KURT VONNEGUT JR.

Sara grew up to be a copy editor, a profession she compares to walking behind an elephant in a parade and scooping up what it has left on the road.

— Anne Fadiman,
in her memoir, "Ex Libris"

"The surest way to make a monkey of a man," said Robert Benchley, "is to quote him." And a sure way to make readers curious about a story is to display a wise, witty or controversial quote in one of the columns of text.

As the examples above show, liftout quotes can be packaged in a variety of styles, enhanced with rules, boxes, screens or reverses. They go by a variety of names, too: *pull quotes, breakouts, quoteblocks,* etc. But whether simple or ornate, liftout quotes should follow these guidelines:

◆ **They should be quotations.** Not paraphrases, not decks, not narration from the text, but complete sentences spoken by someone in the story.

◆ **They should be attributed.** Don't run "mystery quotes" that force us to comb the text for the speaker's identity. Tell us who's doing the talking.

◆ **They should be bigger and bolder than text type.** Don't be shy. Use a liftout style that pops from the page to catch the reader's eye – something distinctive that won't be mistaken for a headline or subhead.

◆ **They should be 1-2 inches deep.** Shallower than that, they seem too terse and trivial; deeper than that, they seem too dense and wordy.

COMBINING QUOTES & MUGS

Words of wisdom are attractive. And when we see the speaker's face, we're attracted even more. That's why mug/quote combinations are among the best ways to hook passing readers.

Quotes with mugs can be boxed or unboxed, screened or unscreened. Whatever style you adopt, adapt it to run both horizontally (in 2- or 3-column widths) and vertically (in 1-column widths or indented within a column). Be sure the format's wide enough, and the type small or condensed enough, to fit long words without hyphenation.

"I'm like a dung beetle, pushing this ball of dung up a mountain."

BETTE MIDLER,
on working on her sitcom,
"Bette"

"People have got to know whether or not their president is a crook. Well, I am not a crook."

— RICHARD NIXON

LIFTOUT QUOTES

MORE ON ▶

◆ **Making stories fit** *by adding liftout quotes* **86**

◆ **Quote packages:** *Special treatments for collections of quotes* **163**

◆ **Skews and text wraps:** *Guidelines for dummying special type effects* **190**

GUIDELINES FOR DUMMYING LIFTOUTS

◆ **Be sure you have a quote worth lifting before you dummy it in.** You can't expect great quotes to materialize automatically — some stories, after all, don't even *use* any quotations.

Read the story first. Or talk to the reporter. Remember, once you develop the habit of promoting great quotes, it encourages reporters to *find* more great quotes. As a result, both stories and readers will benefit.

◆ **Don't sprinkle liftouts randomly through the text just to kill space:**

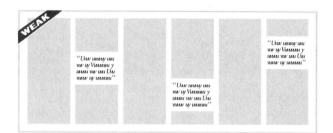

That's too distracting. For maximum impact and better balance, dummy quotes symmetrically (below left). Or create a point/counterpoint effect with two mugs (center). Or combine multiple quotes into an attractive package (right).

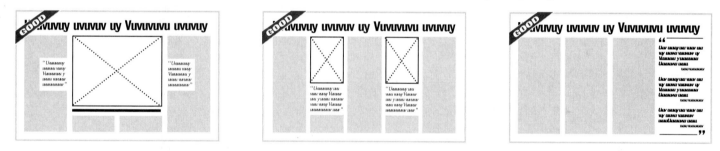

◆ **Never force readers to read around any 2- or 3-column impediment.** Text that jumps back and forth like that gets too confusing (below left). Use 2-column liftouts *only* at the top of the text (center). One-column liftouts usually aren't quite as confusing, but as an alternative, you might try indenting a window for the liftout, then wrapping the text around it (right).

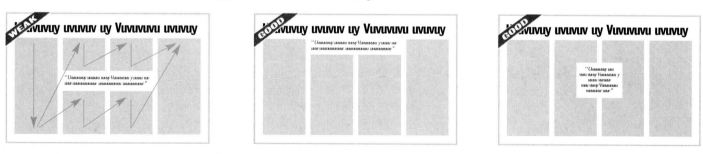

◆ **Keep liftout quotes as typographically tidy as you can.** Avoid partial quotes, parentheses, hyphenation, ellipses and widows.

The liftout below actually ran in a student newspaper. The editors probably thought they were keeping the quote accurate, but the distracting typography sabotaged the quote's readability:

> **"... possible enhancements (such as) ... an essay as a direct measurement of writing skill ..."**

DECKS & SUMMARIES

One of the most persistent problems in all of newspapering is The Headline That Doesn't Really Make Sense:

Schools bill falls

Copy editors are only human, usually, so headlines like that are inevitable. But one way to make headlines more intelligible — especially on important stories — is to add a *deck* below the headline to explain things further:

Schools bill falls
Senate vetoes plan to finance classes by taxing cigarettes

This example uses a 36-point boldface headline and an 18-point lightface deck. Decks are most effective in lightweight or italic faces that contrast with the main headline. In news stories, they're usually set flush left in the first leg of text.

Quite often, decks make more sense than headlines. Which shows you how valuable they can be.

Years ago, papers stacked decks in deep rows (see example, page 24). Today, most use only one deck per story. Decks for news stories are often 3-4 lines (6-12 words); decks for features are generally longer (10-30 words).

Some editors think decks are a waste of space and use them only as filler when stories come up short. That's a mistake. Since most readers browse the paper by scanning headlines, it's easy to see that a good head/deck combination adds meaning — and increases readership.

BASIC DECK GUIDELINES

◆ **Use decks for all long or important stories.** Remember, readers are more likely to plunge into a sea of text if they know in advance what it's about.

◆ **Use decks with all hammer or display headlines.** It's fine to write a clever feature headline like "Heavy Mental." But if you don't add a deck to explain what that means, readers may never decipher your cleverness.

◆ **Give decks contrast — in size and weight.** By sizing decks noticeably smaller than headlines, they'll be easier to write. They'll convey more information. And they'll look more graceful (as magazines discovered long ago). Though most papers devise their own systems of deck sizing, decks generally range from 12 to 24 points, depending on the size of the headline they accompany.

For added contrast, most papers use either italic decks (with roman heads) or lightface decks (with regular or boldface heads). Whatever your paper's style, it's important to set the deck apart — with both spacing and typography — from the headline and the text.

◆ **Stack decks at the start of the story.** Don't bury them in the text, stick them in some corner or banner them across the full width of the page. Decks are functional, not decorative. Put them to work where they'll lead readers into the text — usually in the first leg (though in wider layouts, 2-column decks work fine).

In fancy feature layouts, you can be more creative. But that comes later.

DECKS & SUMMARIES

MORE ON ▶

◆ **Headlines:** *Different styles of headlines and how to size them.....* **24**

◆ **Display headlines:** *How to add variety to feature headlines...* **197**

◆ **Fast-fact boxes:** *How they summarize stories for readers in a hurry..............* **154**

SUMMARY DECKS

Some papers call them *summaries*. Others call them *nut grafs*. Either way, they're more than just downsized decks. They're a response to busy readers who say, *I'm in a hurry — why should I care about this story?*

In 1987, The Oregonian became the first American daily to add summaries to all key stories on section fronts. Today, hundreds of papers use them on all their stories to distill the content of the text into 20-30 words:

Compare this headline/ deck combination with the one on the facing page. Which offers more information at a glance? This example uses 13-point type. It begins with a dingbat to catch your eye (and to distinguish the summary from the text that follows).

Schools bill falls

■ By a 78-12 vote, the Ohio Senate rejects a plan to finance classes by adding a 10-cent tax on each pack of cigarettes sold this year

The simplest way to create a summary is to write a longer-than-usual deck using smaller-than-usual type. But some papers try more creative approaches, both in the typography they use and in the way they highlight information:

This summary uses a boldface lead-in to highlight key words — followed by more detailed summary material in contrasting lightface italic type.

TAX PLAN DEFEATED: *By a 78-12 vote, the Ohio Senate rejects a plan to finance classes by adding a 10-cent tax on each package of cigarettes sold this year*

BRIEFLY
Background: To compensate for a projected $3 million budget shortfall, the Ohio Senate debated a plan to finance classes by adding a 10-cent tax on each pack of cigarettes you buy.
What it means: By rejecting the bill 78-12, the Senate may force drastic school budget cuts.

This summary reverses BRIEFLY in a bar, then uses boldface key words to set up a detailed summary of the story. The type is 9-point — which may be a bit small for a deck like this.

SUMMARY GUIDELINES

◆ **Don't rehash the headline and the lead.** Each element — the main headline, the summary and the lead of the story — should add something different to the reader's overall understanding. That means you should avoid repeating words or phrases; more importantly, it means writing those three elements as a single unit, with a flow of logic that leads the reader smoothly into the text.

In many newsrooms, the writer of the story contributes the wording for the headline and summary. That's an excellent way to maintain accuracy and avoid redundancy.

◆ **Use conversational language.** Summaries should be complete declarative sentences in the present tense. Unlike traditional decks, summaries are couched in a reader-friendly, conversational style. As the examples above show, there's no need to eliminate articles (a, an, the), relative pronouns or contractions.

Don't be stodgy or pretentious. Avoid obscure words or jargon. Simple words always work best — and short words will make hyphenation unnecessary.

◆ **Don't worry about bad breaks.** The traditional rules of headline writing don't apply here. A subject can be on one line, a verb on the next. Nobody will care if an infinitive is split between lines. But do avoid leaving a widow on that last line.

◆ **Feel free to improvise.** Many papers add quotes or mug shots to summaries, transforming them into graphic elements. How far is your paper willing to go?

BYLINES

To reporters, bylines are the most important graphic element in the entire newspaper. What a shame, then, that readers rarely give bylines a glance as their eyes dart from the end of the headline to the start of the story.

It's necessary, though, to give credit where credit is due (especially when readers have complaints or questions about a story). Papers differ on byline policies, but most put reporters' names on stories of substance — that is, stories more than about 6 inches long.

Bylines generally run at the start of the story in a style that sets them apart from the text: boldface, italics, one or two rules. The first line gives the reporter's name; a second line tells whether he or she writes for an outside organization (The Associated Press, for example), works as a free-lancer (often labeled a "special writer" or "correspondent") or belongs on the staff (most papers run either the name of the paper or the writer's title).

Every newspaper should adopt one standard byline style. Some examples:

By MOE HOWARD
The Daily Planet

By Larry Fine
THE DAILY PLANET FILM CRITIC

By CURLY HOWARD
curlyhoward@news.com

Student newspapers sometimes use loud, eye-catching byline styles, perhaps as a bribe to lure reporters onto the staff. Screened, reversed or indented bylines can be fun, but they call too much attention to themselves. Proceed with caution.

BY HARPO MARX

By CHICO MARX
...................
of the Times

By GROUCHO MARX

For short sidebars or columns of briefs, credit is often given in the form of a flush-right tag line at the end of the text. As with bylines, these credit lines need spacing and typography that sets them apart from the text:

— The Associated Press

— Compiled from staff reports

Some papers run all bylines at the end of the story (and some even include the reporter's phone number or e-mail address). At the start of the story, the logic goes, bylines just add clutter amid the headlines and decks; since writers' names are less urgent, they can come later.

On photo spreads and special features, newspapers often use a more prominent byline style to credit the writer, the photographer, or both (page designers, sad to say, rarely receive printed credit for their work). These special credits are

Story by
STAN LAUREL

Photos by
OLIVER HARDY

either parked at the edge of the design or indented into a wide column of text, like the Laurel & Hardy credit here.

CREDIT LINES

Artwork, like stories, should be credited — whether the art comes from staffers, free-lancers, wire services or library files. Different styles of credit lines serve different functions:

◆ For photos and illustrations, they provide the name and affiliation of the photographer or artist who produced the image.

◆ For old, historic photos or maps, they tell readers where the documents come from (i.e., The Bozoville Historical Society). Often, credit lines include the date a photo was taken, which is necessary for any photo that could mistakenly be considered current.

◆ For charts or diagrams, an additional "source" line tells readers where the artist obtained the data that was graphicized. Citing such sources is just as important for artists as it is for reporters.

◆ For copyrighted material, they provide the necessary legal wording *(Reprinted with permission of . . . or ©2002 by . . .).*

Not all papers credit all photos, however. Most papers, for instance, don't bother crediting run-of-the-mill mug shots. And publicity handouts — movie stills, fashion shots, glossies of entertainers — usually run uncredited, too (probably because editors resent giving away all that free publicity).

Most papers run credits in small type (below 7-point), in a font that contrasts with any cutlines nearby. Some papers still run photo credits at the *end* of their cutlines, like this —

Tokyo citizens scream in terror Friday as Godzilla destroys the city. (Staff photo by Dan Gustafson.)

— but that credit style isn't as effective as it could be. Ideally, there should be a clear distinction between cutlines and credit lines, just as there's a distinction between text and bylines.

Most papers run credit lines flush right, just a few points below the bottom edge of the art and a few points above the cutline. Some papers run them flush left; some run them on top; some have even tried running them sideways along the right edge, though that's difficult to read and tends to jam up against any adjacent leg of text. (When graphics use both a source line *and* a credit line, they should be dummied in two separate positions to avoid confusing readers.)

Below, you can gauge the effectiveness of each location:

MORE ON ▶

◆ **Photo spreads:**
Tips on designing photo pages — and positioning photo credits.................. **118**

◆ **Credit lines:**
Guidelines for non-standard credit styles **148**

Some papers run credit lines above the photo, flush right — though many readers habitually look for them down around the cutline.

Many magazines run credit lines sideways — but even if the type is tiny, it risks crowding into adjacent columns of text.

Most papers run credit lines flush right, a few points below the photo. Whatever you choose to do, keep it consistent — pick one position and run all credits there.

*Not many papers run credit lines in the lower left corner. Instead, it's common to run the **source line** here — that's the line in a chart, map or diagram that tells the source of the data being used. Putting that information here (or inside the box) keeps it separate from other credit lines.*

The Oregonian/JOEL DAVIS

Source: Department of Redundancy Department

The Oregonian/JOEL DAVIS

This is the cutline (or caption). Cutlines usually run a few points below the credit line and use a font that's bigger and bolder than the credit.

SPACING

Every paper should standardize its spacing guidelines. Here, for example, is how one typical newspaper might space story elements on a typical page:

Friday, April 14, 1997 **5B**

SPORTS

e 9th inning

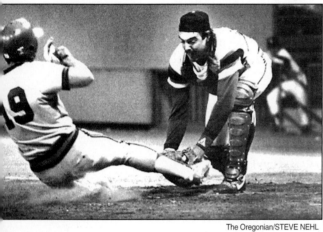

The Oregonian/STEVE NEHL

as the Dodgers rallied in the ninth inning to win.

tcher threw,
us terrified
all game.”

— Harris Siegel

ers.” That was a signal nized, although it had assed between him and

as saying, “Pitch to the

big bum if he hammers every ball in the park into the North River.”

And so, at Snyder's request, Bentley did pitch to Ruth, and the Babe drove the ball deep into right center; so deep that Casey Stengel could feel the hot breath of the bleacherites on his back as the ball came down and he caught it. If that drive had been just a shade to the right it would have been a third home run for Ruth. As it was, the Babe had a great day, with two home runs, a terrific long fly and two bases on balls.

Ump claims new balk rule may be unfair

By JACK KENNEDY
Sports editor

For the first time since the American League instituted its controversial new guidelines on

SECTION LOGOS & HEADERS
Above: *Allow 3 points between logos and the folio line.*
Inside: *Maintain 8-point margins between logo type and the edge of the box.*
Below: *Allow 18 points between logos and headlines or photos.*

HEADLINES
Above: *Allow 18 points between logos or unrelated stories and the top of the headline.*
Below: *Allow 6 points between descenders and text/photos below.*
Roundups and briefs: *When compiling packages of briefs that use small headlines (12- or 14-point), use tighter spacing: 1 pica of space above the headline and 6 points below.*

PHOTOS
Credit line: *Allow 3 points between photos and credit lines.*
Cutline: *Allow 3 points between credit lines and cutlines.*
Allow 3 points between photos and cutlines if there's no credit line.

TEXT
Above: *Allow 1 pica between cutlines and text.*
Gutters: *All vertical gutters are 1 pica wide.*
Graphic elements: *Allow 1 pica between all graphic elements (liftout quotes, refers, etc.) and text.*
Below: *Allow 18 points between text and unrelated stories.*

BOXED STORIES/GRAPHICS
Margins: *Allow 1 pica between outside rules and all headlines/text/photos.*

BYLINES
Above: *Allow 1 pica between headline descenders and bylines.*
Below: *Allow 1 pica between bylines and text.*

RULES & BOXES

Newspapers use rules both functionally (to organize and separate elements) and decoratively (to add contrast and flair). Notice, for instance, how the rules in this sig and byline are both functional and decorative:

 NFL ROUNDUP

By ROBIN FOX
Bugle-Beacon staff writer

Rule thickness, like type size, is measured in points. That "NFL Roundup" sig uses a 4-point rule above the type and a 1-point rule below, while that byline uses a hairline rule (that's the thinnest rule available). With so many widths to choose from, most papers restrict rule usage to just one or two sizes — say, .5-point and 4-point: one thin, one thick.

Rules are most commonly used in the following ways:

- ◆ To build logos, bylines and other standing elements;
- ◆ To create boxes (for stories, graphics, ads, etc.);
- ◆ To build charts and graphs;
- ◆ To embellish feature designs and display headlines;
- ◆ To separate stories and elements from each other;
- ◆ To border photos.

This page from The Portland (Me.) Press Herald shows how boxes and rules can help organize story elements.

Decades ago, newspapers used rules to separate all stories from each other. Some ran vertically in the gutters *(column rules);* others ran horizontally beneath stories *(cutoff rules).* That trend faded in the '60s, but it's been making a comeback recently. As Harold Evans, editor of The Sunday Times in London, once said: "The most backward step, under the flag of freedom, has been the abandonment of column rules and cutoffs which so usefully define columns and separate stories."

Many modern papers run most stories unruled and unboxed, saving box treatments for big news packages, sidebars, stand-alone photos, etc. As we've said before, it's best to box stories only if they're special or if they need to be set apart from other stories on the page – not to compensate for butting headlines or poorly placed photos. A weak design is a weak design, even if you add rules to soften the impact of colliding elements.

You'll often be tempted to use decorative rules or borders for special effects. But like other graphic gimmicks, it's easy to use them clumsily or excessively — so go easy.

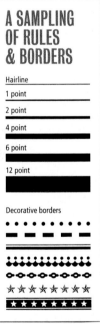

This box is bordered with a plain .5-pt. rule.

Thick frames and fat shadows add too much noise and clutter. Avoid them. It's best to use thin rules to build boxes and border photos.

Underscoring

Someday, you'll get bored with news headlines and decide they look better with a rule (called an *underscore*) beneath them. But avoid doing that. Save rules for kickers or display headlines (see page 196 for more details).

Rounded corners and decorative borders were stylish 30 years ago, but they look corny and old-fashioned today. Gimmicks like these just call attention to themselves.

REFERS, TEASERS & PROMOS

Throughout this book, we've cross-referenced material by adding "more on" indexes at the top of many pages. They're a handy way to show you where to turn for related information.

Newspapers need to cross-reference their stories, too. And they do that by using lines, paragraphs or boxes called *refers* (see examples below). Some refers are simple; others, with art, are more elaborate. Whatever style your paper uses, refers should:

◆ **Stand out typographically** from the surrounding text. That's why refers often include rules, bullets, boldface or italic type.

◆ **Be specific.** Refers should index all related items — on the TV page, the opinion page, wherever — not just say, "Other stories inside."

◆ **Be tightly written.** Refers are signposts, so they should simply point, not pontificate.

◆ **Be consistently positioned** every time they're used — i.e., above the byline, at the top of a column, at the end of the story — whatever is most appropriate and unobtrusive.

Refer line:

❏ **How Cheney views the tax plan,** Page 5.

Refer paragraph:

NAVY ALERT: Turkish destroyers were placed on red alert Wednesday as Iran launched its first nuclear submarine / **Page 4A.**

Refer box (with art):

INSIDE

▶ *Why Murphy was forced to resign*......... **A5**

▶ *Reaction from other board members* **A6**

▶ *A look at Murphy's stormy career* **A7**

A refer is a signpost that guides readers to stories inside the paper. A *teaser* is another kind of signpost — actually, it's more like a billboard. Where refers advise, teasers advertise. They say **BUY ME: HOT STORY INSIDE.**

The covers of most supermarket tabloids are loaded with titillating teasers. Most newspapers, by comparison, use a more subdued style for their teasers (also called *promos, skylines* or *boxcars).* Teasers are usually boxed in an eye-catching way at the top of Page One. Some are bold and simple —

SPOONER'S GRAND SLAM WINS IT FOR DODGERS / D1

— but the question is: Do readers even *notice* those text-only teasers? A better idea is to combine a catchy headline phrase, a short copy blurb and *art,* since an arresting image is the surest way to grab readers' attention.

Here are two examples of aggressive, successful teasers:

In Great Britain, competition is fierce on newsstands — which is why, to survive, papers need loud, provocative front-page promos like those in Scotland's Sunday Herald, below.

Colorful teasers aren't just for Page One anymore. Many dailies are now producing catchy promos for every section front, like those on this Asbury Park Press feature page, below.

BREAKING UP TEXT

Reading long columns of text is a tiring chore. But if you break up the gray with occasional subheads, initial caps or dingbats, you can better organize your material — and, at the same time, provide rest stops for the reader's eye.

SUBHEADS

Subheads are the most common way to subdivide long stories (i.e., features or news analyses that run over 30 inches). They're often inserted every 8-10 inches, wherever there's a shift of topic or a logical pause in the commentary. Avoid inserting them at random (which won't help the reader's understanding of the material) or at the very bottom of a leg of type.

Subheads come in a variety of styles, but they're usually bolder than text type:

without first having his wife brought to see him; and they had sent an escort for her, which had occasioned the delay.

Under the guillotine

He immediately kneeled down, below the knife. His neck fitting into a hole, made for the purpose, in a cross plank, was shut down, by

This is a typical style for news subheads: bold type, centered, a bit larger than the text.

Sutherland's trip at 7 p.m. Thursday at Pioneer Courthouse Square. The program is free.

■ **Africa preview:** A slide presentation on Kenya and Tanzania will be shown at 10:30 a.m. Wednesday at Weststar Tour and Travel, 19888 S.E. Stark. The show is a preview of a February trip

This format is used to change topics in stories that consist of short, assorted bits and pieces.

$50 for Oslo, but a seven-day second-class rail pass can be bought for about $70 at rail stations.

WHERE TO STAY

The Fjord Pass program offers discounts on rates at 200 hotels. The pass costs $10 and comes with a list of hotels offering discounts for

This reversed subhead helps organize catalog-style stories into clearly labeled sections.

INITIAL CAPS

Initial caps are a classy way to begin features, columns or specially packaged news stories. They're also a decorative (though non-informational) alternative to subheads for breaking up long columns of text.

Be sure the large cap letter is neatly spaced and aligned, whether it's indented into the text or raised above it:

This is an example of a dropped initial cap. These are usually tucked into the first three or four lines of the text.

Here is a raised initial, which sits above the first line of the text.

Even small graphics and sidebars can begin with initial caps to give the text extra typographic emphasis. Use too many of them, though, and it gets distracting.

DINGBATS

Dingbat is the ridiculous-sounding term used to describe an endless assortment of typographic characters like these:

✔ ❏ ❱ ■ ○ ▲ ❄ ● ✚ ◆ ❀ ♥ ♣ ↔ ◆ ☞ ✛ ★ ✂ ✪

Most dingbats are too silly to use in a sober-minded newspaper. Some, however, are handy for relieving long legs of text (see example at right).

Others, like bullets (•) and squares (■), can help itemize lists within text. Remember, however:

◆ Use bullets or squares for three or more related items. Fewer than that, it looks odd.

◆ Keep bullet items short and punchy. Like this.

◆ Don't overdo it. Use bullets only for emphasis.

had left it in that instant. It was dull, cold, livid, wax. The body also.

❖

There was a great deal of blood. When we left the window, and went close up to the scaffold, it was very dirty; one of the two men who were throwing water

JUMPS

Continued from Page 87

and 4.

◆ **Avoid jumping orphans.** An *orphan* (sometimes called a *widow*) is a short word or phrase that's carried over to the top of a new column or page. Like the first line in this column: "and 4."

Orphans often look clumsy — like typographical errors, even if they aren't. And, as you may have just experienced, it's frustrating enough to reach the end of a column, then be told to turn to page 146, then fumble around trying to *find* page 146, then, when you get to page 146, read something cryptic like "and 4" — at which point you realize you've forgotten the rest of the sentence back on page 87.

And that's why readers dislike jumps.

◆ **Label jumps clearly.** Since jumping is so unpopular, use typography to make it easier. There are two ways to do this:

1) Run *continuation lines* (the lines that tell you where a story is continued) flush right, since that's where your eye stops reading at end of a column. Run *jump lines* (the lines that tell you where a story has been jumped from) flush left, since that's where your eye begins reading at the top of a column.

2) Give each jump a key word or phrase, then highlight it typographically.

Suppose, for instance, you're jumping a story on oat bran. You could run a continuation line that simply says **Turn to page 6.** But that's not too friendly — and it's not very informative. When readers get to page 6, how will they spot the jump?

You'd be wiser to say something like **Please see OAT BRAN, page 6.** And when readers arrived at page 6, they'd find a jump headline like one of these:

MORE ON ▶

◆ **Jumps:** *What they are* — *with guidelines on how to dummy them* **87**

Oat bran: Study proves it prevents heart attacks

Continued from Page One

This is a popular treatment for jump headlines. It treats the key word (or phrase) as a boldface lead-in, then follows with a lightface headline written in standard style. Since the key word is played so boldly, jump stories are easy to spot when readers arrive at the new page. To be effective, jump lines should be set apart from text by both extra spacing and type selection.

Oat bran *Continued from Page One*

This is another common style for jump headlines. It uses only the key word (or phrase) to catch readers' eyes, then adds a rule both for emphasis and to separate the text from any columns running above. One problem: Readers encountering this jump story for the first time won't have any idea what it's about if all the headline says is something like "SMITH."

Study proves oat bran can prevent heart attacks

■ **OAT BRAN,** from Page One

This treatment is rather straightforward: a standard banner headline followed by a boldface key word in the jump line. But is it obvious enough to readers that this is the oat bran story they're searching for? Some would argue that unless the jump headline boldly proclaims a key word or phrase, too many readers may get lost.

◆ **Give jumps design attention.** Remember to package jumps as attractively as you'd package any other story. Many newspapers treat jumps like mandatory blocks of gray slop — ugly leftovers from nice-looking pages. And if your deadlines are tight, you may be forced to blow off jump-page designs. But if there's time, add photos. Create mug-quote blocks. Pull out charts or maps.

To summarize: Jumps will never be popular with readers. But if you can devise a clear, consistent format for packaging jump stories, readers will regard them as minor detours — not major roadblocks. And their benefits to designers (higher story counts and increased layout options on key pages) far outweigh the annoyance they cause readers.

TROUBLESHOOTING

 We're redesigning the front-page masthead of our newspaper. How big and colorful should it be?

You mean the *flag?* The masthead is the staff list that runs on the editorial page; the flag (or nameplate) is the front-page treatment of your newspaper's name.

But on to business. You have a wide range of typographic options, from too dull (left) to too manic (right). Most small-town papers err on the side of dullness, thinking their readers are squarer than they are. Many student papers, on the other hand, create crazed, noisy flags that draw *way* too much attention to themselves and drown out the news below.

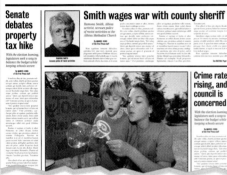

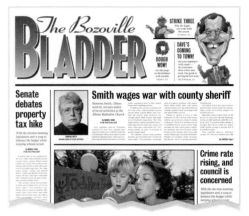

Your best bet: Create prototypes in a variety of styles and sizes, then allow everyone to vote: editors, reporters and especially *readers.*

 Our paper is usually pretty small — 12 pages or less. Do we need to run an index?

Ask anyone who conducts newspaper market research: Readers *love* indexes, roundups, highlights — anything that tells them what you've got and where you've hidden it. Like diners in a restaurant, they want to see what's on the menu.

So even if you're a small paper, give your readers a guide to what's inside. And if an index is difficult to compile — if your paper is just a random collection of 15-inch stories — that may indicate you need to do a better job of organizing topics and providing a mix of briefs, lists, calendars and other regular features.

 We run a row of small promos across the top of our front page every issue. Do readers actually notice those things?

Probably not. Why should they? It's a common problem: Day after day, issue after issue, newspapers run little postage-stamp-sized promos like the one at right. Too often, these promos advertise stories nobody's excited about. Too often, they use tiny, indecipherable images and short, indecipherable headlines. As a result, readers learn to ignore them. And those skyboxes turn into wallpaper.

The solution: Break out of the rut. Mix it up. Design new options that allow you to run three, two or just one *dynamic* image. Use cutouts. Reverse type. Remember: If you don't care about your promos, your readers won't either.

TROUBLESHOOTING

 How do you credit photos taken by someone's family, instead of a newspaper photographer? Or old file photos? Or digitally manipulated images?

When it comes to crediting stories and photos, one solution just won't work for every situation. (For instance, what's your byline wording for a wire-service story that's been expanded and reworked by two of your staff writers?)

In Chapter 8, we'll talk about how essential a good design stylebook is. And every staff's stylebook should contain an entry like the one at right, adapted from The Richmond Times-Dispatch's outstanding 1996 stylebook, anticipating every variation of photo and graphic credits.

If your newspaper runs art and text from a variety of sources, you'll find a guideline like this handy for credit lines and bylines alike. Answering these questions in advance can save valuable time on deadline.

GUIDELINES for CREDIT LINES	
Staff photos:	BENJAMIN BRINK/THE OREGONIAN Photo illustration by TOM TREICK/THE OREGONIAN
Special event staff photos:	JOEL DAVIS/THE OREGONIAN, January 1998
Former staff photos:	THE OREGONIAN
Reporter photos:	KRISTI TURNQUIST/THE OREGONIAN
Free-lance photos:	JOE SMITH/SPECIAL TO THE OREGONIAN
Syndicated material:	©WARNER BROS. RECORDS
Agencies/miscellaneous:	NATIONAL ARCHIVES BBC PHOTOGRAPH LIBRARY ©1995 CAROL PRATT PHOTOGRAPHY
Family photo with date:	1993 FAMILY PHOTO
Family photo without date:	FAMILY PHOTO
File photos:	File photo, 1995
Wire photos:	THE ASSOCIATED PRESS
Wire graphics:	THE ASSOCIATED PRESS N.Y. TIMES NEWS SERVICE
Graphics staff:	STEVE COWDEN/THE OREGONIAN
More than one artist:	DAN AGUAYO, MOLLY SWISHER/THE OREGONIAN
File graphic:	THE OREGONIAN
Shared credit:	Graphic by MIKE MODE, Research by WALLY BENSON/THE OREGONIAN
Digitally altered images:	Illustration by RENE EISENBART/THE OREGONIAN, source material by SUSAN UNDERHILL
Special staff project:	BY THE OREGONIAN STAFF: STEVE COWDEN, artist; RICHARD HILL, writer; MIKE MODE and WERNER BITTNER, contributing artists

 Do readers actually read stories when they jump to another page?

First, the bad news: Very few readers read stories after they jump. In fact, very few readers read more than the first few inches of most stories, whether they jump or not. (If you don't believe this, see page 225 for a survey that will show you how much *your* readers actually read.)

So why don't readers read? They're impatient. They're distracted. They're wary of being bored. They've learned that if a story doesn't get interesting in the first three inches, it probably *never* gets interesting.

But now the good news: If readers care about a story, they'll follow it anywhere. And every story is interesting to *somebody*. Which is why you must write stories as tightly as you can, but run them as long as they need to be.

 In magazines, I see logos and liftout quotes using smaller type than they do in newspapers. How small can those things be?

Many magazines try to push the limits of miniaturization. And because their presswork is so pristine, they can successfully run type and photos much smaller than newspapers normally dare.

But if you're crafty and careful, you can downsize your design components, too. Newspapers that use exotic grids (an 18-column broadsheet, for example) may need to create mug/quote combinations like the one at right — a mere 4 picas wide. But by cropping tightly and selecting condensed fonts, you can keep them both attractive and readable.

Remember: the older your readership, the poorer their eyesight. Student newspapers will be able to miniaturize logos and liftout quotes more successfully than mainstream newspapers.

"How is it that George Washington slept in so many places but never told a lie?"

W e live in a visual age. We're bombarded with movies, videos, photographs and interactive multimedia. We're spoiled. We're impatient. And we're lazy. When we want information, we say *show* me — don't tell me.

Images are strong and seductive. Words take work. So most of us prefer images over words. We'd rather scan the art on that page at right than read this column of text. So what's that mean for news-papers? It means we've entered the age of informational graphics (or *info-graphics* for short). With infographics, newspapers can combine illustration and information into colorful, easily digestible packages.

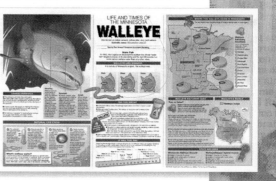

Infographics can be maps. Charts. Lists. Diagrams. They can be created as tiny insets. Or as entire full-color pages.

Do infographics junk up journalism? Some critics of TV and USA Today think so; cartoony charts and goofy graphs just trivialize the news, they say.

But remember: true journalism is *teaching*. You have information; your readers need it; you must teach it to them as quickly and clearly as you can. Sometimes words work best. Other times, information is best conveyed *visually,* not verbally.

Your job, as a designer, is to choose the most effective approach. This chapter will clarify your best options.

CHAPTER CONTENTS

WRITING FOR NON-READERS

It's the first day of a new school year. You're about to begin a tough new class — say, Advanced Biology. You're holding a copy of the textbook you'll be using this term. On the cover, there's a cute photo of a red-eyed tree frog. But when you turn inside, page after page after page after page after page after page after page looks like this:

Your heart sinks. Your intestines churn. "Hoo boy," you groan. If only they'd used maybe a little art to break up all that gray — you know, something like this:

The fact is, you've come face to face with a cruel and ancient law of publication design:

IN VAST QUANTITIES, TEXT LOOKS REALLY DULL

Yes, deep in the childish recesses of our brains, we all share the same dread of text. It's like math anxiety: *text anxiety.* In small doses, text is tolerable. But when we're wading through deep heaps of it, we hate it. Even worse, we hate *writing* it.

And yet we all need to communicate, to share information, to express ideas. It's a primal urge — one that has evolved over the ages. In ancient, prehistoric times, our ape-like ancestors struggled to piece together this primitive kind of narrative:

> Me hungry! Kill moose! Eat meat!

As the centuries dragged by, early humans polished their delivery. After eons of practice, they became skilled storytellers:

> . . . So there I was, trapped in the Cave of Death, staring into the drooling jaws of Mongo, The Moose From Hell . . .

This narrative style reached a climax with the invention of the romance novel:

> . . . Helga, the voluptuous Moose Queen, slowly peeled off her gown and uttered a moan as the mighty Ragnar clenched her in his tawny arms. "Be gentle, my warrior," she sighed as he ran his tongue down her neck. "Yaarrrrrgggh!" he grunted. Helga's bosom heaved with desire as Ragnar's hungry kisses grew ever more furious. *"Yes!"* she cried. *"Yes!"*

WRITING FOR NON-READERS

So far, so good. And perhaps that kind of narrative is what the written word does best – storytelling that transports us *emotionally* from one place to another. As opposed to this type of narration:

> Consumption of moosemeat declined significantly during the first three decades of the ninth century. Marauding hordes of Vikings averaged 14.3 pounds per capita of moosemeat monthly during that period, while consumption among Druids climbed to 22.8 pounds (for males) and 16.3 pounds (females) during winter months, up from 15.5 pounds in summer.

"Yaarrrgggh," as Ragnar might say. For most readers, data turns deadly dull in narrative form. Our eyes glaze. Our bosoms heave. It feels like we're staring into the drooling jaws of The Statistician From Hell.

Such data might work better as a chart or graph:

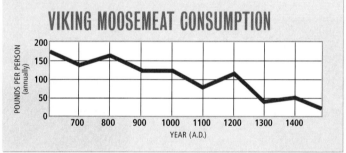

That's a fine match of medium and meaning. It's quick. It's visual. It's precise. And best of all, it's interesting — almost interactive.

It's *non-text,* a form of writing that's — well, a kind of *non*-writing. Which is perfect for today's generation of non-readers.

Now, these *non-text* formats work fine for business reports, government statistics, news features and so on. But they won't work for everything. Take Helga the Moose Queen; something's missing when you write her love scene like this:

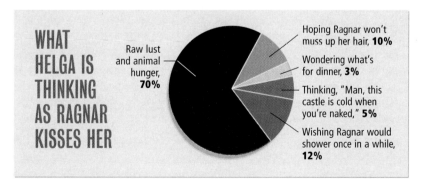

Obviously, some types of information are best expressed in narrative form. And that's fine. Usually.

But pause for a moment and ponder these past two pages. Notice how *visually* we presented our material. Would we have held your interest if we'd explained it all with normal narrative text?

WRITING FOR NON-READERS

So what's it all mean to newspapers? It means that editors, writers and designers must realize that today's readers are visual. Impatient. Easily bored. Readers absorb data in a variety of ways: through words, photos, charts, maps, diagrams. They want news packaged in a sort of "information mosaic": a combination of text, data and images that approaches complex issues from fresh new angles.

Years ago, when big stories broke, editors assigned reporters to write miles and miles of pure text. (And yes, readers would read it.) Today, when big stories break, editors assign reporters, photographers *and* graphic artists to make concepts understandable in both words *and* pictures.

For instance, when the Hindenburg crashed in 1937, most newspapers ran a photo or two but relied upon yards of text to describe the tragedy. If that disaster struck today, you'd see pages like the one at right below. Which do you prefer?

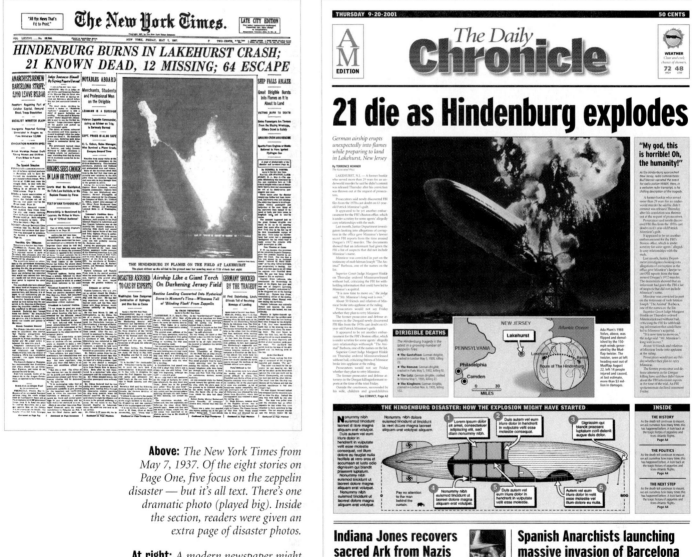

Above: *The New York Times from May 7, 1937. Of the eight stories on Page One, five focus on the zeppelin disaster — but it's all text. There's one dramatic photo (played big). Inside the section, readers were given an extra page of disaster photos.*

At right: *A modern newspaper might package the story using a locater map, a diagram, a list of previous accidents and a sidebar transcribing the live radio broadcast of the tragedy. These days, too, that lead photo would probably run in color.*

SIDEBARS & INFOGRAPHICS

A *sidebar* is any short feature that accompanies a longer story. An *infographic* (short for "informational graphic") blends text and illustrations to convey information visually — clarifying the facts with charts, maps or diagrams.

Years ago, sidebars and infographics were considered optional. Nowadays, they're essential for effective newspaper design. Here's why:

◆ They carve up complicated material into bite-size chunks.

◆ They offer attractive alternatives to gray-looking text.

◆ They let writers move key background information, explanations or quotes out of the narrative flow of the text and into a separate, highly visible spot.

◆ Because they're tight, bright and entertaining, they add reader appeal to any story, whether news or features. In fact, they often attract higher readership than the main story they accompany.

Sidebars are usually specially packaged — boxed or screened — to help them stand apart from the main story. Notice how that's true for our sidebar below: a visual index to all the sidebars and infographics we'll explore in the pages ahead.

SIDEBARS & INFOGRAPHICS: THE MAJOR CATEGORIES

FAST–FACT BOX
Nuggets pulled from the story to give readers a quick grasp of who, what, when, where or why.

Q & A
A way to ask and answer hypothetical questions, or capture an interview's verbatim dialogue.

TABLE
A way to arrange data into columns or rows so readers can make side-by-side comparisons.

BIO BOX
Brief profiles of people, places, products or organizations, itemized by key characteristics.

PUBLIC–OPINION POLL
A survey that samples opinion on a current topic, collating responses into key categories and statistics.

RATINGS
A list of people or products (sports teams, movies, etc.) that lets critics make predictions or evaluations.

LIST
A series of names, tips, components, previous events — any categories that add context to a story.

QUOTE COLLECTION
A series of relevant comments on a topic by newsmakers, readers or random passers-by.

TIMELINE
A chronological table or list of events highlighting key moments in the history of a person, place or issue.

GLOSSARY
A list of specialized words with definitions (and/or pronunciations) to help clarify complex topics.

FEVER CHART
A way to measure changing quantities over time by plotting key statistics as points on a graph.

STEP–BY–STEP GUIDE
A brief "how-to" that explains a complex process by walking readers through it one step at a time.

CHECKLIST
A list of questions or guidelines that itemize key points or help readers assess their own needs.

BAR CHART
A way to compare two or more items visually by representing them as columns parked side by side.

DIAGRAM
A plan or drawing designed to show how something works or to explain key parts of an object or process.

QUIZ
A short list of questions that let readers interact with a story by testing their understanding of the topic.

PIE CHART
A way to compare the parts that make up a whole — usually measuring money or population percentages.

MAP
A quick way to give readers geographical information by showing the location of events relevant to a story.

FAST FACTS

THE KLAMATH FALLS QUAKE

◆ **MAGNITUDE:** 5.4 on the Richter scale

◆ **TIME:** 8:29 p.m. Monday

◆ **EPICENTER:** About 15 miles northwest of Klamath Falls, Ore.

◆ **DEATHS:** One person died when boulders crushed his car on U.S. 97 near Chiloquin

◆ **AFTERSHOCKS:** 5.2 and 4.5

This fast-fact box accompanied a long news story on an Oregon earthquake, delivering essential facts at a glance.

SUPER BOWL XXXV

TEAMS: New York Giants (NFC) and Baltimore Ravens (AFC)

SITE: Raymond James Stadium, Tampa, Fla.

KICKOFF: 6:21 p.m.

ON TV: KGW-TV (Channel 8)

ON RADIO: KRXX (91.3 FM)

BETTING LINE: Baltimore by 3

Boxes like these could accompany any sports, entertainment or political event — and you can add art, as well.

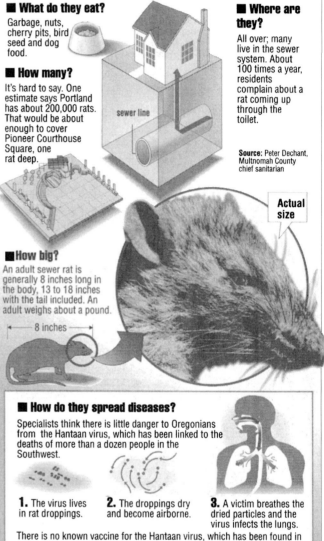

RAT SNAPSHOT

Nobody likes to admit to having rats, but Multnomah County has them. Here's a snapshot of the rat population.

■ **What do they eat?**
Garbage, nuts, cherry pits, bird seed and dog food.

■ **How many?**
It's hard to say. One estimate says Portland has about 200,000 rats. That would be about enough to cover Pioneer Courthouse Square, one rat deep.

sewer line

■ **Where are they?**
All over; many live in the sewer system. About 100 times a year, residents complain about a rat coming up through the toilet.

Source: Peter Dechant, Multnomah County chief sanitarian

Actual size

■**How big?**
An adult sewer rat is generally 8 inches long in the body, 13 to 18 inches with the tail included. An adult weighs about a pound.

8 inches

■ **How do they spread diseases?**
Specialists think there is little danger to Oregonians from the Hantaan virus, which has been linked to the deaths of more than a dozen people in the Southwest.

1. The virus lives in rat droppings.
2. The droppings dry and become airborne.
3. A victim breathes the dried particles and the virus infects the lungs.

There is no known vaccine for the Hantaan virus, which has been found in Asia and Europe but is extremely rare in the United States.

One of the best ways to present news in a hurry is to distill the *who-what-when-where-why* of a story into a concise package. With a fast-fact box, you can add graphic variety to story designs, introduce basic facts without slowing down the text, and provide entertaining data for those who may not want to read the text at all.

Fast-fact boxes can deliver statistics. History. Definitions. Schedules. Trivia. They can update readers on what just happened — or try to explain what'll happen next.

They can even display stand-alone "factoids," like the one at left, that lure readers into the story in the same way that liftout quotes do.

> The average full-time salary of a black female college graduate is less than that of a white male high-school dropout.

WORM FARMING AT A GLANCE

Want to start your own worm farm? It's easy. Just dig these earthy facts:

◆ An earthworm can eat half its weight in food each day.

◆ People are either boys or girls, but earthworms are both male and female.

◆ An earthworm matures to breeding age in 60-90 days given proper food, care and environmental quality.

◆ A mature breeding worm can produce an egg capsule every 7-10 days.

◆ An egg capsule will hatch in 7-14 days.

◆ An egg capsule contains 2-20 baby earthworms, with an average of 7 per capsule.

◆ One breeder can produce 1,200-1,500 worms per year; 2,000 breeders can produce 1 billion worms in two years.

FOR MORE INFO:

◆ *Worm Digest* is published four times a year. To subscribe, send $4 to Worm Digest, Box 544, Eugene, OR 97440.

◆ For tips on building a wormbox, call Metro Recycling Information at 234-4000.

The fast-fact box above tells you everything you need to know about urban rats: their diet, their size, their location, etc. Notice how tightly written the text is. The worm-farming sidebar at left offers a variety of "worm trivia" — but the box that tells readers where to go for more information is a helpful addition.

BIO BOXES

The 19th-century philosopher Karl Marx wrote a revealing self-portrait while playing a Victorian parlor game called "Confessions." Here's what he confessed:

Favorite virtue in a man: *Strength*
Favorite virtue in a woman: *Weakness*
Your idea of happiness: *To fight*
Your idea of misery: *Submission*
Favorite occupation: *Bookworming*

Favorite poet: *Shakespeare, Aeschylus, Goethe*
Favorite hero: *Spartacus*
Favorite color: *Red*
Favorite motto: *De omnibus dubitandum*
(*"You must have doubts about everything"*)

You can gain surprising insights through biographical bits like these. By listing facts in a *bio box*, you can quickly profile almost any person, place or thing. Bio boxes can stick to a strict *who-what-when-where-why* — or they can spin off on specialized (or humorous) tangents, as these examples show:

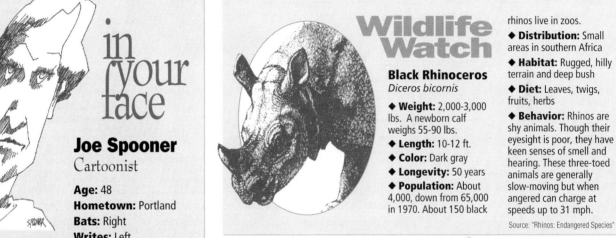

in your face

Joe Spooner
Cartoonist

Age: 48
Hometown: Portland
Bats: Right
Writes: Left

Occupation: Cartoonist and bon vivant
Heroes: Gary Larsen, Dave Barry, Paul Rubens
Ambition: To have someone else pay my health-insurance premiums
Motto: "Je n'ai pas m'empecher de rire — ha-ha-ha!" (*I cannot stop myself from laughing.*)
Forms of exercise: Running and limping
Favorite spouse: Patti
Favorite food: Turkey pie
Favorite drink: Guinness Stout
Favorite dessert: Gobi
Favorite subject in school: Spelling
All-time favorite album: *Abbey Road*
Favorite new music: *Abbey Road* the CD.
Person whose lifestyle I'd most like to emulate: Ernest Hemingway, except for that part about the shotgun
Proudest feat: Getting through five years of flying in the Air Force without killing myself
Bedside book: American Heritage Dictionary
Last words: "Couldn't I just stay until the next commercial?"

Wildlife Watch

Black Rhinoceros
Diceros bicornis

◆ **Weight:** 2,000-3,000 lbs. A newborn calf weighs 55-90 lbs.
◆ **Length:** 10-12 ft.
◆ **Color:** Dark gray
◆ **Longevity:** 50 years
◆ **Population:** About 4,000, down from 65,000 in 1970. About 150 black rhinos live in zoos.
◆ **Distribution:** Small areas in southern Africa
◆ **Habitat:** Rugged, hilly terrain and deep bush
◆ **Diet:** Leaves, twigs, fruits, herbs
◆ **Behavior:** Rhinos are shy animals. Though their eyesight is poor, they have keen senses of smell and hearing. These three-toed animals are generally slow-moving but when angered can charge at speeds up to 31 mph.

Source: "Rhinos: Endangered Species"

When it comes to bio boxes, animals can enjoy the same treatment as people. Above, this tightly-written "Critter of the Week" profiles a celebrity from the animal kingdom.

ESTONIA: FACTS AND FIGURES

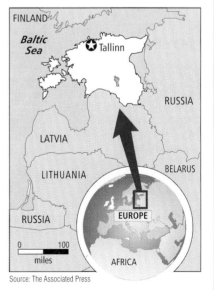

■ **AREA:** At 45,000 square kilometers (about the size of New Hampshire and Vermont combined), Estonia is one of the smallest states in Europe.

■ **HISTORY:** Estonia was dominated by Germans since the 13th century and by Swedes in the 16th-18th centuries. Later ruled by Russia, Estonia became independent after 1917 and was forcibly annexed by the Soviet Union in 1940. It won independence from the Soviet Union in 1991.

■ **POPULATION:** About 30 percent of Estonia's 1.6 million people are ethnic Russians, many of whom moved to Estonia after its annexation by the Soviets.

■ **RUSSIAN TROOPS:** 2,400 Russian soldiers remained in Estonia as of December.

■ **ECONOMY:** Estonian currency, the kroon, has held relatively steady since its introduction in 1992. The GNP rose 3 percent in 1992, making the Estonian economy one of the fastest-growing in Europe.

Source: The Associated Press

Above all else, bio boxes must contain tightly written and meaningful information. But as this sidebar shows, they can also use humor to capture the true spirit of their subject.

This type of fast-facts treatment has appeared in almanacs and encyclopedias for years, summarizing the who-what-when-where of countries around the globe. When used to accompany news stories, these sidebar boxes give readers background data at a glance.

LISTS

What are the most popular movies of all time? The largest fast-food chains? The best-selling Christmas toys? The most prestigious universities?

Ours is a culture obsessed with keeping score. We're *dying* to know who's the richest, the biggest, the fastest, the best. And often the fastest and best way to convey that information is by compiling lists like these.

Lists can be used to itemize tips, trends, winners, warnings — even religious commandments, as the Old Testament proclaimeth. And as David Letterman has shown, they can even get laughs as a comedy bit on late-night talk shows ("*. . . and the Number One Least Popular Fairy Tale:* **Goldilocks and the Tainted Clams!**").

GOT ANY BANANA PUDDING, ELVIS?

These items were to be kept at Graceland "for Elvis — AT ALL TIMES — EVERY DAY":

Fresh ground round	Banana pudding
One case regular Pepsi	Ingredients for meat loaf
One case orange drink	Brownies
Six cans of biscuits	Chocolate ice cream
Hamburger buns, rolls	Fudge cookies
Pickles	Gum (Spearmint, Juicy
Potatoes and onions	Fruit, Doublemint —
Assorted fresh fruit	three packs each)
Cans of sauerkraut	Cigarettes
Wieners	Dristan
Milk, half and half	Super Anahist
Lean bacon	Contac
Mustard	Sucrets
Peanut butter	Feenamint gum

Source: The Associated Press

Random lists: *These items run in no particular order, but stacking them in rows makes them more interesting (and easier to read) than if they'd run in the middle of a paragraph of text.*

HOW TO STAY YOUNG
by Leroy "Satchel" Paige

Satchel Paige, the first black pitcher in major-league baseball, was 59 when he played his final game. Here are his tips for staying youthful:

◆ Avoid fried meats, which angry up the blood.

◆ If your stomach disputes you, lie down and pacify it with cool thoughts.

◆ Keep the juices flowing by jangling around gently as you move.

◆ Go very lightly on the vices, such as carrying on in society. The social ramble ain't restful.

◆ Avoid running at all times.

◆ Don't look back. Something may be gaining on you.

Source: The People's Almanac

Lists itemized with bullets: *Here, we use a combination of dingbats, a hanging indent and extra leading to separate items. Note, too, how the introduction is written in smaller italic type.*

AND THE OSCAR GOES TO...

BEST PICTURE
Gladiator

BEST ACTOR
Russell Crowe, *Gladiator*

BEST ACTRESS
Julia Roberts, *Erin Brockovich*

BEST SUPPORTING ACTOR
Benicio Del Toro, *Traffic*

BEST SUPPORTING ACTRESS
Marcia Gay Gaghan, *Pollock*

BEST DIRECTOR
Steven Soderbergh, *Traffic*

Lists arranged by categories: *Note the typographic elements at work here: boldface caps, italics, extra leading between items. Lists are often centered (like this) rather than flush left.*

THE ESSENTIAL CYBERPUNK LIBRARY

Cyberpunk: Think "Blade Runner." To get familiar with this futuristic literary genre, we recommend:

AMY THOMSON, *"Virtual Girl":* A lovely woman from a Virtual Reality landscape is forced to survive in an alien environment.

K.W. JETER, *"Farewell Horizontal":* A rebel in a horizontal world seeks to attain status by achieving a vertical existence.

ORSON SCOTT CORD, *"Ender's Game":* A civilization under siege breeds a race of military geniuses to battle invading aliens.

WILLIAM GIBSON/BRUCE STERLING, *"The Difference Engine":* The 19th-century Victorian world is moved by a steam-powered computer.

— Paul Pintarich

Lists with commentary: *Any subjective Top 10 list — whether it ranks pop tunes or presidents — will benefit by adding bite-size evaluations that analyze each entry or offer advice to readers.*

MOST COMMON LAST NAMES IN THE U.S.

1. *Smith*
2. *Johnson*
3. *Williams*
4. *Jones*
5. *Brown*
6. *Miller*
7. *Davis*
8. *Anderson*
9. *Wilson*
10. *Thompson*

Top 10 lists: *Notice how the numbers are boldface — and how the periods following the numbers are all vertically aligned.*

THE WORLD'S DEADLIEST DISEASES
(with annual deaths)

		
1	**Cardiovascular diseases**	12 million
2	**Diarrheal diseases**	5 million
3	**Cancer**	4.8 million
4	**Pneumonia**	4.8 million
5	**Tuberculosis**	3 million
6	**Chronic Lung Disease**	2.7 million
7	**Measles**	1.5 million
8	**Hepatitis B**	1.2 million
9	**Malaria**	1.2 million
10	**Tetanus (neonatal)**	560,000

Source: World Health Organization

Top 10 lists with data: *Often it's not enough simply to show rankings — you need statistical support. Here, the death totals run flush right alongside the disease names. Rules and reversed numbers add graphic organization.*

LISTS

THE HARPER'S INDEX

Back in 1984, Harper's Magazine began publishing an addictingly clever page near the beginning of each issue. As editor Lewis Lapham described it, the Harper's Index offers "numbers that measure, one way or another, the drifting tide of events." A typical Harper's Index might include such items as:

> Number of Americans who drink Coca-Cola for breakfast: 965,000
> Percentage of America's lakes that are unfit to swim in because of pollution: 40
> Average weight of a male bear in Alaska: 250 pounds
> In Pennsylvania: 487 pounds
> Number of times Barney Fife wore a dress on "The Andy Griffith Show": 3
> Abortions per 1,000 live births in New York City: 852
> Number of times the average child laughs each day: 400
> Number of times the average adult laughs: 15

As you can see, the basic index format is consistent: a setup (in text) followed by the payoff (usually a number). But what makes these lists fascinating are the strange, curious, often surprising combinations of random factoids — some of which, when juxtaposed like those statistics on laughing, raise provocative cultural questions.

As with most sidebars, the juicier your facts, the more entertaining your list.

GLOSSARIES & DICTIONARIES

Think of dictionaries as immensely long lists. While ordinary dictionaries compile alphabetical lists of words in general use (along with their pronunciations and meanings), specialized dictionaries, or *glossaries*, zero in on subjects that may be unfamiliar to readers. And since every subculture — from skateboarders to Pentagon generals to newspaper designers — has its own lingo, by compiling lists of new or unusual words you can help readers expand their vocabularies while deciphering complex topics.

MOUNTAIN BIKE SLANG

Auger: to take soil samples, usually with your face, during a crash. See *eat mud.*

Bacon: scabs.

Bomb: to ride with wild disregard for personal safety.

Cob clearer: the lead rider who clears out all the spider webs for following riders.

Cranial disharmony: how your head feels after augering.

Eat mud: to hit the ground face first. Synonyms: *auger, hunt moles, taste the trail, go turf surfing, use your face brake.*

Gravity check: a fall.

Gutter bunny: a bicycling commuter.

Mud-ectomy: a shower after a ride on a muddy trail.

POD: Potential Organ Donor.

Potato chip: a wheel that has been bent badly, but not taco'd.

Prang: to hit the ground hard, usually bending or breaking something.

Prune: to use your bike or helmet to remove leaves and branches from the surrounding flora. Usually unintentional.

Snowmine: a rock or log that's hidden by snow on the trail.

Steed: your bike, the reason for your existence.

Winky: a reflector.

Compiled by Doug Landauer

This glossary offers outsiders — that is, most of us "normal" folks — a glimpse of the jargon used by mountain bikers. Though most slang terms are short-lived and regional, some occasionally slip into the mainstream. And they certainly paint a colorful cultural portrait.

FAKING FRENCH
A quick guide to common words and phrases

bon appetit (*BOH* nap-uh-teet): good appetite; a toast before eating.

carte blanche (kart *BLAHNSH*): full discretionary power.

c'est la vie (say la *VEE*): that's life.

déja vu (*DAY*-jah *VOO*): the sensation that something has happened before.

faux pas (fowe *PAW*): a social blunder.

je ne sais quoi (zhu nu say *KWAH*): I don't know what; the little something that eludes description.

joie de vivre (zhwah duh *VEEV*-ruh): love of life.

raison d'etre (*RAY*-zone *DET*-ruh): reason for being.

vis-à-vis (vee-zuh-*VEE*): compared to.

Source: The World Almanac

News stories often introduce readers to foreign words, names, and phrases. And whether a story discusses Russian politicians or Chinese athletes, pronunciation guides increase our word power.

FUN FLICK FACTS

One of the best ways to display interesting trivia is in a rail down the edge of the page, like this:

Number of movies where we've seen the naked posterior of:
◆ Al Pacino: **2**
◆ Mel Gibson: **4**
◆ Rob Lowe: **5**
◆ Dennis Quaid: **5**

Number of movies with the word "scream" in the title: **78**

Stars who made their debuts in Woody Allen movies: **Sigourney Weaver** (*Annie Hall*), **Sylvester Stallone** (*Bananas*), **Sharon Stone** (*Stardust Memories*)

Amount Humphrey Bogart bequeathed in his will to anyone claiming to be his heir: **$1**

Of actors getting top billing, the percentage that were women in:
◆ 1920: **57**
◆ 1990: **18**

Number of people killed by Santa Claus in the 1984 film *Silent Night, Deadly Night:* **9**

Number of heads smashed against walls in *Terminator 2: Judgment Day:* **26**

Most re-released film of all time: **"Gone With the Wind"** (10 times)

Percentage of airline passengers who say their favorite part of a flight is:
◆ the movie: **25**
◆ the in-flight magazine: **27**
◆ the peanuts: **19**

Best-selling candy in Loew's theaters: **Nestlé's Raisinets**

Number of minutes Zsa Zsa Gabor swims nude every day: **30**

Sources: Premiere Magazine, Entertainment Weekly, Willamette Week, Harper's Magazine.

CHECKLISTS

HOW YOU CAN HELP THE EARTH

It's never too late to change your habits, to begin making Earth-saving choices every day. Ordinary people CAN make a difference. And here are a few ways you can help.

WHEN YOU DRIVE

❏ Save gas by avoiding sudden stops and starts. If idling for more than a minute, turn off your engine.

❏ Avoid jackrabbit starts. Better yet, don't speed at all.

❏ Avoid air conditioning. The largest source of ozone-depleting CFC emissions in this country is car air-conditioning.

❏ Buy a fuel-efficient car. Increasing fuel-efficiency standards by a single mile per gallon would save 5.9 billion gallons of gas a year.

❏ Try to get there *without* driving: walk, bicycle, take the bus. Carpool.

WHEN YOU SHOP

❏ Bring your own reusable shopping bag.

❏ Buy organically grown food and favor locally grown products.

❏ Buy in bulk. Repackage in smaller portions with reusable storage containers for pantry or freezer.

❏ Look for unbleached paper versions of coffee filters, milk cartons, toilet paper and paper towels.

❏ Avoid products using excessive packaging. Tell store managers how you feel about over-packaging.

❏ Avoid products made from endangered species or taken illegally from the wild. Before buying a pet or plant, ask the store owner where it came from.

❏ Instead of buying them, rent or borrow items you don't use often, and maintain and repair the things you own to make them last longer.

WHEN YOU DO LAUNDRY

❏ Use detergents without phosphates. Better yet, use soap flakes.

❏ Use chlorine bleach sparingly. Or switch to a non-chlorine bleach.

❏ Only run full loads. Set up a rack to dry small loads (socks or underwear). Consider drying with solar power on an outdoor clothesline.

❏ Keep your dryer's lint trap clean.

❏ When buying a new washing machine, consider a front-loading washer. They use 40 percent less water. When buying a new dryer, consider an energy-efficient gas model, or an electric model with energy-saving features.

Most lists are passive — that is, they itemize information in a concise way, but they don't really ask readers to *do* anything.

But suppose you want to engage readers more actively? To force them to grab a pencil and *interact*? That's dynamic newspapering. And that's what we'll explore in the pages ahead.

Checklists, for instance, are instantly interactive. They can be simple, like this checklist of Macaroni & Cheese ingredients:

❏ **Macaroni** ❏ **Cheese**

Or they can be complex and decorative, compiling tips, asking questions, encouraging responses. The important thing is to *get the reader involved* — to make information as accessible and relevant as you can.

CHILD-CARE CHECKLIST

Not sure what to look for at day-care centers? Here are questions to ask.

■ **How long has this center been operating?**

■ **What kind of training have staff members had?**

■ **What is the child-to-teacher ratio?** Experts say it should be no more than 4:1 for infants, 10:1 for toddlers.

■ **Are meals provided?** If so, what's on the menu?

■ **Are facilities clean and well-maintained?** Are child-safety precautions observed: heat covers on radiators, safety seals on electrical outlets, etc.?

■ **Is there plenty of room for children to work and play?** Are play materials available and appropriate for different age levels?

■ **Are there facilities for taking care of sick children?**

■ **Most important: Do the children look happy and occupied?** Trust your instincts.

IS YOUR HOME BURGLAR-PROOF?

	YES	NO
1. Are exterior doors able to withstand excessive force?	☐	☐
2. Are exterior doors secured with deadbolt locks?	☐	☐
3. Do all exterior doors fit snugly in their frames?	☐	☐
4. Are door hinges pinned to prevent their removal?	☐	☐
5. Are garage doors and windows secured with locks?	☐	☐
6. Does your basement door have extra protection?	☐	☐
7. Is there a wide-angle viewer on the entrance door?	☐	☐
8. Are sliding-glass doors secure against forcing?	☐	☐
9. Are double-hung windows secured with extra locks?	☐	☐
10. Do basement windows have metal screens or locks?	☐	☐
11. Are trees & shrubs trimmed from doors & windows?	☐	☐
12. Are all entrances well-lighted at night?	☐	☐

All three checklists on this page strive to be interactive, either by offering user-friendly tips, by asking a series of questions, or by letting readers quiz themselves with check-off boxes for their answers.

Q&A's

Q: **What's the deal here? Why is this sentence in boldface? And what's with that little "Q" in the dark box?**

A: Good questions. *Journalistically*, we've changed our approach. Rather than conveying information in the usual way — as narrative text in monologue form — we're printing a verbatim transcript of a conversation. *Typographically*, we're giving each voice in this dialogue a distinct identity. The interviewer speaks in boldface sans-serif, while the interviewee speaks in serif roman. And *legally*, I'm interviewing myself because my original plan for this page went down the toilet. I was going to reprint a juicy Q&A with a famous rock star, but the legal clearances got mucked up. So you're stuck with *me* instead.

Q: **A famous rock star? Really? Which one?**

A: Forget it. It's just not gonna happen. I tried, but some editors can be real pinheads when it comes to sharing *old material they're never going to use again anyway.*

Q: **Was there anything, uh, *juicy* in that interview you'd like to share with us?**

A: No. Something about sleeping with Madonna, as I recall. But let's get back to our discussion of infographics, shall we? When you run a Q&A, you want to make sure each voice gets proper spacing, leading and —

Q: **Madonna? Really? Who slept with Madonna?**

A: Look, I don't want to *discuss* it now. Let's talk about Q&As. Like, how effectively they can capture the spirit of an interview, making you feel as if you're actually *eavesdropping* on someone else's conversa—

Q: **Was it Sting? Jim Carrey — wait, no... he's not a rock star... Hey! I know: Hootie & the Blowfish!**

A: Huh?

THE STRAIGHT POOP

BY WALT POOPUS

Does Coca-Cola contain actual cocaine? Was there ever a time when it did?
— **Pat Minniear, Boulder, Colo.**

When druggist John Pemberton brewed his first batch of "French Wine Coca (Ideal Nerve and Tonic Stimulant)" back in 1885, it contained both wine and cocaine. A year later the wine was removed, caffeine and cola nuts were added — and Coca-Cola was born. The original Coke contained (and presumably still contains) three parts coca leaves to one part cola nut. It was advertised as a medicine that would cure headaches, hysteria and melancholy.

Over the years, Coca-Cola quietly switched from fresh to "spent" coca leaves (minus the actual cocaine). Coke's true formula, however, remains a mystery — and its secret ingredient 7X is known to only a handful of Coke employees.

This popular type of Q&A — a stand-alone special feature — gives bold display to a single reader query.

AHOY, VEY!

An allegedly true radio conversation, from the Chief of Naval Operations:

VOICE 1: Please divert your course 15 degrees to the north to avoid a collision.

VOICE 2: Recommend you divert YOUR course 15 degrees south to avoid a collision.

VOICE 1: This is the captain of a U.S. Navy ship. I say again, divert your course.

VOICE 2: No. I say again, you divert YOUR course.

VOICE 1: *THIS IS THE AIR-CRAFT CARRIER ENTERPRISE. WE ARE A LARGE WARSHIP OF THE U.S. NAVY. DIVERT YOUR COURSE NOW!*

VOICE 2: This is a lighthouse. Your call.

It's not a Q&A — but dialogue can make an effective sidebar.

Q&A: INDIVIDUAL RETIREMENT ARRANGEMENTS

What is an IRA?
An "individual retirement arrangement" allows you to save up to $2,000 annually in a special account for your later years. You can postpone paying taxes on your earnings until you begin making withdrawals at age 59½.

What are its tax advantages?
You can fully deduct those $2,000 contributions from your income on your tax return if you aren't covered by a retirement plan at work. If you *are* covered and earn less than $35,000 for single or $50,000 for married taxpayers, you may be able to deduct all or part of your contribution.

What if I can't deduct any of my contribution?
They still are tax-advantaged; earnings on your money accumulate on a tax-deferred basis. That means faster accumulation and more money in the pot at the end.

This "explainer" sidebar poses typical questions readers might ask — an effective way to decode confusing subjects.

QUIZZES

Above: *This quiz from The Oregonian lets readers test their knowledge of lunch-counter lingo. When a waitress tells the cook to "keep off the grass," does that mean hold the vegetables? The lettuce? The cole slaw?*

Left: *This full-page quiz asks, "How thrilling is your life story?" You earn points if you've seen a ghost, survived a plane crash, spent time in jail, etc. — and by totaling your points, you can gauge your "gusto quotient." This feature was enormously popular with readers, largely because it's so offbeat and interactive.*

Most newspaper stories are written in third-person past-tense: THAT GUY over THERE did THAT THING back THEN. As a result, readers often feel disconnected. Detached. Left out.

That's why quizzes are so successful. They're a way to let readers participate in a story, whether the topic is health *(Are You a Candidate for a Heart Attack?)*, sports *(The Super Bowl Trivia Test)* or hard news *(Are You Prepared for an Earthquake? Test Yourself)*. Quizzes, after all, are a kind of game, and readers love games. Feature pages, in fact, sometimes use game-board parodies *(How to Win the Diet Game)* to explore and satirize cultural trends.

Most of the time, you'll need to provide quiz answers somewhere in the paper. But if you're running a contest or reader poll, you'll need to include a mail-in address and formulate a system for processing masses of entries — as well as a plan for a follow-up story that tabulates the results.

As any student knows, tests and quizzes come in a wide variety of formats: true/false, multiple choice, matching and so on. On the next page, we've displayed the most popular quiz formats for newspapers:

QUIZZES

1. How many Elvis albums reached Number One?

2. What was Elvis' major in high school?

3. In 1955, Elvis and his group were rejected when they auditioned for *Arthur Godfrey's Talent Scouts.* Who went on to win that competition?

4. What was Elvis' middle name?

5. What was Elvis' ironclad rule during concerts?

6. Who was Elvis' favorite movie actor as a teen-ager?

7. Which of Elvis' records was his own favorite?

8. What was the name of Elvis' flamboyant manager?

9. How much did Elvis weigh when he died?

10. What was Elvis doing when he died?

ANSWERS

1) None. 2) Shop. 3) Pat Boone. 4) Aron. 5) He never took requests. 6) Tony Curtis. 7) *It's Now or Never.* 8) Col. Tom Parker. 9) 255 pounds. 10) He was on the toilet reading a book on the Shroud of Turin.

This is a typical format for a short trivia test. Note the boldface numbers, the hanging indent, the extra leading between questions. To conserve space, we've run the answers in paragraph form in the answer key. Are they easily readable?

1. Which uses the most energy?
a) Stove
b) Refrigerator
c) Washing machine

2. Which form of energy is most environmentally friendly?
a) Nuclear power
b) Natural gas
c) Coal

3. What percentage of tropical rain forests still exist?
a) 80
b) 50
c) 20

4. How long does it take an aluminum can to decompose?
a) 50 years
b) 150 years
c) 500 years

5. What state has the highest level of carbon dioxide emissions?
a) California
b) New Jersey
c) Texas

6. Which consumes the most water?
a) Washing machine
b) Dishwasher
c) Toilet

ANSWERS

1. (a) But gas stoves are more efficient than electric models. 2. (b) 3. (b) They originally covered 12 percent of the earth; today they cover 6 percent. 4. (c) 5. (c) 6. (c)

Another familiar quiz format. Here, we've boldfaced the questions and aligned everything flush left. The answer box has been printed upside-down to keep readers from cheating — and also because many readers don't WANT to be able to peek at the answers.

Is your job burning you out? For each "yes" answer, give yourself the number of points shown, then add your total. **SYMPTOM POINTS**

1. My job consists of boring, repetitive tasks2
2. It's not likely that I'll be promoted anytime soon2
3. When I'm overloaded with work, there's no one to help me3
4. I have more work to do than I could possibly finish...................3
5. My boss and colleagues are extremely critical of my work4
6. I've been getting sick more frequently lately4
7. I'm using more alcohol/tranquilizers than I probably should5
8. I've lost all sense of commitment and dedication to my job5
9. I act depressed and irritable around friends and family.............5
10. I fantasize acts of violence against my boss..............................7

SCORING YOURSELF

0-10 points: Your job stress is relatively normal. **10-20:** Moderate stress. Cultivate healthy habits to keep yourself optimistic. **20-30:** Stress is affecting your life negatively. Time to consider a change. **30-40:** Get some relief before your job seriously undermines your health.

Unlike the quizzes above, self-appraisal tests have no right or wrong answers. Rather, these tests are checklists that allow readers to evaluate their behavior. Like other exercises in pop psychology, these tests often try to point out problems readers may be unaware of.

1. Favorite TV comedy _____

2. Favorite TV drama _____

3. Favorite TV actress _____

4. Favorite TV actor _____

5. Favorite TV theme song _____

6. Favorite TV news anchor _____

7. Favorite TV talk-show host _____

8. Favorite TV commercial _____

MAIL TO:
Television Survey
The Bugle-Beacon
P.O. Box 1162
Portland, OR 97207

FAX TO:
(503) 221-8069

Entries must be received by noon Monday, April 14. One entry per family, please.

You don't need to add fill-in blanks for most quiz answers, because they take up too much space. But if you want readers to DO something with their answers — add up scores, participate in a survey, enter a contest — then a format like this is helpful. If you want readers to respond, be sure to give them enough room to write.

SURVEYS & POLLS

WHERE DO *YOU* STAND ON FAMILY VALUES?

Test your own views with this cross section of questions from our family values poll, then see how your answers compare to the 400 statewide residents we surveyed last week.

Do you agree or disagree with the following statements:

1. In general, fathers do not make children as much of a priority as mothers do.
☐ **Agree** ☐ **Disagree**

2. Businesses should offer flexible work schedules to accommodate the needs of families.
☐ **Agree** ☐ **Disagree**

3. Families where Dad works and Mom stays home with kids just aren't realistic anymore.
☐ **Agree** ☐ **Disagree**

4. One of the biggest causes of teen problems is that parents don't spend time with their kids.
☐ **Agree** ☐ **Disagree**

5. One family arrangement is as good as another, as long as children are loved and cared for.
☐ **Agree** ☐ **Disagree**

6. Two-income families tend to place material needs ahead of family values.
☐ **Agree** ☐ **Disagree**

7. Two-parent families are the best environment in which to raise children.
☐ **Agree** ☐ **Disagree**

8. When parents can't get along, they should stay together for the sake of the children.
☐ **Agree** ☐ **Disagree**

9. A parent should stay home with preschool children even if it means financial sacrifice.
☐ **Agree** ☐ **Disagree**

10. I've seen just as many problems in two-parent families as in single-parent families.
☐ **Agree** ☐ **Disagree**

STATEWIDE RESULTS

1. 58% agree.
2. 77% agree.
3. 63% agree.
4. 84% agree.
5. 76% agree.
6. 48% agree.
7. 79% agree.
8. 25% agree.
9. 67% agree.
10. 67% agree.

Source: The Oregonian

Checklists and quizzes ask readers questions. But when you want to know their answers, you conduct a poll.

Taking the public's pulse can be fascinating. Frightening. Time-consuming. But it's vital, whether the survey poses a question as simple as this —

If you had $100 million to spare, would you feed the poor or buy a pro baseball team?

Feed the poor **69%**
Buy a team **31%**

— or asks a series of questions like the chart below. As you can see, a variety of design options are available, from plain text to decorative logos, photos and graphics. The crucial thing is to keep data accurate by surveying as wide a sample as possible — and by avoiding biased or misleading questions.

CONGRESS: FIRST DISTRICT

If the primary election were held today, who would you vote for?

DEMOCRATS

Gary Conkling... **28%**
Elizabeth Furse. **39%**
Undecided.......... **33%**

REPUBLICANS

Tony Meeker **58%**
Rick Rolf **19%**
Undecided.......... **23%**

CHEATING: HOW COMMON IS IT?

A majority of high-school high achievers (students who maintain an A or B average) admit they cheat. Most say they've copied someone else's homework, but a surprising 40% confess to cheating on a test or quiz.

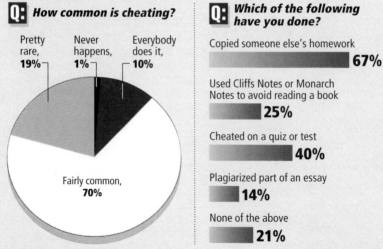

Q: *How common is cheating?*

Pretty rare, **19%**
Never happens, **1%**
Everybody does it, **10%**
Fairly common, **70%**

Q: *Which of the following have you done?*

Copied someone else's homework **67%**

Used Cliffs Notes or Monarch Notes to avoid reading a book **25%**

Cheated on a quiz or test **40%**

Plagiarized part of an essay **14%**

None of the above **21%**

Source: The Associated Press

WHO WOULD YOU RATHER BE?

GEORGE BUSH
13%

BILL CLINTON
22%

GEORGE CLINTON
65%

Survey results can run as plain text — or you can dress them up with graphic extras like these. At left, an election logo identifies this poll as part of a series; above, pie charts and bar charts help quantify poll results; at right, small mug shots add instant reader appeal.

QUOTE COLLECTIONS

STREET TALK: DO YOU SUPPORT THE PRESIDENT'S NEW TAX PLAN?

"The president's plan sounds fair to me. It's time for people to stop whining and start paying their fair share."

MIKE MORGER,
Wilsonville

"No. Enough is enough. I don't think I should be penalized for running an honest, profitable business."

KRYSTYNA WOLNIAKOWSKI,
Lake Oswego

"I don't mind being a bread-winner, but why do those pinhead politicians eat such big slices?"

SNOOKY SPACKLE,
Eugene

Roone Arledge, president of ABC News, once allegedly quipped that when gathering public-opinion quotes, you need only three: one *for*, one *against* and one *funny*.

We've tested that maxim in our man-in-the-street quote sequence above. And whether you agree with Arledge or not, you must admit that those talking heads are both visually appealing *and* engaging — after all, readers love hearing their own voices in their newspaper.

Whether with or without mug shots, quote collections are entertaining and informative. They generally follow one of two formats: a sampling of opinions on one topic from a variety of sources (below left), or a sampling of one person's opinions on a variety of topics (below right).

Either way, a few well-chosen remarks give any subject extra accessibility.

FAMOUS LAST WORDS

Some fond farewells and deathbed wisdom from historical figures as they made their final exits:

"I wonder why he shot me?"
Huey Long, Louisiana governor (1935)

"My fun days are over."
James Dean, actor (1955)

*"The earth is suffocating.
Swear to make them cut me open, so I won't be buried alive."*
Frederic Chopin, composer (1849)

*"Who the hell tipped you off? I'm Floyd, all right.
You got me this time."*
Charles "Pretty Boy" Floyd, gangster (1934)

"I have a terrific headache."
Franklin Delano Roosevelt, U.S. president (1945)

"I am dying like a poisoned rat in a hole. I am what I am!"
Jonathan Swift, satirist (1745)

"I love you, Sarah. For all eternity, I love you."
James Polk, U.S. president (1849)

"I've had 18 straight whiskeys. I think that's the record."
Dylan Thomas, poet (1953)

THE WIT & WISDOM OF MARK TWAIN

Wry observations from the writings of American humorist Samuel Clemens (1835-1910):

"When I was a boy of 14, my father was so ignorant I could hardly stand to have the old man around. But when I got to be 21, I was astonished at how much he had learned in seven years."

"To cease smoking is the easiest thing I ever did. I ought to know because I've done it a thousand times."

"Life would be infinitely happier if we could only be born at the age of 80 and gradually approach 18."

"Golf is a good walk spoiled."

"When your friends begin to flatter you on how young you look, it's a sure sign you're getting old."

"It is easier to stay out than to get out."

"There is no sadder sight than a young pessimist."

"It ain't those parts of the Bible that I can't understand that bother me; it's the parts that I do understand."

"Let us endeavor so to live that when we die, even the undertaker will be sorry."

This quote collection focuses on a single subject — famous last words — though the quotes originated from a wide variety of historical sources. . .

. . . while here, quotes cover a wide range of topics, but all originate from a single source. Either option is an effective sidebar for a longer feature.

CHARTS & GRAPHS

News is full of numbers: dollars, debts, crime statistics, budget percentages, election results. And the more complicated those numbers become, the more confused *readers* become. Take this brutal chunk of text, for instance:

> In 1978, 34,500 units were imported, comprising 16 percent of the national total. By 1988, that number had risen to 77,400, and by 1998 more than 17,000 units were arriving monthly, representing an increase of 591 percent over 1977, the first full year of operation.

Huh? You see the problem. When math gets heavy, charts and graphs come in handy. They present numerical data in a simple, visual way — the simpler, the better. On these pages, we'll look at the three basic types of numerical graphics: line charts, bar charts and pie charts.

The bars in most bar charts stack vertically — but they're equally effective running horizontally, as they do here. Bar shapes and sizes are often determined by the overall shape of the box, and here, that's how they fit best.

This bar chart adds a few extra graphic elements. Those dotted rules were added to help you gauge animal speed. The arrows atop the bars imply motion — as does the graduated tint in the arrows' screens.

BAR CHARTS

The bar chart *compares two or more items by sizing them as columns parked side by side.* It uses two basic components:
1) a scale running either horizontally or vertically showing data totals;
2) bars extending in the same direction representing the items being measured.

Bars are usually stacked in a logical order: either alphabetically, chronologically or ranked by size.

In simple bar charts, each item may be labeled either inside the bar or at either end (as in the examples above). The bars may be screened or given 3-D shadow effects, as long as the data isn't distorted.

In more complex bar charts — where the same items are compared to each other in different times or situations — each item is assigned its own color or screen pattern, which is then explained in a key or legend.

Background grids can be added to help readers track measurements. But though they're usually essential for fever charts, they're optional for bar charts.

CHARTS & GRAPHS

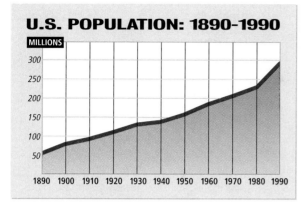

Line charts work best when tracing one simple statistic over time — such as a growing population measured every decade (at left). The shading is an optional element. But you can also plot additional lines to compare different trends — as long as you clearly label which line represents which trend (at right).

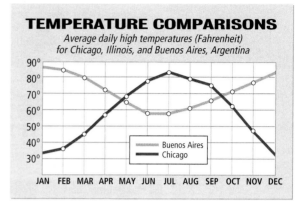

FEVER OR LINE CHARTS

The line chart (also called a fever chart) *measures changing quantities over time.* It uses three basic components:

1) a scale running vertically along one edge, measuring amounts;

2) a scale running horizontally along the bottom, measuring time; and

3) a jagged line connecting a series of points, showing rising or falling trends.

Line charts are created by plotting different points, then connecting the dots to draw a curve. (Charts often include a background grid to help readers track the numbers.) Obviously, a line that rises or falls dramatically will impress readers more than one that barely shows a blip.

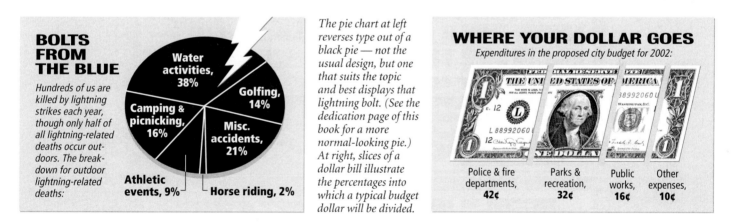

The pie chart at left reverses type out of a black pie — not the usual design, but one that suits the topic and best displays that lightning bolt. (See the dedication page of this book for a more normal-looking pie.) At right, slices of a dollar bill illustrate the percentages into which a typical budget dollar will be divided.

PIE CHARTS

The pie chart *compares the parts that make up a whole.* It usually consists of:

1) a circle that represents 100% of something, and

2) several wedges (like slices of a pie) that divide the circle into smaller percentages. Each "slice" of the pie is an accurate proportion, which means that a segment representing 25% of the total would be one-quarter of the pie.

Figures for each slice are labeled either inside the slice (if there's room) or by scattering type, with pointers, around the outside of the pie. Slices are often shaded or color-coded for clearer distinction (or to emphasize a significant segment). As a rule of thumb, pies should be divided into no more than eight segments; beyond that, the slices get annoyingly thin.

To add impact, you can sometimes create pie charts from drawings or photos of the items being measured. For example, you can slice a dollar bill into sections to show where your tax dollar goes, or draw rings around an oil drum to break down the profits from a barrel of oil.

TABLES

CELEBRITIES AND THEIR REAL NAMES

WOODY ALLEN	ALLEN KONIGSBERG
TOM CRUISE	THOMAS MAPOTHER
STING	GORDON SUMNER
WHOOPI GOLDBERG	CARYN JOHNSON
CARY GRANT	ARCHIBALD LEACH
ADOLF HITLER	ADOLF SCHICKLGRUBER
HARRY HOUDINI	EHRICH WEISS
BORIS KARLOFF	WILLAM PRATT
BEN KINGSLEY	KRISHNA BANJI
TINA TURNER	ANNIE MAE BULLOCK
JOHN WAYNE	MARION MORRISON

THE U.S. & CANADA: HOW THEY COMPARE

	U.S.	Canada
AREA	3,787,319 sq. miles	3,851,800 sq. miles
POPULATION	275,562,673	31,278,097
POPULATION DENSITY	74 per sq. mile	8 per sq. mile
LARGEST CITY	New York (20,124,377)	Toronto (4,700,000)
GROSS DOMESTIC PRODUCT	$8.51 trillion	$688.3 billion
PER CAPITA INCOME	$31,500	$22,400
LIFE EXPECTANCY (at birth)	74 male, 80 female	76 male, 83 female
LITERACY RATE	97%	97%

Source: The World Almanac

Tables using only text: *We've stacked two columns of names side by side to allow quick before-and-after comparisons. No headings or explanations are needed.*

Tables mixing text and numbers: *This simple table stacks two bio boxes side by side — one for the U.S., one for Canada — to allow readers to compare statistics. Note how the columns align with the left edges of the flags. Note, too, how the flags substitute for the names of the countries.*

A **table** is an age-old graphic device that's really half text, half chart. But unlike other charts, tables don't use bars or pie slices to make their point; instead, they stack words and numbers in rows to let readers make side-by-side comparisons.

Tables usually consist of: 1) headings running horizontally across the top of the chart; 2) categories running vertically down the left side; and 3) lists grouped in columns reading both across and down.

In short, tables are smartly stacked lists. They can compare two aspects of a topic (*What's In & What's Out*) or analyze a variety of categories:

WORLD RECORDS: TRACK AND FIELD

EVENT	RECORD	HOLDER	COUNTRY	DATE
100 meters	9.79 seconds	Maurice Green	U.S.	June 16, 1999
1 mile	3:43.13	Hicham El Guerrouj	Morocco	July 7, 1999
High jump	8 ft., 1/2 in.	Javier Sotomayor	Cuba	July 27, 1993
Long jump	29 ft., 43/4 in.	Ivan Pedroso	Cuba	July 29, 1995
Pole vault	20 ft., 13/4 in.	Sergei Bubka	Ukraine	July 31, 1994

To keep tables as neat as possible, carefully align all rows and columns. Though text usually works best flush left, numbers often align better flush right:

AMAZING BIBLE FACTS

Dr. Thomas Hartwell Horne (1780-1862), a student of the King James Version of the Bible, published these statistics in his book, *Introduction to the Study of the Scriptures:*

	OLD TESTAMENT	NEW TESTAMENT	TOTAL
Books	39	27	66
Chapters	929	260	1,189
Verses	23,214	7,959	31,173
Words	593,493	181,253	774,746
Letters	2,728,100	838,380	3,566,480

In small tables, hairline rules between rows may help alignment; in bigger tables, too many lines can look dizzying, so screen effects or occasional rules — every 5 lines, for example — may work better (see the tables at the top of this page). But remember: Keep all wording crisp and tight.

RATINGS

CAST AWAY *(PG-13)* Tom Hanks shines as a workaholic who survives a plane crash and tries to survive on a barely habitable South Pacific island. For more than an hour, the film abondons virtually every common movie convention: music, dialogue, plot. But the rest of the film is a real downer, given the brilliance of the middle. ★★★

The most common way to rate movies, records, TV shows and restaurants is to assign from one (poor) to four or five stars (excellent).

CAST AWAY *(PG-13)* Tom Hanks shines as a workaholic who survives a plane crash and tries to survive on a barely habitable South Pacific island. For more than an hour, the film abondons every common movie convention: music, dialogue, plot. But the rest is a real downer, given the brilliance of the middle.

GRADE B+

Many newspapers (and magazines such as Entertainment Weekly) assign letter grades — instantly decodable by anyone who's ever been a student.

CAST AWAY *(PG-13)* Tom Hanks shines as a workaholic who survives a plane crash and tries to survive on a South Pacific island. For more than an hour, the film abondons every common movie convention: music, dialogue, plot. But the rest of the film is a real downer, given the brilliance of the middle.

Other papers, such as The San Francisco Chronicle, use a series of icons. For good films, the little man applauds; for bad ones, he falls asleep.

Journalists are trained to be objective. Impartial. Evenhanded. Fair.

Sure, that's one way to look at it. We could also argue that bland, impartial reportage puts readers to sleep — and that what readers *really* want is a guidebook to help them navigate through their world, a user's manual full of inside tips on what's good, what's bad and what's ugly.

Some parts of the paper have traditionally run consumer-friendly ratings and reviews: on editorial and entertainment pages, for instance. But ratings can also apply to politicians, hiking trails, stocks and bonds — nearly *anything*. Just choose the right device (stars, grades, thumbs) and label your package clearly.

◆ To the courage of the Magic Man.

◆ To Louisiana's voters, for having the sense to choose a scoundrel over a Nazi.

◆ To the continued dominance of the CHS cross country teams.

◆ To the cast of "Charlotte's Web" for an excellent performance.

◆ To the natural high gained from outwitting the hall monitor.

◆ To people in spandex.

◆ To people who say that a *Terminator* costume promotes violence. They should be shot.

◆ To vandals who can't spell.

◆ To the clumps of freshmen that clog the 3rd floor hallway. Sort of like hairballs in a drain.

◆ To *New Kids On The Block* action figures. Good thing plastic melts in the microwave.

This table runs on the editorial page of The Little Hawk, allowing editors to hurl quick brickbats and bouquets.

RATING THE NINTENDO FOOTBALL GAMES

NAME OF THE GAME	GRAPHICS	PLAYING EASE	SOUND EFFECTS	SPECIAL FEATURES	OVERALL SCORE
10-YARD FIGHT	★	★★★★★	★	★	★★
JOHN ELWAY	★★	★★	★	★★	★
N.E.S.	★★★	★★	★★	★★	★★
JOHN MADDEN	★★★★★	★★★	★★★★★	★★★★	★★★★
TECMO BOWL	★★★★	★★★	★★	★★★	★★★

KEY If playing these games was like going to a real football game, this is how we'd rate them:

★ Kicked out for throwing wieners.
★★ That drunk, fat, shirtless guy in front of you.
★★★ You're there, but you're Bob Uecker.
★★★★ Like your own personal skybox.
★★★★★ On the sidelines, official waterboy.

This table from The Little Hawk rates five football games according to five sets of criteria. Stars indicate ratings, but we could just as easily have used icons, grades or descriptive text.

PIGSKIN PICKS

Our proud panel of prognosticators predicts this weekend's scores

	MADISON at LINCOLN 7:30 p.m. Friday	WILSON at JEFFERSON 2 p.m. Saturday	MONROE at ADAMS 1 p.m. Saturday	FILLMORE at JOHNSON 7 p.m. Friday
Bud Werner Sports editor, *The Times*	MADISON 21-14	WILSON 45-0	ADAMS 21-20	JOHNSON 7-0
Nick Kennedy Commentator, KXX Radio	LINCOLN 35-7	JEFFERSON 28-21	ADAMS 14-3	FILLMORE 21-14
Wally Benson Former Mudhog coach	MADISON 21-3	WILSON 45-7	ADAMS 35-7	FILLMORE 10-7

Another table: Here, a panel of sports experts predicts winners (and scores) for upcoming football games. Once created, this graphic format is easy to recycle week after week.

TIMELINES

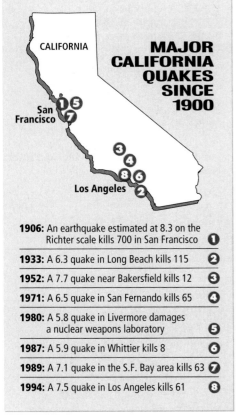

MAJOR CALIFORNIA QUAKES SINCE 1900

CALIFORNIA

San Francisco

Los Angeles

1906: An earthquake estimated at 8.3 on the Richter scale kills 700 in San Francisco ❶

1933: A 6.3 quake in Long Beach kills 115 ❷

1952: A 7.7 quake near Bakersfield kills 12 ❸

1971: A 6.5 quake in San Fernando kills 65 ❹

1980: A 5.8 quake in Livermore damages a nuclear weapons laboratory ❺

1987: A 5.9 quake in Whittier kills 8 ❻

1989: A 7.1 quake in the S.F. Bay area kills 63 ❼

1994: A 7.5 quake in Los Angeles kills 61 ❽

MILESTONES IN MACHINE INTELLIGENCE

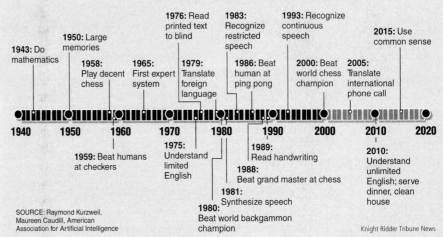

1943: Do mathematics

1950: Large memories

1958: Play decent chess

1965: First expert system

1976: Read printed text to blind

1979: Translate foreign language

1983: Recognize restricted speech

1986: Beat human at ping pong

1993: Recognize continuous speech

2000: Beat world chess champion

2005: Translate international phone call

2015: Use common sense

1940 1950 1960 1970 1980 1990 2000 2010 2020

1959: Beat humans at checkers

1975: Understand limited English

1989: Read handwriting

1988: Beat grand master at chess

1981: Synthesize speech

1980: Beat world backgammon champion

2010: Understand unlimited English; serve dinner, clean house

SOURCE: Raymond Kurzweil, Maureen Caudill, American Association for Artificial Intelligence

Knight Ridder Tribune News

Above: *This timeline chronicles key dates in computer history. Note how the scale turns gray in 2000, signaling a shift from historical events to projections.*

Left: *This California earthquake timeline is keyed to a map. Readers can either read the timeline first, then check the map, or study the map and then consult the timeline.*

Right: *When investigating a crime, it's essential to reconstruct the exact sequence of events. This minute-by-minute chronology paints a clear picture of the action.*

A CHRONOLOGY OF THE BEATING

Here's how events unfolded in Friday's beating of Tony Hewlitt at Lloyd Center:

9:05 p.m. Vice Principal Ted Brooks calls school police to report 40 to 50 "unwanteds" trying to get into a dance at Adams High School.

9:08 p.m. Lt. Steve Hodges of the school police arrives and requests backup from Portland police. Units are sent from North precinct.

9:35 p.m. The dance is shut down.

9:40 p.m. A number of youths drift toward Lloyd Center as police disperse the crowd from the dance.

10 p.m. The crowd of youths arrives at Lloyd Center as Hewlitt and his fiancée, Tara White, wait for their ride. Hewlitt is beaten by two youths. Police arrive minutes later.

When we write fiction, we plot the story chronologically: *Boy meets girl in spring. Boy marries girl in summer. Boy gets hit by a bus in fall...* and so on. But when we write newspaper stories, we often bounce back and forth through time: *Yesterday's meeting discussed tomorrow's vote to repeal a 1995 tax to fund a domed stadium by 2003 ...* and so on.

Time gets tangled up in text. That's why timelines (or chronologies) are so effective. They put topics in perspective by illustrating, step by step, how events unfolded.

The most graphically ambitious timelines combine images and text to create a pictorial recap of past events. Here, mug shots of musicians help to reconstruct the year's musical highlights. (Keep in mind that faces in photos should always be at least the size of a dime; this timeline, like many of the graphics on these pages, has been slightly reduced.)

PORTLAND: THE YEAR IN ROCK

From Tina Turner to Tom Petty, 2000 was a stellar year for local music-lovers. A few selected highlights:

April 14: Despite constant rain and thunder, 120,000 gather in Hebb Park for the Spring Fling Wingding featuring Toejam and Ducks Deluxe.

Aug. 10: The Rolling Stones play a surprise gig at Mummy's Cabaret Lounge. Opening the show is controversial rapper Eminem.

Oct. 17: Tina Turner energizes a crowd of 22,000 at the Schnitz, performing such timeless classics as "Proud Mary" and "Legs."

JAN.	FEB.	MARCH	APRIL	MAY	JUNE	JULY	AUG.	SEPT.	OCT.	NOV.	DEC.

Feb. 17: Melissa Etheridge plays an unplugged set of acoustic blues during the annual Rose City Folk Festival at Civic Auditorium.

May 20: Beck causes a near-riot when he incites fans to storm the Memorial Coliseum stage; four are injured, 22 arrested in the stampede.

Sept. 3: Tom Petty and the Heartbreakers headline a benefit performance for Greenpeace in Pioneer Courthouse Square.

Nov. 25: Local rock legend Elvis King stuns fans by announcing he's retiring from the stage to pursue a career in interior decorating.

STEP-BY-STEP GUIDES

HOW TO RESUSCITATE A LIZARD

1 Scoop the lizard from the pool.

2 Shake out the lizard.

3 Massage the lizard's torso, applying on-and-off pressure directly behind its front legs.

4 Apply mouth-to-mouth resuscitation to the lizard, breathing slowly and forcefully.

Source: The CoEvolution Quarterly

David Sun

Life is full of complex procedures, from changing a tire to baking a cake to — well, resuscitating a lizard. And the clearest way to walk readers through a series of instructions is to arrange them in logical, numerical form:

A step-by-step guide.

If you've ever assembled Christmas toys or wrestled with tax returns, you know how confusing bad instructions can be. That's why step-by-step guides must be as clear, precise and user-friendly as possible. Whenever possible, add drawings or photos to illustrate key steps; as the examples on this page make evident, it's better to *show* than just *tell*.

HOW TO MAKE A HOLIDAY WREATH

What you'll need:

◆ fresh greens (you can cut home-grown evergreens or purchase them from a nursery. It takes about 7 pounds of branches to make a 12-inch wreath).
◆ wire frame (these come in a variety of sizes; a 12-inch frame costs about $1.50).
◆ preservative (this will keep greens fresh for about a month).
◆ pruning shears.
◆ wire clippers.
◆ paddle wire.

What to do:

☐ Clip the greens into hand-sized pieces. Save the fluffy ones; discard woody branches.
☐ Layer 3-4 pieces of greens into a bundle.
☐ Attach each bundle to the wire frame. Pull the wire away from the wreath's center to tighten it.
☐ Continue to attach bundles, overlapping stems with greens, until the frame is completely covered with evergreens. Alternate bundles of cedar (or other greens) with bundles of fir.
☐ Add pine cones. Loop wire around the bottom of the cone, then attach the wire to the wreath.
☐ For special trim, place dried or silk flowers amid the greens.
☐ Attach pearl or other garlands with wire.
☐ Finally, add the bow. Make your own or buy one ready-made.

Left: *This step-by-step guide displays a photo of a finished wreath but uses only text to explain the assembly process. That'll work when time and space are tight — but imagine how much more effective this guide would be if every step were illustrated.*

Right: *This full-color poster page analyzes the mechanics of hitting a baseball — the stance, the stride, the swing — with expert advice from batting coach Ken Griffey Sr. Note the freeze-frame batting sequence running along the bottom of the page.*

DIAGRAMS

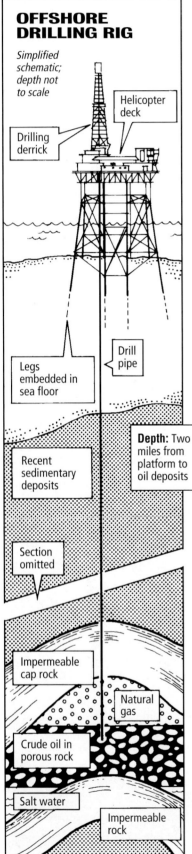

OFFSHORE DRILLING RIG

Simplified schematic; depth not to scale

Helicopter deck

Drilling derrick

Legs embedded in sea floor

Drill pipe

Depth: Two miles from platform to oil deposits

Recent sedimentary deposits

Section omitted

Impermeable cap rock

Natural gas

Crude oil in porous rock

Salt water

Impermeable rock

Maps focus on the *where* of a story; diagrams focus on the *what* and *how*. They freeze an image so we can examine it in closer detail, using cutaway views, step-by-step analyses or itemized descriptions of key components.

Whatever your topic, diagrams will work best if you:

◆ **Focus tightly.** Pinpoint precisely what you need to explain before you begin. What's most essential? Most interesting? Should the diagram be active (showing how the object moves) or passive? (Notice how the passive diagrams on this page simply point to each component.) Whatever the approach — whatever the topic — keep your diagram as clean and simple as you can.

◆ **Design logically.** Let your central image determine the diagram's shape (for instance, that oil rig is a deep vertical). If you're running a sequence of images, find a perspective that lets you show the steps in the most logical order.

◆ **Label clearly.** Avoid clutter by using a consistent treatment for all callouts (sometimes called *factoids)*, whether with pointer boxes, shadows, lines or arrows:

◆ **Research carefully.** You're becoming an instant expert; readers will rely on your accuracy. Do your homework. Cross-check references. Read the story. Study photos. Talk to outside experts.

In short: Become a graphics reporter.

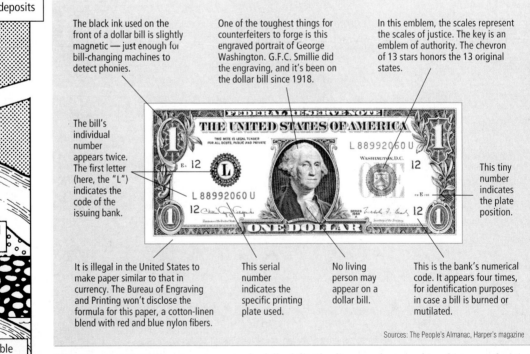

The black ink used on the front of a dollar bill is slightly magnetic — just enough for bill-changing machines to detect phonies.

One of the toughest things for counterfeiters to forge is this engraved portrait of George Washington. G.F.C. Smillie did the engraving, and it's been on the dollar bill since 1918.

In this emblem, the scales represent the scales of justice. The key is an emblem of authority. The chevron of 13 stars honors the 13 original states.

The bill's individual number appears twice. The first letter (here, the "L") indicates the code of the issuing bank.

This tiny number indicates the plate position.

It is illegal in the United States to make paper similar to that in currency. The Bureau of Engraving and Printing won't disclose the formula for this paper, a cotton-linen blend with red and blue nylon fibers.

This serial number indicates the specific printing plate used.

No living person may appear on a dollar bill.

This is the bank's numerical code. It appears four times, for identification purposes in case a bill is burned or mutilated.

Sources: The People's Almanac, Harper's magazine

Want to explore the different components of a dollar bill? The diagram above combines history and trivia to give readers a quick visual tour — something difficult to achieve in text alone. At left, a more traditional diagram uses a cutaway view of the earth's crust to make the offshore drilling process more understandable.

DIAGRAMS

With the right topic, a diagram becomes more than just a supplementary graphic; it becomes lead art that's informational *and* entertaining. For example, these two full-page diagrams combine call-outs and color images to create dynamic feature packages (notice how the turkey page contains no traditional "story" at all).

And though these two diagram packages use illustrations, you can use photos just as effectively, too. All you need is a strong image, clean typography and some solid reporting to achieve professional results.

Above, a Thanksgiving feature page from the Rochester Times-Union offers facts about a turkey's voice, brain, beak and "snood." At right, a detailed look at the pope's fashions (in advance of his Denver visit).

When John Paul II steps out

When the pope arrives in Denver, he will be wearing his everyday clothes. These, like all the garb worn by Roman Catholic clergy, have their origins in the ordinary dress of early Christians and can show rank.

Everyday dress

ZUCCHETTO: Skull cap worn by all bishops, but only the pope wears white

Pope is senior bishop
Bishops are high-ranking officials in the Roman Catholic Church. The rank includes archbishops, cardinals, some abbots and the pope, the bishop of highest rank.

RING: Gold bishop's ring contains his choice of stone; originally, the papal ring was used like a king's, for sealing documents; pope seals with his fisherman's ring, which is not worn and is broken when he dies

PECTORAL CROSS: Contains the relic of a saint or a piece of the Holy Cross; all bishops have two: a simple one for everyday and a more elaborate ceremonial one on a silk cord; evolved from simpler crosses worn by early Christians

COAT OF ARMS: Embroidered on the cincture; John Paul's is blue, with the letter "M" for Mary, Jesus' mother

CINCTURE: Silk sash; only the pope wears white

CASSOCK: Basic clerical garb; only the pope wears white

MANTELLO: Long red wool cloak worn in cold weather

SHOES: Red velvet with embroidered cross; white satin during Easter

Choir dress

Worn at Mass and diplomatic functions

MOZZETTA: Bishop's cape; like a medieval shoulder warmer; pope's is red satin in summer, red velvet in winter, white damask for Easter

STOLE: Silk band indicating authority; only the pope wears it outside the mozzetta

ROCHET: White linen and lace tunic

CASSOCK

Liturgical dress

Worn when celebrating Mass

BISHOP'S MITRE WITH INFULAE (bands): Originally a cap for Roman dignitaries; removed during most solemn parts of Mass

PALLIUM: White wool band with six crosses; shows rank of bishop

CROZIER: Staff; pope's differs from bishops', which is hooked like a shepherd's

CHAUSABLE: Outer vestment; originally a large cloak

ALB: Basic liturgical vestment; similar to Roman tunics

SOURCES: Catholic University of America, Catholic Encyclopedia for School and Home, 1993 Catholic Almanac, The Dictionary of Liturgy and Worship; research by PAT CARR

Knight-Ridder Tribune/RON CODDINGTON

MAPS

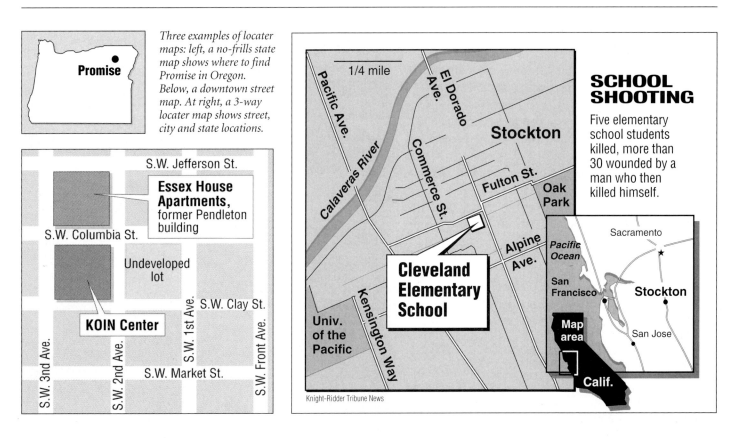

Three examples of locater maps: left, a no-frills state map shows where to find Promise in Oregon. Below, a downtown street map. At right, a 3-way locater map shows street, city and state locations.

Promise

Essex House Apartments, former Pendleton building

S.W. Jefferson St.

S.W. Columbia St.

Undeveloped lot

KOIN Center

S.W. 3rd Ave. | S.W. 2nd Ave. | S.W. 1st Ave. | S.W. Front Ave.

S.W. Clay St.

S.W. Market St.

1/4 mile

Pacific Ave.

Calaveras River

El Dorado Ave.

Commerce St.

Stockton

Fulton St.

Oak Park

Alpine Ave.

Cleveland Elementary School

Univ. of the Pacific

Kensington Way

Knight-Ridder Tribune News

SCHOOL SHOOTING

Five elementary school students killed, more than 30 wounded by a man who then killed himself.

Pacific Ocean

Sacramento

San Francisco

Stockton

San Jose

Map area

Calif.

Most Americans are poor geographers. They have a tough time remembering even the easy stuff, like where New York City is. (Hint: it's on the East Coast — that's the *right edge* of a U.S. map.) So how can we expect them to visualize volcanoes in Fiji? Riots in Lesotho? Train wrecks in Altoona?

With maps. Maps can enhance almost any news story, if you're ambitious enough, but they're especially important for:

❏ any story where a knowledge of geography is essential to the story's meaning (an oil spill, a border dispute, a plane crash), or

❏ any local story where readers may participate (a parade, a new gym).

Maps come in all sizes and styles — world maps, street maps, relief maps, weather maps, etc. Even *animated* maps may soon become more common on newspaper Web sites. But the maps most often produced in newsrooms are:

◆ **Locater maps:** These show, as simply as possible, the location of a key place ("X" marks the spot), or tell the reader where something occurred.

◆ **Explanatory maps:** These are used for storytelling, to show how an event progressed. Often using a step-by-step approach to label sequences, these maps are visually active (as opposed to passive locater maps).

◆ **Data maps:** These show the geographical distribution of data, working like a chart to convey population distributions, political trends, weather, etc.

How are maps created? They're copied. Though you can't cut a map out of a road atlas and stick it in the paper (that's a copyright violation), you can trace a map's highlights, then fill in your own details as necessary.

Every paper should compile a library of maps in a variety of scales, from global to local. Buy a world atlas; collect state highway maps, city and county maps, even brochures from your local chamber of commerce (showing shopping areas, local parks, hiking trails, the layout of the airport).

Be prepared. You never know where news is going to break.

MORE ON ▶

◆ **Making maps:** *A step-by-step guide to creating a map from an outside source* ...**181**

MAPS

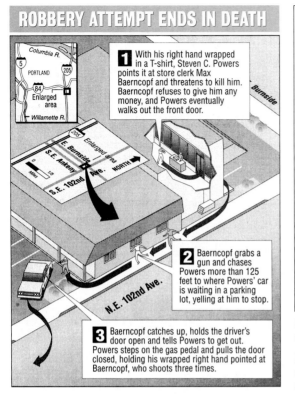

ROBBERY ATTEMPT ENDS IN DEATH

1 With his right hand wrapped in a T-shirt, Steven C. Powers points it at store clerk Max Baerncopf and threatens to kill him. Baerncopf refuses to give him any money, and Powers eventually walks out the front door.

2 Baerncopf grabs a gun and chases Powers more than 125 feet to where Powers' car is waiting in a parking lot, yelling at him to stop.

3 Baerncopf catches up, holds the driver's door open and tells Powers to get out. Powers steps on the gas pedal and pulls the door closed, holding his wrapped right hand pointed at Baerncopf, who shoots three times.

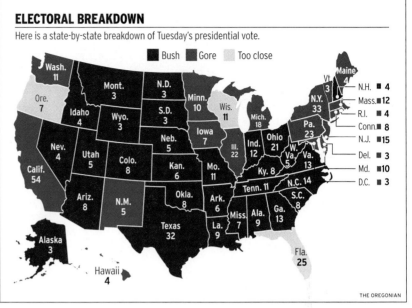

ELECTORAL BREAKDOWN
Here is a state-by-state breakdown of Tuesday's presidential vote.

■ Bush　■ Gore　□ Too close

THE OREGONIAN

Above: *Remember what a cliffhanger the presidential election of 2000 was? This data map ran the day after the voting to show at a glance where each state stood.*

Left: *An explanatory map showing a step-by-step sequence of events. Note the 3-D buildings, the cutaway diagrams, the helpful arrows — all describing a complex series of events in a compact two-column box.*

GUIDELINES

◆ **Create design guidelines for all maps.** You'll save time and give your maps a consistent look if you set clear standards for abbreviations, screens, line weights, symbols — and most important:

◆ **Use type consistently.** Use designated fonts in designated sizes (sans serif will usually work best behind screens). Avoid type that's too big (over 12 point) or too small (under 8 point). Decide where you'll use all caps (countries? states?), italics (bodies of water?), boldface (key points of interest only?).

◆ **Keep maps simple.** The whole planet can fit into a one-column box, if necessary. Make your point obvious; trim away all unnecessary details. Anything that doesn't enhance the map's meaning distracts attention.

◆ **Make maps dynamic.** Don't just re-create a dull road map; add shadow boxes, screens, 3-D effects, tilted perspectives — just be careful not to distort the map's accuracy or destroy its integrity.

◆ **Keep north pointing "up."** If north isn't at the top of a map, include a "north" arrow to show where it is. Otherwise, the arrow isn't necessary.

◆ **Add mileage scales whenever possible.** They give readers perspective.

◆ **Match the map to the story.** Be sure that every significant place mentioned in the text is accounted for on the map.

◆ **Center maps carefully.** Keep them as tightly focused as possible. If pockets of "dead" space occur, you can fill them with mileage scales, callout boxes, locater-map insets or illustrations.

◆ **Assume your readers are lost.** To help them understand where they are, you may need to give your map a headline or an introductory paragraph. You may need to add a locater map to your *main* map if that makes it clearer. (For instance, if you draw a detailed street map, you should show what part of the city you're in.) Above all, include any familiar landmarks — cities, rivers, highways, shopping malls — that help readers get their bearings.

GRAPHICS PACKAGES

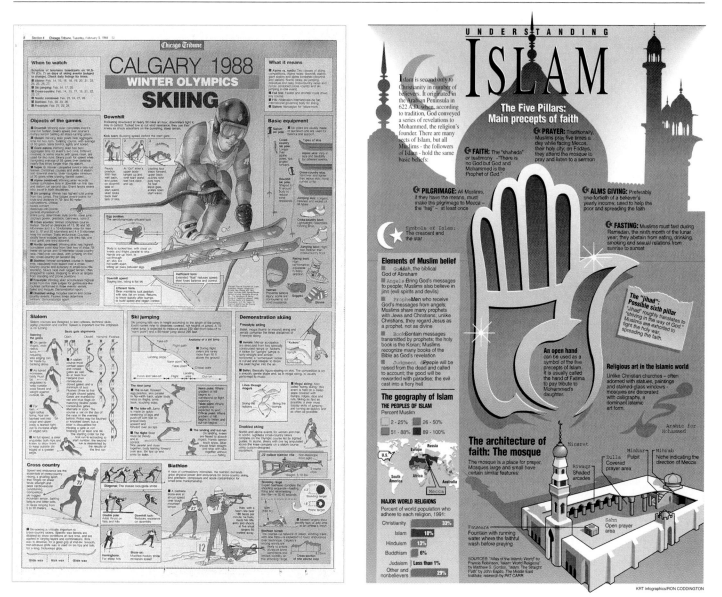

KRT Infographics/RON CODDINGTON

Above, one of a series of award-winning poster pages produced by The Chicago Tribune for the 1988 Winter Olympics. Each full-color page used the same basic format to analyze the techniques, equipment, rules and course layouts for top Olympic events.

The bigger the story, the more explanation it needs — and the more complex its graphics can become. That's why you'll often see dazzling graphic packages, like the ones on these two pages, combining charts, maps, sidebars and more into an encyclopedic extravaganza.

Done well, these packages present as much (or more) information as any news story. But to execute these graphics packages well, you'll need:

◆ **Time.** Some, like the Olympics page above, are part of special series that take months to assemble. Most megagraphics need at least several days to prepare and can't be rushed without dismal results.

◆ **Teamwork.** These aren't solo efforts. They demand cooperation and planning for the research, reporting, art and layout to come together smoothly.

◆ **Expertise.** Sorry to say, these packages are terribly difficult to produce. Don't tackle anything this tricky until you've honed your graphics techniques.

◆ **A firm commitment of space.** Don't let them reduce your full-page package down to 2 columns at the last minute. Get the space you need *guaranteed.*

Above all, don't overdo it. Pages like these take readers right to the edge of "information overload." Ask yourself: How much data can our readers handle?

The Middle East is frequently in the news — and because the Islamic faith plays a central role in the lives of its people, this Knight Ridder Tribune package explains the history, beliefs, geography and architecture of Islam. Note the elegant interplay of art and text.

GRAPHICS PACKAGES

LIFE AND TIMES OF THE MINNESOTA
WALLEYE

Also known as yellow pickerel, yellow pike, dory, jack salmon
Scientific name: Stizostedion vitreum

Text by Ron Schara ● Graphics by Anders Ramberg

State Fish
In 1965, the Legislature declared the walleye the official "state fish" largely because of its popularity and the fact Minnesota has more natural walleye water than any other state.

WALLEYES ARE WINNERS
In a survey of Minnesota anglers, the walleye was...

fish 56% time 50% time 82%

WHERE THE WALLEYE ROAM IN MINNESOTA
The pie charts show the percentage of walleye fishing water in each region.

Walleye hatchery locations
Out of 15 hatcheries statewide, 12 are utilized for the production of walleye:
1. Bemidji
2. Detroit Lakes
3. Fergus Falls
4. Glenwood
5. Park Rapids
6. Cut Foot Sioux
7. Tower
8. Brainerd
9. New London
10. Waterville
11. St. Paul
12. French River

CHARACTERISTICS
- The walleye even looks like a rich catch. With olive-green sides, tinged in gold hues, the walleye has several obvious characteristics, including a white tip on the lower tail and a black spot at the rear base of the dorsal fin.
- A close cousin, the sauger, is missing the white tail and has more dark splotches on its side, including lines of black spots on the dorsal fin.
- Sometimes a "saugeye" is hatched when walleye and sauger cross-breed, and might exhibit identification characteristics of both species.

Hearing
Walleye have an acute sense of hearing. Vibrations are detected by the "lateral line," which are extremely sensitive nerve endings on each side of the fish. Using the lateral line, the walleye is able to home in on fast-moving prey species or lures even in murky water.

Eyesight
Its famed "marble" eyes are designed for effective night vision. As a result, walleye usually avoid bright light and become active in low-light conditions. Walleye can see color, although not as well as other gamefish, such as largemouth bass. Scientists also suspect walleye see most colors as a shade of red or green.

Smell
While walleye have a good sense of smell, the fish is not dependent on smell to find or select prey. To find food in dark water, the walleye might use its lateral line rather than smell.

DID YOU KNOW?
- In the best walleye lakes, the average angler takes more than 4 hours to catch one walleye.
- Although called "walleye pike," the walleye is not a pike and is related to the perch family of fishes.
- In a single night, upward of 50,000 adult walleye have been counted migrating upstream in the Tamarac River from Upper Red Lake at Washkish, Minn.
- Catch-and-release walleye fishing is catching on. On Mille Lacs, anglers are releasing one out of every six walleye caught, according to DNR surveys. Of 126,332 walleye released, more than 13,000 were longer than 20 inches.
- Of Minnesota's 5,483 fishing lakes, only about 1,753 are home to walleye.
- Roughly 3.5 million walleyes are caught annually, weighing 4 million pounds. By comparison, 64 million panfish hit the, well, pan.
- In the 1920s, the daily walleye limit was 15. By 1930, the walleye limit had been cut to eight fish. The current limit of six was set in 1965
- DNR surveys show the average weight catches of walleye have dropped from 2.2 pounds in 1939 to slightly over 1 pound today. Angling pressure increased 700 percent in less than 50 years.

4 million pounds a year

WALLEYE HATCHERY QUIZ
True or false?
- State fisheries crews gather roughly 500 million walleye eggs every spring. **True.** Of those, about 263 million to 300 million walleye of fry and fingerling size are stocked in more than 500 lakes every year.
- If it wasn't for state fish hatcheries, the walleye opener would be a bust. **False.** Although the DNR spends $1 million to hatch and raise walleye for stocking, most walleye caught by anglers are native fish. Of an estimated 3.5 million walleye caught in the state annually, the DNR says only about 4 to 5 percent (or 140,000) came from the state's walleye hatcheries.
- Only a fraction of hatched walleye survive to grow into keepers. **True.** The DNR says out of 1,000 fingerlings, only about 125 will live to be 4 or older. The other 875 fingerlings die of natural causes. Life doesn't improve much once in the lake: Out of the 125 remaining walleye, only about 50 will end up on the end of an angler's line.
- The DNR operates 15 fish hatcheries. In April, all are filled with fertilized walleye eggs for hatching. **False.** Of the 15 active hatchery facilities, walleye are raised in about 12 locations. Minnesota raises more walleye than any other state.

WALLEYE'S WORLD
Walleye range

NATURAL LIFE CYCLE
1. The walleye's spawning ritual begins in mid-April and continues into early May, when water temperatures are between 42 to 50 degrees.
2. Sexual maturity is reached at age 4. A female walleye may produce more than 100,000 eggs, which are immediately fertilized by milt from male fish. The eggs are dispersed randomly over gravel or rock and are not deposited in a nest.
3. Most spawning activity takes place at night. A female's eggs may be fertilized by more than one male fish. Incubation time is about 20 days, depending on water temperature
4. Newly hatched walleye (fry) live on yolk sac and swim toward deeper water. In a few days, fry start feeding on micro-organisms, eventually eating insects. When 1.6 inches long, walleye begin to prey on other fish species. During the first summer, young walleye feed heavily on young perch.

What's walleye water?
A natural walleye lake is dominated with bedrock or glacial sand/gravel substrate of either softwater or hardwater. Most of the state's best walleye water consists of large, wind-swept lakes with sand/gravel/rock bottom. Classic examples are Mille Lacs, Winnibigoshish, Red Lake, Leech Lake, Lake of the Woods and Otter Tail.

IT WAS THIS BIG!
Shown is the average length of a walleye will grow to in its lifespan. Because of great variations in the walleye growth, actual ages of the fish can only be measured by counting the ring patterns (called Annuli) on the scales of an individual fish.

Year 1: 5.1"
Year 2: 9.0", 0.5 lbs.
Year 3: 12.3", 0.7 lbs.
Year 4: 15.1", 1.0 lbs.
Year 5: 17.3", 1.6 lbs.
Year 6: 19.2", 2.2 lbs.
Year 7: 20.9", 2.9 lbs.
Year 9: 23.4", 3.9 lbs.
Year 10: 24.5", 4.3 lbs.
Year 11: 27.1", 5.3 lbs.

STATE RECORDS
Minnesota Walleye Record
- Weight: 17-pounds, 8 ounces
- Length: 35.8 inches; girth, 21.3 inches
- Date: May 13, 1979
- Caught by: LeRoy Chiovitte, Hermantown, Minn.
- Where: Seagull River at Saganaga Lake in Cook Co.

Walleye/Sauger hybrid record
- Weight: 7 pounds, 4.5 ounces.
- Length: 27 inches; girth, 15.25 inches
- Date: April 4, 1987
- Caught by: Thomas Quaal, Minneapolis
- Where: Mississippi River in Goodhue Co.

SOURCES: Department of Natural Resources, Walleye: The Hunting and Fishing Library.

This gorgeous tabloid double-truck spread from the Minneapolis Star Tribune tells you everything you ever wanted to know about the Minnesota walleye. This attractive and entertaining mix combines maps, charts, lists, a diagram, a quiz, a timeline – but because it's so well-organized, it's not overwhelming.

Voter Preferences
Clinton leads Bush on the issues
A recent survey shows how voters rank the candidates on a variety of issues. Most of the time they said they prefer Clinton.

■ Clinton ■ Bush □ Perot

Who would?

Reduce the cost of health care: 49% / 19% / 18%
Improve economic conditions: 38% / 24% / 30%
Not increase taxes: 22% / 41% / 11%
Get things done in Washington: 37% / 24% / 26%
Make wise decisions in foreign policy: 26% / 57% / 9%

SOURCE: Times/Mirror survey of 1,153 registered voters Oct. 20-22; margin of error 3%

Extra, Extra!
More papers for Clinton
Not since 1964 have so many U.S. newspapers endorsed a Democrat for president. That editorial victory for Clinton comes in a year when more papers than ever have decided not to endorse anyone.

Clinton: 149
Bush: 121
Perot: 1
Not endorsing: 542

SOURCE: Editor and Publisher

New Faces
Women and minorities
So many women and minorities are seeking office this year that their numbers are likely to grow considerably after Nov. 3.

Women in the House now: 29
Women candidates: 106
Blacks in the House now: 26
Black candidates: 45
Latinos in the House now: 14
Latino candidates: 30

SOURCE: Los Angeles Times

Realpolitics
A weekly report on Campaign '92

Home Stretch
The long road from New Hampshire
First, Bush was a shoo-in. Then Perot pulled ahead. After he quit in July, Clinton left Bush in the dust. But despite talk about which Clinton aide will be the next secretary of state, at least one survey shows the race may be close after all. The numbers:

■ Clinton ■ Bush ■ Perot

41% 38% 16%
Perot drops out, then rejoins race

2/6-2/9 Bush Japan trip
2/19-20 New Hampshire primary
5/7-10 L.A. riots
7/13-16 Democratic Convention
8/17-20 GOP Convention

The state-by-state count
Bush may be cutting into Clinton's popular vote lead, but he still trails badly in polls measuring strength in the Electoral College. Each state's electoral votes are based on population; a candidate needs 270 electoral votes to win.

Candidates	States	Electoral votes
Clinton	25	274
Bush	2	10
Perot	0	0
Too close to call	24	254

SOURCE: American Political Network's Hotline

The Truth
...and nothing but

" There's just no such thing as truth when it comes to him. He just says whatever sounds good and worries about it after the election. "
Bill Clinton, on George Bush

" You can't have a lot of buts sitting there at the Oval Office. "
President Bush, on his allegations that Clinton waffles

" I told '60 Minutes' when they first called me, I said, 'Approach this with great skepticism.' "
Ross Perot, on his own recent allegations that the Bush campaign was going to disrupt his daughter's wedding

" We know we are not reaching 30 to 40 percent of the people we want to. All I can do is try to get my best sample and then light a candle or grab my worry beads. "
Harris Poll pollster Humphrey Taylor, on the many voters who are not answering pollster's questions

Ad Nauseum
Debate buzzwords
If points were awarded for repetition, Bush, Perot and Clinton would all have been big winners in their three meetings.

Number of times
Clinton said "change": 33
Perot said "the people" or "the American people": 52
Bush blamed Congress: 25
Bush said "character": 14
Clinton said "trickle-down": 12
Bush invoked Mondale, Dukakis or Carter: 5

SOURCE: Entertainment Weekly

Campaignland
The voodoo factor
Top Clinton campaign strategist James Carville is turning to superstition to ward off political devils as the race draws to a close: Recently he has tried wearing his shirts inside out and getting out of bed on the left side. He says he is not, however, repeating the lucky practice he used during the last campaign he ran: wearing the same pair of underwear during the final week of the campaign.

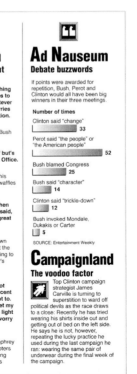

The Knight Ridder Tribune graphics service produces some of the most progressive and clever packages in the business — as these weekly Campaign '92 packages proved. Each week, these reports blended statistics, fast facts, quotes and polls to create a fascinating montage of election information.

PACKAGE PLANNING

MORE ON ▶

··

◆ **The Maestro Concept:**
*A booklet and video are
available from the
ASNE Foundation.
Call ...*(859) 257-4360

Most newsrooms are like factory assembly lines: the reporter reports. The photographer photographs. The editor edits. And then — at the last minute — the designer designs.

That assembly-line process works fine if you're making sausages, but it won't consistently produce award-winning pages. Lavish layouts rarely succeed when they're slapped together on deadline.

So how do you retool your newsroom to produce *this* type of page? By planning: by instituting a brainstorming process that shapes stories *before* they're written.

A few years ago, Buck Ryan – journalism director at the University of Kentucky – developed the Maestro Concept, a method of integrating writing, editing, art and design. Ryan proposed that each newsroom appoint a *maestro*, a visual journalist who could orchestrate the interplay of all key staffers. And to guide the process along, participants would use a story planning form like the one reprinted on the next page.

How does it work? Suppose a reporter has just gathered information for a big story. Before she starts writing, there's a brief meeting. That's where the reporter, editor, photographer and designer, with the maestro's help, explore the story's potential using a form like the one below to produce a package like the one above.

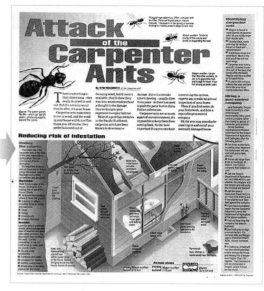

The story idea: *Can you summarize the story in 25 words or less? That's a good test to see if your focus is tight enough – or if you're still struggling with a fuzzy concept.*

Questions readers will ask: *The first question every reader asks for every story is "Why should I care?" Try to answer this question in a highly visual way – in the headline, a photo, a sidebar. Now: What other questions will readers have? Can you answer them in graphic ways? That list of sidebar options provides alternative ideas for reporting and design.*

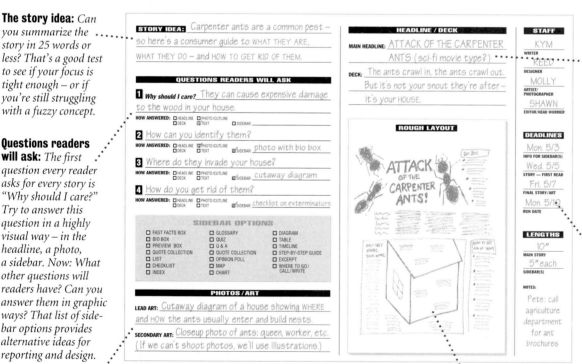

Headline/deck: *Why wait until the story is written – and the clock is ticking – to write a headline? Chances are you have enough info to kick around a clever headline right now, or at least generate key words you can refine later. Writing the deck now also helps the team members clearly define the story angle.*

Staff, deadlines, lengths: *One last chance to ensure that everyone agrees on when the different story elements are due, what sizes they'll be – and most important, who's responsible for what.*

Photos or illustrations: *Too often, photographers are excluded from story-planning conferences, then sent out on assignment with hardly a clue what the story's about. But when photographers are included in this preliminary discussion, they can shape the direction of the imagery AND the reporting. By this point in the planning meeting, an attentive photographer should be able to suggest photo ideas – or, if the story is better served by illustrations, staffers can weigh those options instead.*

Rough layout: *While those ideas for photos, sidebars and headlines are being kicked around, the designer can sketch a layout that integrates all the key ingredients with their proposed shapes and sizes. Everything is subject to change, of course, but by the end of the meeting, all the participants should agree on this preliminary vision of the page. Remember, this is just a starting point — the actual page should only get better. After the meeting, this form should be photocopied and distributed for future reference.*

STAFF

WRITER _____

DESIGNER _____

ARTIST/ PHOTOGRAPHER _____

EDITOR/HEAD WORRIER _____

DEADLINES

INFO FOR SIDEBAR(S) _____

STORY — FIRST READ _____

FINAL STORY/ART _____

RUN DATE _____

LENGTHS

MAIN STORY _____

SIDEBAR(S) _____

NOTES: _____

HEADLINE / DECK

MAIN HEADLINE: _____

DECK: _____

ROUGH LAYOUT

STORY IDEA: _____

QUESTIONS READERS WILL ASK

1 Why should I care?

HOW ANSWERED: ☐ HEADLINE ☐ PHOTO/CUTLINE ☐ SIDEBAR: _____
☐ DECK ☐ TEXT

2 _____

HOW ANSWERED: ☐ HEADLINE ☐ PHOTO/CUTLINE ☐ SIDEBAR: _____
☐ DECK ☐ TEXT

3 _____

HOW ANSWERED: ☐ HEADLINE ☐ PHOTO/CUTLINE ☐ SIDEBAR: _____
☐ DECK ☐ TEXT

4 _____

HOW ANSWERED: ☐ HEADLINE ☐ PHOTO/CUTLINE ☐ SIDEBAR: _____
☐ DECK ☐ TEXT

SIDEBAR OPTIONS

☐ FAST FACTS BOX
☐ BIO BOX
☐ PREVIEW BOX
☐ OPINION POLL
☐ LIST
☐ CHECKLIST
☐ INDEX

☐ GLOSSARY
☐ QUIZ
☐ Q & A
☐ QUOTE COLLECTION
☐ RATINGS
☐ MAP
☐ CHART

☐ DIAGRAM
☐ TABLE
☐ TIMELINE
☐ STEP-BY-STEP GUIDE
☐ EXCERPT
☐ WHERE TO GO/ CALL/WRITE

PHOTOS / ART

LEAD ART: _____

SECONDARY ART: _____

GRAPHICS GUIDELINES

*"Graphical excellence is that which gives to the viewer
the greatest number of ideas in the shortest time
with the least ink in the smallest space."*
Edward R. Tufte

BEFORE YOU BEGIN, ASK YOURSELF:

◆ **What's missing from this story?** What will complete the picture for those who read it — or attract readers who might otherwise turn the page?

◆ **What's bogging down the text?** A series of numbers? Details? Dates? Definitions? Comparisons? Can information be pulled out and played up?

◆ **What data needs clarification?** Statistics? Geographical details? History? Does the story overestimate the readers' knowledge?

◆ **How much time and space do we have?** Can we squeeze in a quick list? A small map? Or should we create a huge clip 'n' save poster page?

◆ **What's the point of this sidebar or graphic?** Is there one clear concept we're trying to emphasize — or are we just compiling a stack of statistics?

COMPILING & EDITING GRAPHIC DATA

◆ **Collect data carefully.** Use reliable sources, as current as possible. Beware of missing data, estimates or projections; if information is uncertain or unverifiable, you must flag it for your readers. In the line chart below, for instance, the artist has labeled two gaps in the data to avoid misleading readers. Does it work?

◆ **Edit carefully.** Every graphic and sidebar *must* be edited. Check all the numbers: totals, percentages, years. Check all spelling and grammar. Check that all details in the sidebar match all details in the text. Finally, check that all wording presents the data fairly and objectively.

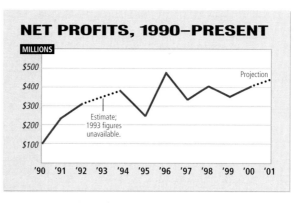

NET PROFITS, 1990–PRESENT

MILLIONS

Estimate; 1993 figures unavailable.

Projection

In this line chart, we used a dotted line to indicate an estimate (for 1993) and a projection (for 2001). Does it succeed? Or does it paint a false picture for readers?

◆ **Convert to understandable values.** Avoid kilometers, knots per hour, temperatures in Celsius. Convert foreign currency to U.S. dollars. Avoid any obscure terms, jargon or abbreviations that will confuse or mislead readers.

◆ **Simplify, simplify.** What's your point? Make it absolutely, instantly clear. Depict one concrete, relevant idea — a concept readers can relate to, not something abstract, insignificant or obscure. Avoid clutter by eliminating all nonessential words and information and by focusing *tightly* on key points.

Above all, don't ever assume the reader plans to read the story's text; your graphics and sidebars must stand on their own.

PACIFIC OCEAN RECORD DEPTHS

NAME	DEPTH IN METERS	DEPTH IN FATHOMS
Mariana Trench	10,924	5,973
Tonga Trench	10,800	5,906
Philippine Trench	10,057	5,499
Kermadec Trench	10,047	5,494
Bonin Trench	9,994	5,464
Kuril Trench	9,750	5,331

In this table, we've measured the deepest depths of the ocean — in meters and fathoms. Can't fathom what it means? We need to convert those depths to FEET for the data to make more sense.

GRAPHICS GUIDELINES

CONSTRUCTING GOOD GRAPHICS

◆ **Keep it simple.** Make sidebars and graphics look easy to understand or you'll frighten readers away. Pie charts, for instance, are the bottom feeders in the great Graphics Food Chain. Many readers *hate* pie charts. So don't make matters worse; don't slice pies into a dozen pieces (with an unreadable key full of stripes and polka dots) if a few broad categories convey the same idea.

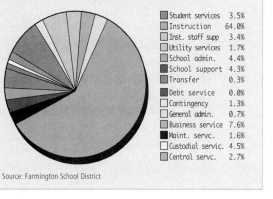

2001-02 SCHOOL BUDGET

Student services	3.5%
Instruction	64.0%
Inst. staff supp	3.4%
Utility services	1.7%
School admin.	4.4%
School support	4.3%
Transfer	0.3%
Debt service	0.0%
Contingency	1.3%
General admin.	0.7%
Business service	7.6%
Maint. servc.	1.6%
Custodial servic.	4.5%
Central servc.	2.7%

Source: Farmington School District

What makes this pie chart so confusing? Is it the excessive number of slices? (Exactly how many categories ARE there, anyway?) Is it the way all those stripes and dots are impossible to tell apart? Is it the use of a separate key to show percentages, rather than labeling or pointing to the pie slices themselves?

Don't cram years and years onto a line chart if only recent trends matter.

Bottom line: Don't overwork a chart. If you want to make several different points, you'll find that several charts are usually better than one.

How to lie with statistics: *Bar charts help us to visualize numbers by depicting them as bars. Tall bars are big numbers, short bars are small ones; in fact, a bar that's twice as tall as its neighbor should be worth two times as much — right? Right. Now study the chart at right. It looks like school spending in 1998-99 is about HALF of what it was in '97-98. Is that true? Or is the chart misleading?*

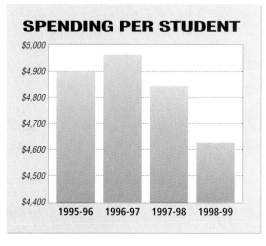

SPENDING PER STUDENT

	1995-96	1996-97	1997-98	1998-99
$5,000				
$4,900				
$4,800				
$4,700				
$4,600				
$4,500				
$4,400				

◆ **Keep it accurate.** As we mentioned before, use trustworthy sources (and print their names in a source line at the bottom of the chart). Double-check their math — then have someone check *your* math when you're done.

When drawing charts, be sure all proportions are true. Slices in a pie chart should be mathematically precise; time units in a line chart should be evenly spaced; bars in bar charts should be accurately proportioned (unlike the bars above, which are disproportionate because they're not stacked on a baseline of *zero*). Some computer programs can help you plot figures with accuracy.

◆ **Label it clearly.** Make sure each significant element — every line, number, circle and bar — is instantly understandable. Add a legend, if necessary. Or write an introductory blurb at the top of the chart to tell readers what they're seeing.

◆ **Dress it up.** Add screens, 3-D effects, photos, illustrations, color — but use them to organize and label the data, not just for decoration. Sure, it's fine to use illustrations to tweak readers' attention (as if to say, *This chart is about shipping — see the little boat? Get it?*), but at too many newspapers it's become common to junk up graphics with cartoon clutter. Used poorly, these effects distort your information and distract your readers. Used with wit and flair, they can make dry statistics fresh and appealing (as in the example at right). Proceed with caution.

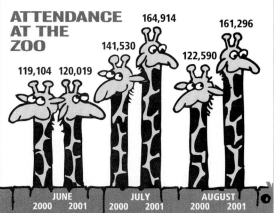

ATTENDANCE AT THE ZOO

JUNE		JULY		AUGUST	
2000	2001	2000	2001	2000	2001
119,104	120,019	141,530	164,914	122,590	161,296

GRAPHICS GUIDELINES

**TYPOGRAPHY
& LAYOUT**

◆ **Develop graphics style guidelines.** You'll save time, avoid confusion and maintain a consistent look if you adopt strict standards for all type sizes, screen densities, source and credit lines, dingbats, etc.

◆ **Give every sidebar or graphic a headline.** Don't force readers to guess what a map or list means. Even a short title *("What They Earn")* clarifies your intent. But as mentioned above, use consistent sizes, fonts and treatments.

◆ **Make it readable.** Avoid type smaller than 8 point (except for source or credit lines). Use boldface to highlight key words. Keep all type horizontal (except for rivers or roads on maps). Use rules and careful spacing to keep elements from crowding each other and creating confusion.

◆ **Dummy graphics as you would a photo.** Generally, small graphics and sidebars are dummied like any other art elements:

MORE ON ▶

◆ **Stylebooks:** *How to codify your paper's guidelines for text and graphics* **219**

◆ **Grids:** *How some papers experiment with alternative page formats* **72**

This 5-column story design uses two graphic elements: a dominant vertical photo and a smaller horizontal tucked into the text.

Here's that same design using a vertical graphic package as lead art, with a sidebar list boxed and dummied atop those legs of text.

For more ambitious packages, consider running graphics in a row, or *rail*, either down the edge of the main story, along the bottom, or both — as these two outstanding story packages from the Ball State Daily News demonstrate:

TROUBLESHOOTING

Quick answers to questions frequently asked by designers perplexed about graphics and sidebars:

Q: **What's the best way to make a map? Do you need special software? And is it OK to photocopy a map or a road atlas?**

You don't need to be a cartographer. You don't need special software. And you don't need to violate copyright laws to produce an accurate map.

Suppose you want to show your readers how to find a local park — let's call it Tualatin Commons Park, the site of an upcoming yo-yo festival. Here's the fastest way to customize your own map from an existing source:

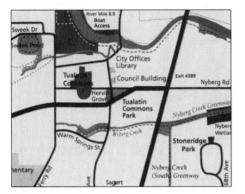

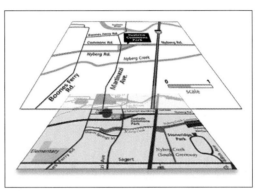

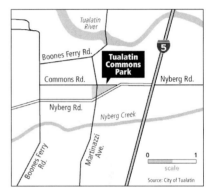

1 *Find an recent, reliable source map: a tourist brochure, a government map, a commercial road atlas, even a Web database. Scan or copy the map into your computer. (Or, if the map won't scan cleanly, make a tracing of the key elements — cities, roads, places of interest — and scan that instead.)*

2 *Fire up almost any drawing, photo or layout software that lets you create curvy lines and add type. Using the imported scan as a guide, trace all key roads, cities and places of interest. Eliminate any unnecessary details — unimportant streets, parks, etc. Keep all cartographic elements (roads, rivers, landmarks) that help readers find what they're looking for.*

3 *Finish your map according to your newspaper's graphic style. (Here, we're using Frutiger Condensed for street names, light italic for rivers, etc.) Add a source attribution, a distance scale and a north arrow, if appropriate. This map can probably be done in less than an hour.*

If you need maps of countries and states, you can find an impressive variety of styles in most clip-art collections (like the example at left). Once you buy the collection, those maps are yours to print or modify. But remember: You *cannot* simply scan and print someone else's map. For one thing, map details don't copy well — they'll probably look messy and fuzzy. But more importantly, most professional maps are copyrighted, and copying is stealing. Use them only as references to guide you in creating your own.

Q: **You said that map above should take about an hour to produce. How long does it usually take to create most graphics?**

That depends on the complexity of the topic and the skill of the artist. A simple chart could take 20 minutes; a mid-sized graphic (with some sort of illustration) might take 3-4 hours; a big color centerpiece can easily take all day. And those complex, exhaustively researched megagraphics you saw a few pages back may take a team of artists, writers and editors weeks — even months — to prepare, polish and print.

But those are the exceptions. Remember, *any* newspaper can supplement stories with short sidebars, fact boxes and lists like the one at right. They're enormously effective, and they don't require time or artistry. Since they simply summarize data that's buried in the text, they can be crafted by reporters — not graphic artists — as they write the story.

MAYOR BOGART'S GOALS FOR 2002

- ◆ Begin construction of a new Central Point library.
- ◆ Establish a pension plan for police and fire department employees.
- ◆ Expand Hebb Park to include river access, boat launch and hiking trails.
- ◆ Install traffic signals at three main Advance Road intersections.

TROUBLESHOOTING

 How do you know which fonts, colors and point sizes to use for graphics?

You can waste a lot of time and energy reinventing the wheel every time you produce a chart, graph or map. That's why smart newspapers create design stylebooks to codify *everything* from headlines to bylines to bio boxes. (See page 219 for more.)

To produce a useful stylebook, begin by creating textbook examples of every kind of graphic. Then label, as clearly as possible:

◆ Fonts and point sizes for all type.

◆ Screen densities and colors.

◆ Rule styles and thicknesses.

◆ Margins and spacing.

◆ Styles for callouts and arrows.

◆ Guidelines for credits and source attributions.

◆ Styles for any graphic extras (north arrows, map scales, shadows, etc.).

The best stylebooks are teaching tools; they use good and bad examples to offer tips and convey philosophy. Sure, they can take weeks to assemble — but in the long run, they can save time by reducing deadline confusion. And by showcasing models of successful graphics, your stylebook may actually inspire staffers to produce them more frequently.

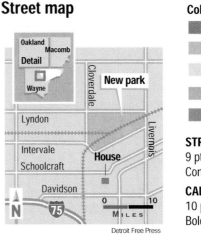

Colors:
- HIGHLIGHTS
- PARKS, FORESTS
- BACKGROUND
- STREETS
- HIGHWAYS

STREET NAMES
9 pt. Helvetica Neue
Condensed Medium

CALL-OUTS
10 pt. Helvetica Neue
Bold Condensed

This entry from the Detroit Free Press' graphics stylebook shows how the paper treats type, color and callouts in maps.

 We're a small paper and we don't have a graphics department. How do we encourage staffers to get more graphics into the newspaper?

To repeat what we said a page ago: You *don't* need to manufacture monster megagraphics. But you *do* need to get small, user-friendly sidebars and fact boxes into more stories more often. So try this:

◆ *Maestro your big stories.* Smart packaging doesn't happen unless you plan it — and unless editors encourage it. Make it newsroom policy that all major stories must be maestroed in advance (see page 177 for a reminder of how this works). Once you train staffers to generate sidebars for centerpieces, they're more likely to do it for smaller stories, as well.

◆ *Make reporters more responsible for graphics.* Successful sidebars don't require drawings, color and artistic talent. In fact, most of your smartest sidebars use just text: tables, lists, Q&A's. Most reporters bury critical numbers in the middle of their stories; train them instead to distill key data into helpful fact boxes.

◆ *Make graphic formats accessible and goofproof.* Create easy-to-use templates for every simple chart, graph and sidebar, then train all your staffers to use them as a part of their regular reporting routine.

◆ *Upgrade your grid.* Some grids — like the 7-column tab format at left — *require* reporters to add extras to their stories (or else you end up with holes in the layout). Experiment with grids that make sidebars essential, not just optional.

There was a time, not too long ago, when all newspaper pages looked serious. Respectable. Gray. Paper was white, ink was black, and everything was locked into rigid gray rows.

Today, that's all changed. Newspapers are livelier than ever. Headlines are red, backgrounds are neon blue, and photos run in eye-poppingly true colors. Feature pages look flashy. News pages look flashy. Even *business* pages look flashy. Go figure.

The best designers now pack big bags of graphic tricks. That's partly to make stories more informative, partly to make pages more lively, but mostly to keep up with a world in which *everything* competes for our attention.

Thanks to innovations in computer graphics, design standards keep rising for all informational media. Just watch the news on TV, read some "serious" newsmagazines like Time or Newsweek, or surf the slickest Web sites. Their presentation is lively; their graphics are zoomy. So if your newspaper insists on being serious, respectable and gray — locking everything into rigid gray rows — you're falling behind the times. You may even be falling *asleep* (along with your readers).

In this chapter, we'll explore graphic techniques that give pages extra energy. These techniques are optional — but with the right combination of taste and technique, special effects like these can find a home on every page in the paper.

CHAPTER CONTENTS

bending the rules

AS YOU HAVE SEEN, EVERY PAPER NEEDS CLEAR AND CONSISTENT RULES FOR ITS DESIGN. BUT EVERY SO OFTEN, BY BENDING THOSE RULES, YOU CAN PRODUCE SOME COOL PAGES LIKE THESE.

Just how far, though, are you willing to bend the rules? Take a closer look at this page you're reading now, for instance. We've stretched and compressed the headline. We've tilted the art. We've flipped the text sideways. Skewed it. And radically restyled it. Just how far can we deviate from our standard design format before we look like some freakish accident? And how far can you push readers before they get tired of watching you jump up and down in your down suit?

Brighten up the summer night with flash and flame

Shish

WILLIE NELSON II

ON THE PHONE AGAIN

★ WILLIE NELSON
8 p.m. Thursday
State Theatre,
19 Livingston Avenue,
New Brunswick
(732) 246-7469

Also 9...
Sands C...
Avenue...
Park,...
(60...
or (8...

George Strazza of Aberdeen painted "Willie," shown on today's Jersey Alive cover.

HE'S AN HONEST-TO-GOSH living legend. He's a writer, performer, actor, activist and — perhaps most importantly — inventor of the casual dress code.

He's Willie Nelson, and he's on the road again.

Nelson's early success came as songwriter of the '60s classics "Crazy" and "Hello Walls" recorded by Patsy Cline and Faron Young, respectively. The Texas-born musician toiled for years in smoky rough-and-tumble honkytonks, ("Just doin' time," are his words for it) until 1975's ground-breaking "Red-Headed Stranger" propelled him "overnight" into the world spotlight. Nelson deservedly began to be mentioned in the same breath as music pioneers Hank Williams Sr., Jimmie Rodgers and Roy Acuff. And 25 years down the road, "Stranger" remains his favorite collection of songs.

"It's a simple thing that I can do every night and it's songs that I really like to do," Nelson said. "I just did that song ("Red-Headed Stranger') last night and I did it for kids, some of 'em never heard of it before. And we all enjoyed it again.

The road Nelson has traveled has not been without potholes. His trademark headband, jeans, T-shirt and running shoes were practically all he had left after an IRS investigation resulted in Nelson being slapped with a $16.7 million bill. Nelson was forced to auction almost all of his possessions in 1991. To help raise desperately needed capital, Nelson sold "Who'll Buy My Memories?" (subtitled "The IRS Tapes") directly through an 800 telephone number. Nelson and the IRS eventually agreed to a $9 million settlement.

As this year's tax-filing deadline looms, Nelson recently phoned Jersey Alive from a tour stop in Florida, speaking at length on a variety of topics ranging from politics to hair care to the cultural significance of George "Goober" Lindsey.

...gonna be playing at the Sands, I ...gonna there April 15. That's an

gonna be at the Sands in Atlantic City and also the State Theatre in New Brunswick.
WILLIE: Yeah? Good.

JA: You probably don't even know that!
WILLIE: No, I don't!

JA: They'll just kind of tell ya. They probably just point you in the direction. Right?
WILLIE: I get off the bus and they lead me up to the stage and I ask 'em, "Is this sound check or a real show?" It's almost that b...

JA: You go to different parts of the country and different parts ... world. How do you find the Jersey audiences?
WILLIE: Oh, they've been great. There used to be a place I pl... called the White Horse Bowling Academy — I think it was... Trenton — many years ago. God, at least 30 years ag... That was a hot country music place back then, for the trad... al stuff, Patsy Cline and all of 'em.

JA: I collect funky old stuff, and I once found an ashtray for... place. So it's kinda neat that you were there. Who knows? Y... may have stubbed out a butt on that ashtray.
WILLIE: Or my OWN butt maybe.

JA: I was reading your Web site (www.willienelson.com). Your daughter puts ... er a little road journal, which is a neat thing...
WILLIE: She does a great job.

BY ED KAZ

JA: I noticed in one of the journal entries ... went back to Nashville and taped one of t... musical roundtable kind of things for Th... Nashville Network. You get to hang out w... those music legends.
WILLIE: Oh, it was great. Chet Atkins was ... (Kristofferson) was there. And uh, let's see... Watson was there.

JA: But why is George "Goober" Lindsey always the...
WILLIE: He was there this time too. You know, you g... him every now and then, and he's a goodhave he kinda glomm...

THE LENO VARIATIONS

Newspaper design is part art, part science. And that's especially true on feature pages, where you start with the basic rules of page layout, then nudge and stretch them as far as your time, creativity, and sense of taste will allow.

For instance, here's a design exercise that demonstrates the range of options designers can choose from. Suppose you're a designer for this daily Living page. Today's cover is entirely devoted to one hugely overplayed feature story, which means you have this space to fill:

The Bugle Beacon
Friday, April 14, 2002

LIVING

INSIDE:
Letterman says
"What about me?"
C2

CAST YOUR VOTE ▶

On the next three pages you'll see a dozen Leno variations. Which do you prefer? To help you analyze each option, we've added checklists like this one:

YOUR OPINION

Headline B

Photo treatment............ C+

Style & flair A–

Overall appeal.............. B

Examine each of the variations. Then write the grades that seem appropriate.

©1995, National Broadcasting Co., Inc.

Our story is a profile of comedian Jay Leno, about to celebrate his 10th anniversary as the host of "The Tonight Show." It's a long piece, so you can jump as much text as you like. But there's only one photo available (left).

So how will you crop this photo? Arrange the text? Write and display the headline? Take a few minutes to create a solution on your own — then, over the next three pages, we'll take a closer look at 12 Leno variations.

THE LENO VARIATIONS

This no-nonsense news approach simply parks the photo in the top two legs of a 3-column layout. It works, but it's dull. The page is swimming in text. And that banner headline is flat and lifeless — fine for a news story, but too bland for a feature. The good news: This design could be done in a real hurry. The bad news: The page is no fun. There's nothing here to grab readers.

YOUR OPINION

Headline

Photo treatment...............

Style & flair

Overall appeal.................

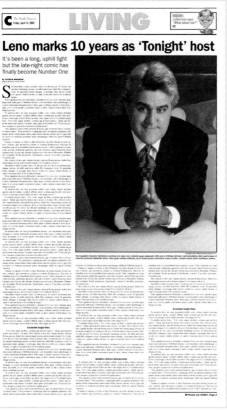

LIVING

Leno marks 10 years as 'Tonight' host

It's been a long, uphill fight but the late-night comic has finally become Number One

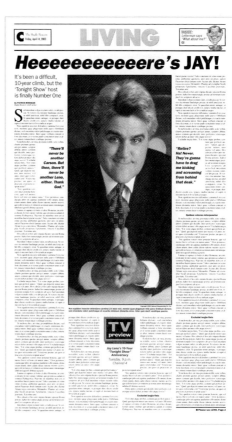

LIVING

Heeeeeeeeeeeere's JAY!

It's been a difficult, 10-year climb, but the 'Tonight Show' host is finally Number One

"Retire? Ha! Never. They're gonna have to drag me kicking and screaming from behind that desk."

We've made the photo more vertical — a more dynamic shape — and anchored it in the middle two legs of a very symmetrical design. We've made the headline bolder and more fun, though it's still a wide horizontal banner. We've indented around two liftout quotes and a reader-friendly TV fact box. Overall, though, the design remains fairly conservative and text-heavy.

YOUR OPINION

Headline

Photo treatment...............

Style & flair

Overall appeal.................

Here, we've taken the headline from #2 and turned it into a colorful display headline (notice the curvy type, the orange-to-yellow gradient, the embossed shadow effect on "JAY!"). The headline alone transforms the page into a much feistier feature. The photo now fills half the page, too. Is that too big? All in all, you can see this page is much bolder than the previous two.

YOUR OPINION

Headline

Photo treatment...............

Style & flair

Overall appeal.................

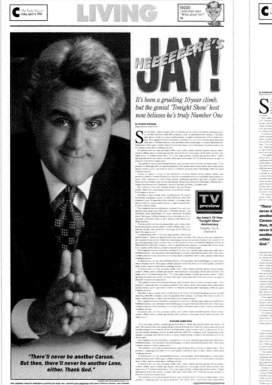

LIVING

HEEEEEERE'S JAY!

It's been a grueling 10-year climb, but the genial 'Tonight Show' host now believes he's truly Number One

"There'll never be another Carson. But then, there'll never be another Leno, either. Thank God."

LIVING

FUNNY BOY

It's been a long, hard 10-year climb, but the genial 'Tonight Show' host now believes he's truly Number One

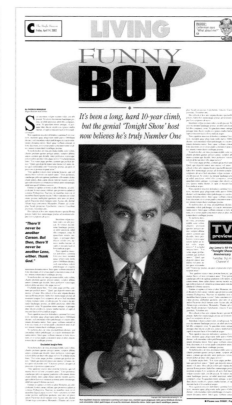

Let's move the photo back to the middle of the page and try a few more symmetrical designs like the one above. In this example, the headline is centered above the photo. Note the white space in the top corners of the page. Is that space wasted, or does it help the design to "breathe"? Note, too, how we force readers to jump across the photo — a bad idea? Or will it work?

YOUR OPINION

Headline

Photo treatment...............

Style & flair

Overall appeal.................

THE LENO VARIATIONS

5

Here, we've moved the headline down, boxing it into the "dead space" in Leno's stomach. Or IS there such a thing as dead space in a photo? (Many photographers and editors would argue that there isn't.) Notice, too, how the text stairsteps down the page. Is that awkward? And does the text become unreadably wide at the bottom — or is that OK to do for just a few lines?

YOUR OPINION

Headline

Photo treatment...............

Style & flair

Overall appeal..................

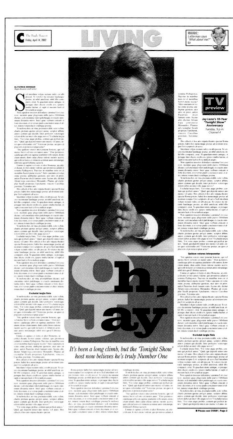

6

Placing a headline so far down the page may not work on Page One — but is it OK here? Will it be clear to readers that they should begin reading at the top of the left-hand leg? (That's one good reason to start the story with an initial cap.) Notice, too, that we've cut out the top of Jay's head. Is that a permissible thing to do to a feature photo? Can we cut him out even more?

YOUR OPINION

Headline

Photo treatment...............

Style & flair

Overall appeal..................

7

We've tried a few new tricks here: First and foremost, we've enlarged the photo as much as we can so we'll have room to reverse the headline out of that dark background alongside Jay. Down below, we've cut a hole in the photo and inserted the text block there. Notice how the headline treatment makes this package seem more like something you'd find in a magazine.

YOUR OPINION

Headline

Photo treatment...............

Style & flair

Overall appeal..................

8

Instead of reversing just the headline, let's try reversing the entire STORY out of the background. Too risky? Bad printing could make the text totally unreadable, even though we've used bigger, bolder type. (Notice the clever way Jay's head seems to overlap the headline?) And for more reader appeal, we've added a short sidebar: some classic Leno jokes. A smart way to lure readers into the page?

YOUR OPINION

Headline

Photo treatment...............

Style & flair

Overall appeal..................

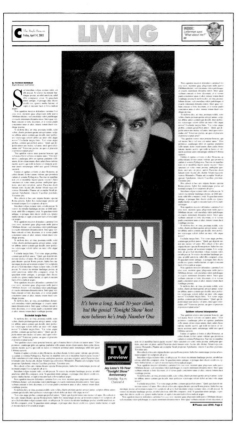

THE LENO VARIATIONS

9

On the previous page, we cut out part of Jay's head, so why don't we cut him out completely? Is that permissible? And how about moving Jay to the bottom of the page? That can be risky; when you shove the dominant image to the bottom of a design, it can look like an ad or intrude into other stories. But here, with Jay's head poking into the text, it anchors the page pretty well.

■ YOUR OPINION

Headline

Photo treatment...............

Style & flair

Overall appeal..................

10

Let's get conceptual. If Jay is celebrating his 10th anniversary, why not make more of the number 10? Here, we've built it into the headline AND the sidebars. The first sidebar is one we used in #8 — Jay's favorite jokes. The second is more interactive: a guide to Leno's books and videos, for fans who want MORE Leno. It's always wise to offer useful tools to the reader whenever possible.

■ YOUR OPINION

Headline

Photo treatment...............

Style & flair

Overall appeal..................

11

How much graphic goofiness can you tolerate? Yes, Leno is a comedian — so if you're ever inclined to bend the rules, this may be the time. But is the headline too loud? The Leno-popping-out-of-the-TV too wacky? It's a risky design, but one with a more aggressive attitude. Like other headlines and photo treatments we've tried, this one relies heavily on Photoshop software.

■ YOUR OPINION

Headline

Photo treatment...............

Style & flair

Overall appeal..................

12

A popular photo-distortion program, Goo, lets you bend and smudge images to create effects like this — allowing you to create the photo equivalent of a cartoon caricature. Is this treatment respectable enough for your newspaper, or is it too cheesy? Would it be OK to use this software to create caricatures for the editorial page? It may depend on the topic — and your artistic skill.

■ YOUR OPINION

Headline

Photo treatment...............

Style & flair

Overall appeal..................

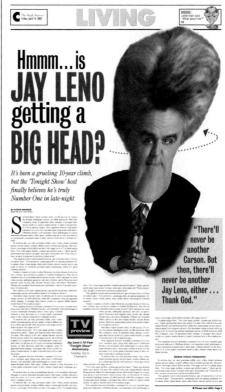

WRAPAROUNDS & SKEWS

As we've previously seen — both in the Leno variations and in the swipeable feature formats in Chapter 3 — text isn't always locked into rigid gray rows. It can, instead, dodge around liftout quotes, flow around photos, and indent around logos and bugs. When a column of text does that, it's called a *wraparound*. (Some papers call it a *runaround*. And when it snakes along a jagged piece of art, it's often called a *skew*.)

Wraparounds can be used with a variety of graphic elements:

MORE ON ▶

◆ **Liftout quotes:**
Using them with wraparounds **136**

◆ **Photo cutouts:**
Using them with wraps and skews ... **192**

| Mugs | Liftout quotes | Headlines | Art or photos |

Until a few years ago, wraparounds were common in books and magazines, but not in newspapers. That's because they required a lot of time, patience and tricky typesetting codes. But with the advent of personal computers and page-layout software, type wraps have become a graphic gimmick that's much easier to play with.

Wraparounds add flair and flexibility to story designs in three ways:

◆ They let you place graphic elements in the middle of a layout without disrupting the flow of the text.

◆ They let a story's artwork interact more closely with its words.

◆ Best of all, they allow you to run graphic elements at their optimum sizes, rather than wedging everything into rigid column widths.

As you can see below, wraparounds help you save space by letting you crop photos more economically:

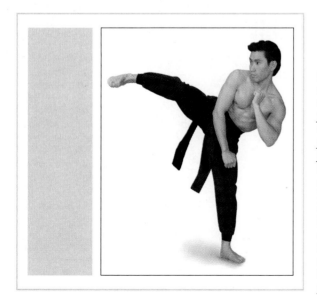

In the layout at left, we've cropped to the edge of the photo frame. But unless we crop into the fighter's leg, we're forced to create a layout that's mostly empty white space. The layout at right, however, fits two legs of type where only one fit before. How? By cropping more tightly, poking both edges of the photo into the text.

WRAPAROUNDS & SKEWS

◆ **Don't overdo it.** Any graphic gimmick will annoy readers if they see it too often, and wraparounds are *very* gimmicky. That's why they're best reserved for features — not hard news.

Remember: The text of a story is a road the reader travels; a wraparound is like a pothole in the road. Steering around one pothole is fun, but who wants to drive a road that's *loaded* with potholes?

◆ **Anchor the text block** as solidly as you can. Then start poking art into it at carefully spaced intervals. As soon as the art starts overwhelming the text, back off. (Take a look at this page. It uses several wraps — but they're shrewdly positioned along this solid column of text.)

In other words, don't let wraps create chaos. Align the text legs solidly on the page grid *first*, then add skews as enhancement.

◆ **Keep text readable.** Severe indents and sloppy spacing undermine your design (see box at right for details).

◆ **Maintain contrast** between the main text block and the object that's poking into it. As you can see here, the sidebar box at right is screened and set off with a drop shadow — and note how the art in the sidebar acts as a buffer between the sidebar text and this main text block.

◆ **Don't cut out photos** simply because you want to skew around them. That makes photographers quite angry. (For more on photo cutouts, turn the page.)

◆ **Smooth out your skews** as much as you can. Abrupt jerks in the width of the text are awkward-looking — and can be awkward to read, too.

◆ **Choose sides carefully.** Believe it or not, skews on the *right* side are preferable to skews on the *left*. Judge for yourself:

□ When you indent an illustration or photo into a column of text, try to run at least three lines of text above and below the indented art (as we do here).

□ Allow a 1-pica gutter between the edges of the art and the text.

□ Run all text at least 6 picas wide (that's our width right here). And keep in mind how tiring it is to read a deep, skinny totem pole of text. Try to limit all thin, indented legs to a few inches of depth, max.

Here's a block of text with a skew along its *left* edge. It looks appealing, but notice the way your eyeballs keep bouncing back and forth as you finish one line, then search for the beginning of the next one. That gets annoying pretty quickly, and it turns readers off.

But when text skews along the *right* edge, it's not nearly as difficult to read. Even though each line ends in a different place, your eye always knows exactly where to go to begin the next line. It's like an exaggerated ragged right. So if you have a choice, skew on the right.

◆ And finally — as we've stressed many times before — try not to force readers to jump back and forth across any graphic element. No matter how simple or ingenious your layout may seem to you, your readers will get confused, lost or annoyed. Is it worth the risk?

Take this example, for instance. It may seem obvious to me, the designer, that you're sup- posed to start reading each line, then jump across this image of Zippy the Pinhead to finish it — but most readers will try to read each column separately, get frustrated, then give up without ever getting this far. Don't believe it? Go back and read the left leg of text there as if you're a typical clueless reader and see how you do.

© Bill Griffith

PHOTO CUTOUTS

We said earlier that photos come in three basic shapes: horizontal, vertical and square. And that's *usually* true. But occasionally, photos break out of the confines of the rectangle:

This photo of Shaquille O'Neal, with its background intact, is cropped into a standard rectangle.

In this partial cutout, Shaq's head and hands poke out of the frame.

This is a complete cutout — the entire background is cut away.

Never forget that many photographers and editors loathe this kind of treatment. They think it destroys the integrity of the image. They call it "cookie-cutter art." Designers, on the other hand, consider it a handy technique for creating stylish images for features and promos. They call them *cutouts* or *silhouettes*.

Why create cutouts? It's usually done for dramatic effect. A photo that's boxed and framed seems flat and two-dimensional. A cutout, by contrast, seems almost 3-D. It pops off the page in a fresh, surprising way.

It's also a good way to eliminate a distracting background from a photograph. And it can tighten up a story design by letting the text hug a photo's central image instead of parking a few inches away.

How do you create cutouts? You don't carve up the original photo; instead, you scan the image electronically, then trim it using software like Adobe Photoshop.

When creating cutouts, remember:

◆ **Respect the photograph** (and the photographer). A bad crop or a silly silhouette can ruin a good photo. So when you can, work *with* the photographer. Discuss cutout treatments in advance. When in doubt, leave it alone.

◆ **Use cutouts on features** — not hard news. If you distort or violate an image, you damage its credibility. That may be OK for celebrity photos or fashion shots, but you must be careful never to change the meaning of news photos.

◆ **Use images with crisp, dark edges.** Light skin and white clothes will fade like ghosts into the background, so be careful. And be especially careful trimming faces, fingers and frizzy hair. Crude cutouts look amateurish.

This tabloid Arts page uses one cutout as a dramatic lead element and another for its downpage story, too.

MORTISES & INSETS

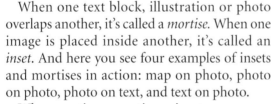

HUDSON RIVER HOT SPOTS
Pollution sites targeted for cleanup by the EPA:

BENSON
CHEMICAL CO. ALLIED TOOL
• Wayneburg SPUMCO

When one text block, illustration or photo overlaps another, it's called a *mortise*. When one image is placed inside another, it's called an *inset*. And here you see four examples of insets and mortises in action: map on photo, photo on photo, photo on text, and text on photo.

When creating a mortise or inset:

◆ Overlap *only* into dead space, or to cover up something questionable or distracting. Avoid crowding or covering any crucial detail.

◆ Mortise only photos of different scale. Always keep readers aware that they're looking at two overlapping elements — not one big, oddly-shaped photo.

◆ Maintain contrast between overlapping elements: dark onto light, light onto dark. If photos have similar tonal values, add a gutter or shadow around the inset photo, as we've done here.

Note: *I've included this page despite hysterical protests from some of my colleagues, who believe mortises are downright **evil**. One even wrote me a letter that went like this —*

The president board said officials met to the new text taxes

— to show that you'd never stack one leg of text on top of another... so why do it with photos?
To which I say: Fine. If you don't like it, don't do it. NYAAAH!!!

SCREENS & REVERSES

Ink is black. Newsprint is white. So how do we create shades of *gray?*

We do it by fooling the reader's eye. Instead of using gray inks, we create the illusion of gray by printing row upon row of tiny black dots in a *dot screen.* And the bigger those dots are, the darker the gray is. We've seen how this works in halftones (page 111), but here's how dot screens create gray tints:

As these examples show, screen densities are measured by percentages. A 50% screen will be half-filled with black dots, while a 100% screen is solid ink. That ink doesn't have to be just black, either. You can create screens with any color ink, or with any combination of colors — for instance, if you look closely at a color newspaper photo through a magnifying glass, you'll see it's actually a mass of red, yellow, black and blue dots (see page 201).

Screens can be used for printing gray type: Or they can create gray rules, bars and boxes: Or they can provide background tints behind type:

When screens are used to create background tints, they impair the legibility of type. It's not too difficult to read black type on a light (10%) screen, but on medium screens, it gets harder. And it's nearly impossible to read type on dark screens unless the type is *reversed* — that is, printed white instead of black.

| This is 10-point type on a white background. It's easy to read, no matter how long the story is. | This is 10-point type on a 10% black screen. It's fairly easy to read, but works best in small doses. | This is 10-point type reversed on solid (100%) black. It's easy to read, but only in small doses. |

Screens and reverses dramatically expand the range of contrast on black-and-white pages. Because they're so conspicuous, they call attention to themselves and are best used to accentuate headers, logos, headlines and sidebars.

They can also be integrated with photos and illustrations to create a tighter, more striking package, as in this example:

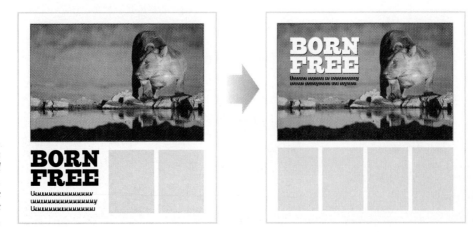

In this feature layout, the photo illustration sits above the text and its sidesaddle headline. But there's empty space in the photograph that could be put to use. . .

. . . and here, a reversed headline and black deck are placed on the photo. This connects the headline to the image and frees up extra space in the columns below.

SCREENS & REVERSES

GUIDELINES FOR USING SCREENS

◆ **Don't overdo it.** Don't splatter screens and reverses at whim, or your paper will look like a cheap circus poster. Use special effects *only* to highlight items that are special or different: a feature headline, a column logo, an infographic. Readers often regard these effects as cosmetic decorations, so think twice before screening hard news stories.

◆ **Don't diminish the readability of text.** *Any* screen or reverse slows readers down (and should thus be used only in small doses), but some combinations of fonts and screens create obstacles that are impossible to overcome:

MORE ON ▶

◆ **Halftones:** *How dot screens are used to reproduce photos* **111**

◆ **Display headlines:** *Examples of different screens at work* **197**

◆ **Color:** *When to use color tints and screens* **202**

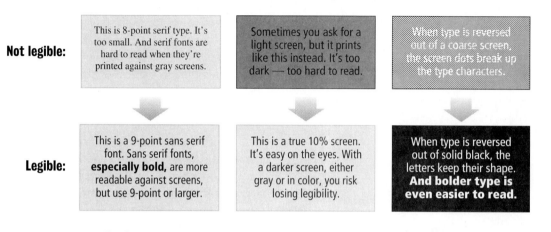

Not legible:

This is 8-point serif type. It's too small. And serif fonts are hard to read when they're printed against gray screens.

Sometimes you ask for a light screen, but it prints like this instead. It's too dark — too hard to read.

When type is reversed out of a coarse screen, the screen dots break up the type characters.

Legible:

This is a 9-point sans serif font. Sans serif fonts, **especially bold,** are more readable against screens, but use 9-point or larger.

This is a true 10% screen. It's easy on the eyes. With a darker screen, either gray or in color, you risk losing legibility.

When type is reversed out of solid black, the letters keep their shape. **And bolder type is even easier to read.**

◆ **Don't screen text type,** unless you want it to break apart. Gray headlines are OK, but be sure the font is big and bold, since the dot screen may give it a slightly ragged edge.

◆ **Position the type thoughtfully.** Avoid violating a good photo composition with a crowded (or awkwardly floating) reversed headline or cutline. Any added type should complement the central image — not compete with it.

This reversed headline fits awkwardly into that negative space. It's jammed too tightly against the image — and there's too much dark dead space above and below it.

Here, the words in the headline have been restacked, giving the image more breathing room and filling the space more evenly. The elements are now better balanced.

◆ **Don't print type against distracting backgrounds.** Look at the mottled, inconsistent background in the photo below. In such cases, a *drop shadow* behind the type may improve legibility — but proceed with caution. As a rule, type is legible *only* when it's dark against light or light against dark.

You can see how a distracting background affects (1) black type, (2) reversed type and (3) reversed type with a black shadow. Try to maintain at least a 50% difference in screen value between type and its background.

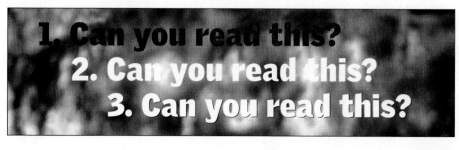

Drop shadows (like those in line 3 at left) are made by sandwiching two layers of type, one behind the other, like this:

DISPLAY HEADLINES

Ordinary news stories use ordinary headlines. And then there are features.

Feature stories let you stretch beyond the confines of those routine *Council-mulls-landfill-zoning* headlines. Using type as a tool, you can make a cultural statement. Forge a new visual identity. Or craft a miniature work of art.

Some newspapers allow designers total freedom to create loud, lively headlines like those on this page. Others insist that display headlines follow the same rules — and use the same typefaces — as the rest of the paper (that's to keep feature stories from looking *too* different from the rest of the news).

So before you plunge too far off the deep end, be sure you know the limits of your editors' tastes — as well as the limits of your own typographic skills.

These wild & crazy display headlines were concocted at The Asbury Park Press (top left), The Oregonian (the two middle pages at left and the middle page below), The Ball State Daily News (bottom left) and The Detroit News (bottom right).

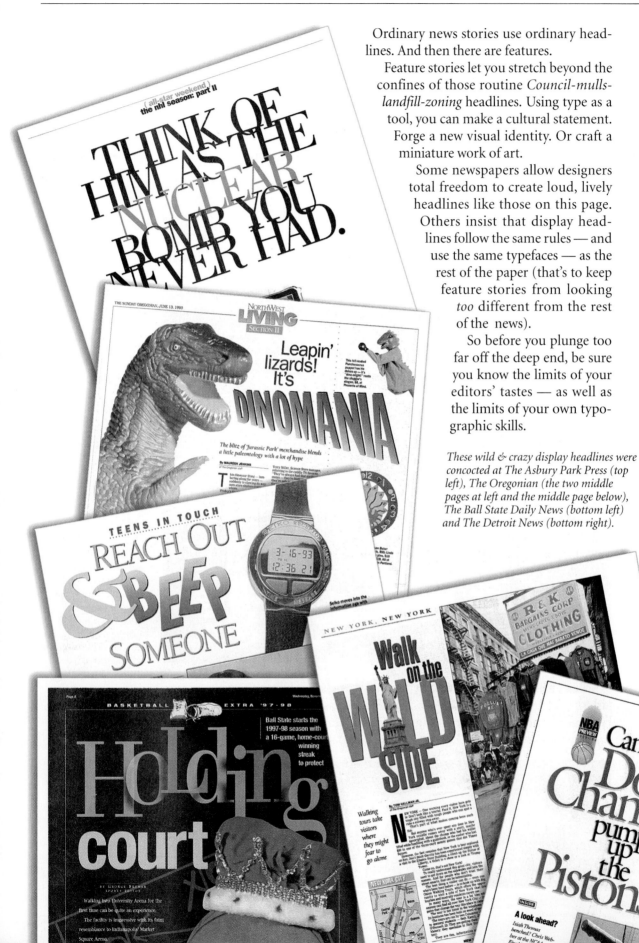

DISPLAY HEADLINES

DUMMYING & BUILDING DISPLAY HEADLINES

It can take hours — *days* — to write the perfect headline for a special story. But while you're waiting for inspiration to strike, you may need to go ahead and dummy that story, leaving a hole for the headline to fill later.

In the dummy at right, the designer left a horizontal space for a headline — which later turned out to be "Beauty and the Beast." With enough time and energy (and a big bag of fonts to choose from), you could fill that hole with a headline like this:

This typeface (Coronet Script) is aqua with both a white and a blurry black drop shadow. The "B" is 92 pt.; the lower-case letters are 116 pt.

A 36-pt. Berkeley italic ampersand, white with a light shadow.

This novelty font (Neuland) is reversed out of black. "THE" is 14 pt., solid white; "BEAST" is 48 pt., with a gradient that runs from yellow to orange.

Like many designers, you may have access to dozens of typefaces and to computer programs that can crunch, curve and contort type. Fine — but go easy. Even if you're restricted to just *one* type family, you can use screens, rules and boxes to add style and variety. The headlines below, for instance, use just the Futura family. Let's take a closer look at how their components were crafted:*

Solid black type

Widely tracked type, centered over a .5-pt. rule

Solid black type

30% black type

Type centered over a 12-pt. bar; screen fades from 0 to 50% to 0

Solid black type

20% black type with a 50% shadow

Type centered between .5-pt. rules spaced 2 pts. apart

Solid black type with a 20% shadow

10% black box with a .5-pt. border and a 20% shadow

Type reversed out of a solid black 6-pt. bar

20% black type (uses two .5-pt. shadows: one white, one 50% black)

Box uses a graduated screen (from 50% top to 5% bottom). Shadow is 40% black, blurred in Photoshop

Type reversed out of a black box with a .5-pt. reversed inline

50% black type

Type reversed out of black, with .4-pt. rules spaced 1.5 pts. apart

* Because screens vary from one printer to another, the densities used here may need adjustment at *your* paper.

DISPLAY HEADLINE GUIDELINES

◆ **Don't overdo it.** Sure, playing with type is oodles of fun. But don't turn your pages into circus posters. Use restraint. Save display headlines for special occasions: big feature stories, special news packages or photo spreads.

Too much: *Sure, it's a matter of personal taste. But if you park display headlines in every corner of the page, it'll look like rebel bands of typographers seized control of your newsroom. When you put too much emphasis on decoration, you distract your readers.*

About right: *Here, we've saved the flashy type for where we need it most: in the lead story and that small feature in the bottom corner. Because the other stories are standard news items, they get standard headlines. This typography subliminally helps readers sort the news.*

◆ **Match the tone of the story.** Be sensitive to your topic. Use bold, expressive type when it's appropriate (below, left) — but don't impose it on topics that require more understated, dignified type (below, right).

◆ **Keep it short and punchy.** To give a display headline maximum impact, build it around one or two key words or a clever, catchy phrase. Think of popular movie titles *(Jaws, Star Wars, Ghostbusters, Home Alone)* and keep your story titles equally tight. Wide, wordy headlines may be fine for hard news stories —

BABY BUNNIES SPREAD EASTER JOY

— but phrases like that may seem clunky or threatening on feature pages.

So play with the story topic to draw out a short, punchy title. Then play with the phrasing to decide where the graphic emphasis should go.

DISPLAY HEADLINE GUIDELINES

◆ **Grid it off.** That's design jargon for aligning your type neatly into the story design. Wild, ragged words that float in a free-form, artsy way just add clutter and noise. And noise annoys readers.

Instead, enlarge, reduce, stretch or stack words so they're solidly organized.

This headline floats too much. It's not anchored. The leading looks awkward and uneven — and worse, none of the words align. It wastes space and calls too much attention to itself. On a busy page, this headline would just add to the confusion.

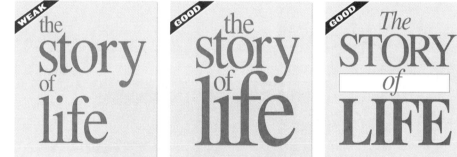

Each of these headlines is neatly stacked. The top one aligns flush right; the bottom one lines up (on a slight angle) along both sides. Notice how some words have been resized to ensure a clean fit. Note, too, how in each head-line the second line manages to avoid the descender of the "g".

As you manipulate the words, watch for natural breaks in phrasing. Will key words play better wide? Narrow? Centered? Stacked vertically, a headline may work best ALL CAPS. And you may want to run a word or line in a different weight or font (be careful) for emphasis or variety.

This headline is all lower case. And as you can see, many lower-case characters don't stack well vertically; the contours of the ascenders and descenders leave uneven gaps that are difficult to fill smoothly.

The words in that middle headline flow around the uneven ascenders and descenders. Notice how the "f" and the "y" flow together; notice how the dot of the "i" has been replaced by the word "of." At right, the key words now use all caps to provide more solid, even contours.

◆ **Go easy on gimmicks.** We've all seen amazing typography on movie posters, beer bottles and record labels. But those are designed by highly paid professionals. *Your* daring headlines may look clumsy — or illegible — if you choose goofy fonts, run headlines sideways, create artsy hand-lettering. So beware, beware of gimmicky type. Do you really want readers to think you're a flake?

Novelty type: *Sorry, but some typo-graphic clichés are hopelessly corny. Silly or gimmicky type can instantly make you look like an amateur.*

Special effects: *Tilting, tinting, stretching, shading — a little goes a long, long way. It's fun to do, but it just adds noise and distraction.*

Sharing letters: *Enlarged caps can add a decorative touch. But trying to share jumbo letters can be confusing. (SUNDAY CHOOL? CHOOLY?)*

Rules and bars: *The stacks in this headline go on and on and on. Too many rules, bars and words make headlines dense, dark and slow.*

COLOR

For years — for *decades* — newspaper editors viewed color with suspicion. Color, they stubbornly insisted, was fine for the Sunday funnies, but *news* pages should be black and white and read all over.

Time passed. TV became full-color. Magazines became full-color. And in the '80s, after USA Today caught on, newspapers finally realized that color isn't just decoration; it attracts readers as it performs a variety of design functions:

Advertising & promotion

There are no ads on this page, since most papers keep Page One off-limits to advertisers. But these color teasers are designed to draw readers in. And there's surely an ad on the back page of this section, since sharing color printing positions with advertisers defrays the newsroom cost of color production.

Typography

Notice the variety of color type treatments on this page: The blue-and-yellow "THIS SUNDAY" header, the red topic labels in the promo column, the colorful "Tropic Hunt" headline. Each has a different job to do — especially those standing headers, which use the same colors week after week — so the colors have been assigned in a logical, well balanced way.

Illustrations

Colorizing art is one of the easiest ways to add appeal to a page. And in this promo column, you can see a few common illustration options: colorized logos of local sports teams; a photo illustration (the dollar sign) using a collage of color photos; and a cartoony illustration for a travel feature. And speaking of cartoons — what would the Sunday paper be without the Sunday funnies?

Photographs

Prior to 1980, photojournalism — in both magazines and newspapers — was primarily a black-and-white craft. But at most modern papers, color photos on section fronts have become mandatory. High-quality photo reproduction is often difficult and expensive, but that cost is offset by the appeal color photos have — and the added information they convey.

Infographics

Charts, graphs and maps rely on screens and rules to separate elements and enhance readability. And adding color makes them even more effective — as in the Mars graphic at the bottom of the page. In maps, readers see at a glance that blue means water, tan means land. And large-scale color infographics can become the centerpiece of a page — particularly when no photos are available.

Quality control

Printing sharp, consistent color isn't easy. If inks aren't properly balanced, faces turn pink; the sky turns purple. That's why many papers print color control bars like this one, which mixes tints of black, cyan, magenta and yellow. By gauging the density of this bar, press operators can ensure that the inks are properly balanced.

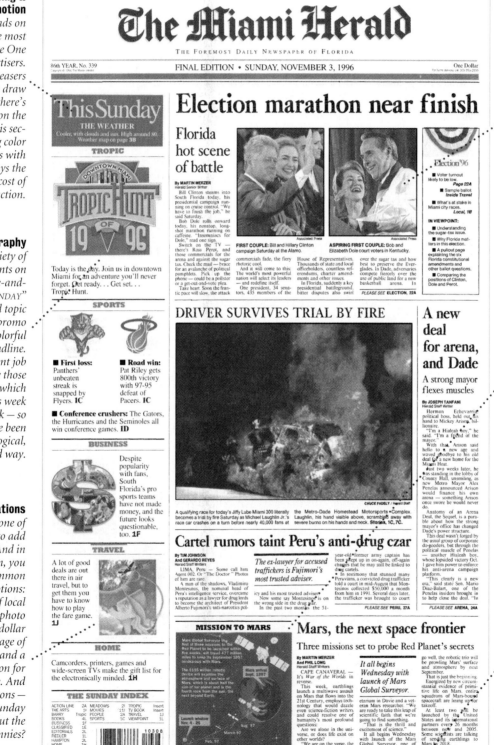

TYPES OF COLOR

SPOT COLOR

Ordinarily, printers use just one color of ink: black. But for a little extra money, they'll add a second ink to the press — a *spot color* — to let you print pages in a new hue.

(For even more money, you can add several spot colors to your paper. But unless you can coax an advertiser into sharing the color and footing the bill, you could blow your whole printing budget on a few flashy pages.)

Any single color — green, orange, turquoise, mauve, you name it — can print as a spot color. But because readers are so accustomed to basic black and white, any added color has instant impact. So proceed with caution. Some "hot" colors (pink, orange) are more cartoony than "cool" ones (blue, violet) — so choose hues that suit your news.

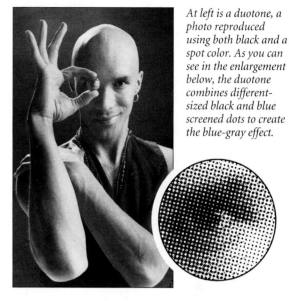

At left is a duotone, a photo reproduced using both black and a spot color. As you can see in the enlargement below, the duotone combines different-sized black and blue screened dots to create the blue-gray effect.

Like basic black, spot colors can print as either solid tones or tints. Here, for instance, are some screen percentages for a spot blue:

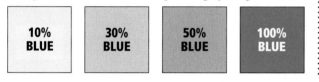

| 10% BLUE | 30% BLUE | 50% BLUE | 100% BLUE |

You add richness and variety to spot colors by mixing in black:

| 20% BLUE+ 10% BLACK | 100% BLUE+ 30% BLACK |

Pastels work best for background screens, while solid tones are best for borders and type:

THIS IS 100% BLUE-20% BLACK TYPE INSIDE A 100% BLUE BOX WITH A 10% BLUE BACKGROUND

PROCESS OR FULL COLOR

But what if you want to print *all* the colors — the whole rainbow? You could add hundreds of separate spot inks, but that would cost a fortune (and you'd need a printing press a mile long). Instead, you can create the effect of full color by mixing and matching these four *process* colors:

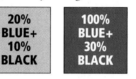

CYAN MAGENTA YELLOW BLACK

By layering these four colors in different densities, a printing press can create almost any hue.

Publishing process color is expensive— not only for the extra ink, but for all the production work that's needed to prepare pages for printing. Though desktop scanning hardware has simplified the procedure, the end result is still the same: color photos and illustrations must ultimately be separated into those four process colors, then recombined as the presses roll. (See page 206.)

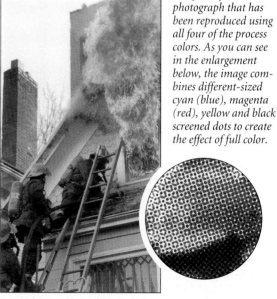

At left is a full color photograph that has been reproduced using all four of the process colors. As you can see in the enlargement below, the image combines different-sized cyan (blue), magenta (red), yellow and black screened dots to create the effect of full color.

Process colors can print as either solid tones or screens. Here, for instance, are the four process colors reproduced as 20% screens:

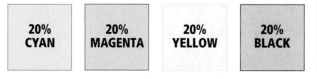

| 20% CYAN | 20% MAGENTA | 20% YELLOW | 20% BLACK |

Combining different values of process colors creates new hues:

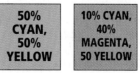

| 50% CYAN, 50% YELLOW | 10% CYAN, 40% MAGENTA, 50 YELLOW |

Pastels work best for background screens, while solid tones are best for borders and type:

50% CYAN-100% MAGENTA TYPE INSIDE A 100% CYAN BOX WITH A 20% MAGENTA-30% YELLOW SCREEN

ADDING COLOR TO A PAGE

This feature page from The Washington Times demonstrates that color doesn't need to be excessive to be effective. The designer, working with a limited color palette, has carefully balanced the color elements on this page.

*Note the screen used in the background of this box. It's called a **gradient** or **blend** because it gently fades from one tint to another. Graduated screens offer a bit more texture than standard color screens but work best when their colors remain subtle.*

"We've got spot purple on this page if we want it." Ohhhh, what a dangerous temptation that is. What a quick way to turn a nice newspaper into junk mail.

Yes, color can be a blessing — or a curse. It can delight your readers or destroy your design. Using color successfully requires tight deadlines. Quality control. Extra money. Extra planning.

So plan for color. Don't treat it like a surprise gift. And above all:

◆ **Go easy.** Resist your initial urge to go overboard. Don't splash color around the page just to get your money's worth. Remember, black and white are colors, too — and newspapers have managed to look handsome for centuries without adding extra inks.

◆ **Don't use color for color's sake.** Remember, this is a *news* paper. Not the Sunday funnies. If you're deciding whether to run a color photo of circus balloons or a black-and-white photo of a bank holdup, choose the image that's meaningful — not just pretty.

◆ **Beware of colorizing false relationships.** Color creates connections, even where none actually exist. Put a *red* headline, a *red* chart and a *red* ad on the same page, and that tint may unite them all in the reader's mind. That can be misleading (depending upon the layout).

Colors speak to each other. So if you don't want to connect unrelated elements, try not to brand them with the same hue.

◆ **Be consistent.** Don't run a purple flag one day, a green flag the next; blue subheads here, red ones there. Give your pages a consistent graphic identity by standardizing colors wherever they're appropriate. Use this chart to plan ahead:

WHERE TO ADD SPOT COLOR

THESE WILL *USUALLY* WORK IN COLOR:*

- ◆ **Illustrations**
- ◆ **Charts, maps and infographics**
- ◆ **Photos (full-color only)**
- ◆ **Nameplates**
- ◆ **Logos and sigs**
- ◆ **Ads**
- ◆ **Rules, headers and art in classified ads**

THESE WILL *OFTEN* WORK IN COLOR:*

- ◆ **Display headlines** (for big feature stories)
- ◆ **Photo duotones** (for special feature stories)
- ◆ **Boxed stories/sidebars** (light screen tints only)
- ◆ **Lift quotes, initial caps** (best if used in conjunction with color headlines or color illustrations)
- ◆ **Decorative rules/bars**
- ◆ **Borders around photos**
- ◆ **Signposts: teasers, headers, indexes, etc.** (but avoid competing with similar colors on the page)
- ◆ **Boxed subheads within a feature story**

THESE WILL *RARELY* WORK IN COLOR:*

- ◆ **Photographs** (printed with just one spot color)
- ◆ **News headlines**
- ◆ **Text type/cutlines**
- ◆ **Boxed or screened hard news stories**

**Depending upon: (1) your choice of tint, and (2) whether the color creates misleading relationships between unrelated elements on the page.*

ADDING COLOR TO A PAGE

Adding color to a black-and-white page is a tricky thing. Where should it go? How much is too much?

For best results, remember that *a little goes a long way.* It would be unrealistic to dictate where color can or cannot be used — but as these examples show, some choices succeed more than others:

Here's a typical page in basic black. It may be gray, but it's not dull: By combining a variety of rules, bars and graphic elements, it presents an attractive mix of contrasts. It doesn't need extra decoration; any color we add should probably be functional, not decorative.

In the race to add color to this page, the advertiser got there first. And since that red ad is so distinctive and loud, any red we add to the news design may seem related to that ad. That's a problem. To maintain a distinction between news and advertising, you can choose to use a minimum of editorial color. Here, we've applied red only to the header — and we've added 20% black to it, to give it a hue that's different from that ad.

Without color in that ad, we're free to colorize our editorial layout. Still, we've used restraint. We've applied spot color for organization, not just decoration. Red bars in the header and news briefs help anchor the layout; red bars in the bar graph make the information easily discernable. And the lead photo is now a duotone – permissible because it's a feature photo, not hard news.

We've made some poor choices here — and now the page looks silly. Pink screens taint the credibility of the news. Red headlines and liftout quotes lose integrity. Red rules and boxes distract readers, calling attention to unimportant design elements. And that red photo? It shows how poorly photos print using only process color. The page is weak — and worse, those colorized news elements all seem related, somehow, to Mike's Bikes.

COLOR GUIDELINES

This Fourth of July trivia page was done on the run: The designer had no art, no budget and no time to play. But this clever solution uses only type and spot color to turn a functional layout into a patriotic pattern. The red, white and blue colors instantly communicate the theme of the story.

This page suffers from poor color choices. Green and purple — not a very popular color combo — are run as solid tones, and the lack of contrast makes the headline tough to read. The color green was probably meant to suggest money (see the dollar bill sign in the headline?), but the overall effect is dismal.

◆ **Use appropriate colors.** Colorize a page the way you'd decorate your living room. And unless you live in a circus tent, that means choosing comfortable hues (blue and tan, for instance) more often than harsh ones (pinks or bright greens). The integrity of a news story will be damaged if wacky colors surround it, and the impact of a page will be negative if readers are turned off by your color choices.

Colors convey moods. "Hot" colors (red, yellow) are aggressive. "Cool" colors (blue, gray) are more relaxing. So make sure your colors produce the effect you want. And remember, too, that certain color combinations have unshakable associations. For example:

Red = blood, Valentine's Day.

Green = money, St. Patrick's Day.

Red + green = Christmas, Mexico.

Brown = Uh, let's just say a stinky brown can *flush away* a good page design.

Like it or not, these color clichés are lodged in your readers' brains. So make these colors work for you — not against you.

◆ **Keep background screens as pastel as possible.** When we examined background tints back on page 195, we saw how difficult it is to read text that's buried beneath a dark screen. Well, it's a problem whether the background is black, blue, brown, or any dark color. Whenever you run text in a sidebar, chart or map, keep all underlying screens as light as you can. (These will usually be below 20%, but actual numbers vary from press to press. Check with your printer to see what the lightest printable percentages are.)

If you must add type to a dark screen, reverse it in a font that's big or bold enough to remain readable even if the printing registration is poor.

This is 10-point type over a 100% cyan screen. Because the background tint is so intense, the type is hard to read.

This is 10-point type over a 10% cyan screen. Because the background tint is pale, the type is easy to read.

This is 10-point type over a 10% magenta/ 15% yellow screen. Because the color is pastel, the type is easy to read.

This is 10-point type over a 60% cyan/ 60% magenta screen. Because the type is reversed and bold, it's easy to read.

COLOR GUIDELINES

◆ **Don't overreach your technology.** Color production is difficult to do well. It's costly. It's time-consuming. And in the hands of a sloppy printer, it's extremely disappointing. So it pays to learn your limits.

Drawings that look gorgeous on a computer screen often look like mud on newsprint. Color photos look worse than black-and-whites when the inking is poor or the registration is off (i.e., the color plates print out of alignment):

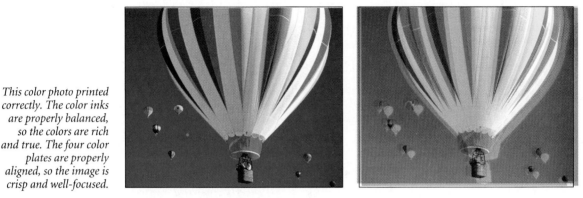

This color photo printed correctly. The color inks are properly balanced, so the colors are rich and true. The four color plates are properly aligned, so the image is crisp and well-focused.

This photo reveals the dangers of poor color production. The inks look washed out and badly balanced. And because the four plates are so far out of alignment, the image looks fuzzy — barely legible. If your color printing looks like this, you're better off using black-and-white.

So use color conservatively until you're certain of the results you'll get. And beware of small, detailed graphics or headlines that demand perfect color registration to succeed — or you'll face legibility problems like this:

THIS HEADLINE REGISTERS THIS HEADLINE DOESN'T

◆ **Watch the volume level of your colors.** Want your page to look like a Hawaiian shirt? That's what you'll get if you use a) too many solid tones, or b) too many different colors. So go easy when you colorize. Use bold, vivid colors for *accent* only, in key locations (drawings, feature headlines, reverse bars). Elsewhere, for contrast, use lighter screens or pastel blends. And if you're designing with full color, try color schemes that accent one or two hues — not the whole rainbow.

Decorative colors are like decorative typefaces. In small doses, they attract; in large doses, they distract.

◆ **Consult a color chart before you create new colors.** Some papers fail to mix colors and end up running all their color effects in basic blue, red and yellow. As a result, they look like a comics section: loud and unsophisticated.

But suppose you want to beef up your blue by adding a little black to it. How much black should you add? 10%? 50%? Or suppose you want to mix magenta and yellow to make orange. Should you simply guess at the right recipe — say, 20% magenta + 50% yellow?

Don't guess. Don't trust what you see on a computer monitor, either — a lot can change between your computer and the pressroom. Instead, ask your printer to give you a color chart (right), which shows how every color combination looks when printed. You can even create your own chart — but be sure it's printed on the same paper your newspaper uses, so all your hues are true.

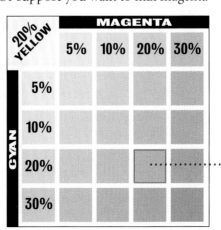

*A **color chart** shows how process inks look when they're combined. This portion of a chart, for instance, shows the tints you get when you add magenta and cyan to 20% yellow. The box highlighted at left shows the tint that results from mixing 20% yellow, 20% magenta and 20% cyan.*

PRINTING FULL COLOR

How do you print full-color art and headlines using just four inks? The technology is complex, but the process is easy to understand. Here's how it works for a typical color image:

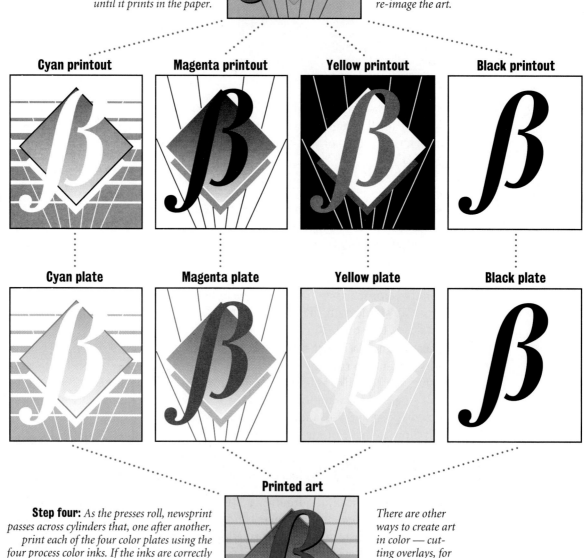

Step one: *The artist draws this color illustration on a computer. As he draws, he creates custom colors from the computer's internal color palette, viewing the results on a color monitor. (Some papers still use black-and-white monitors, but they force you to guess your color values — a bad idea.) When completed, this image exists only in electronic form. The artist will never actually hold the full-color illustration in his hand until it prints in the paper.*

Original art

If this were a drawing on paper or a print of a photo, it would be separated into process colors by either a process camera or a laser scanner, which use color filters to re-image the art.

Step two:
The artist transmits the artwork to a typesetter. Since a typesetter uses only black ink, it can't print the drawing in color. Instead, it electronically separates the art into the four process colors and produces printouts for each color using black ink.

Cyan printout **Magenta printout** **Yellow printout** **Black printout**

Step three:
A process camera shoots a negative of each of the four color printouts. When the page is ready to print, those negatives are transformed into plates for the printing press — one for each color of ink — which produce the images shown here.

Cyan plate **Magenta plate** **Yellow plate** **Black plate**

Printed art

Step four: *As the presses roll, newsprint passes across cylinders that, one after another, print each of the four color plates using the four process color inks. If the inks are correctly balanced — and if the newsprint is properly aligned as it passes through the press — then the colors will be accurate and the image will be sharply focused, or "registered." And only examination under a microscope will show how the differently colored ink dots produce the illusion of full color.*

There are other ways to create art in color — cutting overlays, for instance. That's why it's vital, as you try new techniques, to develop good rapport with your printer and production crew.

TROUBLESHOOTING

Q: **Some art directors say you should never use "gimmicky" headline fonts — that you should never deviate from your paper's font palette. Is that right?**

Never say never. It's true that you should avoid spraying fonts willy-nilly around your newspaper. (You should also avoid fonts with silly names like *Willy-Nilly.*) After all, you don't want your paper looking like a circus poster.

Or do you? Suppose you're running a feature story on clowns, for instance. Which of these headlines is most appropriate?

Most of us might agree that this font is junky and the colors are garish. A handful of headlines like this make a paper noisy and amateurish.

Send in the CLOWNS

Now, suppose this headline uses our standard news headline font. Sure, it's more respectable and refined. But how dull would our paper be if no headline could ever be more exciting than this?

Yes, this headline uses circus type to illustrate a circus story. But is that necessarily bad? Wouldn't this be a successful way to draw readers into the story?

Bottom line: Yes, "gimmicky" fonts can look ugly, sloppy and clichéd. But with the right topic and the right style, they can look fresh and appropriate. It's often a matter of taste. So don't fault the fonts. And don't outlaw typographic creativity.

Most papers work their standard fonts everywhere they can, but they make allowances for special cases. Try to establish guidelines to define what's "special."

Q: **We've asked it before, and we'll ask it again: Overall, how many typefaces should a typical newspaper use?**

That's up to you (see the "Troubleshooting" question on page 38). But before you select typefaces for your newspaper, consider how *versatile* they are. Some type families offer little variation; others come in a variety of styles and weights that will accommodate a variety of topics and headline treatments. For example:

This is Times: a classic, but available in just four fonts. You may find those four fonts don't provide enough versatility.

> Regular
> *Italic*
> **Bold**
> ***Bold Italic***

This is Interstate. It's available in 12 fonts, providing a wide range of styles and weights appropriate for news and feature stories alike:

Q: **My editor never allows us to run text or cutlines either a) flush right, or b) reversed. He says it makes the type unreadable. Is that true?**

As far as flush right text goes, your editor has a point. Too much ragged left text, as we've discussed before, can be annoying. But in small blocks like this one, it's no problem. And cutlines, in particular, often benefit from running flush right against a photo.

If your printer is careful, you should have no problem running reversed type like this. If you're afraid the type will smudge, try running it slightly bigger like this, or bigger and bolder like this. Try a few cautious tests to determine the most legible, readable solution.

This black background, by the way, isn't just solid black. We've also added 15% cyan — an old trick to make the black look darker and richer. Solid black ink, by itself, often looks washed-out or splotchy.

TROUBLESHOOTING

Q: **At our newspaper, we mix colors in an unorganized and inconsistent way. How do we develop a handsome, reliable color palette?**

Good color doesn't just *happen*. It takes careful research and patient testing, *on* newsprint and *on* your press. (Remember, there's a world of difference between the colors you see on your computer monitor and the colors your press actually prints on paper.)

Every newspaper needs an official color guideline like the one at right. To develop it, a team of artists at The Oregonian spent weeks testing hue after hue in maps, charts and headlines until they agreed upon these 10 colors, colors that complement each other while performing every necessary duty.

Want a color palette of your own? Here's a quick three-step method:

1 **Go to a hardware store,** a paint store, a K-mart — anywhere they sell house paint. Pick up booklets or paint chips showing a range of pre-coordinated decorator colors (i.e., the Tortilla Brown that goes so fabulously with their Bahama Blue).

2 **Visit your printer** and ask to see the Pantone ink book. Pantone is a company whose inks have set the industry standard, and they've given every possible hue a number. So match the paint-chip colors you like with the numbers in the Pantone ink guidebook (550 blue, 716 orange, etc.).

Swatch	Label
4,5,8,0	•CHARTBASE 1
5,8,13,0	•CHARTBASE 2 (w/white)
5,8,13,0	•CHARTBASE 3
40,10,0,45	•POINTER
0,80,80,0	•HIGHLIGHT
50,8,40,0	•BAR/LINE 1 (green)
61,16,16,0	•BAR/LINE 1 (blue)
12,100,51,20	•BAR/LINE 1 (red)
100,37,60,0	•BAR/LINE 1 (dk. green)
20,42,55,0	•BAR/LINE 1 (brown)

3 **Sit down at your computer** and open a drawing program (Freehand, Illustrator), a page-layout program (QuarkXpress, PageMaker) or a photo program (Photoshop). Begin creating your color palette by choosing those Pantone numbers, then converting them to CMYK.

Once you've selected a palette of complementary colors — which can range from five to 20 hues — begin testing and fine-tuning them on live pages until they print consistently, predictably and attractively. (By the way, the toughest color to produce is *beige*. Take, for example, the beige we've used throughout this book. After carefully testing and retesting, we finally settled upon this formula: 4% cyan, 5% magenta, 13% yellow. So how well has it printed in *your* version of this book? Is it truly a sandy beige — or is it too pink? Too green? Too yellow?)

4,5,13,0

Q: **Our photo editor won't allow us to run any headlines on photos, or to use any photo cutouts, because it damages the images' integrity. Is that true?**

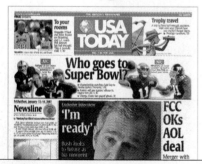

We asked this question back on page 128. We're asking it again now, because it comes up constantly in newsrooms everywhere. Where do you draw the line with cutouts and superimposed headlines?

As we said before, newspapers are behind the curve when it comes to stylizing images. So analyze magazines and newspaper pages like the one at left. Discuss what works. Decide where you'll draw the line — then allow careful experimentation.

S ooner or later, your paper will need new logos. A special themed page. A new section. A major typographic face-lift. Or a complete organizational overhaul.

So where will you begin? Where will you find ideas? How will you know what needs changing? How will you decide on the best typefaces and formats — or more importantly, *who* will decide? Will it be up to the designer? The editor? A redesign committee? The readers?

Long ago, newspapers never worried about these things. They'd go years — *decades* — without changing any of their design components. It didn't matter to the subscribers, so it didn't matter to the editors, either.

But in today's competitive marketplace, every consumer product must remain as fresh as possible. That's why cars are redesigned every year; department stores redecorate every five years; and many magazines get cosmetic makeovers every three or four years.

It's essential for newspapers to regularly reinvent themselves, too. And though any redesign project can seem overwhelming at first, here's a chapter of advice and inspiration to help things run smoothly.

======== CHAPTER CONTENTS ========

REDESIGNS

8

REDESIGNING YOUR PAPER

What do we mean by a *redesign*? Let's take a before-and-after look at a feature
page as it overhauls its typography, its grid and its design philosophy:

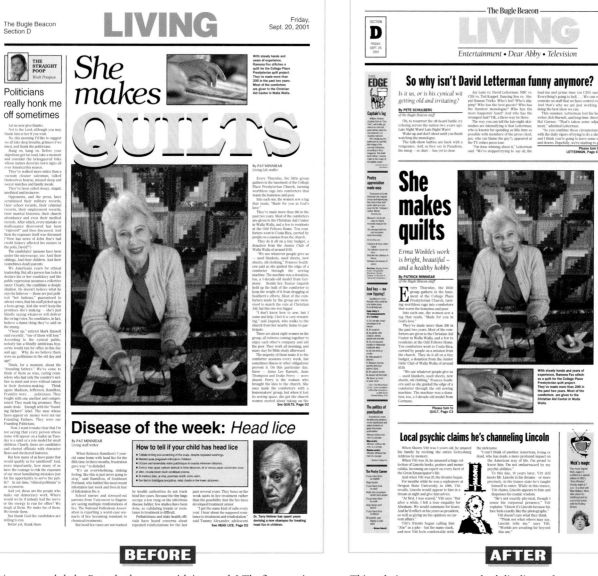

BEFORE

AFTER

This page needs help. But what's wrong with it, exactly? The first step in
any redesign is to itemize the elements that need improvement:

Typography: *The headlines and section flag are Helvetica — a bland font
that lacks personality. Time to dump it (and the Bookman on that lead
story) and find a more modern, expressive font. And those ears are dull,
too (more Helvetica), offering no clues to what's inside the section.*

Color: *A pretty unsophisticated color palette, with those cyan screens and
harsh cyan LIVING. Time to blend some more muted earth tones.*

Story count: *Only three stories, and look how big and slow they are.
Aren't we tired of these topics by now? Most readers demand a better mix,
with more entertainment and a greater range of subjects.*

The page grid: *It's on a standard 5-column grid, which is fine for routine
layouts. But is it versatile enough to organize a page with more traffic?
And haven't we seen enough feature fronts with a columnist dribbling
down the left edge of the page and a dull leftover along the bottom?*

This redesign creates a page that's livelier and more modern-looking.
How did we address each of those problems we originally identified?

Typography: *We made the section flag bigger and bolder — but colored it
gray to tone it back down. We added more index information in the ears.
And the headlines have become Interstate Black Compressed, which allows
a higher character count (that is, a lot more words) in the same space.*

Color: *We're using more pastels for a softer tone, avoiding those comic-
pagey cyans. The headlines are black, so they don't compete with the art.*

Story count: *Now we've got seven elements on this page — a couple
shorter stories, a TV promo, and an offbeat humor column down the left
edge of the page. Is that too much traffic now — or is the speed about right?*

The page grid: *We're now using an unusual 9-column grid, which creates
some dynamic story shapes (notice the Edge column and the TV promo).
This grid might not work on a page with ads at the bottom, but here, it
prevents the high volume of material from becoming too chaotic.*

REDESIGNING YOUR PAPER

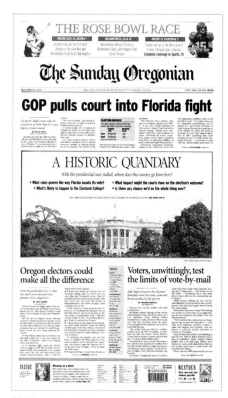

The late '80s: *The Oregonian had been stodgy for decades — and this redesign pushed as far as the old editors would allow. The flag was retooled. A column of briefs ran down the page every day. Summary decks were introduced. (The headlines and decks had to use Helvetica; the publisher was afraid readers would object to any newer font.)*

The mid-'90s: *This redesign adds the energy that was missing before. The flag is engaging and bold, with colorful promos (and an emphasis on the THURSDAY). An 11-column grid helps organize the increased graphic traffic. And the headlines have become Franklin Gothic Condensed, an improvement over the clunkier Helvetica.*

2000: *This redesign was driven by a change in paper size. Like many papers, The Oregonian reduced its width by an inch to save newsprint. Its new editor wanted a more classic, dignified, elegant feel, which is reflected in the Minion headlines, italic decks, wider gutters, and reduced number of graphics and promos.*

Revamping your bylines? Ah, that's easy. Jazzing up your liftout quotes? No problem — that's fun. But launching a bigger project, where you overhaul a page, a section or *an entire newspaper,* is a perilous journey populated with panicky publishers, stubborn staffers and hysterical readers.

Nobody likes change. But every newspaper needs to reinvent itself regularly. And if you can proceed in a logical, orderly manner, you can spare everybody (the staff *and* the readers) a lot of grief.

You've just spent the last 200 pages learning how to assemble a newspaper. Now, in the 10 pages ahead, we'll show you how to take a newspaper apart — and how to piece it together again — as we walk you through our nine steps to a newspaper redesign:

1 Evaluate your newspaper so you'll understand your strengths and weaknesses.

2 Gather examples of other newspapers to provide ideas and inspiration.

3 Make a shopping list of elements you need to change.

4 Build prototypes that explore a variety of design alternatives.

5 Test it by showing it to staffers or readers and assessing their reactions.

6 Promote it with ads or stories that explain the changes to your readers.

7 Write a stylebook that contains detailed guidelines for all the changes.

8 Launch it. *Ulp!* Good luck!

9 Follow through with critiques, discussions and design feedback.

EVALUATING YOUR NEWSPAPER

Every newspaper is unique – and so is every newspaper staff. Some excel in photography. Some produce award-winning text. Some create graphic wizardry.

So how would you assess *your* staff? Before you begin tinkering with your format, take inventory. Make sure your staff agrees on what's working, what's broken – and where a redesign should take you. This do-it-yourself design checkup will help you itemize your newspaper's strengths and weaknesses.

NEWSPAPER DESIGN

REPORT CARD

Answer each question by marking the corresponding box **yes** *(worth two points)*, **somewhat** *(worth one point)* or **no** *(zero points)*. You can earn up to 10 points per category or 100 points overall.

no (0 pts.) / somewhat (1 pt.) / yes (2 pts.) — **score / comments**

HEADLINES & TYPE
- Do news headlines intrigue, inform and invite readers in?
- Do feature headlines project a friendly, appealing personality?
- Do decks summarize and sell stories to readers in a hurry?
- Do headlines and text use an effective mix of styles and weights?
- Are all typographic details consistent and professional-looking?

PHOTOS
- Are photos active and engaging (rather than dull and passive)?
- Are photos cropped, sized and positioned effectively?
- Are photos sharp and well-composed?
- Are key photos in color — and is the color well-balanced?
- Do enough photos appear throughout the entire paper?

GRAPHICS & ARTWORK
- Do maps, charts and diagrams supplement text where necessary?
- Is graphic data meaningful, accurate and understandable?
- Are sidebars and agate material typographically well-crafted?
- Is artwork polished and professional-looking?
- Is there witty/provocative art on the opinion page?

SPECIAL PAGE DESIGNS
- Are special pages active, attractive and well balanced?
- Are display elements — art and type — given bold treatment?
- Are headers and logos polished and eye-catching?
- Is color used effectively in photos, graphics, standing elements?
- Do themed pages use distinctive packaging, formats or grids?

INSIDE PAGES
- Is the content organized in a logical and consistent way?
- Do layouts use modular shapes with strong dominant elements?
- Is there a mix of briefs and analysis throughout the paper?
- Is each page's contents labeled with a consistent header style?
- Are jumped stories well-labeled and easy to find?

212

EVALUATING YOUR NEWSPAPER

NEWSPAPER DESIGN

REPORT CARD

| | | no | somewhat | yes | score / comments |

THE BASIC FIXTURES		no	somewhat	yes	
	Are liftout quotes used often and effectively?	☐	☐	☐	
	Are margins and spacing uniform and appropriate?	☐	☐	☐	
	Are column logos and sigs attractive, helpful and consistent?	☐	☐	☐	
	Do rules, boxes and screens effectively organize material?	☐	☐	☐	
	Are bylines and jump lines well-designed and -positioned?	☐	☐	☐	

VOLUME & VARIETY					
	Does the front page cover an interesting variety of topics?	☐	☐	☐	
	Have major stories been packaged with short, effective sidebars?	☐	☐	☐	
	Do key pages highlight special topics of high reader interest?	☐	☐	☐	
	Is there an appealing mix of live news and regular features?	☐	☐	☐	
	Do stories appeal to a broad range of tastes and temperaments?	☐	☐	☐	

ADS & SELF-PROMOTION					
	Do front-page promos catch the reader's eye in a lively way?	☐	☐	☐	
	Did you offer any contests or giveaways? Sponsor any events?	☐	☐	☐	
	Is your Web address easy to find?	☐	☐	☐	
	Are ads well-designed? Arranged in neat, unobtrusive stacks?	☐	☐	☐	
	Have you given readers reasons to anticipate your next issue?	☐	☐	☐	

USER-FRIENDLINESS					
	Is there a complete index in a consistent, obvious spot?	☐	☐	☐	
	Are some stories interactive (quizzes, tips, Q&A's, checklists)?	☐	☐	☐	
	Do you run complete calendars (for meetings, sports, events)?	☐	☐	☐	
	Is it clear how to reach key staffers (by phone, fax, letter, e-mail)?	☐	☐	☐	
	Do you solicit reader input throughout the newspaper?	☐	☐	☐	

PERSONALITY					
	Does your paper's personality match that of its target audience?	☐	☐	☐	
	Are regular columnists given mug shots? Anchored consistently?	☐	☐	☐	
	Is the paper's flag distinctive and sophisticated?	☐	☐	☐	
	Are there any surprises on Page One?	☐	☐	☐	
	Will anything in today's paper incite reactions from readers?	☐	☐	☐	

THE GRADING SCALE	
90-100: Outstanding! A top-notch publication.	
70-89: Good, but could still use new ideas and improvements.	**YOUR TOTAL SCORE** ▶
50-69: Average – possibly dull. Time to think about a redesign.	
below 50: Sorry, but you're old-fashioned. Your readers are probably bored. You need to consider a major overhaul.	

GATHERING EXAMPLES

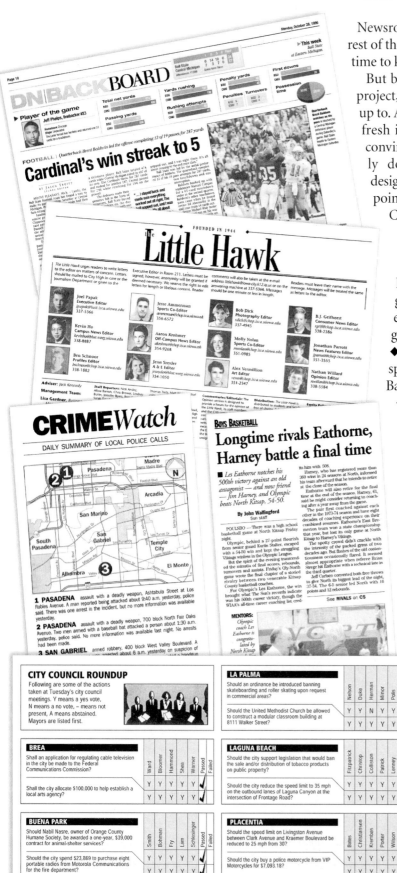

Newsrooms often seem cut off from the rest of the design world. After all, who's got time to keep track of the latest trends?

But before you plunge into a redesign project, find out what your colleagues are up to. A well-designed paper can give you fresh ideas, raise your standards, even convince stubborn staffers that you really do *need* to improve. A poorly designed paper, on the other hand, can point out pitfalls to avoid.

Collect a variety of papers from all across the country: award-winners, trendsetters, the good, the bad and the ugly. Study their headlines, bylines, liftout quotes, grids — *everything* — and keep an eye out for innovative features and graphic elements like these:

◆ A statistical summary of a big sports event, like this one from The Ball State Daily News *(top left)*;

◆ A pictorial staff box, like those in The Little Hawk;

◆ A daily crime map, like this one from The Pasadena Star-News;

◆ Kickers and summaries, like those in The Bremerton Sun;

◆ Council-meeting roundups in grid formats, like those in The Orange County Register.

As you uncover intriguing new design ideas, explore ways you can adapt them to your paper. Add your own creative spins – don't just steal them.

THE WORLD'S BEST-DESIGNED NEWSPAPERS

Each year, judges from the Society of News Design select the world's best-designed newspapers, based on overall content, style, photography and typography. Among the winners from the past few years:

175,000 circulation and over

◆ The Hartford (Conn.) Courant
◆ The National Post, Ontario
◆ The Orange County Register
◆ The Oregonian, Portland
◆ The New York Times
◆ The Seattle Times

50,000-174,999

◆ Reforma, Mexico City
◆ Die Woche, Germany
◆ San Francisco Examiner
◆ The Scotsman, Edinburgh
◆ The Spokesman-Review, Spokane, Wash.

49,999 and under

◆ The Ball State Daily News, Muncie, Ind.
◆ Centre Daily Times, State College, Pa.
◆ Diario de Noticias, Spain
◆ Le Devoir, Montreal
◆ The Longmont Times, Colorado
◆ The Sun, Bremerton, Wash.

COMPILING A SHOPPING LIST

Once you've identified your flaws and established your goals, you can pinpoint specific items that need repair or replacement. As you compile your redesign shopping list, decide what's sacred (your flag?), what's *got* to go (your ugly headline type?) and what's optional (maybe a fancy index would be nice, but not essential).

To help you itemize the changes you need to make, try using this checklist:

WHICH ELEMENTS NEED A REDESIGN AT YOUR PAPER?

HEADLINES & TEXT

☐ **THE FLAG**.................... *Must be unique and expressive, like a corporate logo. Should you try a modern, stylish typeface? Special graphics effects? Color?*

☐ **HEADLINES**.................. *Want them bold and punchy? Or sleek and elegant? Want to try alternative forms (hammers, kickers) — or add topic labels?*

☐ **DECKS**......................... *Should complement the main headline's typeface. Will you add them to every story? Want different styles for news and features?*

☐ **STANDING HEADS**........ *Choose one expressive, stylish type family for all page toppers, logos, sigs, etc. Want screens, reverses, other graphics effects?*

☐ **TEXT**........................... *Must be comfortable to read. What's the ideal size and leading?*

☐ **SPECIAL TEXT**............. *Want a sans-serif alternative for graphics, sidebars, briefs? Should be a font with versatility (strong boldface, italic, etc.).*

ARCHITECTURE & DESIGN

☐ **PAGE GRIDS**............... *Should you try a new system of column widths and page formats? Will this work with ads — or just on open pages?*

☐ **PAGE HEADERS**........... *Where do you want them — at the top? Sideways? Indented? Can they incorporate graphic extras (factoids, calendars, etc.)?*

☐ **BRIEFS**....................... *Should you regard them as fundamental building blocks and anchor them throughout the paper? Can you include art?*

☐ **SPECIAL FEATURES**...... *Polls. Quotes. Stats. Calendars. Quizzes. Contests. Letters. Cartoons. Can you build these into standing page formats?*

☐ **RULES & BOXES**........... *They're a key part of your overall look. Want them loud? Quiet? Decide on ideal line weights. Box styles. Screen densities.*

☐ **PROMOS & INDEX**........ *How prominent? How flexible? How much art can you add?*

☐ **ADS**............................ *Can you keep ad stacks modular? Cleared from key pages?*

CONTENT & ORGANIZATION

☐ **SECTIONING**................ *Can you restructure the news into innovative topics and departments? Can you create special themed pages or packages?*

☐ **SEQUENCING**............... *What's the most interesting, effective flow of topics through the paper? Where can you pile ugly ad stacks to do the least damage?*

☐ **NON-TEXT OPTIONS**...... *Can you repackage information in a variety of forms – besides text and headlines? Can you anchor these alternative formats?*

☐ **INTERACTIVITY**........... *How user-friendly should you be? Where can you give readers more opportunities to speak, participate, interact?*

OTHER ELEMENTS

☐ LIFTOUT QUOTES

☐ COLUMN LOGOS

☐ REVIEW/PREVIEW BOXES

☐ BYLINES

☐ JUMP LINES

☐ JUMP HEADLINES

☐ INITIAL CAPS

☐ CUTLINES

☐ CUTLINES FOR STAND-ALONE PHOTOS

☐ CREDIT LINES

☐ EDITOR'S NOTES

☐ MAPS & CHARTS

☐ REFERS

☐ CORRECTIONS

BUILDING PROTOTYPES

You've collected the ideas. You've called the meetings. Now it's finally time to crank out the prototypes — sample pages that test your new design concepts.

But first, some advice:

◆ **Allow enough time.** You might think you can dream up cool designs in a few hours (and you probably can), but the entire process — exploring new ideas, discussing them with your colleagues, tweaking and revising design elements — can take weeks, even months. Don't get impatient. If you push too hard too fast, you'll be disappointed.

◆ **Be honest.** Stay real. Don't fall in love with pages your staff can't produce. And don't try to sell risky designs that only you understand. If an idea won't fly in the real world, drop it. Speaking of which. . .

◆ **Use dull material.** When you create prototypes, resist the urge to show off. Use bland, everyday content; if your design works with boring stories and dull art, it can only look *better* in real life. Designers often use Latin gobbledygook for text and headlines (as we've done on the facing page) so people won't be distracted by the words they're reading – but once you've made your typographic decisions, you should use real material to test the functionality of your design.

◆ **Don't steal** — or at least cover your tracks. Sure, it's nice to seek a little outside inspiration. But don't blatantly copy another paper's design elements or typography. Sooner or later, someone will find out you've plagiarized — and they'll wonder why you don't have any imagination of your own.

◆ **Stay open to opinions.** Nobody wants to work with a thin-skinned, narrow-minded egotist. Be a good listener. Be a good sport. Seek constructive criticism and intelligent feedback.

◆ **Present plenty of options.** The more options, the better. Suppose, for instance, you need to create a SPORTS SHORTS logo using only Berkeley and Helvetica Compressed type:

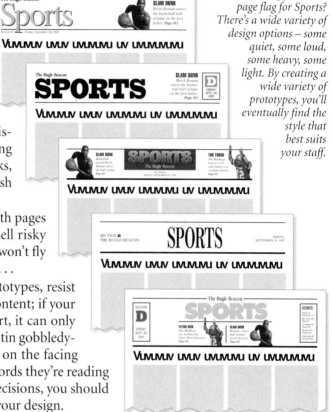

Looking for a new page flag for Sports? There's a wide variety of design options – some quiet, some loud, some heavy, some light. By creating a wide variety of prototypes, you'll eventually find the style that best suits your staff.

Which of these is the best? That's hard to say. Once you've produced a variety of prototypes, it often becomes a matter of taste – someone *else's* taste. After cranking out a handful of options like these, most designers present them to the staff (or the boss) and *they* decide which one works best.

BUILDING PROTOTYPES

How do you decide on new design elements? Create a template — an ordinary, everyday page design – then plug in a variety of typefaces and logo treatments until you find a combination that feels right. For example:

Here we're trying light, elegant headlines (Minion) and bold, trendy display type (Franklin Gothic expanded to around 200%). Notice how we've used phony Latin type and a blurry photo – that way, we force you to concentrate on the typography without getting distracted by the story content.

Now we've changed those light serif headlines to bold sans serif (Franklin Gothic Condensed). And the display type becomes all-cap Palatino, a serif. Like this better? Let's assume your answer is "yes," but that you want a little more oomph and variety from the display elements on the page. . . .

Here, we've given the display elements more color — by adding gray screens and shadows, and by switching to Rockwell, a club serif typeface. But look at the page architecture. Should we keep that conventional 5-column grid...

...or should we try a 9-column grid, as shown here? Notice how the two outermost columns are used for graphic extras — not text. This prototype page ALONE could generate hours of fruitful discussion in most newsrooms.

TESTING AND PROMOTION

Think you know what your readers want to read? The kinds of photos and colors they like? The news they actually *use?*

Well, you can guess (which most editors think they're pretty good at), *or* you can ask your readers directly. And a redesign gives you a perfect opportunity to hear real readers react to your work.

Professional researchers probe public opinion in two ways:

◆ **Reader surveys:** Most newspapers research reader habits through the mail, over the phone, or with a poll printed in the paper. If you're testing a new design, you can distribute a prototype first, then follow up with a questionnaire *("What changes have you noticed?"... "Is it better than what you're getting now?"... "Do you like THIS comic?"...).*

◆ **Focus groups:** These may not be as statistically accurate as large-scale reader surveys, but they let you gauge readers' opinions and emotions in ways that surveys can't. Focus groups allow you to watch readers interact with the paper, whether you're observing participants through a one-way mirror — in an attempt to keep the process as objective as possible — or engaging them in an informal roundtable discussion.

A behind-the-scenes look at a focus-group discussion in Seattle. Participants are often unsure exactly what's being tested – or who might be sitting behind that one-way mirror, watching them react to page prototypes.

Any time you monkey with your newspaper — adding new features, deleting or relocating old ones — you've got to let your readers know. After all, it's *their* paper. And since they'll have opinions about you whatever you do, you might as well try to drum up some enthusiasm (or at least convince them that you know what you're doing).

Whether you're a big daily or a student monthly, your audience consists of these three groups:

◆ **Loyal readers:** They're your faithful followers, and they're intimately familiar with your newspaper. So if you make sudden changes, they'll feel confused or betrayed if you don't clue them in ahead of time.

◆ **Occasional readers:** They know who you are, and they know what they need from you. They may frequently grab you for some specific reason (sports scores, classified ads, movie times). But they might read you more often if you convince them it's worth it.

◆ **Non-readers:** Maybe they're not interested in you. Maybe they don't like you. Or maybe they just don't know about you. With the right ad campaign, however, you could win them over.

So how will you sell your redesign to each of these three groups? If you promote your new look — and explain it in ads like the one at right — you'll generate a buzz among readers and non-readers alike.

WRITING A STYLEBOOK

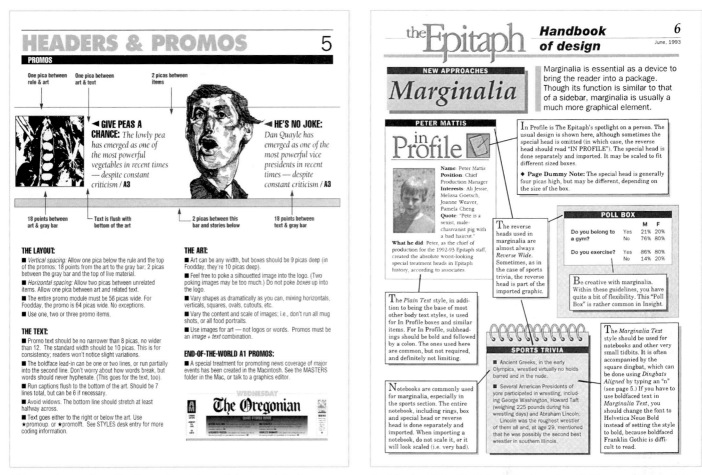

This sample page from The Oregonian design stylebook explains how to produce the daily promos on Page One. Note the detailed guidelines for sizing the art, positioning the text, spacing each element. Fine-tuning these details in advance can help goof-proof any newspaper.

Back in the 1990s, The Epitaph in Cupertino, Calif., unveiled one of the most innovative designs of any high school newspaper. Their 11-page stylebook codified all major components of the design, from decks and dingbats to the marginalia on the Sports page explained here.

You've just redesigned your newspaper. It's perfect. Gorgeous. A newspaper *the very angels in heaven read one unto another.*

It could happen.

But what becomes of all those complicated type codes and logo formats if you get hit by a bus? How will other staffers figure out how to make all those logos, bylines, liftout quotes and pie charts look as gorgeous as *you* did?

Answer: Create a design stylebook.

If you're a reporter or editor, you're probably familiar with writers' stylebooks, those journalistic bibles that prescribe when to capitalize words like *president* or abbreviate words like *avenue*. Newspapers need design stylebooks, too, to itemize the do's and don'ts of their designs, to catalog all the tools in their typographic toolbox.

Stylebooks aren't intended to stifle creativity. They're meant to save time, so that staffers on deadline don't waste energy wondering, "How dark is that screen in our logos?" or "Are we allowed to write **COMIC BOOK** headlines?"

The best stylebooks are detailed and complete, like those shown above. As you proceed through the redesign process, create a stylebook entry for each new format that explains where it goes, when it's used, how it's coded, where it's stored — whatever answers designers will seek in the future.

LAUNCHING — AND FOLLOWING UP

ALL AT ONCE — OR PHASE IT IN?

It's an age-old question: Should you unveil your redesign all at once, with great noise and hoopla, or phase it in more slowly and discreetly? If you're launching a new feature, a new page or a new section, it's probably best to roll it out all at once. But if you're redesigning your entire paper, you should weigh both options.

Launching the redesign all at once:

◆ Provides a golden marketing opportunity to generate excitement among both readers and non-readers with an ad campaign heralding your wonderful improvements.

◆ Energizes the newsroom, encouraging the staff to gear up, dig in and pull together toward a common goal.

◆ May irritate or frighten habitual readers — that vocal minority that resists change of any kind.

Phasing in the redesign over days or weeks:

◆ Keeps the pace manageable, giving the staff time to test new formats, work out bugs and make incremental adjustments.

◆ Eases the transition for readers — many of whom might never even realize you've *made* any changes.

ENFORCING AND REFINING NEW STYLES

It's not enough to simply launch a redesign; you've got to monitor and modify your new formats until they're fully integrated into the newsroom. How?

◆ Appoint a "style cop" to target all design violations — otherwise, no one will take responsibility for ensuring quality control.

◆ Set up a design bulletin board to display successes and analyze mistakes.

◆ Send out memos that discuss problems and summarize solutions (these could include excerpts from the stylebook that deserve special attention).

◆ Above all, hold regular post-mortem sessions where you assess the redesign and make any necessary modifications.

Once it all works perfectly, you can relax . . . and begin planning your next design project. Which raises the question: *How often should you redesign?*

That depends on your audience, your publisher, your paper's personality — and the success of your current design. For weeklies, one redesign per decade may be all the staff (or readers) can handle. Dailies, though, should freshen their appearance every five years. And student papers should redesign annually.

For big papers, redesigns are major undertakings. But for smaller papers — especially student publications — an annual redesign lets each new staff stamp its identity on the paper, as the staff of The Little Hawk in Iowa City has done in this sequence of front pages from 1994 to 1997.

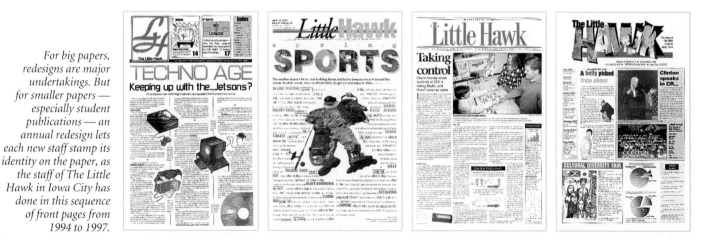

REDESIGN GALLERY

THE EVERETT (WASH.) HERALD

The Everett Herald is a midsize daily (circulation 50,000) just north of Seattle. To better compete against the two powerful Seattle dailies (the Times and the Post-Intelligencer), the Herald upgraded its outdated 20-year-old design in February 2001 under the guidance of design consultant Alan Jacobson.

BEFORE

AFTER

Flag: *That big, black, blocky "Herald" is certain to overwhelm any lead headline directly below it. And those postage-stamp-sized promos don't really sell papers — they just contribute to the noise at the top of the page.*

Typography: *Two bland, unstylish families with too little range: Times (bold headlines, light decks) and Helvetica (logos, graphics, bylines, etc.). The text is Corona — readable, but a bit clunky and old-fashioned.*

Organization: *The gutter widths are inconsistent; the grid is haphazard. The biggest obstacle is that index parked in the bottom-right corner; it's always in the designer's way. And can that weather bug be relocated?*

Story presentation: *Yes, a redesign will offer cosmetic and typographic improvements — but what can be done to upgrade the content? To make stories more accessible to readers? The editors need more tools (fact boxes, liftout quotes, summary decks) to highlight data more efficiently.*

Flag: *A softer, more sophisticated "Herald" — a screened slab serif with a slight shadow. And instead of those small skyboxes, there's now one high-impact promo, which can be either a straight photo or a dramatic cutout.*

Typography: *Most headlines now use New Caledonia; the lead headline on key pages uses Helvetica Compressed. Franklin Gothic replaces the old Helvetica components. And the text becomes a larger, more legible Utopia.*

Organization: *A rigid 6-column grid, with 2-pica gutters between stories. Thin column rules run vertically; double rules run horizontally. The index and weather are now out of the way, running along the bottom of the page.*

Story presentation: *Notice how every story offers readers some sort of extra element — a fact box, a refer, a quote, a guide to more information — to answer key questions. Creating easy-to-use templates for these content enhancements was an integral part of the Herald's redesign.*

REDESIGN GALLERY

THE EMPORIA GAZETTE

One of a vanishing breed of family-owned daily newspapers, The Emporia Gazette was purchased a century ago by William Allen White, a legendary Kansas editor. When design consultant Deborah Withey gave the paper a new look for 2001, she felt compelled to preserve the Gazette's proud, traditional character.

Note: The "after" pages shown here are prototypes; the Gazette's redesign had not yet launched as this book went to press.

BEFORE

AFTER

Flag: *It's hard to create a distinctive flag using bold, bland Times type. And sitting in a news rack beside bigger Kansas dailies, the Gazette seems small and timid by comparison. A new flag could transform Page One.*

Typography: *Those reliable but nondescript headline fonts could use more style and personality. The text type is serviceable but unpolished. Overall, the paper uses a hodgepodge of generic fonts. To recapture a more historic, classic feel, we'll need new type families with more character.*

Organization: *No promos. No news briefs. Stories generally run about 6 inches on the cover, then jump. And buried in the index, at the bottom of the page, is the paper's classic, traditional "Good Evening" greeting.*

Color: *Apart from the color photos, there's no color built into the page — and when color is added, it tends to be haphazard. One reason for that: There's no coordinated color palette for sidebars, graphics or display type.*

Flag: *The new flag instantly restores a grand, 19th-century feel to the entire paper. Hand-drawn, this flag is taller, more attention-getting, and far more stylish (notice the swash on the "R") than the old nameplate.*

Typography: *Two major changes are instantly evident. First, virtually everything (except text and cutlines) is now centered: headlines, decks, bylines, even the promos. Second, note the all-cap headlines (in Agenda). They're for news stories; special feature headlines are downstyle (in Star).*

Organization: *That "Good Evening" greeting has moved up alongside the flag to convey a folksier feel. And now a collection of "Nightly News" promos and briefs runs down the first, second or third left-hand columns.*

Color: *The paper's sophisticated 12-color palette includes a warm brown (like a Kansas wheat field) used for the "Good Evening" device as well as those other headers in the "Nightly News" column.*

REDESIGN GALLERY

Two more before-and-after examples from the Emporia Gazette redesign:

Before: *Nothing wrong with this editorial page, but it could be from any paper anywhere. The paper's famous publishers — William Allen White and his son, William Lindsay White — are lost in the masthead. The headers are dull (all-cap Times). Notice that the columnist's text is bigger than standard text, and the editorial's text is bigger than the columnist's.*

After: *The page now opens with quotes from the father/son publishers, their initials used like old monograms. With those quotes and the flag at the top of the page, we no longer even need the OPINION header. The editorial headline uses Worth italic; its text uses extra-wide leading (10.5 on 12). The columnists get a slightly enlarged introduction and a half-column logo.*

Before: *Good photos — but the meek section flag, the bland headline fonts and the wide, gray legs of type keep things dull. This sports page usually provides a mix of national and local stories; one thing missing here, however, is a daily guide to the top local sports events.*

After: *It's interesting how much punch those all-cap headlines (and decks) give the page. In the section flag (which uses Worth Display type), there's now a listing of upcoming events. The columnist gets an oval logo treatment, and the first few paragraphs of his column are bigger/more widely leaded.*

REDESIGN GALLERY

THE CENTER NEWS

This twice-monthly tabloid is published at the Fred Hutchinson Cancer Research Center in Seattle, Wash. The newspaper's staff is small — just a couple part-time editors and reporters — so when they redesigned in the fall of 2000, design consultant Tim Harrower (that's me) knew he (I) had to keep things simple.

BEFORE

AFTER

Typography: *This is the biggest problem with the old look. In fact, this redesign shows how dramatically a typographic face-lift can transform a paper's personality. Though everything is readable here, the typefaces are bland and dated. The text is Times, the cutlines Helvetica (two tired, overused fonts). And all the big type — headlines, decks, promos, logos, even the flag — is Palatino. That's too much work for one typeface to do.*

Color: *One spot color is available on the cover, and it's used haphazardly: in screens, headlines, initial caps, logos. The color changes each edition, too — one issue it's green, the next it's orange. The editor was considering spending more money to add spot color to every inside page, as well.*

The grid: *All pages are on a 7-column grid. The editor liked the way this grid allowed and encouraged the addition of fact boxes and quotes. Too often, however, huge holes would materialize in stories that failed to generate sidebar material.*

Typography: *A complete overhaul. The flag is boldly stylized to set it apart; it uses Worldwide, as do the logos and those page numbers in the promos. Headlines are Bureau Grotesque. Cutlines, promos and liftout quotes use Palatino (italic ONLY). The text is Utopia. And all other alternative text elements (sidebars, bylines, etc.) use Frutiger. That's five different type families in all — but their duties are all carefully delineated.*

Color: *An alternative proposal: Instead of buying more spot-color ink, why not upgrade the cheap newsprint paper stock? A huge success; the new, whiter paper conveys a more upscale, professional image. And instead of changing spot colors with each edition, blue becomes the standard hue.*

The grid: *Still a 7-column grid (which is, after all, an excellent format for designing sidebar material with stories). Style libraries were created for liftouts, fact boxes, editor's notes and sidebars to make them easy to produce. And new design guidelines helped eliminate awkward white space.*

TROUBLESHOOTING

Q: We can't afford to hire researchers to conduct focus groups or mail surveys. Are there cheaper alternatives?

Sure. You can always mail out your own questionnaires, host round-table chats with readers, even stop people on the street to ask why they just grabbed a paper. But remember: The more informal your methods, the less accurate your results.

Here's an intriguing idea for an unscientific yet revealing reader survey: Recruit 5-10 ordinary readers. Ask them to look at the next few editions of your paper, and circle with a felt-tip pen what they *actually read* (see example at right). Not what they merely glance at — but what they slow down to *read*. It may be just a headline. Just a photo caption. Or just the first two paragraphs of a story. (By *reading*, we mean "paying meaningful attention to." If someone glances at a headline about Bosnian import quotas, then glances away, that wouldn't qualify as actual *reading*.) And when they're done, have them return the complete papers to you.

What will you learn? You may find that certain types of stories are extremely popular — or universally ignored. You may detect demographic trends (do older readers read one way, younger readers another?). You may discover that few readers last more than three inches into any story — yet they're attracted to sidebars and briefs.

Remember, this survey isn't flawless. But at the very least, posting these marked-up pages on your newsroom wall is a great way to stimulate discussion.

Q: How risky is it to change your newspaper's text type when you do a redesign? What's the best way to test the new type in advance?

Yes, if you want to provoke crazed reader reaction, just eliminate a comic, change the TV listings or just *tweak* the text type (no matter how ugly it is). But if you're careful, diligent and sensitive enough, you can pull it off. A few tips:

◆ Test all new fonts *on the press* before you even consider making changes. (Try a paragraph or two at the end of some obscure story.) Watch how the ink and paper combine to thicken or thin the font. Fine-tune the size and tracking. Then:

◆ Print an entire story in both the old and new fonts. Stroll around, newspaper in hand, asking people to study the "before" and "after" text and rate them on a scale of 0 ("hate it") to 10 ("love it"). Chart their responses with dots, like this:

Jot down reader comments in the margins, too (*"It looks too squeezed"*). Poll as many readers as you can — and be prepared to jettison any font that draws too many negative reactions. Most importantly, pay special attention to readers with bad eyes or sour attitudes; they're the ones who'll whine the loudest later on.

Q: How long should it take to do a redesign? Some professional consultants say it takes six months to a year.

A complete overhaul of a complex daily paper can easily take a year. Interestingly, deciding what the new design *looks* like is often the easiest part; it's the reader research, staff training and computer coding (usually for several different production systems) that can take months. And whether you're a big daily or a small weekly, writing a detailed stylebook — accounting for every possible design decision — is one of the most time-consuming parts of the project.

On the other hand, smaller papers can be redesigned in a matter of weeks — or, if you're trying to set a record, *days*. But that's more a typographic face-lift than a full-blown overhaul. And instead of writing detailed stylebooks for projects on tight deadlines, you can create guidelines like the one shown here.

What do you do when you redesign a paper using QuarkXpress — but the staff uses Page-Maker software? The solution: Assemble a diagram like this to pass along all the font, size and spacing details. (For more on this redesign, see page 224.)

Q: Do you recommend formulating some sort of mission statement before you begin a redesign?

Absolutely. Reaching consensus on your goals is a valuable way to launch any project. A concise mission statement can clarify those goals — and itemize the strategies you'll use to achieve them. For instance, your redesign mission statement might consist of a series of points like this:

GOAL: *Increase our appeal to busy, impatient readers.*
STRATEGY: *Shorten story lengths. Increase story count. Improve summary deck style. Encourage the addition of fact boxes and graphics to every major story.*

Another tip: Use memorable adjectives. If everyone agrees that your goal is to create a *classic, elegant* design, that will help you filter out any inappropriately wild 'n' crazy ideas that creep into the prototypes. If your feature section's goal is to be *helpful and entertaining,* that can later serve as a guide to editors and reporters alike. (*"Sorry. Your story about quilting is neither helpful nor entertaining. Can we fix it — or should it run someplace else?"*)

Q: In our upcoming redesign, our publisher wants to begin running ads on the front page. Will that be the end of respectable journalism as we know it?

Over the years, front-page ads have come and gone. At most U.S. papers, they're still taboo; journalists find them vulgar. Degrading. A symbol of *greed.* (And besides, they can overwhelm the news with noise, as Web sites demonstrate.)

But if you're desperate and survival's at stake, you may need to learn to live with them. Keep the ad units as modular as possible, so they don't intrude into the news design. If possible, strip them along the bottom of the entire page, like this:

Will electronic newspapers replace dead-tree newspapers someday? Probably. They'll be cheaper to produce, more enjoyable to read, more timely, more comprehensive . . . the list goes on and on. *Paper* newspapers, sadly, will become smelly, yellow antiques. And worst of all, I will stop collecting royalties on this nice book.

 But enough about me. How will online design change the way *you* approach page layout?

 Creating pages for the World Wide Web requires the same understanding of type and images that you need when creating pages for print. But it's a different environment, one where *readers* have more control than ever before. Instead of designing pages that sort the news in a pre-arranged progression, you create an interface where readers interact at random.

Instead of organizing stories in two dimensions the way newspaper pages always have, like this — — you link related topics in three dimensions, letting readers roam from story to story, like this:

 To unlock the power and potential of online design, you've got to enhance your sense of *navigation.* You've got to craft a site that's inviting, informative and intuitively logical, a site that lets users roam effortlessly, poking their noses into every intriguing corner, following their curiosities to customize their news.

 This chapter provides a brief introduction to Web design. We won't recap Internet history, train you to use JavaScript or ponder the impact of hypertext on the great media paradigm shift. For one thing, this chapter's only 12 pages long (including *this* useless page). If you're serious about achieving Web expertise, supplement this book with some intensive training.

 For another thing, Web technology is changing so rapidly, this chapter was out of date before I even *wrote* it. But it's a start. So get started.

CHAPTER CONTENTS

TRANSFORMING NEWSPAPER PAGES...

When the Web first caught on back in the '90s, it became a playground of visual razzle-dazzle. Creating a simple site was seriously uncool; it had to be jam-packed with colors, shadows, groovy patterns and wiggy type. You couldn't just call yourself *The Bozoville News;* no, you had to be . . . *News-o-matic!*

Since then, the Web has evolved even further, with animated graphics, streaming soundtracks, images that bulge, blink, jiggle and bounce. It's fabulous! It's fantastic! It's — sort of scary.

If you've never designed a Web page before, it's easy to feel intimidated. But relax. You don't need flash. You don't need to worry about making hardcore Webheads happy. You're a journalist, remember. You've got data to deliver. A Web news site doesn't need to be cool; it needs to be:

◆ **Informative.** That means useful news, not whizbang gimmickry.

◆ **Easy to navigate.** That means a clean, uncluttered, user-friendly interface.

◆ **Fast-moving.** That means it's responsive — quick clicks from link to link.

◆ **Current.** That means you guarantee freshness every day.

How complicated is online design? Sure, there are new computer terms and technology to learn. But the same basic design goals and guidelines apply whether you're creating a newspaper page or a Web page. Take the story at left, for instance. It's fairly simple: a photo, a cutline, a headline, some text, and a box that refers to related stories. We've folded the text into three legs to fit the space.

On the Web, that story looks like this: same elements, different configuration. Instead of three legs, we use one long column of text that fills two computer screens. Otherwise, it's not new or unusual at all.

In a newspaper, space is finite, and you spend your time making the puzzle fit. On the Web, the page is smaller, but space is infinite, and stories can run on forever (now, there's a scary thought).

In fact, you can generally divide most online newspaper pages into two categories: *stories,* like the one shown here, and *menus* — those home pages and section fronts that function as super-indexes to guide readers through your Web site. Designing a story is easy. Designing an effective menu is trickier.

Orbilium dictare; sed emendata videri pulchraque et exactis minimum distantia miror. Inter quae verbum emicuit si forte deco.

State champs!

The Bugler girls' volleyball team defeats Central to capture title

By LEX MINNIEAR
Bugle-Beacon staff

It took seven long years. But the Lady Bugler volleyball team of Lincoln High School captured the state championship Friday night for the first time since the 1994 season.

The final win against Central High School brought the team's overall record to 22-6, setting a school record.

The Buglers took the match against Central in only two games with scores of 15-7 for each. Teammates Robin Fox, Holly Lukas, Krystyna Wolniakowski and Lorrie Richardson landed 100 percent in serves to help clutch the victory. Patty Snow and Claire Puchy combined for 11 kills while Kathy Hughes and Sue Payseno chipped in with two hits.

Coach Georgia Eldridge was pleased with their performance. "I love these girls," she said. "There was never a point in this tournament when I thought we wouldn't go all the

> **INSIDE**
> ◆ **Tournament results:** How other local teams fared / Page 7
> ◆ **The MVP:** Betty Coffman wins for her game-saving spike / Page 8
> ◆ **Fan reaction:** Bugle supporters celebrate in the streets / Page 9

way."

Eldridge credited the Elite Eight seniors, Kathryn Wigginton, Nancy Casey, Holly Lukas, Krystyna Wolniakowski, Lorrie Richardson, Patty Snow, Claire Puchy, and Kathy Hughes for keeping the team focused and under control.

"They've each done a good job playing important roles for us and I am very proud of everything these kids have accomplished in the last two seasons," said Coach Eldridge.

The Lady Buglers were the runners-up in the state finals last year behind Northville. Nine of the returning players were on the team that advanced to the regional quarterfinals but were defeated by North Farmington.

Returning senior Holly Lukas said, "We determine our destiny. There is no mountain too high if we play as a team."

Freshman team star Lori Robinson proclaimed, "We showed them who's boss out there on the court! Now everyone knows we're back, we're bad — deal with it!"

The team showed a lot of character after coming back to beat North Farmington earlier in the district race. After being defeated by the Lady Eagles previously in the season, they knew the Central matchup would be crucial.

The Central coach was philosophical.

"We gave it our best," said Marion Frederick. "But tonight, the best team won. I've got to hand it to the Buglers. They played a heckuva match out there."

The Buglers took the match against Central in only two games with scores of 15-7 for each. Teammates Robin Fox, Holly Lukas, Krystyna Wolniakowski and Lorrie Richardson landed 100 percent in serves to help clutch the victory. Patty Snow and Claire Puchy combined for 11 kills while Kathy Hughes and Sue Payseno chipped in with two hits.

Coach Georgia Eldridge was pleased with their performance. "I love these girls," she said. "There was never a point when I thought we wouldn't go all the way."

Eldridge credited the Elite Eight seniors, Kathryn Wigginton, Nancy Casey, Holly Lukas, Krystyna Wolniakowski, Lorrie Richardson, Patty Snow, Claire Puchy, and Kathy Hughes for keeping the team focused and under control.

"They've each done a good job playing important roles for us and I am very proud of everything these kids have accomplished in the last two seasons," she said.

Sports

Bugler girls' volleyball team wins state championship

By LEX MINNIEAR
Bugle-Beacon staff
September 20, 2001

It took seven long years. But the Lincoln High School Lady Bugler volleyball team captured the state championship Friday night for the first time since the 1994 season.

The final win against Central High School brought the team's overall record to 22-6, setting a school record.

The Buglers took the match against Central in only two games with scores of 15-7 for each. Teammates Robin Fox, Holly Lukas, Krystyna Wolniakowski and Lorrie Richardson landed 100 percent in serves to help clutch the victory. Patty Snow and Claire Puchy combined for 11 kills while Kathy Hughes and Sue Payseno chipped in with two hits.

Megan Peter (left) and Jennifer Christy block a shot by Central's Amy Bethany in Saturday night's state championship game. (Bugle-Beacon photo)

Coach Georgia Eldridge was pleased with their performance. "I love these girls," she said. "There was never a point in this tournament when I thought we wouldn't go all the way."

> **MORE ON THE MATCH**
> ◆ **Tournament results:** How three other local girls' teams fared.
> ◆ **The MVP:** Chris Ward wins the Hyatt Trophy for her game-saving spike
> ◆ **Fan reaction:** Bugle fans dance in the streets

Eldridge credited the Elite Eight seniors, Kathryn Wigginton, Nancy Casey, Holly Lukas, Krystyna Wolniakowski, Lorrie Richardson, Patty Snow, Claire Puchy, and Kathy Hughes for keeping the team focused and under control.

"They've each done a good job playing important roles for us and I am very proud of everything these kids have accomplished in the last two seasons," said Coach Eldridge.

The Lady Buglers were the runners-up in the state finals last year behind Northville. Nine of the returning players were on the team that advanced to the regional quarterfinals but were defeated by North Farmington.

Returning senior Holly Lukas said, "We determine our destiny. There is no mountain too high if we play as a team."

Freshman team star Lori Robinson proclaimed, "We showed them who's boss out there on the court! Now everyone knows we're back, we're bad — deal with it!"

The Central coach was philosophical.

"We gave it our best," said Marion Frederick. "But tonight, the best team won. I've got to hand it to the Buglers. They played a heckuva match out there."

The Bugle-Beacon's Lex Minniear can be reached at (394)555-8776 or minnear@bugle.com

▲ BACK TO TOP

...INTO WEB PAGES

As you can see, basic story design may actually be *easier* to do on the Web than on paper. You just pour in the text until the story ends.

But what about page design? Well, pages like the one at left don't exist on the Web, so many of the problems that go with them — like squeezing unrelated stories into a limited space until everything fits perfectly — don't exist, either.

Except on the home page.

Just as the front page is the doorway to the printed newspaper, the home page is the gateway to the online newspaper. And because the home page links users to every inside page, it *must* be comprehensive, yet easy to navigate.

Here's what you'll find on a typical newspaper home page:

MORE ON ▶

◆ **Web terminology:**
If you encounter unfamiliar technical terms in this chapter, consult our glossary on page**253**

The flag: *For online editions, newspapers often devise a new name and spiffed-up logo, while maintaining some connection to the print version.*

Time/date: *If you update your site more than once a day, you should include the time of this edition, as well.*

Index *(or navigation bar): It's easy to get lost in cyberspace. That's why a complete, clickable index is vital on the home page — AND on every other page in the site, as well.*

Lead story: *It's usually just a summary, but you can click the headline to link to the full text — or click the icons below to see photos and a video clip. That lead photo may seem small, but large images force pages to download much more slowly.*

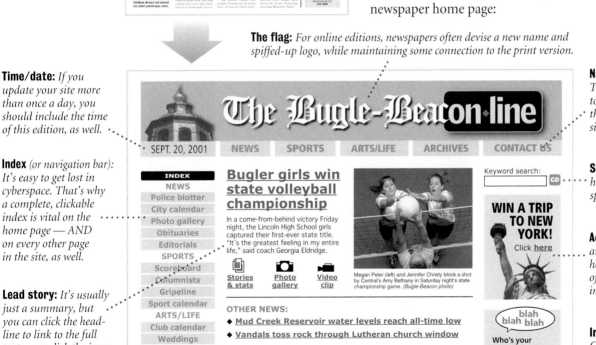

Navigation buttons: *These quickly link users to key sections of the site; the index down the left side is more complete.*

Search engine: *This helps users hunt for specific topics or names.*

Ads/promotions: *These are usually dummied horizontally at the top of the page or (better) in this right-hand rail.*

Interactive extras: *Online newspapers provide features that ordinary newspapers can't: Webcams. Polls. Photo galleries. Games. Animated graphics. See our list on page 232.*

Page depth: *This page is designed to fit on one screen, so readers won't have to scroll. It's best to avoid never-ending vertically scrolling home pages — which requires smart planning and tight editing — but usually, the bigger the site, the deeper the home page.*

Footer: *Every page on every Web site should include copyright information. But this is also a good spot to solicit e-mail feedback from readers or provide links to other sections of the site.*

Links: *Click on these headlines to read the site's other top stories. Many sites add summaries or photos to these headline collections — but that also deepens the page and slows the download time.*

ORGANIZING A WEB SITE

How do you organize a complete Web site? For a terrific example, let's study
how the Baltimore Sun's online edition covered the 2001 Super Bowl:

The home page:
It's Monday, Jan. 28, 2001. In yesterday's Super Bowl, the Baltimore Ravens whomped the New York Giants, 34-7. Here's how SunSpot, the online edition of the Baltimore Sun, covered the big game.

The lead story, as you'd expect, is the post-game wrapup. And readers have a huge menu of Super Bowl links to choose from: text, photos, audio clips, statistics. Ordinarily, this SunSpot home page is more rigidly formatted; the lead story will rarely use a display headline and such a wide variety of links as this. But this is a big news day.

Notice the overall organization of this home page: the navigation bar running down the left side, the promos down the right, the news down the center. Notice, too, how the colors — especially beige and green — help organize the content, contrasting with the blue links and the red time-stamps.

SunSpot's newsroom is separate from the Sun newsroom. At the time these pages were produced, the staff consisted of three editors and eight "producers" — so named because they help produce multimedia content.

Billick looking ahead
``Of course we want to repeat'' coach says

By Dave Goldberg
Associated Press
Originally published Jan 29 2001

TAMPA, Fla. — After a sleepless night, Brian Billick was looking forward, not back.

``Of course we want to repeat,'' the Baltimore Ravens' coach said Monday, less than 12 hours after his team won the Super Bowl by beating the New York Giants, 34-7. ``But we have to recognize that teams turn over and that all kinds of things can happen. I think the people in St. Louis, in Baltimore, are happy we don't have dynasties any more.''

Prognostication is, indeed, impossible these days — six different teams have been in the Super Bowl the last three seasons.

A year ago, the St. Louis Rams, coming off a 4-12 season, beat the Tennessee Titans, who were 8-8 the previous season. The Ravens were 8-8 a year ago and the Giants were 7-9, unlikely candidates, then, for this year's

The lead story: *During the game, a SunSpot sports editor updated the coverage after every quarter. Now that it's over, editors will select the strongest stories.*

The photo gallery:
This is one of several photo galleries available to site visitors. Here, you can review the Sun photo staff's "greatest hits" from the days leading up to the big game. This collection of images focuses on the fans and the hoopla — the game photos are in another gallery.

The big business story: *Life goes on. And at many daily newspapers where the home team HADN'T just won the Super Bowl, this story was big news: massive layoffs at Chrysler. This is what users saw after they clicked that link on the SunSpot home page — but keep in mind that this page also included ads, the flag, the index, etc.*

DaimlerChrysler to cut 26,000 U.S. jobs
Six manufacturing plants to be idled through 2002; large losses cited

Associated Press
Originally published Jan 29 2001

AUBURN HILLS, Mich. 6
DaimlerChrysler AG today announced it will cut 26,000 jobs over three years at its U.S.-based Chrysler division.

As part of the restructuring plan designed to pull Chrysler out of the red, the company announced it would cut about 20 percent of its North American work force.

The plan also calls for six manufacturing plants to be idled through 2002. Chrysler said it expects a large part of the job-cutting to be done through retirement programs, achieved within the framework of existing union contracts.

``To be competitive, the Chrysler group needs to be a more nimble company,'' Chrysler group president and chief executive Dieter Zetsche said in a statement. ``Along with exciting products, this will establish a sound basis for future growth.''

Chrysler said the job cuts will include 19,000 hourly workers and 6,800 salaried employees.

The job cuts will be through a combination of retirements, special programs, layoffs and attrition.

Chrysler expects that three-quarters of the overall reduction will be achieved this year.

``Today's actions will help remove the uncertainty many of our employees have been feeling,'' Zetsche said. ``Part of this process may be painful for many people. However, to be truly competitive in today's auto industry environment, we need to be a more nimble company, more closely aligned with current and future market conditions.''

Zetsche said Chrysler will unveil its complete plan to turn around the loss-

ORGANIZING A WEB SITE

The Sports front: *Like the home page, this section front is a big menu, too — only more specialized. A sports index runs down the left side; the Super Bowl coverage fills the center. Notice the abundance of user-friendly options: There are stories, yes, but also photos, graphics, audio interviews and more.*

The game in images:
Moving big photos into separate "galleries" helps ordinary Web pages avoid slow download times. This gallery displays the best images from the game. Photographers using digital cameras were able to transmit from the stadium, and their images appeared online almost instantly.

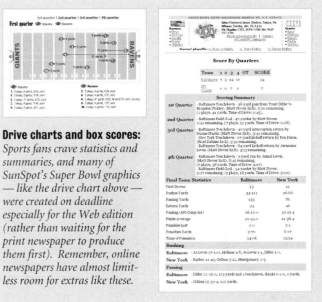

Drive charts and box scores:
Sports fans crave statistics and summaries, and many of SunSpot's Super Bowl graphics — like the drive chart above — were created on deadline especially for the Web edition (rather than waiting for the print newspaper to produce them first). Remember, online newspapers have almost limitless room for extras like these.

Championship drinks
Area bartenders celebrate the Ravens with special drink recipes.

SunSpot Staff

Originally published Jan 18 2001

Hosting a Super Bowl party to honor the Ravens? Forego the usual keg and take a cue from the tenders of some of the best (and busiest) bars in the area. We asked them to shake up some Ravens-inspired drink recipes for us, and what they produced us libations with a twist of local flavor.

Ray Lewis wrecker
•1/3 part black raspberry schnapps
•1/3 part Blue Curacao
•1/3 vodka
•1 oz. pineapple juice
•Splash of 7-Up

Mix all ingredients and serve.

—Brian Smith and Tommy 'The Kid' Wintz, Bar Baltimore

Ravens rock
•Black raspberry schnapps
•Rum
•Triple Sec
•Vodka
•Cranberry juice
•7-Up

Mix equal parts of all ingredients, except use just a splash of 7-Up.

—Jason Williams, Bohager's

Ravens' power play
•2 oz. vodka
•1/2 oz. Chambord
•Splash of Triple Sec
•Juice of 1/2 lime

Shake and strain into a martini glass. Garnish with a fresh raspberry. Go for the extra point and add an extra ounce of vodka.

—Judy Singer, McCafferty's Restaurant

Raven rum runner
•1 oz. light rum
•1/2 oz. dark rum
•1/2 oz. Chambord
•1 1/2 oz. orange juice

The feature spinoff: *When your team is in the Super Bowl, your readers party. And on the SunSpot home page, the hoopla and celebrations warrant their own separate category. These drink recipes, inspired by the Ravens, originally ran in the weeks preceding the game. But in cyberspace, you can easily recycle old material as needed.*

COLTS WIN CHAMPIONSHIP
DEFEAT GIANTS, 23-17, AS AMECHE SCORES IN SUDDEN-DEATH PERIOD; Myhra's field goal with nine seconds to go in regulation game ties score, 17-17; Berry breaks playoff records

By Cameron C. Snyder
Sun Staff Correspondent
Originally published Dec 29 1958

New York, Dec. 28 — Six years of sweat and frustration bore fruit today as the Colts stormed 80 yards in thirteen plays to win the National Football League championship, 23 to 17, in a sudden-death playoff with the New York Giants at Yankee Stadium.

Propelled by John Unitas's passes and Raymond Berry's catches the Colts forced the game into the first sudden-death extra period in pro history when Steve Myhra place kicked a 20-yard field goal with nine seconds left in the regulation time.

Placekick Ties Score at 17-17

That placement evened the game at 17-17 and gave the Colts their winning chance, which Alan Ameche cashed on a 1-yard scoring plunge after 8:15 minutes had elapsed in the sudden-death period.

The first team to score in a sudden-death period is the winning team, no matter how the score is achieved.

Actually the Colts almost allowed the title to slip through their fingers, much to the dismay of 16,000 Baltimore rooters and the delight of a larger New York crowd composing a surprising attendance of 64,185. Pre-game forecasts had predicted a capacity gathering of 70,000 plus.

Helped by Strong Defense

It was only the cold, calculating and deadly play calling of Unitas and the clutch catching of Berry, who set a championship game record with twelve receptions, that brought the Colts back from what would have been a dismal and disappointing defeat.

This pair, augmented by a stout offensive line and the likes of L.G. Dupre, Ameche and Lenny Moore were just too much for the Giants.

Fortified with luck and a burning desire after their defensive unit had staged a magnificent goal-line stand in the third period, the New Yorkers struck twice within the space of five minutes to pull ahead of the Colts.

The historical reprint:
Yet another online bonus. Unlike the print newspaper, where space is always tight, the online edition can dig into the archives to fetch classic material from the old days — in this case, stories and photos from the '50s and '60s.

Feedback

SunSpot feedback | Baltimore Sun feedback | Letters to the editor | Send a new subject | Subscriptions | Change Your Mailing Address and Phone Numbers

Frequently Asked Questions
Read through our new FAQs page before sending a question

SunSpot feedback

Use this form to contact us about the SunSpot website.
• If you wish to use regular email, send your letter to feedback@sunspot.net.
• If you have questions related to circulation or the delivery of your newspaper, send email to Customer Satisfaction@baltsun.com.
• For advertising-related questions, email wyoega@sunspot.net.
• The Sun's mailing address and phone numbers

Your Subject:

Your Name

Your Email Address

Send Now! SunSpot will not share your email address with any other person or company

Baltimore Sun feedback
Please use this form to address issues related to the The Sun's news coverage only. Your feedback will be sent to Ed Hewitt, The Sun's Readers' Representative. Comments and concerns will then be passed on to the appropriate editors and staff.
• If you wish to use regular email, send your letter to edhewitt@sunspot.net.
• If you have questions related to circulation or the delivery of your newspaper, send email to Customer Satisfaction@baltsun.com.
• For advertising-related questions, email wyoega@sunspot.net.
• Baltimore Sun phone numbers

Your Subject:

Your Name

Your Email Address

Send Now! SunSpot will not share your email address with any other person or company

Letters to the Editor
Please write your letter to the editors of The Baltimore Sun in the space below. Be sure to include contact information, including both day and evening phone numbers. If you wish to use regular email, send your letter to letters@baltsun.com

Your Subject:

Your comments:

Feedback and e-mail:
Most print newspapers only give lip service to reader access. But from the very beginning, Web newspapers encouraged interactivity. The footers on every SunSpot page provide an easy way for readers to ask questions, share comments, suggest news stories, send letters to the editor or start subscribing to the print edition. Unlike most newspaper sites, where the Webmaster routes these e-mail messages to the proper departments, SunSpot offers a variety of e-mail forms to deliver messages more precisely.

SETTING UP YOUR SITE

MORE ON ▶
....................................

◆ **Newspaper Web sites:**
*For current links to
recommended online
newspapers, visit the
McGraw-Hill Web site
at www.mhhe.com/
harrower*

Ready to begin construction on your newspaper's Web site? Here's what to do:

1 **Take a tour of online newspapers.** Spend a couple of days — or, ideally, weeks — getting familiar with online newspapers. Visit web sites for magazines, local TV and radio stations, big dailies and student papers. Once you're familiar with their styles and strengths, zero in on newspapers your size. Evaluate their successes and failures (using the checklist on page 238). Make screen captures of pages you like. Study their color. Typography. Grids. Indexing.

Experiment, too, with making online newspapers your *only* source of information. That way, you'll better understand the medium's strengths and weaknesses — the gaps in its coverage and the frustrations of its readers.

2 **Discuss your goals and ambitions.** Launching a Web site is like adopting a puppy: Most people don't realize how much constant care and feeding it requires, and how the slightest neglect results in unpleasant "accidents."

So how ambitious will this site be? Will it deliver fresh, new material, or just recycle old newspaper stories? (That's called "shovelware.") Must you sell ads and make money — or will this be an expensive gift to your adoring public?

Brainstorm. Push the envelope. Draft an inspiring mission statement. Just remember: The more complex the site, the harder it'll be to create and maintain.

To help you balance your wish lists and your workload, it's best to. . .

3 **Plan your site.** *Planning?* Ugh. Forget it. If you're like most newspaperpeople, you hate planning. You're too creative! But remember what we said in the chapter introduction: good Web design is all about *navigation*. And without a solid plan for linking stories and pages, you're doomed.

Begin by listing your content. Organize it. Prioritize it. Figure out the smartest, cleanest way to group topics. Start sketching an organizational tree, like the one at left, that shows how readers will move from branch to branch.

The best thing about a Web planning session is that it frees you from your two-dimensional orientation. Think structure. Think *link*. How can you anticipate your readers' next need? How can you keep them from getting lost?

Remember the three-click rule: Try to keep every page in your Web site within three clicks of the home page (as our model at left tries to do).

Once you have the site planned, you'll have a rough sense of the overall traffic flow and workload. This will help you determine how much stuff — and staff — is needed for each page, and how much time you'll have to enhance those pages with value-added extras like those in the shopping list at right.

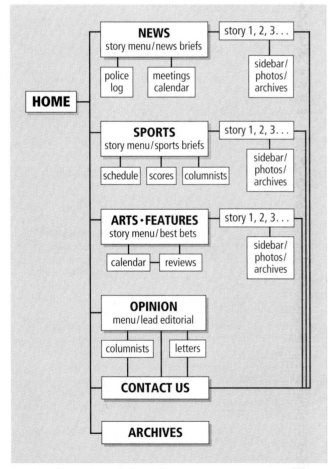

Here's a planning map for a small online newspaper. Can you follow the proposed links as you move around the site? Notice how every story links readers to the feedback page. And though it's not shown here, remember that every page will link to the home page and main index.

WEB SITE EXTRAS

Sure, your Web site will provide headlines, stories and photos. That's good, but is it enough? As you plan your site, consider value-added extras like:

A text-only option (for users with slow modem connections).

A digital version of your newspaper's front page.

Reader polls.

Reader forums: chat rooms, discussion groups and message boards.

Photo galleries that are organized by event, topic or day.

A search engine for the entire site.

Downloadable audio (speech or music excerpts, interviews) or video (sports highlights, broadcast TV clips).

A local Webcam.

A contact for buying photos or back issues of the newspaper.

A "print this story" option.

A link that lets users e-mail any page or story to a friend.

An e-mail subscription service for news stories, sports scores, weather, reviews, etc.

FAQs about your paper, campus, town, etc.

A complete staff list with phone numbers and e-mail links.

An overall site map.

Stock market quotes.

Local weather or traffic updates.

Interactive games, puzzles or contests.

MP3 clips of local bands.

Links to downloadable software necessary to run any of these extras: audio, video, games, etc.

E-mail postcards.

Animated infographics.

SETTING UP YOUR SITE

4 **Evaluate your computer resources.** If you already paginate your paper, you're probably well-prepared to go online. It takes *hardware* —

◆ A gutsy computer (either Mac or PC, with a big monitor and lots of memory);

◆ A Web server (a goofproof computer to host your site. You can always use your own, but it may be smarter to lease space from an Internet Service Provider);

◆ An Internet connection for browsing the Web (a modem's OK, but a high-speed DSL line or cable modem is preferable);

— and it takes *software:*

◆ An image-editing program (like Photoshop) to compress your graphics into GIF and JPEG files;

◆ A Web browser (most likely Netscape Navigator or Microsoft Internet Explorer, the two current favorites);

◆ A text-editing program (like SimpleText or WordPad) *or* a Web design program (like DreamWeaver or FrontPage) for writing your HTML.

What's HTML? It's *HyperText Markup Language,* the coding that controls all the text and formatting of Web pages (see the before/after example at right).

Mastering HTML takes time, practice and one of those heavy, 400-page manuals. But it's not rocket science. And there *is* an alternative: Web-design software that lets you design pages as you would with a page-layout program — drawing boxes, sizing photos, importing text — and then crafts the HTML coding for you.

Which way should you go? If you're serious about Web design, learn HTML. If you want to view and "borrow" the source codes of any cool Web pages you find, learn HTML. If you're too cheap to go out and buy Web-design software, learn HTML.

Otherwise, Web-authoring software will let you create most pages quite successfully. But for best results, every staff should include someone who's HTML-savvy to debug glitches and fine-tune your site's underlying foundation.

```
<HTML>
<HEAD>
<TITLE>A Quick Peek at HTML
Coding</TITLE>
</HEAD>
<H1>This is a headline</H1>
<P>
<BODY>And this is basic text,
though you can <I>italicize</I>
words, <B>boldface</B> words,
even add hypertext links that
send you to <A HREF="http:
//www.news-o-matic.com">
news-o-matic.com.</A>
</BODY>
</HTML>
```

In HTML, it's those tag commands <THE WORDS IN BRACKETS> that let you control type and layout.

A Quick Peek at HTML Coding

This is a headline

And this is basic text, though you can *italicize* words, **boldface** words, even add hypertext links that send you to <u>news-o-matic.com</u>.

5 **Design your page prototypes.** It's just like redesigning a newspaper. You've got to explore suitable, stylish options for:

◆ *The flag* — a spiffed-up version of your old flag? Or something radically new?

◆ *Indexes* — Horizontal? Vertical? With icons, buttons or pop-up submenus?

◆ *Headers* — What sizes and fonts are most effective for story and page signage?

◆ *Colors* — Which hues complement our content and project our personality?

◆ *Grids* — What's the ideal width for indexes and text? Where will the ads go?

◆ *Traffic flow* — How crowded can pages be? How quickly must they download?

Eventually, you'll standardize all these design elements as you create style sheets and templates to save time for staffers (and prevent design mutations).

6 **Test, test, test.** On big, new computers. On lousy, outdated junk. On Mac and Windows. On Netscape and Explorer, both current and *old* versions — that's called "backward compatibility." Test your pages on slow modems and slow-witted users to see what crashes and crawls. Remember, not everybody surfs the Web all day with a superfast Internet connection like *you* do.

Think testing is a waste of time? Wrong. On the next page, we'll explain why.

WEB DESIGN GUIDELINES

DEALING WITH DIFFERENT DOWNLOAD TIMES

In the future, we'll all have lightning-fast Web connections that instantly display lavish, complex pages jam-packed with audio and video.

But unfortunately, this is *now*. And nowadays, we all download pages at different speeds. Some of us are fast. Some of us are painfully slow.

Thus, every Web designer needs to appreciate that the more complex a page is, the more slowly it downloads. The more slowly it downloads, the more frustrated users become. Therefore:

◆ **Keep things simple.** When in doubt, minimize. Don't overload pages (especially home pages) with images, colors and unnecessary eye candy.

◆ **Avoid gimmicks.** News sites really don't need type that dissolves, sparkles or blinks, unless it's a warning that your site is about to explode. Use special effects for good reason — animated infographics, for example — not for frills. Don't waste bandwidth. Make every K count.

◆ **Keep images small.** Set a limit on routine image file sizes (20K?). To display full-size photos, use clickable thumbnails that link to larger images.

◆ **Monitor your users.** Suppose 95 percent of your users have new computers and superfast access. Would that make it OK to load your site with huge graphics? Run browser-detection software to analyze who your users really are, then decide.

Different Web connections download pages at different speeds. Take the page below, for example, where the combined elements total 100K. How long would it take this page to materialize using different Web connections?

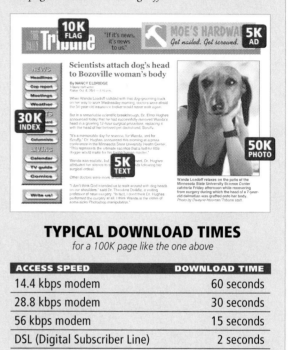

TYPICAL DOWNLOAD TIMES
for a 100K page like the one above

ACCESS SPEED	DOWNLOAD TIME
14.4 kbps modem	60 seconds
28.8 kbps modem	30 seconds
56 kbps modem	15 seconds
DSL (Digital Subscriber Line)	2 seconds
Cable modem, Ethernet	less than 1 second

Source: "Creating Web Pages for Dummies"

COPING WITH DIFFERENT PLATFORMS

No matter what you do — whether you use fancy Flash animation or the simplest HTML coding — your site will look different to every visitor. Pages that look terrific on my big monitor may not quite fit on your little laptop. I may use Netscape 6.0 on a new Mac; you may use an Explorer 1.1 on an old PC.

Does that matter? Yes. Take text type, for instance. That chunk of text you just posted on your Web site will appear smaller on Macs, as a rule, than on PCs:

ON A MAC:
Too soon we reach the end; too late we start to sing these quiet hymns within our heart.

ON A PC:
Too soon we reach the end; too late we start to sing these quiet hymns within

In addition, HTML won't let you choose *exact* point sizes for text; you can only choose one of seven *relative* sizes. You can't select exact fonts, either (since users may not own the font you're using); you can only *suggest* fonts for users who have them installed. And to complicate things even more, all users set up different defaults in their browsers. (My text may default to Times, yours to Helvetica.)

So what can you do? Wait for Web software to evolve. And until then:

◆ **Test carefully.** View all your pages on all platforms and all browsers. Stay aware of the inevitable flux, so you can build a little flex into your layouts.

◆ **Remember your text-only users,** those viewing your site on browsers with the graphics turned off (or the visually impaired, whose browsers read the page aloud). Will your pages be navigable to them? At the very least, provide ALT tags for every image, so if the images don't appear, short descriptions of them do.

WEB DESIGN GUIDELINES

ORGANIZING PAGES

◆ **Avoid clutter.** Too many Web pages — and especially home pages — look like the page at right: a distracting hodgepodge of bitsy-witsy lines, colors, dingbats and words. Which elements are news? Ads? Promos? What's the day's top story?

Remember, the same rules apply whether you design a page for print or for the Web. You need clean, rectangular modules. You need a dominant image to anchor the page. You need to group related elements (ads go *here,* the index goes *there*) so that readers can navigate quickly and intuitively.

Don't get sloppy or lazy. Don't settle into a dull, inflexible format. Keep pages fresh. For every edition, design your top stories with dramatic headlines and visuals, just as you would in your newspaper.

◆ **Make easy navigation a priority.** Clutter is bad enough; it's even worse to scroll down, down, down with no clue what comes next. The busier the page, the more you must label and group everything — like a restaurant menu. Use colors, headers and navigation bars *consistently.* Help readers search, click and exit *effortlessly.*

◆ **Watch your page width.** Web dimensions are measured in pixels (with 10 pixels to a pica). The standard width for Web pages is 595 pixels. At that size, they'll fit on all standard monitors. Don't make them any wider; *you* may have a jumbo monitor, but most of your readers don't, and scrolling sideways is distracting.

The standard monitor depth, by the way, is 480 pixels. If possible, design pages to fit in that depth. And if it's not possible:

◆ **Let 'em scroll.** Some Web experts insist that you fit all your data on one screen, especially on your home page, then link to everything else. Force readers to scroll, they warn, and they'll quit in frustration. Good theory; impractical in reality. Besides, it's not *scrolling* readers dislike — it's being *bored.* Successful design has

always been about fitting the maximum data into the smallest space, so keep pages (especially home pages) to one or two screens, if you can. Otherwise:

◆ **Think vertical.** Like those classic newspaper pages of the 1800s (see page 4), newspaper Web pages flow vertically as you scroll downscreen. You'll have fewer traffic-control problems, then, if you plan your pages in ever-deepening vertical modules — like a window shade that keeps unrolling.

This might be a good time to remind you that long, long legs of text are just as boring on the Web as they are on paper. Edit stories tightly; when possible, **link** to sidebars and alternative stories instead of scrolling endlessly downward.

◆ **Include fixed page elements.** Don't ever let readers get lost or confused. When designing pages and creating page templates, keep navigation bars close by at all times. Remember, too, that users often print out pages or save them to disk. To ensure your ownership remains attached, make sure every page contains your publication's name, the date and all relevant contact/copyright information.

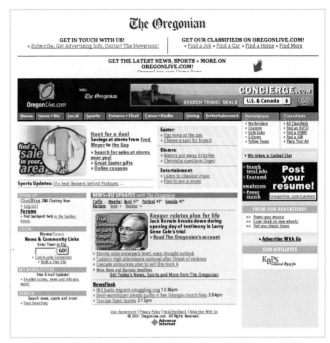

Too much clutter. So how would you improve this page? Start by giving more punch to the flag, then add more punch — and a clear hierarchy — to the news. Give the top story a strong headline. Add an appealing image. Group the day's best news, sports and feature stories so they're easy to browse. Group the ads and promos instead of scattering them around the page. And adopt a consistent color palette to make all headers and buttons instantly recognizable.

WEB DESIGN GUIDELINES

The Sacramento Bee's "sacbee" site is simple, well-organized and user-friendly. Notice how effectively those four modular vertical columns and the layered background colors help to organize the page. Note, too, how helpful those bars are (SUBSCRIPTIONS, LATEST LOCAL NEWS) in helping readers scan the page.

MSNBC uses bolder colors and more stylish design than most newspaper sites, and the results are more dramatic and engaging. Notice how well-organized and modular the architecture is. That horizontal ad in the middle of the page will attract attention but doesn't disrupt the design.

USING EFFECTIVE PAGE GRIDS

Whether you're designing a simple story or a complicated home page (like those above), you need to divide the page into modules and assign every module a specific job: the *index* module. The *big news* module. The *sports* module. The *cheesy promotional gimmick* module.

You can organize your modules with rules, with labels, with background screens and colors — whatever it takes to unify the elements without creating clutter. Other advice:

◆ **Avoid random or redundant modules.** Prioritize and sort *everything*, especially on crowded, busy home pages. Make every element's function and identity clear. (Some sites feature "Top Stories" and "Latest News" — what's the difference?)

◆ **Align those ads.** Is that Moe's Hardware ad drowning out your flag? Does your home page look a race car covered with sponsors' decals? Get those noisy ads under control. Stack them neatly, just as you would on a printed page.

◆ **Avoid overcrowding.** Design white space into the layout, a little extra air between modules. Make all your gutters at least a pica wide to let the page breathe.

ADDING COLOR

◆ **Use browser-safe colors.** Netscape and Explorer have standardized a palette of 216 official colors. Use it. If you create your own hues, they may turn weird and blotchy (called *dithering)* and load more slowly on everyone else's monitors.

◆ **Use color consistently and strategically.** Develop a color palette (like the sacbee example above) that's part of your overall navigational system, one that helps to organize page elements and direct traffic without adding unnecessary noise. Select just a few colors that harmonize well together and reflect your paper's true personality (happy? bright? subtle? moody?).

This is blue type on a red background. It's loud. It's annoying to read. And though this link is readable, it looks like this link after it's been clicked.

◆ **Beware of dark, textured or colorized backgrounds.** Unless you've got a terrific reason, stick to black type on a white background. Too much color adds clutter, reduces readability and makes printing problematic. Use color sparingly; save it for signage and for dramatic display elements.

WEB DESIGN GUIDELINES

SIZING AND SAVING GRAPHICS

On the Web, the word *graphics* refers to a variety of elements: photos, display type, flags, illustrations, icons, navigation buttons and bars. Almost anything on your site that's more complex than HTML text and headlines — including any type you want to craft precisely — will need to be imported as a graphic.

As we've learned, too many imported graphics will slow your download time and constipate your page flow. But too *few* images can result in pages that are wordy, messy or dull. Either way, you lose. So what can you do?

◆ **Compress all your images** by converting them into either GIF and JPEG files. They're the two most common Web image formats. What's the difference?

GIF images work best, as a rule, for line art; for images with just a few colors or with large areas of solid color; for display type; for black-and-white images; for images smaller than, say, a postage stamp.

JPEG generally works best for photos and complex illustrations.

Which compresses images more efficiently? Hard to say. That depends on the image — which is why you need to experiment with both formats to learn which produces the smallest files and the best image quality. Or use a graphics optimization tool like ImageReady to audition the before/after results.

◆ **Use fewer and smaller images.** Yes, as you know, big photos are a bandwidth-clogger. So until Web technology speeds up, use thumbnails (tiny postage-stamp images) to *link* to your full-sized photos. Try to avoid turning your readers into thumb-twiddling zombies while they wait for big, dumb, unnecessary stand-alone images like this to appear:

The Bugle-Beacon-line

Balloon festival takes off in Bozoville this weekend
For the third year in running, the skies over Bozoville will be filled with beautiful color Saturday as the Happy Valley Balloon Festival brings more than 30 hot-air balloons to town for a three-day visit.
"We're as excited as can be about the return of this wonderful event," said Mayor Bud Bogart. "It's a great way for families to spend the day, enjoying these exciting balloons."
The mayor himself plans to ride a balloon in the opening ceremonies 8 a.m. Saturday at East Island Park. After that, a

MORE ON ▶

◆ **Scanning images:**
Guidelines for choosing the right resolution for Web images...... **113**

What's wrong here?
◆ *That huge balloon photo could take a few minutes to download — and readers wouldn't even know what they were waiting for.*
◆ *The text runs the full width of the screen, with no space between paragraphs: too hard to read.*
◆ *No navigation bar. Users are forced to keep scrolling downward in hopes of finding the exit.*

USING TYPE EFFECTIVELY

◆ **Keep your text width comfortable.** Because stories will scroll down, down, down, stacking them in narrow legs (like newspapers do) won't work. It's better to use one wide column. But don't make it *too* wide. Browsers vary in their text display sizes, but the ideal column width will range from 15-30 picas, or 150-300 pixels. (This column of 12-point text is 29 picas wide. Is it readable?)

◆ **Avoid excessive text on home pages.** In fact, you should generally avoid running more than a paragraph of text there. Think of the home page as a menu or superindex; think of its main elements as promos. Your goal is to click users ahead.

◆ **Avoid underlining text**. Underlining must be reserved exclusively for links, or readers will get confused. For that matter, Web visitors have been trained to think that any differently colored or differently styled type is a clickable link. So don't colorize ordinary type; colorize only **links**.

◆ **Be creative when installing links.** Remember, you can link with headlines, words, icons or images. Experiment to expand your hyperlink repertoire:

The **emperor** issued a decree on gladiators.
This links you to a biography of the emperor.

The emperor issued a **decree** on gladiators.
This links you to a transcript of the decree.

The emperor issued a decree on **gladiators.**
This links you to information on gladiators.

◆ **Use different fonts for different jobs,** just as you would for the printed paper. Mix bolds and italics when crafting headlines, decks and bylines. Use display type, saved as small GIF files, to create appealing headers and special headlines.

WEB SITE CHECKLIST

On this page, we've collected the key Web design principles presented in this chapter. Use this checklist to evaluate the online newspapers you encounter — or, more importantly, to critique your own.

LAYOUT & DESIGN

YES NO

- ☐ ☐ Is the home page attractive, inviting and well-organized?
- ☐ ☐ Can readers easily differentiate between promos, ads and live news?
- ☐ ☐ Is there a clear hierarchy of news content on the home page? In other words, is it instantly obvious which stories are most important?
- ☐ ☐ Do the headlines and design of the top stories on the home page show creativity or flair (rather than being predictably pre-formatted)?
- ☐ ☐ Does the site's design style match the personalities of its readers?
- ☐ ☐ Do pages use attractive, appropriate and consistent colors?
- ☐ ☐ Does the site avoid unnecessary blinky-floaty-glowy animated effects?
- ☐ ☐ Does the text on most pages avoid becoming too wide and wordy?
- ☐ ☐ Does the site use consistent styles for the basics: headlines, bylines, subheads, etc.?
- ☐ ☐ Does the site use consistent styles for the extras: graphics, liftout quotes, sidebars, etc.?

USER-FRIENDLINESS

- ☐ ☐ Does the home page download quickly?
- ☐ ☐ Does the site offer a "Sunday Brunch"-style menu of stories, visuals, reader forums and multimedia options (audio, video, animated graphics, etc.)?
- ☐ ☐ Does the site provide services, stories and sidebars not available in the print newspaper?
- ☐ ☐ Are users always a single click away from the home page or main section fronts?
- ☐ ☐ Is a concise index constantly viewable, from any page in the site?
- ☐ ☐ Does the flag appear atop every page, to remind users where they are?
- ☐ ☐ Are all images necessary? Tightly cropped? Compressed into GIF or JPEG formats?
- ☐ ☐ Does the site function successfully with all images turned off in the browser?
- ☐ ☐ If someone visits this site looking for a specific piece of information, will it be easy to find?
- ☐ ☐ When reading the text of stories, do users find helpful links that expand/explain topics?
- ☐ ☐ Can users search the newspaper's back issues? Are the archives reasonably complete?
- ☐ ☐ Does the site provide helpful links to related resources *outside* the newspaper?
- ☐ ☐ Is it easy to send e-mail feedback, news tips or letters to the editor?
- ☐ ☐ Most importantly: Will visitors tend to bookmark this site and visit it again?

SITE MANAGEMENT

- ☐ ☐ Does the site design feel current? (Has it been upgraded within the past year?)
- ☐ ☐ Are all stories time-stamped (or, at the very least, dated)?
- ☐ ☐ Are all stories and headlines well-edited?
- ☐ ☐ Do all pages share a well-coordinated system of navigation controls, typography and color style throughout the site?
- ☐ ☐ Are there annoying technical glitches (temperamental graphics, expired links, pages "under construction") that might frustrate users?
- ☐ ☐ Does the site provide newsroom phone numbers and addresses, for those who need to do more than send e-mail?
- ☐ ☐ Are the publication name, Web address, date and copyright notice posted on every page (and do they appear on all printouts of stories)?
- ☐ ☐ Does anything on this site violate someone else's copyright?

APPENDIX

EXERCISE ANSWERS: FUNDAMENTALS

1 That's a 94-point headline. Remember, you measure type from the *top* of an ascender to the *bottom* of a descender. If there's no descender, you need to approximate how deep one might actually be.

2

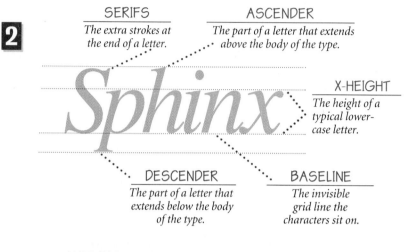

SERIFS
The extra strokes at the end of a letter.

ASCENDER
The part of a letter that extends above the body of the type.

X-HEIGHT
The height of a typical lower-case letter.

DESCENDER
The part of a letter that extends below the body of the type.

BASELINE
The invisible grid line the characters sit on.

Whasssuppp?

3 **Weight:** Bold (actually, it's an extra-bold weight called Helvetica Black)
Size: 36 points

Whasssuppp?

4
- ◆ We've italicized the type.
- ◆ We've tightened the tracking so the letters are now overlapping.
- ◆ We've expanded the set width (or scaling) of the type — to 150% of its regular width.

5 The following characteristics apply to the type in this box:
- ◆ Sans serif
- ◆ Light weight
- ◆ 12 point
- ◆ Condensed
- ◆ Tight tracking
- ◆ Flush left
- ◆ 14 points of leading
- ◆ Phrase is written downstyle (normal upper and lower case).

> Here is another
> typographic brain-teaser

6
- ◆ The type is now all caps.
- ◆ The type is now centered.
- ◆ The type is now reversed.
- ◆ The tracking has been increased.

HERE IS ANOTHER
TYPOGRAPHIC BRAIN-TEASER

7 The box is 13 picas wide, 3 picas and 3 points — or 3p3 — deep. (Remember, the horizontal measure is always given first.)

8 The box has a 1-point border.

EXERCISE ANSWERS: FUNDAMENTALS

Best picture: "Gladiator"
Best actor: Russell Crowe in "Gladiator"
Best actress: Julia Roberts in "Erin Brockovich"

● **Best picture:** "Gladiator"
● **Best actor:** Russell Crowe in "Gladiator"
● **Best actress:** Julia Roberts in "Erin Brockovich"

9 The text in the column on the right:
◆ Uses bullets (dingbats) to highlight each new category.
◆ Uses boldface type for each new category.
◆ Adds a few points (3) of extra leading between categories.
◆ Uses a hanging indent.

10 Type specifications can vary, depending upon the software you use (this headline was created on a Macintosh running QuarkXPress), but here are the key typographic components:

Larry *is flush left, 51-point lowercase Times. The spacing on both sides of the "a" has been tightly kerned.*

The ampersand *is flush left, 57-point Times. The set width (scaling) is expanded to 220%. It rests on the same baseline as the word "Curly," but it has been moved behind the "M."*

MOE *uses 76-point Helvetica Black. The set width (scaling) is expanded to 130%. The tracking is -23. The letters are screened 30% black.*

Curly *is flush right, 57-point Times Bold. The set width (scaling) is 100%. The tracking is -13.*

11 Drawing a dummy, as we've explained, isn't an exact science. But if you measured those components carefully, you'd draw a dummy like this:

EXERCISE ANSWERS: STORY DESIGN

1 A 5-inch story should be dummied either in one leg 5 inches long or in two legs 2.5 inches long. You should avoid dummying legs shorter than 2 inches, which rules out a 3-column layout for this story.

Though styles vary from paper to paper, this story might use a 1-30-3 headline on Page One, and a 1-18-2 (or 3) or 1-24-2 (or 3) at the bottom of an inside page.

On Page One, this 2-column layout might use a 2-30-2 or 2-24-2 headline. At the bottom of an inside page, it would become a 1-line headline: 2-18-1 or 2-24-1.

2 Your three best options are a 1-column format, a 2-column format and a 4-column format (in the 4-column format, the mug could be dummied at either the right or left side).

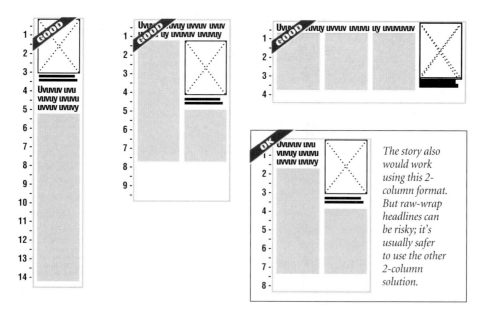

The story also would work using this 2-column format. But raw-wrap headlines can be risky; it's usually safer to use the other 2-column solution.

In a 3-column layout, the headline would need to run above the photo, with roughly a half-inch of text below the photo. That's not enough; you *must* dummy at least 1 inch of text in every leg. For this layout to work, you need either more text or a smaller mug indented into any of the three legs.

EXERCISE ANSWERS: STORY DESIGN

3 **1.** Avoid dummying photos between the headline and the start of the text. As a result, this story seems to begin in the second column.

2. The headline wraps clumsily around that left-hand mug. Ordinarily, all lines in a news headline should align evenly with each other (here, both lines should be 4 columns wide).

3. Mug shots shouldn't be scattered through the story, but grouped as evenly as possible. The two middle legs might work best in this layout.

4. Mug shots should run at the top of each leg of text, not at the bottom.

4 Because this is the day's top story — and because that photo grows more dramatic the bigger it runs — you should run the photo *at least* 3 columns wide. (A 2-column treatment of that photo would weaken its impact and make the story seem relatively insignificant.)

But because it's a busy news day, you can't afford to devote *too much* real estate to this story — which is what would happen if you ran the photo 5 or 6 columns wide.

So the best approach is one that uses the photo either 3 or 4 columns wide. Here are the most common, dependable design options:

This vertical design uses the photo 3 columns wide, which means about 5 inches deep. A solid, reliable solution.

This horizontal design also uses the photo 3 columns wide. The text fits snugly alongside the photo, and everything squares off cleanly (which isn't always easy to do).

Another good solution using the photo 3 columns wide, with an L-shaped text block. With a shorter story, those legs under the photo might be too shallow.

This design runs the photo 4 columns wide. The photographer will vote for this, since the big photo has drama and impact. But it does take up lots of space.

EXERCISE ANSWERS: STORY DESIGN

Here's what you get if you park the photos alongside each other. (Remember, Keith should stay to the left, facing into the story.) In the top example, Mick is 4 columns wide; Keith and the headline fill out the left-hand leg. Below, the two photos drift off the grid, but they're aligned horizontally so that a wide headline can run below them.

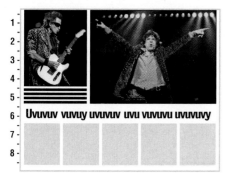

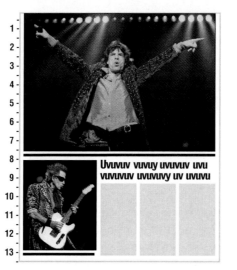

Here's what you get when you run Mick as big as possible. The problem you're left with is: What do I do with Keith and the headline? Keith needs to face into the story, so far left is best, with the headline parked alongside. This gives you neat, orderly, rectangular shapes.

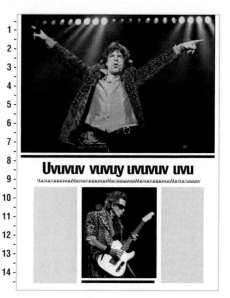

A very symmetrical solution. Everything is centered: Mick, Keith, the headline, even the text, indented and parked alongside Keith in a bastard width. Is that acceptable?

5 Which is the lead photo? It's gotta be Mick Jagger. He's the frontman and star of the band; it's a more dramatic, dynamic shot. And besides, that square-shaped photo of guitarist Keith Richards, when played huge, would probably make the layout clunkier-looking than the horizontal photo does.

6 **A.** There's no need to use a raw-wrap headline in this layout. That last leg of text might collide with text from another story. Instead, the headline should be one line, 4 columns wide across the top of the story.

B. The photo is poorly placed. It should never be dummied between the headline and the start of the text. Instead, scoot it over one or two columns to the right.

C. This story design is not rectangular. Assuming the photo belongs to that top story, the text should square off along the bottom edge of the photo. To do that, either the text must be deeper or the photo must be shallower.

 However: If both stories related to that photo, you could argue that the two stories and one photo together form one package, shaped rectangularly. And that would be acceptable.

D. Both photos are sized too similarly. One needs to be clearly dominant for this design to work best.

E. The reader is forced to jump blindly across the photo in the middle two legs. That's occasionally permissible for some feature pages (as in that top-right Rolling Stones page above), but it's awkward and risky for news layouts.

F. Headlines should generally cover only the text; this head is too wide. And photos should not be sized identically like this — one should dominate. *But* if this were a before/after sequence that needed to create visual impact, this treatment might be effective.

EXERCISE ANSWERS: PAGE DESIGN

1 The box below is 40 picas wide. Using 1-pica margins and gutters, here are the text widths for 2-, 3- and 4-column layouts:

2 Here are three acceptable layouts — and one that just won't work:

This layout lets you run both stories at their full lengths. The smaller story uses a raw-wrap headline; its second leg of text keeps the headlines from butting. This layout works best when used, as it is here, at the top of an inside page.

This layout uses a raw-wrap headline for the longer story; that third leg of text keeps both headlines from butting. The smaller story has been cut an inch to fit. This layout may look odd, but it satisfies the page's requirements.

This layout forces you to trim the smaller story by an inch while boxing it beside the first story. This treatment works best if the smaller story is a special feature; otherwise, avoid boxing stories just to keep headlines from butting.

Note: This common solution may have been your first response — but it won't work here. Those long horizontal headlines take up too much space and force you to cut the stories more than an inch apiece. They won't fit.

3 **A.** The page has no dominant element; all three stories have the same weight and impact, and all the headlines are the same size. In addition, everything is horizontal and static. The page needs more art, and that photo should not be dummied at the bottom of the page.

B. The photo is ambiguous — which story does it go with? Are all those stories at the top of the page related? You can't be sure. The boxed story on the left butts awkwardly against that banner headline (this is sometimes called an "armpit"). The lead story is not a rectangular shape. And the right-hand leg of text seems to come up an inch short.

C. The page is off-balance; all the art is on the left side, forcing four stories to stack up along the right edge. The page seems divided into two sections (for this reason, you should avoid deep gutters running the full depth of the page). And there's not enough text under the mug shot.

EXERCISE ANSWERS: PAGE DESIGN

4 The best solution is **B**; it's well-balanced and correctly organized. What's wrong with the others? In example **A**, the entire midsection of the page is gray and type-heavy, while the top of the page uses two small, weak headlines that could mistakenly be related to that big photo. In example **C**, the photo is ambiguous (it could belong either to the story alongside or below) and headlines nearly collide. In example **D**, the lead photo is ambiguous again, and both photos are bunched together.

5 Many page designers park promo boxes and indexes in the bottom right corner of the page, as "page-turners" that send you off into the paper. Using that philosophy, our first solution (below left) would be preferable. But if you choose to use the promo box as a graphic element to break up those gray stories, you could slide it toward the middle instead (below right). In either case, it works best at the very bottom of the page.

6 If the lead photo is strong, you should play it as big as possible — and in this case, there's room to run it 4 columns wide at the top of the page. Once that photo, headline and text are anchored, your options become limited for those other two stories. This solution balances the art, mixing horizontal and vertical shapes. The small story is boxed to keep the headlines from butting — but that's OK, since it's a "bright" feature that warrants special treatment.

EXERCISE ANSWERS: PAGE DESIGN

7 The solution at right is clearly the better of the two. It avoids any nasty collisions between stories (though those two headlines in the middle of the page do butt a bit — if you prefer, you can box the short feature on the right). That story with the mug shot is the only one that needed to be trimmed to fit; it lost an inch and a half.

Though those two left-hand legs run a bit deep, it's acceptable. To lessen the problem, you could either add a deck or park a liftout quote about halfway down (either in the right-hand leg or, even better, *between* the two columns, with the text wrapping around). Either way, you'd need to trim an inch or so from the text.

You could argue whether the layout at left succeeds or not — but since some designers will try it, we'd better discuss it.

The problem, of course, is in the upper-left corner: the juxtaposition of that mug shot and the lead story's headline. Is it confusing? Yes. Would it work better if we ran a column rule between those two butting stories or boxed the lead story? Maybe. But readers might still think that mug shot is connected to the headline beside it — which it isn't.

To make the text fit, we had to trim 3 inches from that left-hand leg. And, as you can see, we padded the lead story a little by adding a liftout quote and a deck.

EXERCISE ANSWERS: PHOTOS & ART

QUESTIONS ▶ 129

1 The two strongest images — the ones that say "woman jockey" in the most arresting way — are the race photo and the tight portrait. The other two should be supporting photos; they're informational, but not really interesting enough to dominate the page.

Here are three likely layouts using the race photo as the lead. If you've created a radically different page, congratulations — but check the guidelines on page 118 to be sure you haven't made some mistakes.

In this design, the race photo is used as the lead shot and runs across the top of the page, sharing a cutline with the photo below. (That's a photo credit floating below the cutline in the right margin.) The other two photos are stacked across the bottom of the page.

Note how the page is divided into three horizontal layers. In the second layer, the photo and text could have swapped positions, with that photo at the left side of the page — but then we'd have two similarly sized photos parked one atop the other. To avoid that, we could transpose the two bottom photos — but then the mug shot would be looking off the page. This layout, then, balances its elements well and avoids violating the directionality of the mug.

This layout isn't very different from the one at left. The race photo runs big across the top; together, the four photos form a "C" shape with the story tucked in the middle. (The page at left forms a backward "C.") The sidesaddle headline treatment provides an alternative to the more standard approach used at left. The headline and deck form one wide column; the text sits beside it. (That leg is pretty wide; it could be indented or run as two legs instead.)

One final note: All three of these layouts close with the shot of the jockey washing her horse. Does that seem like an appropriate "closer"? Or would we make a stronger exit by closing with the shot of the jockey walking off the track, splattered with mud?

This design, like the one at left, uses the small portrait to set up the headline; pairing those two elements shows instantly *who* is on the fast track. The cutline beside the mug also describes the action in the lead photo below. The other two photos stack along the bottom of the page, with the photo credit floating in the left margin.

Note how headline, text and two vertical photos are all given an extra indent.

If there's a drawback to this layout, it's that it uses a big headline, a big deck, big photos — and a small amount of text. At some papers, editors may prefer to downsize those photos and increase the amount of copy.

EXERCISE ANSWERS: PHOTOS & ART

These layouts represent three common design approaches using the portrait of the jockey as the dominant photo. That portrait is strongly directional. As a result, your options are more limited, since you must position the lead photo looking into rather than *off of* the page.

Getting all four photos to fit properly is tricky when you're working around a directional dominant photo. In this case, the race photo is used as a scene-setter at the top of the page. The lead portrait runs below it, sharing a cutline. The other two photos fit in the space below the lead photo.

Some would say this is a very clean design, with the art aligning on one side of the page, the text running in one leg alongside. Others might find it too off-balance, with a preponderance of weight on the left side.

That leg of text is a bit too deep. We're relieving the gray by indenting a liftout quote halfway down.

Here, the lead photo runs at the top of the page, and the other photos arrange themselves in the rectangular module below. Note how the shapes and sizes of the photos vary. This helps to avoid static, blocky configurations.

If there are drawbacks to this design, they would be:

1) The excessive white space along the left edge of the page, around the cutline and photo credit. That's hard to avoid, however. It's hard to size that horse-washing photo much wider. The cutline, too, is about as big as it should be.

2) The small amount of text. Playing these photos as big as they are doesn't leave much room for the story. This is a very photo-heavy layout.

Here's a page that gets a bit crowded at the top but seems to work anyway. Three photos are grouped together in a tight unit; the race photo, however, is set apart from the rest for extra emphasis (and to give the page more of a "racing" feel).

The racing photo also could have been dummied in the right-hand three columns instead of the center three; in that case, a 2-line, 2-column deck would have been preferable. But as it is, this design produces a more symmetrical page.

EXERCISE ANSWERS: PHOTOS & ART

 Several additional images would enhance this selection of photos. Among them:

◆ A stronger racing shot — one with clearer details and a greater sense of motion, perhaps shot from a more dramatic angle.

◆ More emotion — the thrill of victory, the agony of defeat. These four photos fail to capture any athletic dramatics.

◆ An interaction shot, showing how this woman jockey relates to her colleagues in a male-dominated sport.

◆ Detail shots — whips, boots, saddles, even trophies — especially some racing apparel or artifact that's unique or meaningful to this jockey.

3 Here are some of the major problems on these pages. Remember: When it comes to page design, tastes can be very subjective. You don't have to agree with every nitpick — but you should understand the principles that underlie our design guidelines.

The text snakes around the photos in a clumsy, unattractive way — and that first leg of text is way too deep. There's no white space designed into this page, which results in a layout that feels dense and crowded, more like a typical news page than a photo spread. And that feeling is reinforced by the sizes of the photos — the lead photo isn't quite dominant enough, and there's no sense of interplay among the rest of the pictures.

The lead photo faces off the page. If this page design were flopped, that problem could have been avoided. But there's still a problem with that big cutline blob in the center of the page. It's unclear which photo or photos it belongs to. (Does the bottom photo have a cutline?) There's too much trapped white space in the middle of the page. There's also too much white space above the headline. Finally, those two legs of text may be too thin — one wider leg would be better.

Overall, this page looks handsome, but there are some subtle problems. It's divided into three very separate chunks: 1) big photo, 2) gray text and 3) small photos. There's no interplay between elements; in fact, this seems like a formulaic page design that you could plug any photos into. In addition, there's no white space, and the shapes are too blocky and static. It's also difficult to determine which cutline describes the center photo in the bottom row.

EXERCISE ANSWERS: PHOTOS & ART

4 Cropping can be a subjective, emotional thing. So we sent this Tiger Woods photo to 50 professional photographers, editors and designers across the country to see how the "experts" would handle it. As you might have predicted, many moaned and groaned about the "lame, crappy picture" ("I'd hire a new photographer if this is his/her only shot," said one). But here's what most decided:

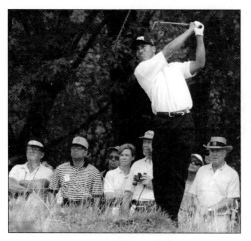

54%

This, or something close to it, was the most popular solution. Tiger is big enough to have impact, yet we see the diversity of his fans, too (the local aspect of the photo). Some of our participants complained that this shape was too dull and squarish. But others liked how this crop observed the "rule of thirds": a compositional principle that recommends positioning key elements one-third of the way in from the photo's edges.

23%

This is certainly a dramatic shape. But it omits most of the onlookers; if the story is about Tiger's huge following, aren't they a key element? Beware, too — the image will get fuzzy if you try to enlarge Tiger too much.

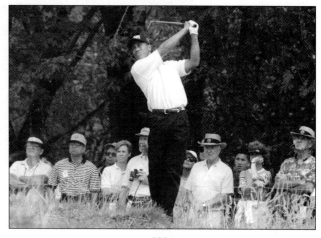

13%

This crop is virtually full-frame. We've cropped in a little on the sides and bottom, down a bit from the top. Many of those who chose this crop did so to avoid ending up with a big square, although a few argued that THIS is the way the photographer shot the scene — with Tiger in the middle, and greenery all around — so to respect the photographer, you should leave the shape alone. (One designer decided to crop this as an extreme horizontal, running the full width of the page, by slicing right through the necks of the spectators. Try it and see what you think.)

The remaining 10% cropped even tighter to create a closeup of Tiger.

As we looked at the winning crop (above left), we couldn't help noticing all that green, treesy dead space next to Tiger. Would it work to put the headline *there*? So we tried it, sent our new solution back to the experts and asked them to vote:

a) *Love it. Run it.*
b) *It's OK, but not the best solution.*
c) *No way. Keep your stinkin' type off the photos.*

Putting type on photos is still a controversial act in most newsrooms, as you can see by the breakdown of the voting:

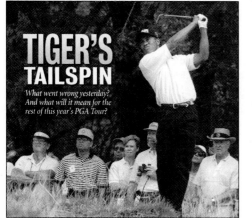

Love it. Run it — 50% of our respondents approved of the new headline. "Ten years ago I might have answered *no way*," said one designer. "But times have changed. Readers are more sophisticated about type on photos."

"No reader will be bothered by the type on the photo," said another. "Only photographers might take offense."

No way — 25%. Many of these were photographers. Most, however, said they might approve the idea if this were a feature story — but *not* if it were breaking news.

It's OK, but not the best solution — 25% quibbled about the headline size, font, color, gradient, etc., proving once again that *there is no greater force known to man than the desire to change someone's layout.*

WOODS WORDS

Comments from the cropping experts on that headline/ photo combination:

"The scary part about doing pages with a package like this is managing to not screw up the rest of the page and make the whole thing look too excessive."

"The heads indicate the photo is from yesterday, meaning it's LIVE DOCUMENTARY JOURNALISM. Keep your stinking type off of live documentary journalism!"

On the photo itself:
"Actually, all golf shots appear to be identical. Can't we just run the best photos over and over for eternity?"

THE PROPORTION WHEEL

Before there were computers — back in the Stone Age — we all used pica poles and proportion wheels. Some of us still do. So here's a quick history lesson to demonstrate how to resize photos the traditional way:

THE PROBLEM: HOW DO YOU CALCULATE NEW PHOTO SIZES?

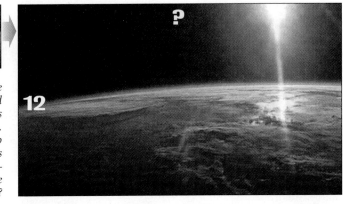

The small photo above is 7 picas wide and 4 picas deep (always state the width first). Suppose you want to enlarge it so that it's 12 picas deep — how wide will the photo then become?

THE SOLUTION: USING THE PROPORTION WHEEL

1 *Notice how there are two rows of numbers on this gizmo: an inner wheel and an outer wheel. On the inner wheel, find the original depth:* **4.** *Got it? Now turn the wheel so the* **4** *(the old depth) lines up with the* **12** *(the new depth) on the outer wheel. Remember: The inner wheel is the* **original** *size; the outer wheel is the* **reproduction** *size.*

2 *Now, without turning the wheel, locate the original width (***7***) on the inner wheel. It should be lined up against* **21** *on the outer wheel. That means the new width of your reproduction is* **21**.

3 *At some papers, you need to tell the production department the percentage of reduction or enlargement you need. Look in the window here for that figure: In this case, you'll be enlarging the photo 300%.*

Note: *The proportion wheel is marked in inches. But don't let that throw you. Your proportions hold true whether you're measuring inches, picas, light-years or cubits.*

OR IF YOU'D RATHER USE A CALCULATOR . . .

A proportion wheel is just a mathematical short-cut, a way of showing that the *original width* is to the *original depth* as the *new width* is to the *new depth*. If you'd rather do the math by hand or on a calculator, use this formula:

$$\frac{original\ width}{original\ depth} = \frac{new\ width}{new\ depth}$$

For our example above, you'd use this equation to find the new width:

$$\frac{7}{4} = \frac{x}{12}$$

7 is to 4 as what is to 12? To find the missing number, multiply the diagonals (7 X 12 = 84) . . .

$$4x = 84$$

. . . then divide that total by the remaining value (84 ÷ 4) . . .

$$x = 21$$

. . . to find the missing width.

GLOSSARY

To liven up this boring glossary, we've added a gallery of gorgeous, award-winning newspaper pages, beginning with Linda Shankweiler's classic "Blue Rose" design. Back when I first started out in newspapers, this was my favorite page — the one that inspired me to be a newspaper designer.

Agate. Small type (usually 5.5 point) used for sports statistics, stock tables, classified ads, etc.

Air. White space used in a story design.

All caps. Type using only capital letters.

Amberlith. An orange plastic sheet, placed over a pasted-up page, that contains shapes that the printer needs to screen, overprint or print in another color.

Anchor. An image, word or phrase (usually in color and underlined) that, when clicked, connects you to another Web page.

Application. A computer software program that performs a specific task: word processing, page layout, illustration, etc.

Armpit. An awkward-looking page layout where a story's banner headline sits on top of a photo or another headline.

Ascender. The part of a letter extending above the x-height (as in *b, d, f, h, k, l, t*).

Attribution. A line identifying the source of a quote.

Banner. A wide headline extending across the entire page.

Banner ad. An advertisement stripped across the top or bottom of a Web page.

Bar. A thick rule. Often used for decoration, or to contain type for subheads or standing heads.

Bar chart. A chart comparing statistical values by depicting them as bars.

Baseline. An imaginary line that type rests on.

Baseline shift. A software command that allows you to raise or lower the baseline of designated text characters.

Bastard measure. Any non-standard width for a column of text.

Bleed. A page element that extends to the trimmed edge of a printed page.

Blend. A mixture of two colors that fade gradually from one tint to another.

Body type. Type used for text (in newspapers, it usually ranges from 8 to 10 points).

Boldface. A heavier, darker weight of a typeface; used to add emphasis (the word **boldface** here is in boldface).

Border. A rule used to form a box or to edge a photograph.

Box. A ruled border around a story or art.

Broadsheet. A full-size newspaper, mea-

suring roughly 14 by 23 inches.

Browser. A software program (such as Internet Explorer or Netscape Navigator) that enables you to view Web pages.

Bug. Another term for a sig or logo used to label a story; often indented into the text.

Bullet. A type of dingbat, usually a big dot (●), used to highlight items listed in the text.

Bumping/butting heads. Headlines from adjacent stories that collide with each other. Should be avoided when possible. Also called *tombstoning.*

Byline. The reporter's name, usually at the beginning of a story.

Callouts. Words, phrases or text blocks

"These were the early years of poster-like, single-subject feature pages. The editor says we're doing a story called "In Search of the Blue Rose" — have at it! No Macs, lots of amberlith, antique presses and a patient composing room. All of us from those days at the Morning Call have fond memories of the magic that happens with the powerful chemistry and synchronized vision of the word people with the visual people."
— **Linda Shankweiler,**
designer

MARCH 31, 2000 ✦ **HOME NEWS TRIBUNE** ✦ EAST BRUNSWICK, N.J.

"Faced with four file shots of questionable quality and one day to pull off a special section cover, I (like most designers) turned to old boxing posters for inspiration. Actually, since all teams are of equal importance, this solution seemed like a natural. (Plus, I got to use spot yellow for the background!)"

— **Harris Siegel,**
managing editor/
design and photography,
Asbury Park Press

used to label parts of a map or diagram (also called *factoids*).

Camera-ready art. The finished page elements that are ready for printing.

Caps. Capital or uppercase letters.

Caption. A line or block of type providing descriptive information about a photo; used interchangeably with *cutline.*

CD-ROM. Computer disks (CDs) with huge amounts of memory, used for music, photo archives, font libraries, interactive games, multimedia programs, etc.

Centered. Art or type that's aligned symmetrically, sharing a common midpoint.

Character. A typeset letter, numeral or punctuation mark.

Clickable image map. A graphic or photo

containing "hot spots" that, when clicked, link you to another Web location.

Clip art. Copyright-free images you can modify and print as often as you like.

CMYK. An acronym for cyan, magenta, yellow and black – the four ink colors used in color printing.

Column. A vertical stack of text; also called a *leg.*

Column inch. A way to measure the depth of text or ads; it's an area one column wide and one inch deep.

Column logo. A graphic device that labels regularly appearing material by packaging the writer's name, the column's name and a small mug or drawing of the writer.

Column rule. A vertical line separating stories or running between legs within a story.

Compressed/condensed type. Characters narrower than the standard set width; i.e., turning this M into M.

Continuation line. Type telling the reader that a story continues on another page.

Continuous tone. A photo or drawing using shades of gray. To be reproduced in a newspaper, the image must be converted into a *halftone.*

Copy. The text of a story.

Copy block. A small chunk of text accompanying a photo spread or introducing a special package.

Copyright. Legal protection for stories, photos or artwork, to discourage unauthorized reproduction.

Crop. To trim the shape or composition of a photo before it runs in the paper.

Cutline. A line or block of type providing descriptive information about a photo.

Cutoff rule. A horizontal line running under a story, photo or cutline to separate it from another element below.

Cutout. A photo where the background has been removed, leaving only the main subject; also called a *silhouette.*

Deck. A small headline running below the main headline; also called a *drop head.*

Descender. The part of a letter extending below the baseline (as in *g, j, p, q, y*).

Dingbats. Decorative type characters (such as bullets, stars, boxes, etc.) used for emphasis or effect.

GLOSSARY

Disk. Used to store computer information: *hard disks* are the internal memories for computers; *floppy disks* are small, square, removable cartridges; *CDs,* also removable, store vast amounts of information.

Display headline. A non-standard headline (often with decorative type, rules, all caps, etc.) used to enhance the design of a feature story, photo spread or news package.

Doglegs. L-shaped columns of text that wrap around art, ads or other stories.

Dot screen. A special screen used to produce tiny rows of dots, thus allowing newspapers to print shades of gray.

Dots per inch (dpi). The number of electronic dots per inch that a printer can print – or that a digital image contains. The higher the dpi, the more precise the resolution.

Double burn. The process by which two different elements are overlapped when printed (for instance, printing type on top of a photo); also called *overprinting*.

Double truck. Two facing pages on the same sheet of newsprint, treated as one unit.

Download. To retrieve a document or image from the Web.

Downstyle. A headline style that capitalizes only the first word and proper nouns.

Drop head. A small headline running below the main headline; also called a *deck*.

Drop shadow. A thin shadow effect added to characters in a headline.

Dummy. A small, detailed page diagram showing where all elements go.

Duotone. A halftone that uses two colors, usually black and a spot color.

Dutch wrap. Text that extends into a column alongside its headline; also called a *raw wrap*.

Ear. Text or graphic elements on either side of a newspaper's flag.

Ellipsis. Three periods (…) used to indicate the omission of words.

Em. An old printing term for a square-shaped blank space that's as wide as the type is high; in other words, a 10-point em space will be 10 points wide.

En. Half an em space; a 10-point en space will be 5 points wide.

Enlarge. To increase the size of an image.

JULY 30, 1994 ♦ **ANCHORAGE DAILY NEWS** ♦ ANCHORAGE, ALASKA

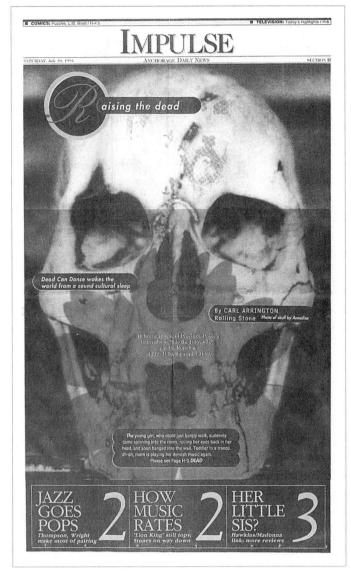

EPS. A common computer format for saving scans, especially illustrations (short for *Encapsulated PostScript*).

Expanded/extended type. Characters wider than the standard set width: i.e., turning this M into **M**.

Family. All the different weights and styles (italic, boldface, condensed, etc.) of one typeface.

FAQ. Frequently asked questions.

Feature. A non-hard-news story (a profile, preview, quiz, etc.) often given special design treatment.

Fever chart. A chart connecting points on a graph to show changing quantities over time; also called a *line chart*.

File size. The total number of electronic

"The Impulse section was designed to attract younger readers using bold, poster-like images and headlines. This page, on the music trio Dead Can Dance, is one of my all-time favorite covers. My goal was to engage readers on many emotional and graphic levels. Before they connect with the headline or text, they are already absorbing the conceptual content of the skull juxtaposed by the two ghosted faces of the band."

— **Galie Jean-Louis,**
former design director

GLOSSARY

JANUARY 17, 1991 ◆ **THE DETROIT NEWS** ◆ DETROIT, MICH.

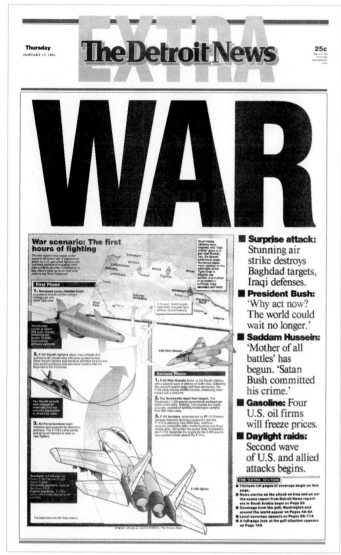

"War was coming. The Detroit News prepared exhaustively. After interviewing military experts, visual journalists created an explanatory graphic of a "first strike" scenario. When the U.S. attacked Baghdad, the graphic proved so accurate that the editors decided to build the front page around it. This graphic approach to a historic event was the first page in the 130-year history of The Detroit News that did not contain a narrative story."

**―Bob Peskin,
managing editor**

pixels needed to create a digital image, measured in kilobytes. The more pixels an image uses, the more detail it will contain.

Filler. A small story or graphic element used to fill space on a page.

Flag. The name of a newspaper as it's displayed on Page One; also called a *nameplate.*

Float. To dummy a photo or headline in an empty space so that it looks good to the designer, but looks awkward and unaligned to everyone else.

Flop. To create a backward, mirror image of a photo or illustration by turning the negative over during printing.

Flush left. Elements aligned so they're all even along their left margin.

Flush right. Elements aligned so they're all even along their right margin.

Folio. Type at the top of an inside page giving the newspaper's name, date and page number.

Font. All the characters in one size and weight of a typeface (this font is 10-point Times).

Four-color. The printing process that combines cyan (blue), magenta (red), yellow and black to produce full-color photos and artwork.

Frames. Web design tools that divide pages into separate, scrollable modules.

Full frame. The entire image area of a photograph.

GIF. *Graphic Interface Format,* a common format for compressed Web images, especially illustrations and graphics.

Graf. Newsroom slang for "paragraph."

Graph. Statistical information presented visually, using lines or bars to represent values.

Grayscale. A scan of a photograph or artwork that uses shades of gray.

Grid. The underlying pattern of lines forming the framework of a page; also, to align elements on a page.

Gutter. The space running vertically between columns.

H and J. Hyphenation and justification; the computerized spacing and aligning of text.

Hairline. The thinnest rule used in newspapers.

Halftone. A photograph or drawing that has been converted into a pattern of tiny dots. By screening images this way, printing presses can reproduce shades of gray.

Hammer head. A headline that uses a big, bold word or phrase for impact and runs a small, wide deck below.

Hanging indent. Type set with the first line flush left and all other lines in that paragraph indented (this text is set with a 10-point hanging indent).

Header. A special label for any regularly appearing section, page or story; also called a *standing head.*

Headline. Large type running above or beside a story to summarize its content; also called a *head,* for short.

High-resolution printer. An output device

GLOSSARY

capable of resolution from 1,200 to 5,000 dots per inch.

Hit. The term used for counting the number of visitors to a Web page. (Technically, it refers to the number of elements on each Web page; accessing a page with text and three images would count as four hits.)

Home page. The main page of a Web site, providing links to the rest of the site.

HTML. *HyperText Markup Language,* the coding used to format all Web documents.

Hyperlink. An image, word or phrase (usually in color and underlined) that connects you to another Web page.

Hyphenation. Dividing a word with a hyphen at the end of a line (as in these hyphenated lines here).

Image. In Web design, any photo, illustration or imported graphic displayed on a page.

Image size. The physical dimensions of the final scanned image.

Import. To bring an electronic image into a computer software program.

Indent. A part of a column set in a narrower width. The first line of a paragraph is usually indented; columns are often indented to accommodate art, logos or initial caps.

Index. An alphabetized list of contents and their page numbers.

Infographic. Newsroom slang for "informational graphic"; any map, chart or diagram used to analyze an event, object or place.

Initial cap. A large capital letter set at the beginning of a paragraph.

Inset. Art or text set inside *other* art or text.

ISP. An abbreviation of *Internet Service Provider;* a company that provides a connection to the Internet.

Italic. Type that slants to the right, *like this.*

Java. A programming language that features animation.

JPEG. A common format for compressed Web images, especially photos. Created by the *Joint Photographic Experts Group* and pronounced "jay-peg."

Jump. To continue a story on another page; text that's been continued on another page is called the *jump.*

OCT. 13, 1991 ◆ **THE WASHINGTON TIMES** ◆ WASHINGTON, D.C.

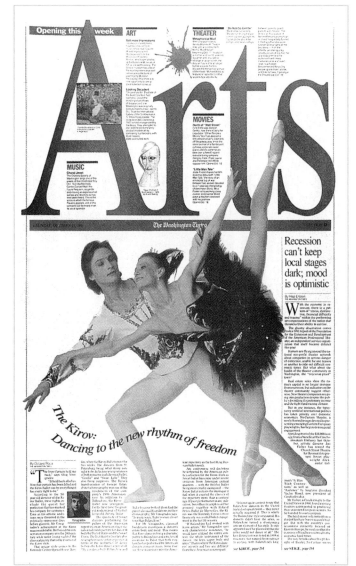

Jump headline. A special headline treatment reserved for stories continued from another page.

Jump line. Type telling the reader that a story is continued from another page.

Justification. Mechanically spacing out lines of text so they're all even along both right and left margins.

K: An abbreviation for "kilobyte," a unit for measuring the size of a computer file.

Kerning. Tightening the spacing between letters.

Kicker. A small, short, one-line headline, often underscored, placed above a larger headline.

Kilobyte. A unit for measuring the size of a

"In terms of its material quality, newsprint isn't very different from toilet paper. Even with the best pre-press and printing, it's a lousy medium for visual expression. My bold, oversized design style grew directly out of my frustration with the limitations of newsprint. I wanted to take full advantage of the one graphic opportunity offered by a 14"x 22" sheet of toilet paper: It's the size of a poster."

— **John Kascht,**
former art director

"En la edición de este día (Enero, 1, 2000) cuidamos todos los detalles y cada centímetro de la presentación y edición del periódico. Buscamos hacer un periódico de colección. Hicimos una exhaustiva edición de fotografías. Seleccionamos únicamente lo mejor de lo mejor. Sólo por esta edición cambiamos la fuente de nuestros titulares (Milenia e Interstate). En toda esta edición se hizo énfasis editorial en la visión del futuro de los distintos temas de cada sección."

Adrián Alvarez,
Editor Gráfico, EL NORTE

computer file equal to 1,024 bytes; abbreviated as "K."

Laser printer. An output device that prints computer-generated text and graphics, usually at a lower resolution than professional typesetters.

Layout. The placement of art and text on a page; to *lay out* a page is to design it.

Leader. A dotted line used with tab stops.

Lead-in. A word or phrase in contrasting type that precedes a cutline, headline or text.

Leading. Vertical spacing between lines of type, measured in points.

Leg. A column of text.

Legibility. The ease with which type characters can be read.

Letter spacing. The amount of air between characters in a word.

Liftout quote. A graphic treatment of a quotation taken from a story, often using bold or italic type, rules or screens. Also called a *pull quote.*

Line art. An image comprised of solid black and white – no gray tones, as opposed to a *grayscale* image.

Line chart. A chart connecting points on a graph to show changing quantities over time; also called a *fever chart.*

Lines per inch (lpi). The number of lines of dots per inch in a halftone screen. The higher the lpi, the more precise the image's resolution will be.

Logo. A word or name that's stylized in a graphic way; used to refer to standing heads in a newspaper.

Lowercase. Small characters of type (no capital letters).

Margin. The space between elements.

Masthead. A block of information, including staff names and publication data, often printed on the editorial page.

Mechanical. The master page from which printing plates are made; also called a *paste-up.*

Measure. The width of a headline or column of text.

Modular layout. A design system that views a page as a stack of rectangles.

Moire. An eerie pattern that's formed when a previously screened photo is copied, then reprinted using a new line screen.

Mortise. Placing one element (text, photo, artwork) so it partially overlaps another.

Mug shot. A small photo showing a person's face.

Nameplate. The name of a newspaper as it's displayed on Page One; also called a *flag.*

Offset. A printing process, used by most newspapers, where the image is transferred from a plate to a rubber blanket, then printed on paper.

Orphan. A short word or phrase that's carried over to a new column or page; also called a *widow.*

Overlay. A clear plastic sheet placed over a pasted-up page, containing elements that the printer needs to screen, overprint or print in another color.

GLOSSARY

Overline. A small headline that runs above a photo; usually used with stand-alone art.

Pagination. The process of generating a page on a computer.

Paste-up. A page assembled for printing where all type, artwork and ads have been placed into position (usually with hot wax). To *paste up* a page is to place those elements on it.

Photo credit. A line that tells who shot a photograph.

Pica. A standard unit of measure in newspapers. There are 6 picas in one inch, 12 points in one pica.

Pixel. The smallest dot you can draw on a computer screen (short for "picture element").

PMT. A photographic paper used for shooting halftones. Short for photomechanical transfer; also called a *velox.*

Point. A standard unit of measure in printing. There are 12 points in one pica, 72 points in one inch.

Pork chop. A half-column mug shot.

Process color. One of the four standard colors used to produce full-color photos and artwork: cyan (blue), magenta (red), yellow or black.

Proof. A copy of a pasted-up page used to check for errors. To check a page is to *proofread* it.

Pull quote. Another name for *liftout quote.*

Pyramid ads. Advertisements stacked up one side of a page, wide at the base but progressively smaller near the top.

Quotes. Words spoken by someone in a story. In page-design jargon, a *liftout quote* is a graphic treatment of a quotation, often using bold or italic type, rules or screens.

Ragged right. Type that is not *justified;* the left edge of all the lines is even, but the right edge is uneven.

Raw wrap. Text that extends into a column alongside its headline; also called a *Dutch wrap.*

Refer (or reefer). A line or paragraph, often given graphic treatment, referring to a related story elsewhere in the paper.

Register. To align different color plates or overlays so they're perfectly positioned when they print.

Resolution. The quality of digital detail in

OCTOBER 23, 1999 ◆ THE VIRGINIAN-PILOT ◆ NORFOLK, VA.

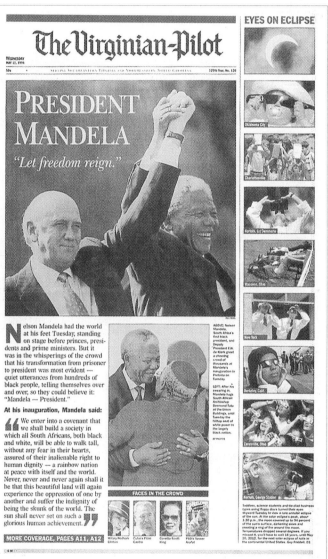

an image, depending upon its number of dots per inch (dpi).

Reverse. A printing technique that creates white type on a dark background; also called a *dropout.*

RGB. An acronym for *Red, Green, Blue* – a color format used by computer monitors and video systems.

Roman. Upright type, as opposed to slanted (italic) type; also called *normal* or *regular.*

Rule. A printing term for a straight line; usually produced with a roll of border tape.

Runaround. Text that wraps around an image; also called a *wraparound* or *skew.*

Sans serif. Type without serifs: This is

"I designed this page while serving as The Virginian-Pilot's front page editor after helping them launch a new design for the entire paper. There were no important local or national stories this day, but there was a historic event in South Africa and a peculiar event in the U.S. Both events provided great images. The most striking thing about this page is what's missing: There are no 'stories,' just headlines, photos, cutlines and quotes."

— Alan Jacobson

GLOSSARY

"The Yankees were rolling to their third world championship in four years, so I had plenty of practice in designing the Stein-brenner's-Evil-Empire-Goes-To-Yet-Another-World-Series-Preview. My favorite part of the page: the 2p3-by-7p flamingo silhouette of El Duque layered over the banner and the Yankee Stadium facade."

— **Wayne Kamidoi,**
art director/Sports

sans serif type.

Saturation. The intensity or brightness of color in an image.

Scale. To reduce or enlarge artwork or photographs.

Scaling. The overall spacing between characters in a block of type.

Scanner. A computer input device that transforms printed matter (photos, illustrations or text) into electronic data.

Screen. A pattern of tiny dots used to create gray areas; to *screen* a photo is to turn it into a *halftone*.

Serif. The finishing stroke at the end of a letter; type without these decorative strokes is called *sans serif*.

Server. A computer used for storing and sending users the pages that make up a Web site.

Shovelware. A condescending term for dumping information onto your Web site without changing its format or enhancing its content.

Sidebar. A small story accompanying a bigger story on the same topic.

Sidesaddle head. A headline placed to the left of a story, instead of above it; also called a *side head*.

Sig. A small standing head that labels a regularly appearing column or feature.

Silhouette. A photo where the background has been removed, leaving only the main subject; also called a *cutout*.

Site map/storyboard. A visual outline of a Web site showing the page-layout plan.

Skew. Text that wraps around a photo or artwork; also called a *wraparound* or a *runaround*.

Skyboxes, skylines. Teasers that run above the flag on Page One. If they're boxed (with art), they're called *skyboxes* or *box-cars;* if they use only a line of type, they're called *skylines*.

Solid. A color (or black) printed at 100% density.

Spot color. An extra color ink added to a page; also called *flat color*.

Spread. Another term for a large page layout; usually refers to a photo page.

Stand-alone photo. A photo that doesn't accompany a story, usually boxed to show it stands alone; also called *wild art*.

Standing head. A special label for any regularly appearing section, page or story; also called a *header*.

Style. A newspaper's standardized set of rules and guidelines. Newspapers have styles for grammar, punctuation, headline codes, design principles, etc.

Style sheets. Coding formats (size, leading, color, etc.) that can be applied instantly to selected text in desktop publishing programs.

Subhead. Lines of type, often bold, used to divide text into smaller sections.

Summary deck. A special form of deck, smaller and wordier than most decks, that capsulizes the main points of a story.

GLOSSARY

Table. A graphic or sidebar that stacks words or numbers in rows so readers can compare data.

Tabloid. A newspaper format that's roughly half the size of a broadsheet newspaper.

Tab stops. Predetermined points used to align data into vertical columns.

Tags. HTML codes, enclosed in brackets, containing formatting information, anchors, etc.

Teaser. An eye-catching graphic element, on Page One or section fronts, that promotes an item inside; also called a *promo.*

TIFF. One of the most common computer formats for saving scans (an abbreviation of *Tagged Image File Format*).

Tint. A light color, often used as a background tone, made from a *dot screen.*

Tombstoning. Stacking two headlines side by side so that they collide with each other; also called *bumping* or *butting heads.*

Trapped white space. An empty area, inside a story design or photo spread, that looks awkward or clumsy.

Trapping. A slight overlapping of color plates to prevent gaps from appearing during printing.

Tripod. A headline that uses a big, bold word or phrase and two smaller lines of deck squaring off alongside.

Typeface. A family of fonts – for instance, the Futura family, which includes Futura Light, Futura Italic, Futura Bold, etc.

Underscore. To run a rule below a line of type.

Uppercase. Type using capital letters.

URL. *Uniform Resource Locator;* the address used to locate a site on the World Wide Web.

Velox. A photographic paper used for shooting halftones. Also called a *photomechanical transfer,* or *PMT.*

Web. Short for the World Wide Web, or WWW.

Web page. A single document, with text and/or images, viewed with a browser.

Web site. One or more linked Web pages, accessed via a home page.

Weight. The boldness of type, based on the thickness of its characters.

Well. Ads stacked along both edges of the page, forming a deep trough for stories in the middle.

White space. Areas of a page free of any type or artwork.

Widow. A word or phrase that makes up the last line of text in a paragraph. (See *orphan.*)

Wraparound. Text that's indented around a photo or artwork; also called a *runaround* or *skew.*

WYSIWYG. *"What You See Is What You Get";* used to describe software that shows you exactly how documents should look when printed or viewed on a browser.

X-height. The height of a typical lowercase letter.

JULY 25, 1999 ♦ SAVANNAH MORNING NEWS ♦ SAVANNAH, GA.

"A convict had escaped from Toombs County Detention Center. While discussing how the prisoner climbed through a 10"-by-12" window, the graphic artist remarked how incredibly small a space it was. She folded a piece of paper to the approximate size and showed it to me. I was aghast, and I knew instantly that we had to show readers the improbable crawlspace. I had a mockup done in 15 minutes."

— **Joshua Gillin,**
designer

ACKNOWLEDGMENTS

The author is sincerely grateful to the following friends and colleagues:

◆ **Editing:** Patty Kellogg, without whose insight and enthusiasm this book would never have been born; Wally Benson (aka the legendary Johnny Palmer); Katherine Miller; Lois Breedlove; Clay Frost; Jessica Bodie; John McKinney.

◆ **Art and photography:** Patty Reksten (big thanks); Randy Cox; Contessa Williams; Steve Cowden; Fred Ingram; Michael Lloyd; David Sun; Joe Spooner; Ron Coddington; Bill Griffith; Steve Gibbons; Joel Davis; Randy Rasmussen; Ben Brink; Ross Hamilton; Steve Nehl; Kraig Scattarella; Lois Bernstein; Pat Minniear.

◆ **Contributors of pages & images:** Steve Dorsey; Harris Siegel; J. Ford Huffman; Alan Jacobson; Deb Withey; Wayne Kamidoi; Linda Shankweiler; John Kascht; Galie Jean-Louis; Josh Gillin; Adrián Alvarez; Matt Mansfield; Ryan Schierling; Bill Marsh; Jack Kennedy; Terri Fleming; Jim Denk; Warren Watson; T. J. Hamilton; Joe Hutchinson; Dennis Brack; Bill Pliske; Michael Price.

◆ **The McGraw-Hill staff,** especially Valerie Raymond and Jean Starr.

◆ And most of all, once again and always: my sweet Robin. I owe you bigtime.

CREDITS The following photographers, artists and publications were not previously identified in text or cutlines:

Front cover: Fred Ingram (Norman Rockwell parody); Steve Cowden (collage).

6: The Oregonian.

12: Photo by Michael Lloyd/The Oregonian; Web site of washingtonpost.com.

13, 30, 34, 42: Photo by Kraig Scattarella/The Oregonian.

14: All photos by PhotoDisc except tornado and nurse (Corbis).

15: The Oregonian.

17: Computer photo by Pat Minniear; all others by PhotoDisc.

20: Illustration by Steve Cowden.

22: The Chicago Tribune.

23: Weekly World News.

28: Babe Ruth photo from UPI/Corbis Bettmann; Truman photo, The Bettman Archive; Oswald photo by Bob Jackson; Vietnam photo by AP Photo/Eddie Adams/Wide World Photos; moonwalk photo by AP Photo/Neil Armstrong, NASA/Wide World Photos; Challenger photo by AP Photo/Bruce Weaver/Wide World Photos.

29: Photos by Steve Nehl/The Oregonian (top and left); Corbis (right).

32: The Orange County Register.

33: The Oregonian.

38: Photos by PhotoDisc.

46: Photo by Gregory Pace/Corbis Sygma.

50: Copyright 1985 Lois Bernstein/The Virginian-Pilot

51: Photo by Michael Lloyd/The Oregonian.

56: Photos by Corbis.

57: Photos by Max Gutierrez (top left); Robert E. Shotwell (bottom left and top right); Holley Gilbert (bottom right).

67: Photos by PhotoDisc.

68: Big mug shot by Randy L. Rasmussen/The Oregonian; other photos by PhotoDisc.

69: Photo by Steve Nehl/The Oregonian.

70: Photos by Ross Hamilton/The Oregonian.

82: The Orange County Register.

92: Both photos copyright Associated Press and Wide World Photo, Inc.

94: Photo by Corbis.

95: Gore photo by Michael Lloyd/The Oregonian.

99, 108: Photo by Steve Gibbons/The Oregonian.

100: Photos by Randy L. Rasmussen (top); Michael Lloyd (center and bottom).

109: Photo by Dana Olsen/The Oregonian.

110: Photo by Joel Davis/The Oregonian.

111: Photo by Tim Harrower.

112: Illustration by Joe Spooner.

114: Photo by Michael Lloyd/The Oregonian.

116: Photos by Tim Jewett/The Oregonian.

120: Photos by PhotoDisc except for the thinking man, by Corbis.

121: Phone lady photo by Corbis.

127: Balloon and squirrel photos by Corbis; other color images by PhotoDisc; Oswald photo by Bob Jackson.

128: Photos by PhotoDisc.

129: Photos by Randy L. Rasmussen/The Oregonian.

130: Photo by Bob Ellis/The Oregonian.

131: The Oregonian.

133: The Honolulu Star-Bulletin, RIP (left); The Detroit Free Press (center); The San Jose Mercury News (right).

134: Photo by PhotoDisc.

135: Logos by Jim Denk, The Detroit Free Press.

136: Midler photo by Dana E. Olsen/The Oregonian; Nixon photo copyright Associated Press and Wide World Photo, Inc.

147: Waste photo by Corbis.

148: Photo by Randy L. Rasmussen/The Oregonian.

149: The Minneapolis Star Tribune.

154: Rat graphic by Steve Cowden, The Oregonian.

158: Ecological art by Joe Spooner; burglar photo by PhotoDisc.

162: President photos courtesy of the White House; George Clinton photo by Marcy Guiragossian, Intersound.

168: Photos by The Oregonian.

169: Lizard drawings by David Sun; photo by PhotoDisc; page from The Oregonian.

171: Graphic courtesy of the KRT Media Service, Reprint Department.

172: The Oregonian (left); school shooting map courtesy of the KRT Media Service, Reprint Department.

173: The Oregonian.

174: Islam page courtesy of the KRT Media Service, Reprint Department.

175: The Minneapolis Star Tribune; Realpolitics page courtesy of the KRT Media Service, Reprint Department.

176: The Oregonian; art by Molly Swisher.

184-5: Times Publications (left); Asbury Park Press (center, lower right); The Anchorage Daily News (top right).

186: Photo from "The Tonight Show with Jay Leno," courtesy of NBC Studios.

190: (top right) Ron Coddington, courtesy of the KRT Media Service, Reprint Department; photo by Corbis.

191: Zippy the Pinhead mug courtesy of Bill Griffith.

192: Photo by Joel Davis/The Oregonian; page from the San Antonio Current.

193: Photos by Corbis.

194: Photo by Corbis.

195: Photo by PhotoDisc.

198: Photo by PhotoDisc.

201: Photo by Tim Jewett (top); Michael Lloyd (bottom).

205: Photo by Corbis.

208: USA Today.

218: Photo courtesy of Gilmore Research Group, Seattle, Wash., and Portland, Ore.

Back cover photo: Serge McCabe.